Editors

CHERYL ROBSON is a producer of several short independent films, most recently *Rock 'n' Roll Island*, selected for Raindance Film Festival. She worked at the BBC for several years and then taught filmmaking at the University of Westminster, before setting up a theatre company producing and developing women's plays. She also created a publishing company where she has edited over fifty books including co-editing *Celluloid Ceiling: women film directors breaking through*. She has published over 150 international writers and won numerous awards. As a writer, she has won the Croydon Warehouse International Playwriting Competition and has had several stage plays produced.
www.cherylrobson.net

REBECCA GILLIERON is an editor with over 15 years' experience working on fiction and non-fiction titles for independent publishers. Also a musician, she has played guitar, keyboards, drums and sung in a number of bands (Subway Sect, The Ghosts, Private Trousers), releasing three critically acclaimed albums on high profile UK and US labels with her band Wetdog and touring Europe and the US. Her next move is to start a record label 'Southend Records' in the town where she now lives.

First published in the UK in 2015 by
SUPERNOVA BOOKS
67 Grove Avenue, Twickenham, TW1 4HX
www.supernovabooks.co.uk
www.aurorametro.com

Counterculture UK © copyright 2015 Supernova Books

Production: Simon Smith

With thanks to: Ellen Cheshire, James Hatton, Alice Lumley, Tracey Mulford and Lucia Tunstall.

Cover design © 2015 Joe Webb www.joewebbart.com

ISBNs:
978-0-9566329-6-8 (print version)
978-0-9932207-1-5 (ebook version)

Printed in the UK by 4edge Limited

COUNTERCULTURE UK

– *a celebration*

edited by
**Rebecca Gillieron and
Cheryl Robson**

SUPERNOVA BOOKS

IMAGES

Sunflower Seeds, photograph by Mike Peel, http://www.mikepeel.net CC-BY SA-4.0, 2010

My Heroes, photograph by Karl Steel, CC-BY-NC-SA-2.0, 2012

Pussy Riot, photograph by Igor Mukhin, CC-BY-SA-3.0, 2012

Jenny Éclair, photograph by J. Mark Dodds, CC-BY-ND-2.0

Omid Djalili and Susan Murray, photograph © Claire Haigh, http://www.clairehaigh.co.uk

Susan Murray and Marcus Brigstocke, photograph © Simon Goodwin Goodwin Photography, http://www.goodwinphotography.co.uk/

Mark Edward, contemporary dance performance, two photographs © Idi Kazancel, 1996, pg. 75

Mark Edward, contemporary dance performances, four photographs © Stuart Rayner, 2007, pp. 79, 94

Dance floor, Wigan Casino, photograph © Glenn Walker-Foster/Sharron Wolstencroft, 1975

Occupy London tent, photograph by Neil Cummings, CC-BY-SA-2.0, 2011

Sally Potter OBE, © Rex Features

Bram Stoker International Film Festival 2103, photograph © Dean Geoghegan

Russell Tovey, photograph by Charlotte Pitchard, CC-BY-2.0, 2009

The Sex Pistols, Paradiso, Amsterdam, photograph by Koen Suyk, CC-BY-SA-3.0, 1977

Johnny Rotten on stage, Nationaal Archief, The Hague, CC-BY-SA-3.0 1977

The Stratford Rex, Public Domain, photograph by PedleySD, 2008

Westfield, Shepherd's Bush, photograph by Panhard, CC-BY-2.5, 2009

Stratford Centre, photograph, © Haley Hatton, 2014

The People Show No. 1, photograph, © Graham Keen, circa 1966

The People Show No. 128, photograph, © Zadoc Nava, 2015

Complicite rehearsal images, two photographs © Sarah Ainslie, 2015

The Last Adventures publicity image, © Hugo Glendinning, 2014

Tricia Cusden photograph, © Ronnie Temple, 2015

4

CONTENTS

Introduction

Rebecca Gillieron and Cheryl Robson

'Tomorrow belongs to those who can see it coming.'
 – David Bowie

What exactly is *counterculture*? The term suggests resistance to the norm and has come to encompass everything from alternative lifestyles to large movements advocating social change. Today, in advanced Western democracies, where mass protest seems to have little impact on government policy, the value of group resistance needs to be re-examined. Simultaneously, the ways in which individuals can have a voice and influence society have mushroomed as a result of the new digital age.

The term 'counterculture' was originally used by Theodore Roszak in *The Making of a Counter Culture: Reflections on the Technocratic Society and its Youthful Opposition* (University of California Press, 1969). His analysis of technocracy and its opponents was highly perceptive, identifying a shift from social activism towards a 'politics of consciousness'.

Alternative groups and communities have existed throughout the ages, including travelling communities who have created and followed their own traditions and cultures for centuries, regardless of larger society and its mores. Religious communities have also long existed, following a spiritual path laid down by founding members which is often critical of the fast pace and competitive nature of the outside world. A more recent example is the Findhorn community and ecovillage founded in 1962 in Scotland. Its community vision is to be:

> '... an international centre for holistic learning, helping to

unfold a new human consciousness and create a positive and sustainable future.'[1]

Free Love?

In the UK, as with the US, the period associated most closely with the emergence of counterculture was the decade of free love – the swinging 60s. It wasn't only the introduction of the contraceptive pill in 1961 – called 'the greatest scientific revolution of the 20th century' by some commentators – which made the sexual revolution possible, it was also the emergence of youth culture creating a self-identifying group of young people primed to rebel against the post-war lifestyle of their parents.

With the advent of psychedelic drugs, pro-peace issue-based campaigns like CND and the anti-Vietnam protests, and with an incredible cocktail of radical literature, art and music being created, this decade was an explosive time for 'the underground', which was the term used then to describe the countercultural scene.

In publishing, along with the many local publications being produced, Felix Dennis' *Oz* magazine and London's *International Times* were proving that, although apolitical and suspicious of mainstream political parties, counterculture was largely dominated by leftist, radical values. In art, Situationist artists were advocating lifestyles other than those promoted by capitalism (in the UK Ralph Rumney was the sole member of the London Psychogeographical Association) and the Fluxus movement was set on destroying the boundaries between life and art altogether – as documented by 'Fluxbritannica' at the Tate in 1994.

Pink Floyd were introducing trance to the nation and even the global phenomenon of the Beatles, whose origins were in purely crafted pop, embraced psychedelia with a vengeance in both their music and recreational drug-taking. In 1969, David Bowie's first major hit 'Space Oddity' was inspired by Kubrick's film *2001: A Space Odyssey*, and introduced us to the first of his stage personae, Major Tom. In 1972 he appeared on *Top of the Pops* in his androgynous Ziggy Stardust persona, singing 'Starman'. The subsequent personae and changes in style which he adopted over the next four decades, refusing to be pinned down by critics, encouraged his fans to create their own styles and identities too.

Bowie's influence on performance, design and popular culture was far-reaching, as the recent exhibition at the V&A Museum in London testified.

Off-beat clubs like The Colony Room in Soho, established by lesbian Muriel Belcher in 1948, offered creative hubs for artists and writers such as George Melly, Isabella Blow, Jeffrey Bernard, Francis Bacon and Lucien Freud. Later a younger generation including Damien Hirst, Tracey Emin and Will Self frequented the venue until it closed in 2008 – then the action moved on to the Groucho club nearby.

Throughout the country, the established repertoire of regional theatres was being challenged throughout the 60s and 70s with new works by political playwrights, advocating equality and social change. Today, political theatre is popular again, as audiences crave new visions for the future and satirical renderings of the present. Vicky Featherstone, Artistic Director of the Royal Court Theatre has said of a recent season of plays on the theme of revolution:

'… in these plays you can't hide from the questions that the writers are asking – about the individual's ability to make change happen, about whether there is a political will to effect genuine change. They are often not party political, but they can be anti-establishment. And I think that comes from a huge unease about the status quo.'[2]

What Remains of the 60s' Legacy?

While economists argue whether austerity is the right strategy to enable nations to rebound from the global financial crisis, working people in the UK, as elsewhere, bear the brunt of the downturn as governments reduce benefits and working tax credits. Coupled with youth unemployment, the gentrification of the inner cities and rising rents, few young people today have the means to leave home and live in rented accommodation while they develop their artistic skills and experience. But the internet is a new tool for millennials to use to express their discontent and creative talents. Whether grouping themselves with other like-minded individuals on Facebook, organising events or protests, or blogging about the absurdities of modern life, there is a generation of young people which is well aware of the failings of politicians and the

insatiable, planet-despoiling greed of modern corporations.

Although the dominance of the corporate/industrial/military establishment might seem unassailable, resistance to its beliefs and values is growing. The desire for freedom from government meddling as well as from the 'mindless regulations served up by Brussels' is very widespread. For those demoralised by the uncaring nature and backwardness of recent government policies, journalist Zoe Williams writing in the *Guardian* asks if there is any point in resistance but still calls for us to re-imagine society:

> 'There is nothing in the immediate term that we can do, but nothing here that we can't use: the very baseness of this government's agenda is the rock bottom from which we can finally ask fundamental questions about how we want society to look. Resistance is not futile: but it's just the beginning.'[3]

Multicultural Britain

> 'I think some of us submit to the dominant power or culture at the time. I think it is important to keep where you are from alive.' – Lowkey, UK hip-hop artist

A dominant 'way of life' is not easy to identify in all parts of Britain today. In 2003, David Walliams' and Matt Lucas' *Little Britain* TV comedy series excelled at satirising small-mindedness. It parodied social types with fixed attitudes and limited beliefs. In 2010, the 'scripted reality' TV show *The Only Way is Essex* is exploring similar social types while making celebrities of its cast.

New Labour's ideal of multicultural Britain has recently been discredited by members of the Left such as Trevor Phillips, former head of the Equality and Human Rights Commission, as well as in the right-leaning press such as the *Daily Mail*. The mass migration of peoples caused by war, conflict and poverty is causing problems in all the countries of resettlement, as diverse ethnic communities live by different beliefs and values to their host cultures. In the *Independent*, columnist Yasmin Alibhai-Brown reflects wryly on Britain's short-lived love affair with the exotic culture arriving on its shores, referring to the '3S' model of 'saris, samosas and steel drums'. As the growing popularity of UKIP attests, anti-immigrant sentiment is rife and will probably continue

to grow while the economy is stagnant and resources scarce.

Despite this recent antipathy to multiculturalism, there are many artists whose cultural heritage has enriched British culture, such as the hijab-wearing, Muslim hip-hop rebels *Poetic Pilgrimage*, African theatre companies IROKO, Tiata Fahodzi and the black-led Talawa, MCs like Logic and the aforementioned Lowkey, comedians like Shappi Khorsandi and Omid Djalili, filmmakers like Steve McQueen and Gurinder Chadha, authors such as Hanif Kureishi, Zadie Smith and Andrea Levy, poets such as John Agard and Benjamin Zephaniah – to name a few. Not forgetting modern artists such as Tracey Emin and Chris Ofili, the Turner Prize-winning painter who was one of the few artists of African/Caribbean descent who was counted amongst the YBA movement of the 90s, and more recently Lynette Yiadom-Boakye whose portraits of imaginary black people were exhibited at the Serpentine Gallery.

There are many fantastic new venues worthy of mention, which aim to showcase culturally diverse work, such as London's black-led Bernie Grant Arts Centre in Tottenham and Rivington Place in Shoreditch, as well as those which have already made their mark like Rich Mix in Bethnal Green and 198 Gallery in Brixton. They all make it their mission to highlight the experiences of different ethnic minorities within the UK and explore the complexities of multiculturalism today, as a hybrid of values and cultural preferences are created by third-generation immigrant communities. For some modern Muslim women, for example, wearing a hijab may be countercultural, because it rejects cultural imperialism and is an assertion of feminism on their own terms.

Social Justice

Another important legacy of the 60s is that the desire for social justice and equality continues. Wider than male/female equality, the drive for equality has motivated the LBGT community, ethnic minorities, disabled people and those with mental health issues to actively pursue their rights and to seek expression through the arts. One example of the arts positively influencing social discourse around disability was the installation of Marc Quinn's marble sculpture titled *Alison Lapper Pregnant* on the fourth plinth

in Trafalgar Square from 2005–2007.

As was demonstrated in the opening ceremonies of both the Olympics and the Paralympics in London in 2012, the UK has much to be proud of with regards to its diverse arts and culture. According to a 2013 report by the Centre for Economics and Business Research, businesses in the arts and culture industry generated £12.5 billion in turnover in 2011, despite both arts funding and consumer spending on the arts declining. Acting as a huge attraction for tourism too, the aggregated estimate for tourist-related expenditure in the UK is around £856 million. Overall, the creative industries support around 5% of UK employment, 10% of GDP and 11% of exports.

The arts can have a transformative effect; they can help regenerate rundown areas throughout the country and bring vibrancy and colour back to communities. Although proven to encourage creativity, communication skills and a sense of well-being, arts education and arts subsidies are under constant attack in Britain today. Will future artists be able to achieve high quality work and risky innovation without the same level of investment? Will British cultural life be stifled as a result? Teenagers in suburban Britain now turn to their electronic devices for the latest countercultural experience rather than gathering together to make music or dance at an illegal rave.

The Digital Revolution

There is no question that the impact of the internet on the development of counterculture across the globe has been phenomenal. As a person who suffered tremendously due to his sexual orientation, it seems fitting that Alan Turing, who helped pave the way for the invention of the computer, also contributed to the rise of the internet and a new means for individuals to form instant communities at the touch of a button.

It is no exaggeration to state that Turing, together with other computing giants like John von Neuman,[4] Konrad Zuse,[5] Linus Torvalds,[6] Dennis Ritchie,[7] Ken Thompson,[8] Sir Tim Berners-Lee[9] – and then Bill Gates and Steve Jobs, contributed to the development of a model of information storage and communication – the internet – which hasn't 'just' revolutionised

virtually every aspect of the way we live our lives but has also literally saved lives. In the essay on social media in this book we find examples of lonely teenagers, often the victims of bullying, who have narrowly avoided suicide by forming friendships online. Within the essay on LGBT culture there are further examples from individuals who have found the strength to 'come out' and even meet partners online, citing the internet as their means to find social inclusion and overcome feelings of extreme isolation.

The internet not only allows artists, musicians, publishers, comedians, filmmakers, social or political campaigners and more to distribute their message or art form amongst far larger numbers than they might do otherwise, it also encourages individuals to participate in artistic, social or political communities.

Filmmakers can use YouTube to trial shorts of their film projects before seeking investment, musicians can use this channel and others (Myspace, then Bandcamp, then SoundCloud and so on) to launch careers or, alternatively, cement an underground cult status, and artists such as Banksy can cut out the middle-man by setting up online galleries exhibiting their work. Those without the funds to rent a physical space to exhibit work can do so online. One example is LondonArt (www.londonart.co.uk), which claims to be the UK's biggest online gallery, and was founded with the aim of bypassing the elitism of the art world and producing a more inclusive art-buying experience. Its founder, Paul Wynter, says,

> 'Online galleries democratise the art-buying process. They make original art available to a wider audience and give more artists the opportunity to show their work.'

New Age: New World
Perhaps the real significance of the internet lies in the outlook it engenders: the positive influence of a new world-view, an ethos of information sharing, as well as a belief in the possibilities for reform that the internet creates. Another aspect of the internet has been the ability of individuals to challenge the propaganda of both governments and corporations by exposing lies and misinformation, the most famous platform being Wikileaks.

In his article 'Wired to the counterculture', published by *Le*

Monde diplomatique, Philipe Breton joins those who draw parallels between the ethos of internet users today and the ideals that fuelled the original countercultural revolution.

> 'The continuity is striking: the world of the internet is, in its own way, today's counterculture – a space in which you can leave the "ordinary world" behind you. People who spend their time on the Net are in a sense the "drop-outs" of today, and many of the descriptions of young surfers remind you strikingly of Kerouac's "desolation angels". In the 1960s you "hit the road" to get a different, more spiritual sense of what life was about. Today you surf the "information highways" of the Net.'

This Collection of Essays

The value of this book lies is in its overview of the many strands of counterculture which have developed to express creativity, resistance and revolt. Britain's countercultures weave a densely interconnected fabric and share a long and continuous history. The 1960s was definitely a high point for new ideas, innovation and technology, as well as being a time when young people had access to free university education for the first time and were testing boundaries and exercising new freedoms. And the will to disrupt and change society still lives on in younger generations, as evidenced by punk and the Occupy movement. Individuals continually create new subcultures, challenge the mainstream in new ways and new places, and they will keep doing so as they try to translate their desire to create a better world into action.

Visionary Vacuum

> 'It's the same each time with progress. First they ignore you, then they say you're mad, then dangerous, then there's a pause and then you can't find anyone who disagrees with you.' – Tony Benn

The lack of vision from our politicians and the limited choices on offer to young people today are disappointing. These may contribute to a desire to escape to other more exotic places, where the adventure of armed conflict or the certainty of religious dogma may seem more attractive. While government ministers

berate the value of arts subjects, surely it is creative thinkers possessing both humanity and imagination who will envisage a better future for us all. Banks and financial institutions are now actively seeking to recruit graduates from the arts and humanities. They think these individuals may be better placed to understand that ethical values matter when making decisions about how to do business.

With declining influence on the world stage and the London financial hub being threatened by restrictions from the EU, the UK government is reorienting itself towards the burgeoning markets of Asia. To compete on an equal footing, countries like the UK may need to drive down wages and reduce benefits significantly. At the same time governments must invest to keep pace with and grow the new knowledge-based economy through design, innovation, new technology, sharing networks or more traditionally, selling services and expertise.

Paul Mason writing in the *Guardian* believes that the new 'sharing economy' will lead to a post-capitalist age in which information will be freely available and those seeking to limit or suppress it, such as the authorities in North Korea and China, will fail. He points out that information technology has already changed both when and how we work, that automation will reduce the need for workers even further and that cooperative ventures based on volunteers such as Wikipedia offer us a new model for the future.

> 'The main contradiction today is between the possibility of free, abundant goods and information; and a system of monopolies, banks and governments trying to keep things private, scarce and commercial. Everything comes down to the struggle between the network and the hierarchy: between old forms of society moulded around capitalism and new forms of society that prefigure what comes next.'[10]

As we transition to a new age in which work becomes more collaborative, information is shared globally and capitalist market forces no longer hold sway, new countercultures will appear, grow, fade and disappear to help us come together and find our way.

ART

How the Rebels Got Rich

Mark Sheerin

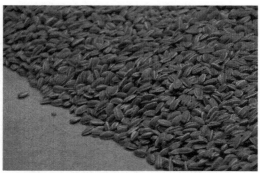

Sunflower Seeds by Ai Weiwei, at the Tate Modern

Art can be dangerous. It can be subversive. Artists throughout the centuries have risked imprisonment and worse for expressing unacceptable ideas. Chinese artist Ai Weiwei is one well-known recent example, but in the last decade, many others have been arrested for upsetting established ideas such as American Spencer Tunick whose art involves photographing crowds of naked people in public places, Indian artist M.F. Husain who went into exile after receiving death threats for his portrayal of Hindu gods and goddesses and Zimbabwean artist Owen Maseko who was arrested for his critical paintings of Robert Mugabe. All this seems a far cry from the almost sanctified auction rooms in major cities where rare art works change hands for ever greater sums.

In the last fifty years, the collecting of fine art has become big business. It has led to the appearance of two art worlds: one in

which sincere, committed artists struggle to get their work seen and heard, where academics and press officers write dense texts in support of well-researched and soul-nourishing exhibitions; then there's the commercial side of the art world in which works by well-known artists are bought and sold for eight figure sums to end up in banks, city halls and the collections of the super-rich.

Art is the planet's sexiest investment, a realm in which subversion and style are packaged up and sold to the one-percenters. (But that's not as strange as it may seem. To get really, really rich, and to make really, really good art, both require a spirit of anarchy. Art and those who can afford it are seemingly made for one another.)

This chapter will look at subversive contemporary art in the UK since the 1960s. The last fifty years have been nothing if not interesting. In this time we have witnessed some of the most controversial artworks ever made. Artists have earned furious headlines in the popular press. Homegrown talents, rebels of the art world who are not afraid to challenge the dominant values of their time, have arguably become more famous than any of their indigenous forebears. And we must thank them for transforming Britain from a relative backwater of visual culture into a world leader with a capital to rival New York.

In this chapter we'll look at the ways in which cutting-edge art became the mainstream and the way cutting-edge artists became the establishment. And we'll look at how craft became cool, and how, using the web, crafters have created a worldwide movement. Along with the YBAs we'll look at the Turner Prize and its impact on the nation's consciousness. And we'll look at those who make art on the street, and those who live on the social margins. We'll also explore a traditional art movement, Stuckism, which bucks the trend for idea-based art and demonstrates that figuration and painterliness could be the most defiant qualities around. Finally, we'll look at the opportunities for difficult artists to find an audience via the web and question the prevalent serious and often lo-fi aesthetic which is emerging with the newest generation of artists.

The current period of austerity in Britain has an intriguing

antecedent. As late as the 60s the UK was still emerging from a period of post-war rationing and rubble. Art could go one of two ways: technicolour splendour with the psychedelic movement or the terse cerebral statements made by proponents of conceptual art. The former was drug-induced, music-influenced and utopian. What remains of the latter tend to be the monochrome photos or typeset record cards on which the most serious artists of their age documented their often fleeting actions.

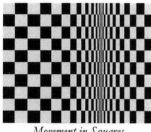

Movement in Squares
by Bridget Riley

What's more, the two movements are roughly sequential, with an explosion of hope in the summer of 1967 followed by disillusion and a more militant approach to art. But although the current landscape owes a great debt to these two countercultural strands, few of the artists are household names. Perhaps only Bridget Riley, whose abstract paintings could well be described as 'trips', qualifies as a 'famous psychedelic artist'. A 1971 appearance at the Old Bailey ensured the editors of the controversial issue of *Oz* magazine with a certain notoriety, but little lasting glory. Conceptual artists, and their close relations, minimalists, tended to fly under the radar.

Then, as now, however, it took little to bait the mainstream media. Feminism was, in the 1970s, perhaps the most subversive game in town. The ICA drew fire in 1976 by showing a six-part installation by US artist Mary Kelly about the birth of her own child. What irked the tabloids was the inclusion of a series of her young son's dirty nappies. 'Post-Partum Document' took half the decade to make and the results are as cerebral as they are visceral.

In many ways the punk movement was anti-art. For subversion at the end of the 1970s one might find most of it in the growth of zine culture which, thanks to cheap photocopying, took off at the same time as British music got stripped down. The 80s were the last real years of the avant-garde. Academia was ablaze with debates about race, gender, sexuality and AIDS. Given this concern with identity politics it is perhaps no surprise that

performance art, including theatre, dance and multimedia became what was called (by *People* magazine) the decade's defining art movement. But given that live art is by definition by the few for the few, it is little surprise that by the end of the upwardly mobile 1980s, unless you were buying it, contemporary art in Britain was at its least visible.

Brit Art Hits the World Stage

In the economic upswing of the 1990s, artists were experiencing a moment of cultural confidence that felt both very new and very reassuring. Artists were taking control of their own careers, but doing so in the spirit of 1970s punk or the upwardly mobile 1980s: the DIY ethic and entrepreneurial streak of Brit art in the 1990s was a blend of the underground and a Thatcherite love of private enterprise. And like the Pistols at the 100 Club, there was one show which came to embody the zeitgeist. The name was 'Freeze' in 1988 and the venue was a warehouse not a gallery – the kind of place we had come to expect a rave, rather than an exhibition. The impresario, meanwhile, was an undergraduate called Damien Hirst. 'Freeze' was to hijack the art world's imagination and send a fleet of cabs to ferry the capital's influencers to the Docklands. Charles Saatchi came, notoriously set the precedent for buying work from Young British Artists, and a movement was born.

This was no longer the dead serious conceptualism of the 1970s. This was the overheated market-driven 1980s. If there was one creative endeavour in which we led the world it was advertising. And so an adman would push up and build demand for the most market-friendly generation of artists the world had so far seen. A businessman, albeit a highly creative one, rather than a critic or curator, was in the driving seat of art history, as Charles Saatchi liaised with the Royal Academy to stage a blockbuster exhibition of these new artists in 1997. 'Sensation', a word the former copywriter may have once used to describe, say, a soft drink, was now the byword for a group of artists so controversial they bordered on the offensive.

That show did what it said on the tin and the tabloid press, who once ignored art, wrote outrage pieces about Marcus Harvey's portrait of Myra Hindley (overleaf), painted entirely in child's

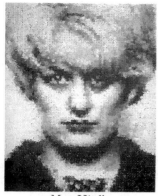

Myra Hindley
by Marcus Harvey

hand prints and the equally disturbing child mannequins by Jake and Dinos Chapman, which traded noses for penises, mouths for anuses. It was a long way from, say, Sir Joshua Reynolds.

By the time 'Sensation' was launched the Chapman Brothers and Tracey Emin had been brought into the fold. The number of great careers this show launched is remarkable. Some criticised the RA's seal of approval, for what they saw as canny marketing by Saatchi. But we should remember that the collector has opened doors to the public for free in three different venues since 1985 and in 2010 tried to gift his £30 million collection to the nation. Saatchi also gets credit for helping to bring to life one of the most iconic artworks of the 20th century; Damien Hirst's formaldehyde shark began life as an expensive doodle on the back of his proverbial fag packet. (But note: 'The Physical Impossibility of Death in the Mind of Someone Living' might have frightened a few children, but it will never pose a challenge to the state.)

YBA Dissent: More Than Just a Pose?

Though many were quick to judge the new Brit artists as attention seeking, celebrity hungry and lacking serious intent, there was still a certain political aspect to the YBA movement. 1997 saw the election of the first Labour government in eighteen years. Fashion, music and art came together in a way which enhanced British industry. Pop stars were invited to Number 10 and our headline-grabbing artists were hitched to the Cool Britannia brand. It was the first and perhaps last time a UK government would manage to co-opt what was still essentially a rebellious practice. Such was the importance of art to our national identity that money was found to build the Tate Modern (£134m) and London became the capital of the art world, with a number of young turks (including Gavin Turk) as the darlings of a global art

media. And to think British art was once on the staid side. It is all too easy to believe a tale in which Sir Winston Churchill said he would 'kick Picasso up the arse'. It would have astounded the great statesman to come across Tracey Emin's unmade bed.

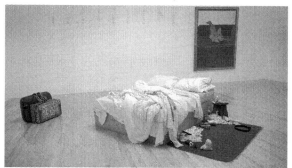

My Bed by Tracey Emin, at the Tate Gallery

But it wasn't solely through political association that the movement was influential. It inspired other artists, outside their studios, not just in terms of the content of their work. Cliff Lauson, co-curator of the 2011 Tracey Emin retrospective at the Hayward Gallery, London, weighs up the legacy of the YBAs. 'I think a number of the YBAs were quite subversive in the sense that they came from nowhere,'[1] he says. 'They were enterprising and established their own careers rather than depending upon the art establishment to accept them.' He describes this as a kind of 'institutional subversion,' which is quite different from the political or artistic variety, in that the focus was on rejecting the traditional means of establishing yourself as an artist. These were the times to get an agent or a gallery to represent you, and target the major London galleries as the 'be-all-and-end-all'. These emerging rebels of the art world stuck two fingers up at the art establishment and made their own rules.

Old Hands Cash In, New Talent Emerges

In the coming decade, the market would continue to throw up surprises. Damien Hirst bought back all his work from Saatchi in 2003 and in 2008 cut the dealers out of the loop by selling direct to his buyers with an auction at Sotheby's. This was at once highly

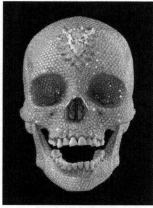

For the Love of God
by Damien Hirst

independent and 'therefore hip', and also deeply in bed with worldwide collectors. Hirst has said he makes art with whatever he finds at hand and in 2007, it was money which surrounded him as he brought a £50 million diamond encrusted skull into the world. UK art's *enfant terrible* had just made the most expensive artwork of all time. It was radical, but not quite right. Sensing he could go no further in this direction, Hirst returned to painting in 2009 with a show at the Wallace Collection. It came under fire from many critics who questioned whether it was his fame rather than his talent for painting that had secured the show.

Tracey Emin, meanwhile, was canny enough to maintain a drawing practice. In 2011 she was made Professor of Drawing at the RA. Works on paper and embroidery have underpinned the Margate artist's career and put the seal on her 2011 retrospective at the Hayward Gallery. In 2012, Damien Hirst, who once said he'd never show at the Tate, did just that. In the year London hosted the Olympic Games, the city swung like it was 1997 all over again; the cultural Olympiad, which brought art to the rest of the UK, spelled a coming of age for a dynamic contemporary art scene which began back in the late 1980s.

But as artists got richer and more professional, the next wave made an attempt to kick against that. A new craft sensibility came to the fore following the millennium. And the Turner Prize threw up a shock result when it gave the 2003 award to a man best known for pottery, albeit vases with detailed and angst-ridden political decoration. Grayson Perry, also a cross dresser, picked up his £25,000 cheque with the words: 'It's about time that a transvestite potter won.' As it frequently seems in the art world, anything seemed possible. And the UK media found a new British eccentric as Perry and his garish frocks appeared on

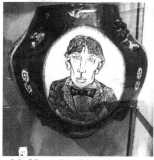

My Heroes by Grayson Perry

prime-time TV. In 2013 he was widely celebrated for delivering cogent and accessible Reith lectures on Radio 4. His transition from rank outsider to national treasure seems to have been completed in no time. That's how fast the art world, and the media, can absorb a foreign body and, if we're being cynical, neutralise its threat.

Art Party Conference Says 'No!' to Tuition Fees

Thanks in part to Perry, there's plenty of craft to be found in the art world today. His fellow Royal Academician, Bob and Roberta Smith, is, despite the confusing name, a down to earth sloganeer and a sign-writer. It could be said he's an agitator, which gives a certain tension to his august position at the RA. He too has a performative persona whose work blends the personal and political. In 2013, with the help of funding from DACS,[2] the CASS[3] and the Art Fund,[4] he established the Art Party Conference in Scarborough: a timely response to the hike in tuition fees at art school. Public enemy number one was former education secretary Michael Gove. Smith is moving things on and in 2015 he stood against Gove in the Conservative MP's Surrey Heath constituency.

But art schools remain edgy places, and during his time as Secretary of State for Education, Gove had little time for them; the feeling was mutual. The rise of tuition fees to £9,000 a year looked like an attack on the humanities and sit-ins were staged in Goldsmiths, Chelsea and a number of other schools across the country. Fees could price out the working and middle classes and put off all but the well-heeled and most careerist. Vital, life-changing institutions could become finishing schools for upper class hobbyists. The revolutionary potential of our famous schools has been recognised too late. We perhaps didn't know we had it so good, and Cool Britannia seems a distant memory. Bob and Roberta Smith, who has interests in philosophy and

literature, is a much-needed champion for the arts in the broadest sense. We should be thankful he's a Royal Academician, even if that's not quite of a piece with the spirit of, say, May 1968.

Modern Craft: The Revenge of Skill

Which brings us back to craft which, compared with contemporary art, has previously had a cosier relation with tradition. But something is brewing in the workshops of middle England. In 2007-08 the Crafts Council toured a show of subversive craft called Deviants and in 2011 a further revelatory show devoted to technology, Lab Craft. So craft today is as likely to echo Meret Oppenheimer (who in 1936 produced his iconic furry tea cup and saucer), as it is to call to mind Josiah Wedgwood. We have seen pottery with no clear function (from Geoffrey Mann), virtuoso displays of 3D printing (from Zachary Eastwood-Bloom), vases inspired by QR codes (from Martin Eden) and ornaments which flirt with ugliness (from Justin Marshall). In seeming response to the conceptual world of art, craftspeople, with an undeniable skill, are putting a conceptual spin on their wares. This unsettles both the art versus craft hierarchy and denies the audience the functionality they have come to expect. And subversive craft has thrown up some big names: Richard Slee, Hans Stofer and, yes, you'd have to say Grayson Perry. So if conceptual thought and skilled practice are put in opposition to one another then what we are seeing is the revenge of skill.

Craft has even made it out onto the street; it's no longer a purely domestic pursuit. Knitting, for example, now requires a touch of urban daring as well as skill and patience. This is the phenomenon known as *yarn bombing*. It's the wool based equivalent of graffiti with taggers leaving knitted sleeves and tunics on everything from tanks to bicycle racks to fire hydrants. The results are colourful and cosy, even if legally this is a grey area. The pictures travel well online, so yarn bombing serves two groups: locals wherever it crops up; and a global community of like-minded craft fans. One of the better known practitioners is Lauren O'Farrell who uses graffiti knitting to tell 'stitched stories'. Now that knitting is a leisure pursuit rather than a way of creating cheap clothing for the family, women are reclaiming the craft for self-expression.

Threadymade founder, Sonja Todd, has even used cross-stitch to make a political statement. 'I did a cross-stitch protest outside Downing Street for the campaign for electoral reform. I got members of the public to stitch a sampler saying, "Make my cross count."'[5]

Most street art, which will be discussed shortly, majors on risk, heroism and personal brands. But a multicoloured scarf on a mailbox can puncture that pretension. So here we have an

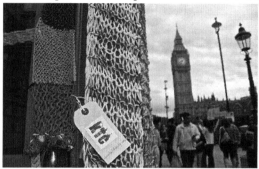

Knit the City by Deadly Knitshade

art trend which subverts another art trend which itself remains one of the most subversive on offer. If yarn bombing has a message it is ecological, polite and positive. Street knitting is an amusing juxtaposition. But the gentle takeover of public space can also be seen as part of the serious and radical Reclaim the Streets movement.

Re-envisioning Community Arts

It is unfair. But, like craft, community arts have long been frowned on by those with saleable careers. But if genius is a mainstream myth then collaboration and mass participation are the ways to bring about cultural change. (It's worth noting the 2014 Turner Prize showed signs of wanting to dispel the notion of genius with the nomination of Ciara Phillips. The Glasgow-based printmaker is known for collaboration with other artists and printmakers.) In actual fact, most people who make art don't give too much thought to the art establishment and are quite happy to sell work to friends or people in their locality. What is perhaps a very

British convention is the Open House season, in which makers and artists scrub up their residences and invite interested people to come and browse. If you don't mind showing off your kitchen at the same time as your art, this can be lucrative. Open Houses generate £1m in Brighton alone and the practice is going strong in Cambridge, Bristol and London also – to name just a few places which support this trend. And out of season these cities are on trend also with a number of pop-up galleries and artists with entrepreneurial streaks who are only too ready to sell direct to the public and cut out curators, critics, dealers and auctioneers. It must work since these places appear to thrive. (In Brighton one finds Gallery 40, in Cambridge there's Cambridge Contemporary Art, and more…)

Dad's Halo Effect by Ryan Gander, Beswick

But can community art ever be cutting edge and critical? Conceptual artist Ryan Gander, who in 2014 delivered a major new public statue in Beswick, Manchester, says, as long as we change the name, it can be:

> 'I wouldn't say it was community art, I'd say it was art for the public. There are lots of different terms and they all have different bearings, don't they? And suggest different things…'[6]

Gander claims it's a lot more difficult than working in a gallery:

> 'Essentially it has to contribute to the history of art and be something in tune with your own practice and your own trajectory that you want to see exist in the world, like all art, but then there's a million more things it has to do.

It has to be motivational. It has to be non-elitist, it has to be all encompassing. It has to be good value for money. It has to promote discourse.'

The Turner Prize: Controversy and Column Inches

It's worth looking again at the Turner Prize, that well-established prize on the cutting edge of culture. Tate Britain hosts it in their grandiose 19th century building. Channel 4 broadcasts it. The *Daily Mail* reports on it. Everyone in the country has heard of it (if not many could tell you the name of the latest winner). It has a reputation for sparking outrage. People complain that year after year conceptual art gets the nod, and not all of these people have even visited the Prize exhibition. But perhaps the most scandalous days of this £40,000 prize are behind us. Looking back over the years we find plenty of furore at the fact Chris Ofili was painting with elephant dung, that the Chapman Brothers had defaced a set of Goya etchings, and Emin's bed remained unmade. These artworks got the country talking, albeit through the lens of a largely hostile media.

As Andy Warhol said: 'Don't pay any attention to what they write about you. Just measure it in inches.' So if you can measure subversion in terms of column inches, the annual art Prize committee is doing something right. In 2002 Kim Howells, then culture secretary, famously branded the entire affair 'cold conceptual bullshit'.[7] And anything that annoys a government representative must be doing something right. It can seem at times as if the inaccessibility of the prize strikes an annual blow for the intellect, a quality which is quite absent in most other competitions. Even the Booker steers clear of experimentalism. And we won't even mention structured reality television contests. It's just such a shame that intellectualism has to alienate the man on the UK street.

But does the Turner Prize offer an accurate reflection of where the UK art scene is really at? It could be argued it was slow to recognise video and performance. In 2014, as mentioned, we saw only the first ever printmaker. It can seem the Prize nominees and winners are selected in an ivory tower. Nevertheless, those who do visit the Prize exhibition tend to get into the swing of things.

The comments wall is one of the liveliest national forums for art debate, and it's a rare chance to pick an art favourite at bookmakers William Hill. And yet it's understandable that many artists, whose faces wouldn't fit with the country's most influential tastemakers, hate the annual hoopla. In 1993, musician, artist and prankster Bill Drummond launched the K Foundation and offered £40,000 to the worst artist in Britain. Rachel Whiteread collected the Turner Prize at the Tate and then collected Drummond's Prize on the steps of the building. Yes, the Turner can seem elitist. No, its chosen exhibitions are not always the most accessible. But that is the difficulty of art in the 21st century and it requires a suspension of disbelief to enjoy.

Stuckism

Charles Thomson, father of the Stuckist movement

In recent years Tate Britain has been picketed by an art movement which champions figurative painting: the Stuckists. But in a sign of the weary times, in 2014, these mavericks didn't even bother to protest in advance of the award: turning up only on press day and on the night of the award to voice their objections and giving themselves a couple of months off beforehand. The Stuckists have agitated against all the brightest and the best in the art world, who in turn do a sterling job ignoring voices of dissent. They call modern art a total scam and make an articulate case. The movement was set up in response to an outburst by Emin, who told then boyfriend Billy Childish he was 'stuck' in his artistic ways and the name itself also stuck. Childish founded

the movement with poet and painter Charles Thomson. So now it is the energetic Thomson who leads the campaigning. Stuckist work mixes expressionism, pop and satire. Whether painting Tate Chairman Sir Nicholas Serota or, once again, Saatchi, they can be as caustic as any group of talented people left out in the cold. But their rejection of conceptual art and theory, must be called reactionary. They rally behind a 1999 manifesto and their avowed objective would seem to be turning the clock back, rather than smashing the mechanism. Indeed, Stuckist painter Ella Guru expresses scepticism about art's power to subvert. 'I don't know if you can still be subversive nowadays,' she says. 'Modern art has degraded into gimmickry and shallowness.' In our brief phone interview, she doesn't miss a chance to brand the Turner Prize a 'joke'. So, real subversion is off the 21st century menu in Britain, but, she points out:

> 'There's a Stuckist group in Tehran, and merely depicting a human figure in a painting is subversive. That's where they're really pushing the boundaries because they could be arrested for what they're doing over there.'

Guru praises both the technical skills of her colleagues in Iran and the bravery they need to conduct life drawing classes in secret.

Outsider Art

If the Stuckists find themselves on the fringes of the art world, there are some artists on the fringes of society itself. If you make art with a severe psychiatric complaint or an address at HM Prisons you could consider yourself an outsider artist. Outsider art was first identified as an aesthetic value when French painter Jean Dubuffet coined the term *art brut*, raw art, in the 1940s. He would have been surprised to find that in the 21st century, artists of this type would be showing in major London galleries such as the Wellcome Collection and Hayward. A pop-up exhibition of outsider art even came to the commercial epicentre of Selfridges on Oxford Street. Established artists like Peter Blake have spoken of their admiration for outsider art. These days, many outsider artists have access to the web, to art schools, to life drawing classes. What the trajectory of outsider art tells us is that there is no outside in terms of contemporary art – and few outsiders.

Kate Davey, an outsider art blogger and curator comments:

'I think there's more of an acceptance of it now and the term itself is becoming increasingly blurred, so it's very difficult to distinguish between outsider art and mainstream art.' Nowadays outsider artists are liable to have trained at art schools and enjoy broadband connections. And when asked about the effect of recognition and sales, Davey adds:

> 'It's a really positive thing [for outsider artists] to have their work exhibited in high profile venues, selling their work has such a huge impact on their self-esteem and their confidence as artists and you know the fact that people are enjoying this type of art… yeah, I think it's definitely positive.'[8]

Be that as it may, we are still back to a scenario where what was once considered dangerous and transformative, has been rendered safe and easily digestible. By money, by the media, and, it must be said, by an adventurous public.

Graffiti: Icons from the Street

The picture is also familiar in the urban realm where street artists have gone from rebellion to entrepreneurship in barely a decade, it seems. For those who grew up in the 1980s, graffiti, as it was once called, was one of the most exciting US imports. From stealing spray paint to breaking into train yards, there was plenty about this scene which broke rules and broke new ground. *Wildstyle* was a style of graffiti that was colourful, daring and – if one was not privy to youth culture and visual language – illegible. No less a personage than Norman Mailer even called it a bearer of occult meaning in his book *The Spooky Art* (2003). So the movement behind street art had depth and a lifestyle to go with it. As a truly urban art form, it was incomprehensible to councillors, train operators and surely the political classes.

But if you were to fast-forward to the present you would be shocked. *Wildstyle* graffiti is now sanctioned by some property owners and developers have even invited writers to decorate the walls of their hoardings. As such it has become a force for gentrification and rising house prices. Dangerous? Well, not any more. Hip-hop inspired graffiti of this sort is as likely to invite

the attentions of a selfie-taker as it is the attentions of the police.

The history of train carriage art can be traced back to the 1920s in New York. So the history of street art as we know it today is relatively short. Evidence of the *Wildstyle* gangs reached the UK through the work of photographer Martha Cooper. The art form went mainstream here in Britain about the same time as hip-hop broke through. But whereas technicolour pieces and fluid tags were all about territory, political street art came to be nomadic and just as decentered as the online media outlets which report it.

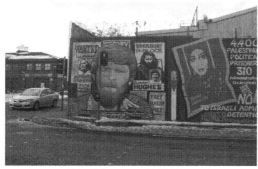

Republican mural, Belfast

And perhaps the political dimension is the UK's greatest contribution to urban art. Since the 1970s the two warring sides in Northern Ireland took their messages to the street in the form of highly charged murals. Some 2,000 of these artworks have been documented since the first Republican murals appeared in Belfast and Derry-Londonderry. The author was fortunate enough to view many of these works in situ, from where it could be seen that those in Bogside added a visual arts pedigree to Derry's successful stint as UK City of Culture 2013.

Compared with radical social messages in a combat zone, stencil art can seem like a short cut. And that is where we are today. Although the stencil was first used in Paris in the early 1980s, it is ubiquitous in the UK thanks to the pioneering efforts of the world's best-known anonymous artist, Banksy. Banksy, who has been painting street art since 1992 has made work in his native Bristol and as far afield as Los Angeles or the West Bank. His politically charged works risk censure as well as arrest.

Banksy mural, wall of The Prince Albert, Brighton

Using stencils has allowed Banksy to effect quick getaways and as a result he has never, to our knowledge, been caught or charged. Thematic targets have included the UK supermarket Tesco, the police, sweatshops, private property and even recently GCHQ and mobile technology. His work is raw, radical and really very valuable. Yes, this too sells at auction. The anonymous artist makes a lot of cogent points with wit and theatre. But it is debatable whether his work has subverted anything at all. You can buy Banksy prints for your middle class home, knock off Banksy canvases for your student digs, and, if you are a hedge fund manager you can buy walls which include original Banksy artwork wholesale. There are some very wealthy people collecting street art, as the success of galleries like Lazarides and Black Rat Projects can testify. And if these customers are not the very problem then who is?

But that's not the only paradox surrounding the agitprop art of the man called Banksy. His solo show at Bristol's City Museum and Art Gallery broke records for the venue. The enigmatic artist has also staged hugely popular exhibitions from London to LA. And one of his most celebrated pranks has been to take his own works of art and hang them in the UK's National Gallery. In other words, he's crowbarring his way into the mainstream art world. Nothing changed during his brief appearance on the walls of the best art gallery in the land, but a psychologist might say this was a piece of wish fulfilment. And well he might dream. Street art is so inoffensive these days that a US president has risen to power on the back of a poster campaign by famed street artist Shep Fairey and our current Prime Minister has presented said President with a piece of art by a UK street artist, Ben Eine. For the current crop of artists, whose works reach critical mass in places like Shoreditch, Berlin and Brooklyn, the street is really their shop window. The real business has come to seem like knocking out expensive prints in stores like Art Republic. Or like

John Bargeman, for example, selling vinyl toys. And it is fair to say that if Shep, Eine or Banksy chose to 'decorate' the side of your house, your estate agent would be rubbing his or her hands with glee.

Tame Art Future: New Challengers

If all of this has made you depressed about art's limited powers of subversion, try not to be too down. This tame art world is just the price we pay for a fairly liberal democracy. Art is recognised as a space to have your say. And although a paper like the *Daily Mail* might occasionally complain about contemporary art, most of the adult population is happy to ignore the goings on in galleries and performance spaces. Those most affected by art tend to be artists themselves or other people who work in the field: curators, staff in galleries, press folk, journalists, bloggers, armchair fans. For these people art needs to feel subversive even if it isn't. To quote the late great poet Adrienne Rich, 'Subversive has a certain charm/and art can really do no harm.'[9] Perhaps art can subvert paradigms, but those tend to be paradigms in art, not government. This was demonstrated by a recent touring show from the Government Art Collection. It just went to show that cabinet ministers are not averse to a bit of modern or contemporary art. The Culture Minister (at the time of this perplexing exhibition) was Ed Vaisey. And he chose the edgy YBA, and Conservative supporter, (once again) Emin.

So with formerly radical artists in Britain now staunch members of the establishment, we have to look to other countries for examples of art which is risky and subversive. As mentioned previously, China's Ai Weiwei, risks his life and liberty to make his art. For years he has been under close surveillance in his own home. All of which makes Ai one of the bravest artists on the planet. When you put your life on the line, it is more impressive than putting your latest piece of work on the line. In 2011 *Art Review* named Ai as the No. 1 most powerful person in the art world. (It made a change to see an artist top that list rather than a collector or a super-curator.) Ai's most emblematic work is a series of photos he's taken of his own right hand flipping the middle finger at various government buildings at home and

abroad. This is confrontational, but is it really subversive? Well, the Chinese government appears to think so.

Meanwhile in Russia, three members of an all female punk band were jailed for disrupting a service at the Christ the Saviour cathedral in Moscow. The Russian president Vladimir Putin comes across as a traditionalist, so it should come as no surprise he's no great fan of performance art. And this is a pity because Moscow is awash with jaw dropping art pranks which would earn official censure in most any country in the world.

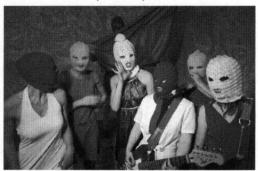
Pussy Riot, in their trademark balaclavas

After Pussy Riot, the best-known collective are Voina, who have torched police vans, over-turned police cars, staged orgies in courtrooms and smuggled dinner home from a supermarket inside a female member's vagina. In perhaps their best-known stunt, they closed down a drawbridge in St Petersburg, painted a giant phallus on the tarmac of the bridge and watched it rise to present the KGB HQ opposite with a monumental rebuke. No less committed is Petr Pavlensky, a lone agent with nobody to tell him that his performances may not be the best idea in the world. In 2013, he nailed his scrotum to Red Square in protest against social apathy. He has also sewn his mouth shut and cut off an earlobe. It defies belief, but can we expect a like reaction from our own artists against the austerity cuts? Well, as you sip white wine at an opening, it is hard to imagine many of our contemporary crop actually wounding themselves in the name of art. It just doesn't have critical currency. How many current artists would claim to be inspired by the tragic Sebastian Horsley,

who arranged his own abortive crucifixion?

But while they may not put their bodies on the line, there is still an untamed *avant garde* in the UK. It is low profile and in many cases quite lo-fi, but there are an ever-growing number of countercultural artists out there if you know where to find them. Hint: you'll find them in South East London, in artist led spaces around the country, and in the digital realm. Social media is allowing artists to build followings and connect to new audiences in a direct and personal fashion. Facebook and Twitter also provide spaces where the art community can meet their peers and offer mutual support. This is such a 'thing' as they say on the web, that US sites like Point & Line and ello.co have been quick to meet demand. Of course, no one is making any money or very little of it. But not making money, in this day and age, could just be the most subversive non-activity of all. Even if that is cutting off your nose, or your ear, to spite your face.

Paul Kindersley is a UK-based performance artist with more than 33,000 followers on Twitter. And his blend of selfies, video blog posts and risqué uploaded drawings is winning more fans all the time. 'I have a weird relationship with the internet, but it's just an amazing tool to use,' he says. 'But also I like the way it is like sketching, well for me anyway, so it's the way you would have an idea and want to realise it instantly.' Kindersley is also one of those undermining art's hegemonic relation to profit: 'I think once your actual practice is bound up in making money, I would personally find it very difficult to make things and to work out why I'm making stuff.' But there are still reactionary forces to contend with in the digital realm. Kindersley says he finds the censorship hard to deal with, because, as he says, 'It never crosses my mind that something might be censored, so when it is I'm always surprised.' The artist frequently appears nude or depicts nudity, which is frowned upon in the California HQ of Facebook. Kindersley is aware his work is 'cheeky and subversive', but he adds: 'I don't understand the rules or know what they're doing, but I quite like to work within them.'[10] Artful lighting and creative use of props means he usually gets away with what is generally forbidden.

Beyond this all-pervasive virtual world, there is a corner of London where challenging things still go on. That corner is the South East, a remote part of the capital best navigated by the enterprising South London Art Map. SLAM locates some fifty notable galleries in Peckham, some thirty in Deptford and more than twenty in Bermondsey, as artists gravitate towards the less expensive parts of town. It is hard to characterise all of the work here, but it can be serious-minded, professional and buoyed with the optimism of youth. There is little gloss and plenty of improvisation. There are artist-led studio and gallery spaces like Sunday Painter which shows the likes of installation artist Leo Fitzmaurice and sculptor/filmmaker Rob Chavasse. There are new media collectives like Lucky PDF who brought a web TV studio and bar to Frieze in 2011. And, a personal favourite, studio and space Arcadia Missa. From their base in a railway arch under Peckham Rye, Arcadia Missa have, among other activities, staged a 24-hour militant training camp, so things couldn't really be more subversive than that.

The emerging art scene even has its own art fair in Sluice, a biennial event organised by an artist and an art historian, Karl England and

he listened, 2012, by Corinna Spencer

Ben Street, and last held in 2015. Sluice could be the perfect place to pick up work by one of the new breed of figurative painters. Painting is going strong at grass roots level with a number of emerging artists (such as Cathy Lomax, Corinna Spencer, and Alli Sharma) who often work from found images in the media. Not quite as young as those names, but subversive of the cult of

youth, the last five years have seen the discovery of Rose Wylie, whose poppy celebrity portraits and so on won her the John Moores Painting Prize in 2014.

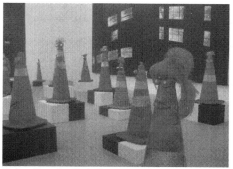

Safety Cones by Rob Pruitt, at Frieze, ART 2013

But money is the elephant in any room where you find one or more subversive artists. What chance do they have of making an impact when, in any given week, money is talking, at the auction room, at the blue chip gallery and for one wild week in October at Frieze Art Fair in Regent's Park? Frieze manages to be at once a multi-million pound venture for the benefit of oligarchs, and the epitome of coolness and buzz for the rest of us. Galleries pay. The public pay. And the whole affair is given an imprimatur of worthiness with a sculpture park, new project-based commissions, a programme of talks and film screenings. If anyone is planning to subvert the art world, they will need to take down Frieze first. But can it be done? You'd have to doubt it. Not for nothing is Frieze in a marquee. And to bastardise a famous sentiment from former US President Lyndon B Johnson, 'It's probably better to have art world dissenters inside the tent pissing out, than outside the tent pissing in.'[11]

BLACK AND MINORITY ETHNIC ARTS

Whose Voice Is It Anyway? Ethnicity and Authenticity in Contemporary British Arts

Coco Khan

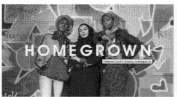

Publicity images, *Homegrown* and *Exhibit B*

In the early days of August 2015, in the usually peaceful world of contemporary UK theatre, something shocking happened. It happened quietly and without fanfare. A play examining the ISIS radicalisation of British teenagers, devised by the National Youth Theatre (NYT), was closed just two weeks before it opened.[1] NYT pulled the plug on the immersive production set in a school, *Homegrown*, citing 'quality reasons' – but accusations of censorship have flown.

When attempting to gain an understanding of any society throughout history, a good place to start is finding out where the moral boundaries of that society lay – to figure out what that society found tolerable and intolerable, acceptable and unacceptable. Morality is significantly shaped by culture, but at an individual level it is ultimately subjective, and so often these boundaries occupy a grey space and are without definition, shifting dramatically depending on the individual or group. Nevertheless, at the crudest end of this moral sliding scale is censorship.

BLACK AND MINORITY ETHNIC ARTS

The mere discussion of censorship in contemporary art feels anachronistic – indeed these days you are far more likely to hear of creatives courting controversy than being shushed into submission by the Mary Whitehouse-inspired and their moralists. After Sarah Kane's 1995 production of *Blasted*, there didn't seem to be much left in the 'taboo' column. Kane's visceral attack on the atrocities of the Bosnian War featured an on-stage male rape, as well as cannibalism of an infant child. Indeed, contemporary theatre has never shirked away from investigating the most depraved of human acts and the reasons for them – David Hines explored paedophilia from the perpetrator's perspective in *Nymphs and Shepherds*, not to mention Phillip Ridley's *Mercury Fur* in which a ten-year old child is graphically tortured and assaulted to please wealthy guests in a dystopian London.

Another example of a play by an Asian playwright which was axed back in 2004 is *Behzti (Dishonour)* by Gurpreet Kaur Bhatti. In this case, the theatre (Birmingham Repertory) chose to close the play, following violent protests by the local Sikh community, on the grounds of the theatre's inability to guarantee the safety of the audience. There were also death threats made against the playwright. The play, which offended the Sikh community for its portrayal of rape and murder within a Sikh temple, has since been translated and staged many times in Europe and has become a set text in university drama departments in the UK. Bhatti says of it:

'My experience showed me that freedom of expression is precious, both as a gift and a right. When it is taken away, there is nothing left but abject, depressing silence. The only way of filling the void is to create anew. If artistic institutions honestly want brave work, then they must do as artists do – overcome fear in order to say what others cannot and will not, whatever the cost.'[2]

However, many other less-controversial plays by black and Asian playwrights have been successfully produced over the last half century. Some of the most interesting include: *Play Mas* by Mustapha Matura (1974), *Scrape off the Black* by Tunde Ikoli (1980), *Migrations* by Karim Alrawi (1982), *Chiaroscuro* by Jackie Kay (1986), *A Hero's Welcome* by Winsome Pinnock (1989), *East*

is East by Ayub Khan-Din (1996), *Made in England* by Parv Bancil (1998), *The Waiting Room* by Tanika Gupta (2000), *Elmina's Kitchen* by Kwame Kwei-Armah (2003), *Fallout* by Roy Williams (2003), *Gone too far* by Bola Agbaje (2007), *The Trouble with Asian Men* by Sudha Bhuchar, Kristine Landon-Smith and Louise Wallinger (2007), *Speechless* by Linda Brogan (2010) and *My Name is…* by Sudha Bhuchar (2015).

What Was So Controversial About *Homegrown*?

The production of *Homegrown* had already run into trouble before its formal axing. It was due to be staged at Raine's Foundation Upper School in Bethnal Green, East London, but was moved due to concerns it would be 'insensitive' following the high-profile case earlier in the year, in which three teenage girls from a neighbouring school, Bethnal Green Academy, travelled to Syria to join ISIS. Rather than being pulled at that point, the production was moved to another area of London, and continued as normal until two weeks before it was due to premiere.

It's worth mentioning that in 2010, a Canadian play – ironically also called *Homegrown: a true story* – had its funding pulled after criticism that the production had portrayed the terrorist too sympathetically. The play was a dramatisation of a true eighteen-month friendship between Catherine Frid, the writer of the play, and Shareef Abdelhaleem, a convicted terrorist whom she was visiting in the interest of writing a play about prison.[3] Here in the UK, the artistic tradition as a whole has always been committed to the psychology of human nature; asking 'why do people do bad things' is time and time again addressed in plays, novels, and fine art – from any of Shakespeare to Ballard. We cannot know for sure that what happened to the Canadian *Homegrown* is what happened here in the UK, but if the messages of the cast and director are to be considered, it's a prospect that can't be ignored:

> As Nadia Latif, director of *Homegrown*, states, 'This show was about having an intelligent conversation around an issue that has hysteria attached, and instead voices have been silenced with no explanation and without the content ever being seen because of this landscape of fear that we live in.'

So Who Can Speak and Why?

Before we delve deeper into this, contrast the state of *Homegrown* to another performance piece from last year. Brett Bailey's *Exhibit B* was also pulled after protestors picketed the exhibition, brandishing the performance-art installation as racist and salacious. The piece aimed to recreate the 'human zoos' and ethnographic displays that showed Africans as objects of curiosity, popular through both the 19th and 20th century. Visitors to the exhibition would wander the space and find bruised, chained and undressed black actors, voiceless, passive, communicating their despair with their eyes. One particular tableau, of a slave girl chained at the neck to her French owner's bed was the subject of many complaints, not least because of reports the actors and actresses were subject to abuse from the audience. One actress, Berthe Njole (playing the role of Sara Baartman, also known as 'The Hottentot Venus' who was brought to Europe in 1810 and placed in a zoo for spectators to observe her physique) described her experience:

> 'We were playing a festival in Poland. A bunch of guys came in. They were laughing and making comments about my boobs and my body. They didn't realise I was a human being. They thought I was a statue. Later, they returned and each one apologised to me in turn.'[4]

Supporters of the piece argued that art should not be censored no matter how uncomfortable, repulsive, or shocking it may seem. Indeed, often this discomfort is precisely the point, to make the spectator re-evaluate themselves and the world in context of the viewing. Objectors to the piece stated that the use of black bodies as props, and in often degrading and humiliating scenarios, was inherently racist and had no place in today's society.[5]

The creator of the piece, Brett Bailey, a white South African playwright rejected the concerns of the protestors, stating that he 'stand(s) against any action that calls for the censoring of creative work or the silencing of divergent views, except those where hatred is the intention.'[6]

Exhibit B, despite being closed down, made it to the general public. *Homegrown* did not. It is possible therefore to speculate

that it is the *intent* rather than the actual *content* itself of the work, that is the deciding factor in what is allowed to be seen and what is not. It is worth pointing out that this rule of thumb is in fact reflected in the regulations for the British Board of Film Classification when rating films for audience appropriateness.

Is the Intention to Portray a Young Jihadi as a Complicated Human Worse Than the Intention to Portray a Human as an Object?

To understand this, we need to look a little bit closer at the industry itself. The decision to close *Homegrown* would not have been taken lightly. It had been a huge-scale production with a cast of 112, most of whom were young ethnic minorities. This fact alone already made it noteworthy.

The crisis around participation in the arts from Black and Minority Ethnic (BAME) groups has been headline news in the arts for many years now. The debate around diversity reached a head recently after statistics showing a *decline* in the amount of BAME people working in the creative industries (such as film, advertising, radio, gaming and television) despite growing numbers of these communities in the UK.

The Creative Skillset employment survey 2013 revealed that the proportion of BAME people in the creative sector had declined from 7.4% in 2006 to 5.4% in 2012.[7] Many high-profile celebrities and media-stalwarts expressed their shock and concern at the damning report, arguing that no new breakthroughs had been made in diversity since the huge strides taken in the 80s and 90s.

> Krishnan Guru-Murthy, Channel 4 News anchor, observes: 'As an industry, we are failing. There is no doubt that we have gone backwards over the past 10 to 15 years [in promoting diversity].
> A lot of the people who are senior in television, either on- or off-screen, are the same as when I was coming into the business 25 years ago.'

In response to the damning report, many arts funding organisations introduced diversity measures and even quotas in order to actively pursue BAME and other underrepresented candidates. Since 2014, any production seeking funding from

the British Film Institute must demonstrate its commitment to diversity based on ethnicity, disability, gender, sexual orientation and socio-economic background. To do this, a certain amount of staff on the production must fit any one of the above categories, in order to meet the quota.

The Arts Council England (ACE) have not gone so far as to enforce similar quotas, however it is worth noting that the ACE's levels are considerably better, with 13% of their organisations being represented by BAME groups. This is against a national average of 15%. Nonetheless, Sir Peter Bazalgette, chairman of Arts Council England warned arts organisations to make progress with diversity or risk losing their funding:

> 'There has to be a reckoning.'
> 'The progress our funded organisations make with the diversity of their programmes, their audiences, their artists and their workforce will inform the decisions we take on their membership of the next national portfolio after 2018.'

The key word in that quote is 'audiences'. When we talk about diversity in the world of work, at the centre of the debate is a widely-held belief that greater representation of minority groups in the workplace will increase the interest in said industry from those groups – for example, if there were more prominent female engineers, you may find more women becoming interested in engineering. This becomes critical information when you consider the low interest and uptake in the arts from the BAME community.

A 2015 survey found that around 80% of white adults engaged with the arts in the past year, compared with 68% from black and minority ethnic groups.[8] This is a rather jarring statistic. In a philosophical sense, this statistic could represent a failure to engage non-white, and migrant communities with the fabric of Britishness, its oldest traditions; it illustrates a continued chasm between white and BAME communities, and could be seen to epitomise race relations in the country. In a creative sense, the backbone of the arts is information and insights. The creative industries are all about discovering new ways to make and share

experiences – a cross-pollination of viewpoints so to speak. To not take advantage artistically of Britain's diverse demographics seems almost wasteful. Moreover, in a practical sense, it also represents an untapped audience of consumers who could be investing in the arts – be that buying a ticket to a show, or committing in the long-term professionally. It therefore makes both ethical, creative and commercial sense to try and bridge the gap, and enhance BAME audiences in the arts. However, while there is truth in this methodology, it is perhaps misguided to assume that simply more BAME people on the screen or stage will automatically result in a more diverse audience. A black Hamlet will mean much to those engaged in the arts already, but very little to anyone else.

In 2013, I wrote a piece for the *Independent*, looking specifically at race in classical music.[9] In terms of sheer whiteness and lack of diversity, classical music was perhaps the most extreme artistic discipline I could have explored. With its reputation for pomposity (Last Night of the Proms anyone?) and outrageous ticket prices (mainly in ballet and opera), as an industry it was failing hugely in terms of its diversity. At the time of writing the article, only 5% of classical music professionals identified as BAME. Writing that feature, I conducted a number of interviews – from high profile players, to conductors, to students – and I remember vividly one word that would show up in nearly every interview: *alien*.

What these professionals pointed to was that the work *itself* was alien to those who were not already familiar to it through upbringing or other experience. Of course, it is 'daunting', to use Julian Lloyd Webber's word, to walk into a concert hall as a person of colour and only encounter white faces, but what is more daunting is the work itself.

Think of classical music as essentially a language. Those who had not learned the language were simply unable to understand the sound, let alone enjoy it. Knowing just a few words in this musical language – that is, having some experience of the music in a way that was accessible and could be grasped – could be enough to pique the interest of newcomers to perhaps learn

more, therefore creating new dedicated audience members whose knowledge will deepen and expand over time. Without these initial key experiences, the genre will remain locked out of reach for new audiences. Indeed, in classical music's case, it being a Western form of music made it considerably more likely that a BAME person did not have the gateway experiences to access this unique language, making audience diversity incredibly unlikely to improve.

Something similar can be said about many of the arts. Shakespeare, post-modern theatre, contemporary visual art – all of these require a certain amount of prior knowledge or exposure to its tradition to gain some kind of enjoyment from them. It is therefore crucial that the arts actively create alternative entry points to culture in the form of engaging, and accessible work, in order to set the journey of the arts in motion for new audiences. New BAME roles have to be written, not just relying on the novelty of old roles being played by non-white people. These entry points need to distinctly differ from tradition, and to position themselves closer to the cultural references and experiences of the audience they wish to engage, in this case the BAME community.

But Which Audience Are BAME Creatives Really Working For?

Let's return to *Homegrown* – an ambitious production created for the BAME community, by the BAME community, yet potentially pulled for posing a view that may be uncomfortable to the wider, predominantly white, UK. This is the heart of the matter, and the greatest obstacle for Black and Minority Ethic artists in Britain today: *authenticity to the subject.*

It stands to reason that a piece written and directed by young British Muslims would have a greater insight into the experiences of communities affected by radicalisation than non-Muslims. But if what those creatives intend to present is compromised by what a white audience might think about it (and the piece subsequently altered), it can lose its authenticity. The impact of this is threefold:

1) The piece fails to engage the BAME audience as it fails to challenge the mistruths circulated by dominant discourse

on various issues affecting the audience, therefore offering the community nothing new.

2) The piece fails the BAME community by not adequately conveying new insights into the received notions of the group.

3) It fails the artistic community in its mission to widen audiences and create new expansive work.

Earlier in this essay, we spoke about *intent* rather than *content* as the deciding factor in censorship. If the intention of *Homegrown* was to challenge the established narrative around ISIS radicalisation, we have to ask ourselves which audience did the National Youth Theatre have in mind when they may or may not have decided that mounting this challenge was unsavoury, immoral or offensive? Was it the same audience the Barbican had in mind when they decided Brett Bailey's *Exhibit B* was challenging but had not crossed the line? This can be perceived as a kind of curatorial white privilege, and it begs the question: by whose standards do BAME artists have to live – and what if those standards are based on mistruths, and are inherently disadvantageous to the expression or experience of the non-white artist?

I should point out here, that although *Homegrown* is a production about Islam, and Islam is a religion not a race, nearly all Muslims in the UK are not white. Although Muslims might be from a variety of races, in contemporary UK society we see the word 'Muslim' used interchangeably for person of colour, and we see the term often used as a racialised pejorative. For this reason, I believe *Homegrown* is a good, contemporary instance of this kind of racial authenticity problem, but there have been numerous examples throughout the history of BAME British Arts.

Mostly, this kind of external pressure to conform to certain narratives does not result in the extremity of censorship. Instead the pressure is applied more subtly – a kind of soft power yielded by a predominantly white arts industry. In April 2015, an independent report commissioned to look at diversity in the book publishing industry found that the best way for a BAME author to be published was to write fiction that both conformed

and indulged a racially stereotypical view of their communities:

> 'Writers find that they are advised by agents and editors
> to make their manuscripts marketable in this country by
> upping the sari count, dealing with gang culture or some
> other image that conforms to white preconceptions.
> Black and Asian authors complained that they were
> expected to portray a limited view of their own cultures
> or risk the accusation of inauthenticity if their characters
> or settings did not conform to white expectations.
> Failure to comply, many felt, limited their prospects
> of publication.'[10]

This isn't necessarily a new thing; as far back as 1956's *The
Lonely Londoners*, by Trinidad-born writer Sam Selvon, we can find
this kind of racial stereotyping. Nearly all the characters from *The
Lonely Londoners* are West Indian, and they all smoke weed, chase
women, conduct petty crime and occasionally beat their wives.
Sam Selvon's brilliance was confirming these stereotypes while
proffering up alternative narratives for a white audience who had
not encountered them before. But this same formula applied
over fifty years later is failing both the artistic community who
seek to find new audiences and create new forums and work, as
well as failing the BAME community. Black playwrights are often
expected to write plays which portray stereotypical characters
such as gangsters, rappers and drug-dealers, or the ravages of
life in the underclass, while Asian writers are encouraged to write
about the British Muslim experience of alienation and angst in a
post 7/7 Britain.

> 'Contrary to the all-pervasive mood of multicultural
> bonhomie and self-congratulation, there is actually
> something rotten in the state of black British theatre.
> With the exception of Kwame Kwei-Armah and one or
> two other playwrights, on closer inspection black British
> theatre is languishing in an intellectually vapid, almost
> pre-literate cacophony of expletives, incoherent street
> babble and plots which revolve around the clichéd staples
> of hoodies, guns and drugs.'[11]

The consequence of this ghetto-type play is that it not only

distorts the reality of black experience but also limits BAME actors to continually playing stereotypical roles. Black Theatre in Britain has a long history as evidenced by the Black Plays Archive (www.blackplaysarchive.org.uk) where the first play by a black playwright recorded in the archive was *The Lily Bermuda* by Ernest A. Trimmingham written in 1909. The Black Plays Archive offers a wealth of text-based information, as well as visual and audio material demonstrating that black playwrights such as C.L.R. James, Errol John, Wole Soyinka, Barry Reckord and Mustapha Matura have been exploring much wider themes and subject matter for almost a century. The current limited range of plays being produced by theatres reduces the opportunities for BAME actors to play more complex nuanced characters. Actors such as David Oyelowo, who recently starred in du Vernay's film *Selma*, have complained about the failure to cast BAME actors across the board in British Theatre and he and other black actors have left to work in the USA where there are greater opportunities.

White Pages

In contemporary literature, we see further examples of Asian characters being portrayed as marginalised and oppressed minorities. Perhaps the best example of this was Monica Ali's *Brick Lane,* a number one best-seller which enjoyed five star reviews from the broadsheets, but was picketed by the Bangladeshi community whom the book was based upon for reinforcing 'pro-racist, anti-social stereotypes' and of containing 'a most explicit, politically calculated violation of the human rights of the community.' This was according to Abdus Salique, chairman of the Brick Lane Traders' Association who organised the protest.[12]

However, there are many notable British authors whose work rejects the limitations which publishers and agents may wish to place on them. Popular BAME novelists whose work seeks to challenge stereotypes, offering more complex world views for the British reader, include: Zadie Smith, Hanif Kureishi, Andrea Levy, Kazuo Ishiguro, Mohsin Hamid, Malorie Blackman, Ben Okri, Meera Syal, Merle Collins, Courttia Newland and Salman Rushdie.

A recent report titled 'Writing the Future' launched at the

London Book fair in 2015, showed that publishing remains the domain of white middle class people with non-whites relegated to the margins. The tendency to recruit graduates from Oxbridge and to utilise unpaid interns has led to institutional bias and a conservative monoculture.

Former Children's Laureate, Malorie Blackman who used her position to encourage diversity in literature, sees a worrying trend:

> 'Over the last three or four years, I seem to have gone back to being the sole face of colour at literary or publishing events. What happened?'[13]

In poetry, new platforms such as youtube.com offer poets new opportunities to connect with audiences. But with under 1% of poetry books published in the UK written by black or Asian poets there is a huge imbalance. Those who have achieved varying degrees of success include: Benjamin Zephaniah, Linton Kwesi Johnson, Patience Agbabi, Mimi Khalvati, John Agard, Malika Booker, Nii Ayikwei Parkes and Dorothea Smartt.

Carlos Acosta and Then?

Ballet Black publicity image, *Dogs Don't Do Ballet*

In the world of dance, Ballet Black (www.balletblack.co.uk) is leading the way with a professional company helmed by Cassa Pancho for international dancers of black and Asian descent. Their aim is to bring ballet to a more culturally diverse audience by celebrating black and Asian dancers in ballet and to encourage a shift towards more equality in dance. Contemporary dance companies such as Ballet Rambert and London Contemporary Dance have long employed mixed companies of dancers but elsewhere discrimination is common particularly in the UK's classical ballet companies.

> 'Neither the Royal Ballet nor the English National Ballet currently employs a single black ballerina. The path to ballet stardom is generally easier for black men than women: black men are considered well built for lifts and *pas de deux* work. Just ten dancers in the Royal Ballet's

98-strong company are not white – of those, only four are black, and all of them, like Acosta, are male. At ENB, just eight out of seventy-one dancers are not white. Only one is black, and he is also male.'[14]

While ballet is perceived to be exclusive to white, Western middle class culture, it will be difficult to attract students from BAME backgrounds to train as dancers – although recent publicity for American prima ballerina Misty Copeland may help to challenge perceptions. As a classical ballet dancer generally requires around ten years of training, unless the ballet schools proactively recruit young people from non-white backgrounds, and challenge discriminatory thinking around body shape, then this unequal state of affairs is likely to persist for a long time. Outreach programmes to schools to attract a more diverse audience are essential, so that the large subsidies received by the leading companies are used to develop audiences from communities which are currently excluded.

In the field of choreography there is a paucity of non-white artists too. One company, State of Emergency, whose founder Deborah Baddoo is a black choreographer, has taken the initiative to support and encourage the development of choreography by black artists. For more, see www.blackchoreographers.co.uk

The Artist vs the Entertainer: Can BAME Creatives Enjoy the Same Freedoms and Artistic Licence as White Creatives?

Much like no man is an island, no industry lives outside of dominant culture entirely. Across a number of industries, there exists an issue with non-white persons and their perception by the public (and institutions) as leaders; the arts are no exception. Even in popular music where a considerable number of the individuals at the top will be non-white, we still find a cultural favouritism for the white musicians over the non-white. To use a popular example, we revere the Sex Pistols' Johnny Rotten as an artist, but would regard Kanye West a charlatan when the comparisons between the two in terms of success, influence and (often obnoxious) behaviour are noteworthy.

However, this culture is slowly changing, across politics and

education. There are still limited opportunities for non-white creatives to fulfil their potential as artists outside of a strict predetermined box, defined by white professionals often based on misinformation. This becomes quite a cruel joke: when BAME persons cannot become artists, the BAME community can disengage with art; if the BAME community disengages with the arts, they are less likely to produce artists, and so on it goes.

Increasingly, the awareness of racial privilege is being addressed and this will no doubt break down the remaining barriers for non-white creatives in the arts. In many respects, the arts are leading the way. Its commitment to diverse voices, and even the implementation of quotas is testament to this – it's a brave move that not many industries have been willing to undertake. Institutional racism is continuing in the arts as elsewhere in Britain. The decline in the number of BAME writers and the limitations placed on the range of material which can be written or produced by black and Asian artists is a matter for concern. The Arts Council's belief that companies will reform themselves and champion equality and diversity in the future seems unfounded. Only a system which ensures that grant subsidy to companies is spent on employing and commissioning equal numbers of men and women with a quota that 15% must be people of colour, can reverse the institutional bias which currently exists.

COMEDY

The Changing Landscape of Comedy

Susan Murray

This chapter is dedicated to Rik Mayall. R.I.P.

'Crop rotation in the 14th century was considerably more widespread after John...' oh sorry, force of habit, a *Young Ones'* quote that I've been saying since I was fourteen when that BBC sitcom BLEW MY MIND.

The anarchy, the chaos, the violence. My parents hated it ('It's just shouting') which made it all the more brilliant. Rik Mayall really did inspire a generation of comedians. And then he died on June 9th 2014, aged fifty-six. What a complete and utter bastard. I'd never actually cried about a celebrity before. Now I know how all those Princess Diana wankers felt.

It's a Laugh, Though, Innit?

But let us go back to the 1970s, when every single thing was brown, unless it was exceedingly fancy and then it was orange. Even the immigrants were brown, or very, very dark brown, and lots of the indigenous population (Romans, Anglo-Saxons, lots of men called Norman, Vikings, Danes – because no one ever invaded Britain EVER did they?) didn't like that and this was reflected in the racis... err... sorry, I mean 'culture' which included comedy. Stand up comedy in the 14th century was considerably more... God... sorry force of habit. Stand up comedy pre-1979 was performed by men in dickey bows in working men's clubs sandwiched between the bingo and the meat raffle. The jokes were shared about, rarely original (someone must've written

them first, but no one knew who) and women, immigrants or homosexuals were usually the butt. How delightful.

We Sow the Seed...

Towards the end of the decade in 1978, when everything was still brown but with more orange, insurance salesman Peter Rosengard met club owner and fledgling comedian Don Ward at a party. At that time Don had recently bought the Nell Gwynne Club in London's Dean Street (off Jimmy Jacobs, a Jewish comedian). Turns out they had both been to America and seen a new type of comedy at The Comedy Store in LA. So in 1979 they decided to open a comedy club in the room underneath the Nell Gwynne called the Gargoyle room. Auditions were held and in among a long line of nutty hopefuls they found a man who was even more angry and foul-mouthed than most scousers: Alexei Sayle. He impressed them so much they made him their resident MC and a whole new subculture was born (or stolen off the Americans depending on how you look at it). The timing was perfect. Thatcher's Britain was riddled with angry youths and ripe for having its 'alternative comedy' cherry popped. This was a new style of comedy performed by and to marginalised youth. It was punk rock with a punchline. Alexei inspired many a new act.

For comedian Steve Gribbin:

'It was like St Paul on The Road to Damascus... it was 1982, and I saw him at The Albany Empire in Deptford and was totally blown away by the anger, the pure vitriol, but also the wit and intelligence. Everything about him, from the Scouse accent to the too-tight two-tone suits, was all part of an electrifying package. For me, he encapsulated The Spirit of Alternative Comedy... angry, subversive, utterly committed to what he was doing and with a real sense that those dinner-jacketed dinosaurs of Light Entertainment were on their way out.'[1]

At that time, The Comedy Store was the place to be. It was anarchic, creative and bizarre. Gribbin recalls:

'First time I went there Tony Allen was on the bill, looking very dapper dressed in a pinstripe suit, who had a pint of beer poured all over him but just carried on talking as if

nothing had happened. I also saw Keith Allen doing his all-Japanese version of *Wild Thing* in which, even though the audience were yelling and catcalling, he did not break character once, and ended up getting a standing ovation, for balls if nothing else! The Iceman was hysterical... he just stood on stage waiting for a block of ice to melt...'

Gribbin went on to gig there himself as part of his then double act Skint Video.

'I remember going in the entrance on Dean Street and then having to go up in the lift along with the punters and the strippers from the bar below, all crammed into this tiny lift. I was absolutely terrified. The atmosphere in the actual venue was very antagonistic... it was almost like they were willing you to fail.'

Nature Grows the Seed...

Around about the same time performers from fringe theatre, poetry and musicians were converging in bohemian west London's Ladbroke Grove. Tony Allen who first coined the term 'alternative comedy',[2] met Sayle at the Comedy Store and they set up their own club in Ladbroke Grove called Alternative Cabaret, which is ironic because, with the exception of Headliners Comedy Club (previously Ha Bloody Ha) in Chiswick, West London has always been the place where comedy clubs have the life span of a mayfly.

Despite the fact that received wisdom claims alternative comedy was mostly political acts, this was not necessarily the case.

Rob Hitchmough, a writer and comedian who started out in 1987, says the whole political thing is a myth, 'It wasn't as political as people thought it was, lots of people ranting about Thatcher who weren't very funny.'[3]

It was only acts like Andy de la Tour and Tony Allen from the Ladbroke Grove lot who were deemed funny enough to actually play the Comedy Store.

Culture-cross

There has always been subculture crossover. Tony Allen and Andy de la Tour came from the fringe theatre scene. Many acts

Jenny Éclair

came from the poetry scene, including Phil Jupitus and Jenny Éclair. Phil called himself Porky the Poet. Eddie Izzard came from the street performer circuit as did Andy Smart. It still happens today; Stu Goldsmith and Windsor (famous for his sticky up pony tail and wonderful inability to write new jokes) both started out as street performers in Covent Garden.[4]

At the time of print, I can safely say that 80% of comedians in the UK who are over the age of 45 are failed musicians. Being in a band was part of growing up. Nowadays stand up comedy is seen as a viable career option. 'None of us thought it would lead to a career. I only started because my band had split up and I needed to earn some money,' muses Tony De Meur aka Ronnie Golden, another of The Comedy Store originals.[5]

Jumping the Mother Ship

In 1980, Peter Richardson was looking for a room where he could put on a play and then take his comedy chums from The Comedy Store and put them on after the play. He gave up on the play when he found a room suited to the comedy night he wanted to produce at the Raymond Revue bar in Soho, a well-known strip joint, hence the name The Comic Strip. Due to the nature of the host club, a right-on audience were mingling with the audience of the strip shows at the shared bar where soft porn would be playing on TV screens. Eventually, the intervals had to be staggered to avoid this. There you had politically correct artists and their left-leaning audience mixing with the lecherous punters of seedy Soho. 'It was a most paradoxical venue to be in,' Nigel Planer recalls.[6] He was in a double act with Richardson called The Outer Limits and he and other double acts including Rik Mayall and Ade Edmondson in 20th Century Coyote (which had started off as a bunch of improvisers at Manchester Uni Drama Dept, they were to later become The Dangerous Brothers), French

and Saunders (who'd answered an advert by Richardson looking for female performers), Alexei Sayle and Arnold Brown were all persuaded to sign contracts pledging their allegiance to the group. Peter Richardson said, 'It seemed like there was a group of us who had a kind of energy I suppose and a rough edge kind of comedy. We got on well and there was a feeling that we could do something together.'[7] Other performers were also occasionally Keith Allen and Robbie Coltrane.

Cheryl Robson, co-editor of this book recalls:

> 'I remember going to The Comic Strip and seeing Rik Mayall, Ade Edmondson, Dawn French and Jennifer Saunders. The club was in the middle of Soho's sleazy sex district and as a young woman, queuing up for it at night was not a great experience. Once you were inside, the atmosphere was electric. The humour was irreverent, politically left of centre, much of it improvised and based on narrative rather than one-liners. It was the first time I'd seen women comedians doing anything radical. I loved it and felt a sense of belonging to a generation who were reeling from the country's lurch to the right under Thatcher.'

Have We Got a Video?:
Why *The Young Ones* Was So Radical

This group of new comedians soon came to the attention of Channel 4 and ended up making over forty shows of *The Comic Strip Presents...* (In 1990 they switched to the BBC and then back to Channel 4 in 1998 with *Four Men In a Car*, which was the first TV outing for Rik Mayall after his quad bike accident.)

In response to this, the BBC wanted their own new comedy show and in 1981 Rik Mayall had the idea of using their core chums (Richardson, Planer, Edmondson, Sayle) in a sitcom and asked his old Manchester Uni chum Ben Elton to help him. It was written along with Mayall's then girlfriend Lise Mayer, who was responsible for the surreal bits: animated chips, ice skating on a plate or 'Roger' Bannister talking to camera.

This would become *The Young Ones* which was first broadcast on BBC 2 in November 1982 and ran for two series. It ended in

Cast photo, *The Young Ones*

June 1984, after it had BLOWN THE MINDS OF EVERYONE UNDER THE AGE OF TWENTY. Me included. (See opening paragraph.)

Christopher Ryan took the character 'Mike', otherwise known to us as 'the boring one', who'd been earmarked for Peter Richardson. Richardson didn't take the part due to a disagreement with the show's Producer Paul Jackson. One can't help but wonder what the show would have been like if Richardson had taken his rightful place. The entire world of *The Young Ones* was one of sheer anarchy: exploding lentils, beds falling through the ceiling, arson, lots of cartoon violence, brilliant characters, the fourth wall broken, all walls broken, bad agit-prop poetry, flash frames, hilariously quotable lines and a live band on each week: Motörhead, Madness, The Damned. Possibly the best comedy sitcom ever made.

The only other shows that ever came close were *Blackadder* (1983–1989) penned by Ben Elton and Richard Curtis and starring Rowan Atkinson, *Brass Eye* (1997–2001) created by Chris Morris and other writers including Charlie Brooker, Peter Baynham, Jane Bussmann, Arthur Mathews, Graham Linehan and David Quantick, the wonderful *I'm Alan Partridge* (1997–2002) by Armando Ianucci, Peter Baynham and Steve Coogan who starred and Ricky Gervais and Stephen Merchant's *The Office* (2001–3). Really? Boooooo.

By breaking nearly every rule in the comedy book, *The Young Ones* encapsulated the 'fuck it' attitude of the times. It was an era of recession, huge unemployment, riots, massive social unrest, and this energetic sitcom referenced all the politics that concerned the youth of the day; police brutality, Apartheid ('Neil, are these lentils South African?'), fascism, racism, class war, sexual politics of freedom and coming of age. Its brilliant, wildly scathing, almost punk rockesque attack on society and the hypocrisy of the establishment really spoke to the bright and educated young working classes like myself. Previous mainstream

57

comedy successes had been utterly sexist tripe like *Benny Hill* (I loathed this) or silly surreal Oxbridge comedy like *Monty Python* which seemed to be aimed at older people who found men dressing up as women hilarious. Alternative comedy was for the young guns of the era, not for the 'squares' of old. They didn't have that sense of entitlement that the Oxbridge lot had, it wasn't impressive, clever or silly stuff about clever stuff. As comedian Simon Pegg said on the BBC tribute in 2015 titled *Rik Mayall: Lord of Misrule*, 'It belonged to us.'

The performers, like their audience, wanted something different to the stifling and frustrated norm, and boy did they give it to us. Roughly, from in front.

When asked about his subsequent character, Alan B'stard, Tory Cabinet Minister in another hit 80s UK comedy *The New Statesman*, Mayall said this was, 'Probably the only good thing she did and even that was unintentional…' Go MAGGIE.

I Am Not Getting Aggressive! – Hardee and the Tunnel Club

It was comedian Arthur Smith who said: 'If Tony Allen, "The Godfather of Alternative Comedy," was the theory of anarchic comedy, then Malcolm Hardee was its cock-eyed embodiment.'[8] Hardee was the ex-jailbird, cock and ball bearing MC at the legendary Tunnel Club at The Mitre, Deptford 1984–89. It was a notorious gig with the shambolic Hardee eager to get his genitals out at any opportunity and dunk them in some poor, passed-out punter's pint. This gig truly embodied the phrase 'bear pit'.

Jenny Éclair remembers that: 'At the Tunnel Club I've seen Harry Enfield throw up before he went on stage because he was so nervous. You used to walk on stage and your feet would be grinding because of the broken glass and the carpet was sticky with blood.'[9] One infamous anecdote stars host Hardee, who pissed all over a man who had passed out at the front after the rest of the audience egged him on.

> 'It was a moment in comedy history that everyone from Mark Lamarr to Jon Ronson claims to have been present at with the host downing pint after pint in preparation before unleashing an arc that glittered in the spotlights

like liquid comedy gold. When the snoring victim later woke up, sodden and stinking, his friends told him what had happened and, apparently, he was just chuffed to have been such an integral part of the show (apparently).'[10]

Arthur Smith was doing a gig there with a double act called Clarence and Joy Pickles who weren't doing at all well when someone threw an ashtray that hit Joy in the face. The blood streamed and Arthur steamed with rage:

'I deliberately did the best material I could possibly do... I was slaying them. And then I stopped and said, "If you think I'm going to do anymore you've made a big mistake, because what you did to that act before was absolutely disgraceful – so fuck off the lot of you," and I walked off.'[11]

Harry Enfield, Vic Reeves, Bob Mortimer, Jo Brand, Chris Lynham, Punt & Dennis, Jim Tavare, Mark Lamarr, Julian Clary, Jeremy Hardy, Steve Coogan, Rob Brydon, Jenny Éclair and Simon Day all cut their teeth at this club. It was significant not just because it allowed them all the absolute freedom to be as extreme as they desired, as outlandish as required in their choice of material. It was important because it set the tone for other clubs which would encourage comics whose acts went against the grain of your typical Saturday night stand-up. The alternative scene was being constructed with some gob-smackingly loud foundations.

As possibly one of the most original working class alternative comedians, Hardee's fuck-it attitude made his own act brilliantly and deliberately shambolic. He subverted loads of old, music hall type jokes, to produce lines like, 'I met the wife in Jamaica... I said what the fuck are you doing here?' He was one of a kind and nurtured outstanding acts like Simon Munnery who created anarchic characters like Alan Parker: Urban Warrior and Bucket Head. He also managed anarchy comedy magician Jerry Sadowitz for a while. In his own work with The Greatest Show On Legs, he and Martin Soan would always go for freewheeling, anarchic stuff, marrying an old-fashioned 'variety' approach with an almost punk sensibility. (Google it, I can't do it justice with words.)

In later years, Hardee was to co-own the not-quite-so-notorious-

but-still-scary-as-fuck club Up The Creek in Greenwich until his untimely comedy death at the age of fifty-five. In January 2005, he fell into the Thames late one night, drunk, whilst trying to get onto his houseboat from Greenland dock. Legend has it that he still had a bottle of beer clutched in his hand when his body was found in the river. Oh Malcolm.

His funeral was attended by over 700 people and his legend lives on in the form of The Annual Malcolm Hardee Award For Comic Originality and The Malcolm Hardee Cunning Stunt Award for the best fringe publicity stunt at the Edinburgh Festival each year as organised by John Fleming, co-author of Hardee's autobiography *I Stole Freddy Mercury's Birthday Cake* (he really did).

Sadly the spirit of Hardee only really lives on in very few acts who have blazed their own unique anarchic comedy trails – like Paul Foot or Johnny Vegas. It takes a certain type of act that will stick to their guns and not pander to an audience, even if it means dying on their arse on a regular basis in the early developmental years.

Boom Boom Boom Shake the TV Comedy Boom

Saturday Live DVD cover

Besides the precursors to alternative comedy, such as Dave Allen, Billy Connolly and Jasper Carrot, some 80s comedy shows also influenced many would-be comedians. These included *Kick Up The 80s*, *Absolutely*, *The Kenny Everett Television Show*, *Three of a Kind*, *Wood and Walters*, *Alas Smith and Jones*, *Kevin Turvey – The Man Behind the Green Door* (Rik Mayall's 'investigative reporter' had started on *Kick Up the 80s* which was his first TV break), *A Bit of Fry and Laurie*, *Alexei Sayle's Stuff* and of course *Saturday Live*.

In time, the latter became *Friday Night Live*, and made household names of its host Ben Elton and many regular guests, such as Harry Enfield doing his Loadsamoney and Stavros characters,

Stephen Fry and Hugh Laurie, Patrick Marber, Morwenna Banks, Chris Barrie, Emo Phillips and Josie Lawrence to name but a few.

Not the Nine O'Clock News was a huge hit 1979–1982 but TV comedy was no longer dominated by the Oxbridge set. Scumbag College[12] had made its mark. These alternative shows had taken over from the middle class satire of the 60s like *Python*, and *That Was the Week that Was* and even classic sitcoms like *Porridge* and *Rising Damp* of the 1970s. Comedy was turning away from the traditional culture of the past.

Room for More

CAST (Cartoon Archetypal Slogan Theatre) was the UK's 'original left-wing underground theatre group in the 60s'[13] and Claire Muldoon played a key part in it:

> 'Towards the end of our time as a Theatre Group we were developing a more direct cabaret comedy style using mics and mic stands … We used GLC money to subsidise lots of acts, bands and stand ups, poets and speciality acts. Although the authorities didn't appreciate this, then we took over the Hackney Empire knowing we had strong links with the emerging comedy world.'[14]

She and husband Roland still run the New Act Of The Year competition which started as the Hackney New Act of the Year competition in 1982 and propelled the careers of acts such as Nina Conti, Daniel Kitson, Micky Flanagan, Gina Yashere, Lee Mack and Tim Vine.

Jongleurs: Survival or Sell-out?

Jongleurs, Camden

In 1983, drama teacher Maria Kempinska took out an overdraft and opened up a comedy club in a room above a pub she had roller-skated in as a child. Jongleurs was born in Lavender Hill in Battersea. She and her then husband John Davy cultivated a specific kind of party audience and marketed their evenings to hen and stag parties, birthday parties and so on. Large

groups could sit at their own table, have food brought to them, be entertained, be thrown out if they got too drunk or disruptive, and if they could still stand at the end of the night, have a boogie at the after-show disco. The next clubs opened in Dingwalls at Camden Lock, then Bow, then the rest of the UK. In 2000, Kempinska and Davy sold 51% of Jongleurs to Regent Inns for £8.5 million but still booked the acts. Regents Inns collapsed in 2009, taking their Bar Risa chain that hosted many Jongleurs nights with them. Most of the clubs shut down but one of the directors of Regent Inns bought the survivors in Birmingham, Glasgow, Leeds and Camden, and called his company 'Intertainment UK'. The comedy chain became 'Highlights' (sounds more like a hairdresser) while Maria retained the Jongleurs name as part of the original buyout and started more clubs. Some lived, some died, and in 2014 Highlights and Jongleurs merged to become... Jongleurs and lived happily ever after.

The all-new Jongleurs clubs are the largest employers of comedians in the UK to date and in some ways have become the new version of the working man's club. The principle by which they are guided is the same; they seek to provide an affordable night out with friends, food and entertainment; just in a more modern environment. The complete taking over of the comedy scene means that the counterculture of comedy has now become normalised, so that society as a whole is moving away from nonsense like sexism and racism even though we've still got a long way to go. The problem is that acts that are 'radical' are seen as a risk that a lot of clubs aren't prepared to take when punters have paid £15 to get in. Most of these acts tend to have their own fan base and do solo tours to great success like Simon Munnery, Josie Long and Tony Law. The lesser known weirder acts tend to do smaller, more forgiving clubs. For a time in the early 2000s there was a supposed trend towards 'whimsy' and too much 'nice' comedy, which was largely derided as just not funny. I'm not sure if this was mostly mythological, however, because when comedy critic Steve Bennett was asked who these 'whimsy comics' were, even he could only identify Josie Long, who has since developed her style to be more personal and political.

Awards Time:
It's Not About the Winning – Well, Actually...

The Foster's Edinburgh Comedy Award has had several names and sponsors over the years but was originally the Perrier Award. It was started in 1981 to encourage new talent. It can be the springboard to stardom – Frank Skinner, Steve Coogan. Or not – Simon Fanshaw. Who?

The editor of the *Chortle* website Steve Bennett thinks: 'The importance of the awards has dwindled loads. The media have TV development teams out and about through the year, not just at Edinburgh.'[15] A sentiment echoed by Julia Chamberlain who produces the new act competition, 'So You Think You're Funny' and books the acts for Jongleurs. 'I take no notice of it anymore because they don't seem to know what the fuck they're talking about. Every year I'm absolutely aghast at the nominations.'[16]

Edinburgh Festival

The biggest bun fight, erm, I mean, arts festival in the world can be a ticket to stardom or a year of paying off 'Edinburgh debt' until you go up again and do the same thing. The original big venues are The Pleasance, Gilded Balloon, Assembly Rooms, The Stand (which is actually a wonderful permanent comedy club) and relative newcomers include The Underbelly and Just The Tonic.

Joe Public always seems shocked to find out that it's a very expensive venture for any performer. Even a veteran comedian of Richard Herring's calibre, having done twenty-three festivals in twenty-seven years, thinks that overall he's broken even.

PR, shitty and overpriced accommodation (you should see how the locals cash in and bugger off to the Maldives on their sub-let profits), venue hire, posters, flyers, brochure entry, adverts – there's an endless list of expenses that have to be covered just for an opportunity to tell jokes and involve yourself in a gamble that may or may not pay off. That is, unless you do the Free Fringe, which has expanded exponentially over the last five years. The Free Fringe was started in 1996 by the wonderfully eccentric Peter Buckley Hill. Over the years, the Edinburgh Festival has become increasingly corporate, making a mockery out of the definition of 'Fringe' with TV acts going up there, playing huge

venues and leeching the audiences away from the smaller shows. Herring sums this up nicely:

> 'It's polarising between Free Fringe and TV names and the majority in the middle are left fighting for scraps. There's less point in spending money on PR and big posters and realistically it's probably better to go to the Free Fringe and create a good show rather than spending ten grand to do a show at a paid venue where no one will see you and you won't get reviewed.'[17]

Edinburgh Festival really has to be seen as Boot Camp for comedians. Artistically it enables them to break out of the constraints of a twenty minute club set and flex their comedy muscles for a whole hour. And if you've worked hard and produced a great show, maybe other work will come off the back of it. TV comedy *This Morning With Richard Not Judy* started as an Edinburgh show. Even though Richard Herring lost £40,000 on a play he took up in 2014, he's marvellously philosophical about it in the way only a true artist can be:

> 'It's short-sighted to look at profit and loss in that way. It was tough in the early years when I was making very little money, but also the Fringe was like my holiday and the most social month of my lonely year. And even in 2014, I knew that my play was going to lose money and was prepared to risk it because I thought the idea was good and the potential rewards justified the gamble. It didn't pay off this time, but it has lots of other times. And we learn more from failure than we do from success. The Fringe is about what you learn, not what you earn... spirit of art over commerce.'

Jenny Éclair once said, 'Edinburgh's like a big holiday camp for people of a certain age who are old enough to know better.'[18] Punters have no idea of the shenanigans going on behind the scenes. Comedians throwing up at 7am on a Tuesday morning in the Penny Black pub which opens at 5am – just after Late N Live finishes – punch-ups (Ricky Grover famously broke Ian Cognito's jaw after he insulted Ricky's Mrs. It was the first week of the festival), drug fuelled sex in graveyards etc – ya cannae

beat it. But as comedians seem to get more and more professional with every generation, the hedonism seems to have calmed down somewhat. The singular most annoying thing about the festival apart from Festival Flu (pretty much guaranteed for everyone doing the whole run) is flyers and flyering. You pay people to do it for you or (gulp) do it yourself. In the rain. On the Royal Mile. Fighting for attention with literally a thousand other performers including the lowest of the low: drama students. Even worse, POSH English drama students. I was performing at Edinburgh during the London Riots in 2011. I would rather have been on Tottenham High Street than on the Royal Mile surrounded by fucking drama students. At least if you punch a hoodie in the face they don't make a big song and dance about it.

May the Seed of Your Loins Be Fruitful in the Belly of Your Woman

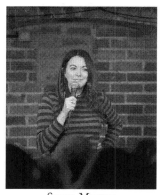

Susan Murray

Before the 'alternative' scene evolved, the few female comedians or 'comediennes' as they were called (CRINGE) were Faith Brown, *New Faces* winner Marti Caine and runner up Victoria Wood. Comedy Store original ladies were Helen Lederer, Pauline Melville (who played Vyvyan's Mum in *The Young Ones*) and French and Saunders, who along with Jo Brand were the first women to blaze a trail through the male dominated world of comedy. Claire Muldoon remembers how she supported the women who closely followed them, 'Linda Smith, Hattie Hayridge, Jo Brand, Jenny Le Coat, Ronnie Ancona – we got their feet in the stage door.'[19]

In 1995 Jenny Éclair won the Perrier Award, the first of only three women to ever do so. Laura Solon won it in 2005 and more recently Bridget Christie in 2014. Josie Long, Sarah Millican and Roisin Conaty have all won Best Newcomer. This may seem a piss-poor number of women but it's a numbers game. If the

rough ratio of male/female is 80/20, we're not doing so badly.

There are more and more women doing comedy and the overall quality is now very high. We are only just beginning to overcome the whole 'Women aren't funny' nonsense. That's the kind of thing said by idiot men, and, astoundingly, some women. But if you thought Jo Brand was the only female comic of note and she wasn't your cup of tea, and you were a short-sighted prick who only hung out with women who were as dull as dishwater, then you would get a very narrow view of what 'funny women' were. In the 21st century there are so many different styles of female comedian: Josie Long, Kerry Godliman, Zoe Lyons, Mary Bourke, Jo Caulfield, Janey Godley, Debra-Jane Appelby, Bethany Black, Jojo Sutherland, JoJo Smith, Tiffany Stevenson, Sarah Kendall, Barbara Nice, Karen Bayley, Allyson June Smith, Grainne Maguire, Tanya Lee Davis, Janice Phayre, Mandy Knight, Sarah Pascoe, Holly Walsh, Jen Brister, Mandy Muden, Susan Calman, Lucy Porter, Shazia Mirza, Maureen Younger, Ninia Benjamin, Pam 'Cougar' Ford, Angie McEvoy, Shappi Khorsandi, Andi Osho, Gina Yashere, Katherine Ryan, Nina Conti, Diane Spencer, Jo Enright, Susan Morrison, Juliette Meyers, Angela Barnes, Wendy Wason, Ria Lina, Meryl O'Rourke, Suzi Ruffell, Ava Vidal – oh God I hope I haven't missed anyone out, I'll be booted out of the coven. Anyway, the point is that there are bloody loads of us now so if you don't like *any* of us, that's your problem not ours and you're a bell-end.

Even though audiences are generally less sexist these days, a woman has less time to win an audience over. Part of Sarah Millican's success is her quality of succinct joke writing – there's no flab, every line is a punchline, upon punchline upon punchline.

Interestingly, when the 'home of alternative comedy' The Comedy Store celebrated its 30th anniversary in 2009, Bruce Dessau, comedy critic for the *Evening Standard* wrote:

> '… bizarrely, there was no female in the three-hour show. From French and Saunders to Jo Brand and beyond, women have been part of the Store. Their absence was a major niggle, not a giggle.'[20]

At the time, the owner Don Ward said there were no funny

women on the horizon... just as Sarah Millican toured pretty much non-stop for three years, landed a prime time TV slot and was commissioned by BBC Radio 4 to do a series.

To do this job you have to be a tough old bird. Many would be put off by the sheer practicalities of trailing around on your own on public transport at weekends surrounded by drunken lunatics, driving for hours and hours in the middle of the night, alone, on a motorway that's been closed with no warning, living off Ginsters pasties from service stations, having zero social life because you're always working at weekends, dealing with male punters being weird and resenting you because you've got the balls to do the job they haven't etc. Also the problem of having to juggle children with the commitments of performing means that the dropout rate for women is quite high, sadly, but we persevere. And despite what people may think, it's a very supportive community, mainly because we all know how hard it is, and we never get to work with each other because if you have more than one female comedian on the bill the world shifts on its axis. Fact.

Saying that, in 2014 I did a gig for Toby Foster at the Last Laugh in Sheffield, where, for the first time in my entire career as a professional, I was on a bill with two (yes two!) other women. JoJo Smith appeared as MC, Debra-Jane Appelby opened, I was middling and we had a token bloke closing – Gary Delaney (Mr Sarah Millican if you must know) who ironically was the only person that night to do a period joke. Older Yorkshire men aren't exactly known for their liberal views and that night the audience was cock heavy, including a fifty-strong stag do. I'd been dumped by text the day before so none of this boded well. BUT... we fucking slayed 'em. It was a great feeling to know that in the space of two hours we had changed the minds of at least a hundred Yorkshire men about whether women were funny or not. Champion. But as Claire Muldoon says, 'The struggle against male domination continues' and so say all of us.

We Haven't Got Any Bread

As an open spot (rookie) I trembled in my shoes waiting to do my *Daily Telegraph* Comedy Competition at Edinburgh in 1996, and the MC of the gig that night, Boothby Graffoe said to me 'Even

in a recession, comedy does well' and he had a point. Alternative comedy had thrived during the recession of the 1980s. Anger and marginalisation was literally translated into brilliant comedy routines by the likes of Ben Elton and Alexei Sayle. The comedy of anger, railing against the injustice of the Thatcher government was at its prime, and the new TV programmes and expansion of TV stations meant that alternative comedy was fresh, exciting and expanding.

In 2008 the global financial crash didn't affect comedy initially and the live circuit was unscathed for about two years. The general public just changed their spending habits. Instead of going to the pub three nights a week, they'd make a night out special by just going out once, and paying for comedy. Then the ongoing austerity bit our industry. Hard. In the arse. 'We are all in this together'… yeah right. Solid established jobbing circuit comedians went from gigging an average of between five and seven nights a week to between zero and four nights. Dozens of small gigs shut down for good. Some gigs that ran three consecutive nights a week reduced to two, then one. It seemed like every week another club died. The Red Rose in Finsbury Park, The Laugh Inn Chester, Jesters in Bristol, The Square in Harlow, The Frog and Bucket in Preston, Cosmic Comedy Club in Hammersmith (yet another west London death. What IS it with those people?) Even the famous Banana Comedy at the Bedford Arms in Balham that would have two rooms running in the same venue every Friday and Saturday was reduced to one gig per night due to dwindling numbers. The original three Jongleurs clubs would run one show on a Thursday, then an early and a late show on Friday and Saturday. The only club now that has a late show is The Comedy Store and even they have reduced the number of acts in that particular show. Many of the smaller clubs have only managed to survive by lowering wages. Some gigs haven't put their fees up in over twenty years making it very tough to make a living out of full-time stand up.

Hands Up Who Likes Me

'Comedy is the new Rock 'n' Roll' is a statement popularised by Janet Street-Porter but was actually said by Dave Cohen in

the set-up to a joke. The sentiment was solidified when Avalon Management put their young, funny, hot double act Newman and Baddiel in Wembley Arena in 1993, a show that broke the record for the biggest comedy gig at that time. This gig was 'in the round' meaning that the audio could be heard in all corners of the venue and there was no need for huge screens as the stage was situated in the middle of the audience rather than at one desolate end. In 1996, Avalon tried to break their record by giving Frank Skinner a 6,000-seater gig at Battersea Power Station.

TV always struggled to portray the atmosphere of a comedy club and shows like *Gas* fronted by Lee Mack didn't last more than two series despite having quality comedians on it like Chris Addison, Peter Kay and Gina Yashere. Many 90s shows like *Shooting Stars* etc never quite had the purchase that TV has today with the endless repeats on comedy channel Dave of shows like *Mock the Week* and *8 Out of 10 Cats*.

It was Open Mic's (owned by Off The Kerb Management) gamble in 2004 on *Live At the Apollo* that helped to change all this with their prime time TV slot. Originally called *Jack Dee's Live At the Apollo* for the first two series, the subsequent name change reflected the guest MC each week. Acts such as Joan Rivers, Ardal O'Hanlon, Ross Noble, Omid Djalili, Jimmy Carr, Lee Mack, Rob Brydon, Alan Carr, Sean Lock, Patrick Kielty and Stephen K. Amos appeared.

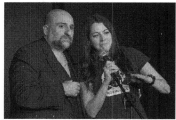

Omid Djalili, Susan Murray (twice), Marcus Brigstocke

It also helped launch the careers of lesser-known talent such as Rhod Gilbert, Frankie Boyle, Seann Walsh, Nina Conti, Sarah Pascoe, Jason Manford, Sarah Millican, Micky Flanagan, Lee Nelson, John Bishop, Kerry Godliman, Greg Davis, Mark Watson, Andi Osho, Russell Kane, Tom Staid, Romesh Ranganathan,

Chris Ramsey, Katherine Ryan, Reginald D. Hunter and the force of nature that is Jack Whitehall.

The Rise of the Stadium Comedian

Has going to a live comedy gig lost its appeal today? Julia Chamberlain explains:

> 'TV has wrecked the live circuit. You can get so much access to live comedy on TV these days and it is "as live" because you've got endless repeats so people can stay in and not have the hassle of going anywhere. People aren't getting the career breaks and it's a self-perpetuating cycle. "Oh well I've seen them on the telly so I'll go and see them in the theatre or I haven't heard of them so I'm not going to bother."'[21]

Another reason for the dwindling club numbers is the amount of comedians touring. Editor of *Chortle*, Steve Bennett, thinks, 'Comics want to work on their own rather than just be a person on a bill... and it's easier to promote yourself because of the internet and people can just follow you.'[22]

If Michael McIntyre is touring venues that have 20,000 seats, that's 20,000 people who would rather spend £50 on a ticket to see him waving his hair about. That's a lot of budget and bums on seats leached away from the local club circuit – the place where the big stadium comedians cut their teeth/paid their dues/died on their arses. But those huge gigs are tricky. Al Murray did two arena nights in 2008 at the O2 in London:

> 'It's difficult and you have to accept that the room is full of distractions. I parked my nerves overnight, woke up after the second show freaking out. It screws with your timing. The audience watch the screen, not you, even the ones at the front, like a TV over someone's shoulder in a pub.'[23]

Back to Bennett, 'Even if they're people you like they're never great gigs in arenas that big.' The superstar comedians appeal to a very broad cross section of society – everyman cockney like Mickey Flanagan or cheeky everywoman Sarah Millican. 'None of the stadium comics have a particularly strong flavour,' says Bennett. Not all of them want to do gigs that big. Sarah Millican

could easily fill the O2 but clearly prefers the smaller-sized theatres which she fills over and over.

A Helping Hand

Out of the many millionaires who rose above the circuit, and went on to TV and big tours, one who cares about his fellow old work chums is the talented and annoyingly youthful Jason Manford. Whenever he is on TV he always mentions the lower level clubs, and whilst on tour he tells the audience about their local smaller comedy clubs. Above all, he's used his fame and influence to start up a chain of clubs in order to give the flagging circuit a much-needed boost. As he says:

> 'There is a circuit of brilliant comics in this country who haven't been on telly for a number of reasons. Maybe they're up and coming, maybe they were on a late-night stand up show in the 80s and called the host a knobhead, or maybe they just have a severe drinking problem... I'm going to carefully select some of my favourite comedians from the circuit and send them to a town near you.'[24]

His very own job creation scheme. All hail Saint Jason.

When Will I, Will I Be Famous?

Getting a break is just not easy. To return to Julia Chamberlain:

> 'To break through and make squillions I think you have to be very lucky and very young and get picked up by someone who thinks they're a kingmaker and they do the job for you and if your writing's not good enough they'll get you writers and they'll put you in the right suit. Avalon and Off the Kerb having got so much of the TV (comedy production) sewn up between them, they can put who they like on TV and people get used to what they're being offered to some extent. Cynically I think it's almost like the studio system, the studios make the star now... to be an original voice and not be within the production house system it's very difficult to break through now.'

Still want to be a part of it? There are dozens of comics who have been slogging their guts out on the live circuit who could easily become huge given half a chance, people that you've

probably never heard of even if they've had some TV or radio exposure. Look up this entire list of full-time, professional, experienced and brilliant comics on YouTube and you will see what I mean; Nick Doody, Ben Norris, Zoe Lyons, Sean Meo, Mary Bourke, Stephen Grant, Ninia Benjamin, Carey Marx, Dave Johns, Mandy Muden, Sean Collins, Mike Gunn, Geoff Norcot, Roger Monkhouse, Steve Harris, Alex Boardman, Kerry Godliman, Ian Moore, Ian Stone, Paul Thorne, Adam Bloom, Angie McEvoy, Boothby Graffoe. Any of the 'famous' comics would agree with me. Fame is arbitrary. It comes if you're lucky enough to get the breaks and find your own 'tribe'.

How to Start (*Don't*)

I did a course, as did many of us. There were two main short comedy courses for years; Jackson's Lane Community Centre (Eddie Izzard, Paul Foot, Hattie Hayridge, myself) and City Lit (adult education centre in London) taught by Gill Edwards (who now teaches her own course in Brighton). There are now about a dozen comedy courses and no shortage of wannabe funnymen and women. The main ones are Amused Moose, Laughing Horse, City Lit, The Comedy Course (mine 'coughs') and Gill Edwards.

Many drama degrees have comedy or even stand up modules. Many comics were taught on the BA Performing Arts at Middlesex Polytechnic (now University) by Downstairs At The Kings Head (Crouch End) original resident MC Huw Thomas. In 2006, Solent University in Hampshire launched a BA in Comedy. This stopped in 2014. In 2012, Salford University in Manchester started offering a BA in Comedy Practices, which is still running in 2015. Salford's alumni include Peter Kay and Jason Manford.

Is It Even Subversive Anymore?

Like most things that are popular, successful alternative comedy eventually becomes the mainstream as observed by the elder statesman of comedy, Barry Cryer,

> 'It's interesting the sequence, because the explosion of
> Ben Elton and then he becomes part of the establishment,
> you know, works with Andrew Lloyd Webber.'[25]

But there are still some comedians that subvert the art form

itself like Stewart Lee who has his own inimitable style of deconstructing comedy. Harry Hill became famous for his structure of callbacks, a technique in comedy writing that involves repeated references to earlier jokes or characters throughout a routine. Robin Ince has made a virtue out of intelligent ranting. Ross Noble is a brilliant improviser who has practically developed his own genre. Simon Munnery's subversive satire has been used by famous graffiti artist Banksy. Jerry Sadowitz needs a mention as he is unrepentantly vile about everyone and always has been.

When it comes to subversiveness, especially involving conspiracy theories, Aussie Steve Hughes is your man and has influenced many new UK comics, having lived in London for over a decade deriding the populist pap served up on TV to numb the brains of the masses. I often think Hughes is saying what Bill Hicks would be saying now if our saviour were still alive. Most comedians are left-wing (i.e. have a heart and soul) but few of us do an entire set on politics. There are some that do: Jeremy Hardy, Mark Steel, Alan Francis, Steve Gribben, the utterly brilliant Marcus Brigstocke, emerging talent Joe Wells and of course Mark Thomas with his political stunts. Oh and we can't forget Russell Brand and his commie hair. Gribben sums it up nicely, 'The scene began to homogenise very quickly, really, to just one white male middle class bloke with a microphone round about 1990, but I think the last five years have really seen a welcome opening up of the comedy scene.'[26] When it comes to radio, it was always dominated by the Oxbridge graduates but it's slowly letting in more proles like myself. Cryer cites BBC Radio 4's *News Quiz* saying it is '… the most subversive thing on radio and it's been castigated recently because Jeremy (Hardy) and Sandi (Toksvig) get away with some really heavy stuff.'[27]

Darling Carrot, Could You Ever Love a Cripple?

Comedy is a lot more inclusive than ever. Steve Day is the UK's first deaf comic and thought he was immune to heckles, 'One gig in Kentish Town a guy had a paper and tried to make a heckling sign by tearing out the letters from the headlines, like a ransom note. I was only doing five minutes so he got no further than "You're sh".'

Chris McCausland is the UK's first blind comedian. He's from Liverpool (life can be *so* cruel) and has a beautiful opening line, 'They put me on first 'cos they know it takes me longer to drive home.'

Francesca Martinez was the first to blaze this trail though. Born with cerebral palsy, a condition she likes to refer to as 'wobbly', wrote a fabulous Edinburgh show 'What the **** is normal?' Indeed. Now the circuit boasts all sorts; Tanya Lee Davids is a midget, Robert White has Asperger's, I myself suffer from Chronic Fuckwittery.

Anyway, You'll Still Never Win 'Cos Nothing Interesting Ever Happens to Us

Only the lucky few 'make it big' but it's still the best job in the world. It truly is. It's also the most childish job in the world. Where else can you get paid to stand on stage like the attention-seeking child that won't go to bed, tell jokes, swear, be rude, get free drinks, legitimately stay up late hanging out with like-minded idiots who also refuse to grow up? The only downside is the lack of job security, having no pension, no social life, crippling career envy, missing every single birthday and wedding (yours and others), getting no sick pay, no holiday pay and battling with an infinite amount of comedians for a finite amount of gigs. Shit. SHIT. Anyone got a job for me? I can multi-task, I can type and swear simultaneously!

If you want to know what it's like on the UK circuit, watch this Hitler's Downfall parody by comedian Dominic Frisby: w w w . y o u t u b e . c o m / w a t c h ? v = N Y 3 W h v N 5 q A w (NB contains industry 'in' jokes.).

Oh and one last thing, every comedian has their own Gig Jinx, the one comedian where you always die on your arse when you gig with them. Mine's Michael McIntyre.

DANCE

Anarchy from the Margins and Free Expression

Mark Edward

Mark Edward (centre) in one of his contemporary dance performances
This chapter provides a broad overview of countercultural happenings in dance in the UK, detailing dance subculture from the days of stomping, twisting and shouting, through to the era of punk, contemporary dance and rave culture; and finally considering the role of dance in future countercultures. Dance is an embodied experiential form, and individual experiences of counterculture and anarchy remain within the skin and bones of one's memory and flesh. In light of this, aside from this over-the-shoulder historical glance at dance in the UK, I provide my own personal and subjective recollections of my own countercultural experiences and those of other fellow researchers, anarchists and dancers who sloped towards the socio-cultural margins. This chapter is therefore partly autobiographical and partly researched.

Counterculture has always been a term which smacks of resistance, denoting cultures on the 'fringes'. Diametrically opposed to mass culture in terms of its identities, it has often been used as an umbrella term to describe movements in diaspora.

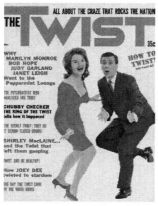

In terms of dance culture, new movements such as jiving or doing 'The Twist' (Chubby Checker) have followed the life cycle of counterculture by initially facing rejection, then growth (or at least partial acceptance) before being absorbed into mainstream culture and then falling into decline. The reason for the decline is arguably due to its absorption into mainstream culture, but decline does not always equate to death. The rebirth of counterculture movements remains possible, as the legacy of such movements often falls into the shadow of mainstream culture and lurks in historical closets awaiting revival. Within Western society, the impact of previous countercultural movements can be seen in examples of the legacy of the hippies, punks and ravers.

As a performance artist with an extensive background within dance culture, I consider dance to be an international language that expresses itself through the human body. It is an ephemeral art form that has the ability to speak without the use of the spoken word. It is movement that has a human purposefulness whether this is to entertain or, as we will see, deployed in the service of specific political, social and cultural agendas. Within today's society, dance serves multiple purposes, as it is incorporated into ceremonies or utilised as a means to create a sense of identity, individual well-being and communal health-related practices.

This chapter does not endeavour to be the definitive dance bible to UK dance genres and their genealogy. I aim, however, to give the reader an introduction to some of the hybrid forms of dance, as well as exploring shifting trends that have been influential to the cultural and social fibre of the UK. It offers the reader a discussion of the transgressive nature of dance in cultural, social and political contexts through personal reflections and experiences. The text here does not give an in-depth account

Ballet Rambert and other stylised forms of dance?

Mary: It was a new beginning, a renewing of the mind and body. I was in more charge of the body, making my own choices and not from an outside artistic influence. I was creating my own context

Mark: How did the dancing feel?

Mary: I felt more in control. It was a different way of moving. More fluidity in the moving, more at ease as a dancer.

Mark: Did you feel empowered?

Mary: Yes. There was a sense of relief, an expansion on what a dancer could be, the ceiling had been lifted off in terms of what I could do and how I could do it.

Mark: You (and the rest of X6) are considered one of the founders of the post-modern dance movement in the UK.

Mary: We did not see it as post-modern dance. We did not refer to it as that. We called it new dance. The label post-modern came after.

Mark: Would you say you were subversive?

Mary: In the sense that we undermined traditional conventions and methods of making and producing work. We were challenging values, aesthetics and the dominant dance culture. The movements in feminism, human rights, and class issues were a part of our discourse and informed our work.

Mark: Were you seen as controversial?

Mary: I hope so!

Mark: If you had only three pieces of advice to give to the aspiring dance artist what would they be?

Mary: Be rigorous. Be true to yourself. Believe in what you are doing and be wary of fashion.

D-I-S-C-O and a Trip to Wigan Pier, 1970s

The sounds, the free-form dance, the colourful costumes and the hallucinogens of the 1960s tripped into the 1970s as a form of proto-disco music began to emerge. As the radio was replaced by the television as the main home entertainment system, the discotheque became a more stable venue to go to in search of

contemporary counterculture as opposed to travelling to hippy pop-up events. As an early 1970s creation myself, and as a birthday treat to myself, I would like to indulge in the discographies of this period by naming a few of my mainstream favourites: Gloria Gaynor's 'Never Can Say Goodbye' and 'Reach Out (I'll Be There)', Patsy Gallant's 'From New York to LA' and everything produced by ABBA. Evidently, it is not only disco balls which are camp. This was post-1960s, in which Donna Summer enjoyed multiple orgasms in her release of 'Love to Love You Baby'. My own playground choreography was fuelled by the sounds of my living room and my sisters' new records.[6] Yes, in the school-yard, I gyrated, bumped and even attempted 'The Robot'. I never quite managed 'The Hustle'. It was only in early adolescence that I discovered *Saturday Night Fever*. Saturday nights in my parents' modest living room saw me spin to Legs & Co and Hot Gossip. This was the era in which dance got professional, with the birth of the forenamed 'professional troupes' and the numerous disco dancing lessons and competitions which pulsated within the discotheques.

But just what was countercultural about this era?

James Perone notes how 'the end of the counterculture era was marked coincidentally by the development of disco music and an entire disco culture.'[7] Thus, here endeth the lesson.

Well, not necessarily. It is highly improbable that US-based Perone has visited my home town. I was fortunate enough to be residing in Wigan, north-west England, and the 'Northern Soul' movement of the 1970s saw the working class youth from my region dancing to obscure Motown music from the 1960s. Northern Soul counteracted the mainstream pop music which dominated the 1970s music scene. The north of England boasted subcultural sites in which the Northern Soul scene was played out, such as Blackpool Mecca and Wigan Casino. What is worthy of note, however, is that the political aims of the 1960s characterised by collective group politics were morphing into the politics of the individual, as the 1970s epitomised the turn towards the self. This is why Northern Soul can be seen as an example of counterculture. Sarah Thornton, who explores

musical subcultures notes the unique and rare nature of Northern Soul as oppositional to mainstream:

> 'The logic of Northern Soul's appeal was not nostalgia but rarity. Taking the Mod taste in soul music (around 1966) off on a tangent, Northern Soul DJs played increasingly rare records from the period. Not only were these records unavailable to dancers but also few of them knew the names of the artists or even record labels to which they danced.'[8]

This unusual and rare music was certainly in the vein of counterculture. Particular dance styles and fashions which were part of this movement were akin to those found in the underground rhythm and soul scene. Mod clothing including braces, button-down shirts and brogues were often worn with blazers. Athletic dance moves responded to a frantic beat combining elements of funk, disco and jazz. Movements such as flips, spins and backdrops expanded the horizons of the dance floor as a space which would be touched by more than just feet. In many ways, the movements found within Northern Soul venues were a precursor to the street breakdances of the 1980s. The clenched fist which became the symbol of the Northern Soul spirit was itself an emblem of the Black Power movement within the United States. Aside from this example of counterculture within the north of England, extending towards the Midlands, there was a reduction in the use of drugs, with amphetamines being the drug of preference which would provide the stamina to stay up and keep moving during the night.[9]

Via email Kate Garner, originally from Wigan and former 1980s 'new wave' Haysi Fantayzee band member, offers some reflection on this era and comments:

> 'I loved the dancing. It made me feel free but I was too immersed in normal teenage anxieties to really take note of the style or form of what I was liking. I was looking for a meaning to my life. I got kidnapped by Jesus Freaks in London, I escaped after a year, hitch-hiked to India. I needed another dimension in my life... The majority of Haysi's songs are political in some way, couched as

nursery rhymes and were totally counterculture as was the whole image we projected. From the way we dressed, our lyrics, our attitude. We were controversial in the disguise of pop.'

If ever counterculture was more akin to political insurrection, it was during the 1980s of Margaret Thatcher. The zeitgeist of the anarchic 1980s was certainly far removed from that of the 'free love' 1960s.

Punks: Pogo, Moshing and Headbanging

Nothing screams anarchy more than the punk. Here I offer just a taster of the dance movement which accompanied the banging punk music of the 1970s and early 1980s, observing how dance floors became sites of aggression and even violence. Let us consider just three of the iconic punk 'dance' movements: the pogo, moshing and headbanging. Firstly, the pogo was a simple movement in which the dancer remained quite rigid and repeated his or her attempt to defy gravity by jumping up and down, often to the accompanying loud beat of punk rock. The jumping was not confined to one spot, however, and 'pogoers', as they came to be known, often traversed the dance space by jumping in any direction, which often resulted in collisions. Researcher in dance and performance, Sandra Philip reflects on her time as a former punk:

> '[Punk dance] was kind of "non" dancing. It was jumping in unison, dodging the gob [colloquial term for spit] and heaving yourself up on the shoulders of others. I remember sweat, energy and a sense of collective angst – that was what fuelled the dancing when it all began... that and amphetamines, until the New Romantics arrived, when dancing became a much more sophisticated affair!'

Secondly, and characteristic of this violent 'dance' movement, was also moshing, in which individuals would purposely collide and aggressively slam into one another to form the mosh pit. Moshpits gained notoriety because of reported injuries and deaths, and I am not sure any other 'dance form' in history can claim such violent infamy. Equally, headbanging was similarly a hardcore movement, in which an individual would thrust his or

her head backwards and forwards in a violent, jerked movement, in order to whip one's hair around, if applicable. Philip continues:

'At times, there was some influence from the skinhead scene, and football, and frequently a lot of fighting but I think it was a violent period, socially and politically. I also remember feeling part of something; a feeling of belonging so the myth of violence certainly didn't impact on my experience of being a Punk. For me it felt positive.'

Certainly visually and in terms of movement, the culture of punk served to counteract the hippy movement, 'extinguishing the "peace and love" logo in the process'.[10] Nevertheless, the hippy ideologies remained to some extent, as punk remained both gender inclusive and anti-racist. Punk was a chaotic eclectic melting pot, expressing angst among the working class as they rebelled against the monarchy, government and poverty. Author, journalist and former punk Alex Ogg, notes: 'I generally have a suspicion of authority and any hierarchy that isn't based on moral concepts which I attribute almost wholly to my punk education.'[11] The aggressive and 'hard' aesthetic was notable through the fashion of leather, vinyl, rubber, denim and the traditional punk Mohawk hairdo. Ogg goes on to say:

'It's more the attitude that's stayed with me, rather than any of the trappings (clothing, extreme hair styles, dance etc). I'd just part by stating that it was the inclusivity of punk that was such an attraction. Everything was up for grabs and there was a compulsion to actually get involved and do something. It was a licence for creative disobedience and I seized it.'

Following punk, we see how the softer and more colourful aesthetics of the New Romantics clashed with the punk counterculture.

For those who toyed with the idea of expressing themselves through alternative fashion, the punk movement provided one alternative look. A second was the New Romantic style coming from nightclub origins in the late 1970s and eventually moving into mainstream culture. TV programmes of the time displayed musicians such as Adam Ant and Boy George (overleaf).

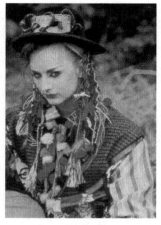

New Romantics were sometimes considered the enemy of punk culture. Make-up and androgynous clothing characterised the New Romantic look, and the movement became more about fashion than music. Synthesisers and a rhythmic beat permeated songs which were quite short in length and the notion of 'synthpop' emerged. This would dominate the mainstream music scene from the 1980s.

1980s: Acid House Raves, from Hardcore to Darkcore

Far removed from the mainstream New Romantics and pop, which dominated this decade, Ecstasy (MDMA), house and techno music filtered into the dance culture of the UK. Redhead notes how this was, in fact, not original: 'acid house was nothing new; it was merely another link in the youth subcultural chain, replaying and reworking the 1960s or 1970s.'[12] That said, this was certainly a shift from the early UK New Romantics style and ethos. As a counterculture, it brought a fresh insight into some of the commodity chart pop music that saturated club venues populated with women dancing around handbags, white high heel shoes and the bright make-up that seemed to be standard among the collective banal fashion. The sexual 'rituals' often consisted of heterosexual men hanging around the plastic glamour of a kitsch cocktail bar whilst drinking pints of lager and being part of the herd of dance floor voyeurs. From this position, they watched the women dance around the aforementioned handbags to the latest cheesy pop track that had been churned out in the name of mass consumerism. However, the emergent acid house dance marked a stylistic change in performativity. This was free expression on the social margins to music that broke away from the mundane and mainstream clubbing; thus the culture of rave emerged.

From a personal perspective, I had now grown out of the playground choreography of the 1970s and had long since

abandoned any desire to be the newest member of Legs & Co or Hot Gossip. The next section offers an 'over-the-shoulder-pad' reflection from my own involvement with the countercultural movement of acid house, rave culture and contemporary dance. What I offer below is a reflective account of my own experiences of dance culture as a gay, white, working class Wigan teenager.

Individual Subjective Counterculture: Acid and a Reflection on the 'Come Down'

It is 1988 and I am out with my friends. I have just swallowed a Strawberry Acid tab whilst thinking *Top of the Pops* completely depresses me. It is the year I have left school, with no qualifications, although, in all honesty, I had gone AWOL two years earlier by becoming a school refuser. For the last twelve months I have been plagued with the threat of being put into a home by the Local Education Authority and told I run the risk of becoming a 'delinquent'. I had to look that word up in the dictionary. It lies somewhere in between the entries for 'dance' and 'detention'. For years I have been resisting, or catapulting myself away, from engaging with the commodity beige girls and boys in school (with their hair 'don'ts') and their 'take' on popular culture. I am an oddity you see. Not only due to my insolence towards compulsory education but the fact I am gay, and living in working class Wigan (pits, pies and pubs). I have developed my own ability to challenge the queer bashing and daily 'faggotry banter'. I am positioned in between the freaks, the ones who do not get picked in PE line ups, those who are possibly borderline psychiatric cases, and the boys who are in constant punch-ups.

I have coloured my hair, in an attempt to remove myself from the camouflage of the dominant brown and black hair, and it is now the brightest of white and blue. I don my newly acquired T-shirt, not the one with a bright yellow smiley face on the front, but a psychedelic top full of vibrant colours. I purchased this from Wigan market. I am queuing to get into a 'Madchester' Manchester club. Being underage isn't my main concern, I am more worried

about looking at the cashiers in case they know I have taken something. My friends say they can tell by looking into the pupils of my eyes. As I near the club doors I am looking anywhere but directly into the gaze of the staff. The palms of my hands are sweaty, my heartbeat is racing and I bang into people, all whilst I am trying not to draw attention from the door staff.

Dance floor, Wigan Casino, 1976

Earlier in the week I had heard a track entitled 'This is Acid House' and I was overwhelmed with excitement. I had seen people on TV dancing with repetitive arm gestures and waving them about in the air. These were accompanied with a musical beat that had me transfixed and longing to join in. I entered into the club space to an explosion of banging music. Inside, I felt like Alice entering Wonderland, or the child who entered a closet and found Narnia. I mean who goes into closets nowadays? My own wonderland extends before me: a crowded room full of sweaty bodies hurtling themselves around, arm gestures suggesting some form of transfixion or hallucination, whilst under the influence of good music, cheap drink and, in some cases, costly drugs. This dancing was far removed from anything I had previously experienced. I could just see the faces on the people in my local pub at the thought of their Friday night classics: Wham, Drifters and Jennifer Rush. I imagined them being overtaken by this tidal wave of hedonistic music and dance movement. Half of the community were still living in the passé land of disco and the other half were salivating and gyrating over the newly-formed Bros. In my pre-rave days, the nearest I had got to introducing them to something remotely new was by taking a copy of Divine's 'Maid In England' and asking the DJ to play it. This they did yet it was followed by Sandy Shaw's 'Puppet on a String'!

As I enter onto the dance floor, the acid tab gives me

DANCE

a sense of euphoria. I have an energy starting to pump through my body, a desire for dance and an abandonment of all those previous burgeoning sub-standard dance routines I used to be part of. Those dance 'routines' that seem to oversaturate *Top of the Pops* and are usually background fillers for some poor pop band or happily danced at school discos by the girls wanting to impress the latest 'must-have' attractive person. As my arms move to the beat of the music I have a sense of belonging. A sense of connectivity, not only to those dancing all around me but also a sense of connection to myself. This is not *Saturday Night Fever* this is every night fever. This was my new religion, I had found my god. I could dance forever. Several hours later and I am back in my pokey bedroom in the suburbs of Wigan. I have sneaked upstairs, avoiding the creaking fourth step, and it is the early hours of the morning. I am hoping my ageing parents will not notice the time. I am drenched in sweat and drinking Lucozade (I was told by another clubber to keep hydrated). My arms and legs are aching and the walls are moving. I am tripping and having some anxiety on the 'come down'. The faces on my wall posters are 'speaking' to me. I try to discard this contrasting alternative reality and accept the bleakness of my returning to my home environment. A council house in the middle of a grey semi-rural community. However, it is too late. I have experienced a dancing sensation and there is no going back! Rick Astley may have said, 'I'm Never Gonna Give You Up', but I was certainly going to wave goodbye to him and the rest of the blow-waved-hair boppers.

Clubbing and dancing swiftly became my world: illegal raves, underground parties, holidays in Ibiza and the cat-and-mouse games I played with not being caught. This was a way of living. On reflection I do not think there is anything more countercultural than a room full of highly charged bodies dancing around a room (with very little rhythmic obedience) high on music and even higher on drugs. This was the anarchic wave of clubbing in the UK. A club culture movement or zeitgeist that

swept across the country by a music-and-dancing force. From its earlier days surrounded by controversy and a 'mobilising underground' dance form, where you had to gather at petrol stations to find out where and when it would be happening (pre-mobile phone and pre-internet days), right up to the more popular, easily accessible and enhanced dance nights hosted by the mega night clubs. This was my experience with the phenomenon now known as rave.

Of course, like all things countercultural, I had no idea I was part of a subversive group. For those who did engage with dancing under the influence of ecstasy and acid there was often a decision to be faced as they effectively positioned themselves in opposition to the mainstream. The dance movement within club culture was a series of performances policed by the authorities and considered a deviant subculture – anarchic.

Acid house culture was countercultural for two reasons. It was an underground movement and it was illegal (not just the drugs but the trespassing and the appropriation of derelict warehouses or huge outdoor spaces). Rave culture, aside from the adult risk-taking behaviour of drugs and inhabiting illegal spaces, was childlike. Just consider the huge yellow smiley face, grinning from ear to ear which became the symbol of rave. The whistles, the handheld glow-lights, hyper-coloured T-shirts and baggy clothing – the warehouses were playgrounds. The hedonism of the 1960s, possibly because of the link with drugs, was reinterpreted and represented in this new form. Dancers required stamina to keep moving all night and into the daylight hours; they required water to keep hydrated and swallow the pills; they needed space and music in order to climb the metaphorical stairway to utopia.

As I reflect upon rave culture, I believe it offered young people a way to understand themselves as individuals and social beings in the world. Rave dance was ritualistic and spiritual. Dance is both personal and relational. It offers experiences which are felt through the body and the senses, and these experiences are both

social and cultural. We can learn about ourselves through these experiences: they are part of our physical and social development. This helps to bridge the possibility of breaking away from dancing 'norms' which have been prevalent in mainstream performing arts culture. It is a somatic endeavour in which you can learn through your own movement and interactions with others, rather than be forced to repeat a complex codified technique.

From my own point of view, acid house dance offered a way to self-actualise. Rave culture counteracted the sexualised animalistic rituals which permeated mainstream discotheques and trendy wine bars of the 1980s, where heterosexual men were voyeurs to women who shuffled around handbags. Reynolds argues that within rave culture 'heterosexist impulse' was removed by the interface of drugs and music, and notes how the effect of this individualised rapture and abandonment epitomises the 'self-pleasuring, masturbatory quality to rave dance – closer to the circle jerk than the courtship rituals that most forms of dance dramatise.'[13] The rave community was one in which its adherents were physically at one with each other. Emotions became chemically induced and signs of physical affection for others, such as massage, extended beyond sexual desire or intent. Within rave, you did not just fall in love with another, you fell in love with yourself and became one with the world.

Granted that by the 1990s house music and styles had diversified and became assimilated to mainstream culture, examples of which include lyrics such as 'Es are good' ('Ebeneezer Goode') by the Shamen as the hits had become adopted by clubs who saw the profit potential of such tunes for weekend clubbers. This reflects the life span of all countercultures and my involvement with rave was in the days of its inception. And following the lifespan of countercultures, as it is accepted into the mainstream, then begins its decline. The iconic yellow smiling face was replaced by something much darker. The impact of the pharmacological elements of the movement took its toll on numerous ravers. Out of those who were lucky enough to dodge the contaminated substandard batches of drugs, a few began to suffer from anxiety and mental health issues which were possibly a direct result of the

impact of such artificial highs on the nervous system. Reynolds notes how hardcore became 'darkcore', observing how 'the rave experience can be literally mind blowing – as in a fuse burning out rather than a psychedelic bliss.'[14] Many did not make it back from the party in one piece.

> After my many come downs and making it back from the party, albeit in several pieces, my heightened kinetic perceptions, profound dance floor sweats, my 'unclassifiable' dancing style and a disassociation, through boredom, of a clubbing culture that had started to become more mainstream was, for me, coming to an end. I migrated towards the genre of contemporary dance. This literally happened overnight due to a friend inviting me to watch the deviant of classical dance, Michael Clark and Company in *Mmm...* at the Blackpool Grande Theatre. I sat on the seventh row from the front of the stage. I was heavily under the influence of cannabis. So dense was the smell from my clothing that two gentlemen six rows in front remarked very loudly 'There is a strong smell of drugs in here.' A fit of giggles erupted between my friend and I, and we were threatened with being escorted out of the theatre for 'unruly behaviour'. Ironic considering what was about to be shown on stage by one of the most controversial dance artists of the time. Laughter aside, it was during Clark's work *Mmm...* that possibly influenced my career into becoming a dance maker and performance artist. Here I was (in Blackpool, stoned) discovering a world in which rock music, classical music, nudity, sexual overtones, queer iconic imagery, subversive costumes and the beauty of classical and contemporary dance technique merged into a visual concoction of absurdity, both in conflict and concord.

Clark has been drawing the gaze of attention since the 1980s. His dancing ability, which demonstrates high levels of technical dance proficiency, coupled with his refreshingly irreverent attitude towards the dance 'establishment' eventually brought him a cult following. Through his unsavoury reputation and growing admiration, coupled with his nocturnal clubbing antics with (now

deceased) fashion icon and club legend, Leigh Bowery, it has given him prestige in the dance, fashion and club scenes throughout the UK. His hybridisation of forms within his choreographies seemed to upset the purists whilst provoking delight amongst the post-modernists. This itself enticed different kinds of viewers to the genre of contemporary dance, as it began to move away from its modern principles, and began to embrace postmodernism.

Beyond Counterculture?

Following rave, it was during the 1990s that the internet became widespread in homes across the UK. Although at first expensive to use, the internet enabled like-minded non-mainstream groups to meet up in a safe, virtual 'world'. Individuals only needed to surf the computer-generated space to find thriving groups with similar political and countercultural aims. Moreover, the anonymity of the internet allowed people to experiment with deviant cultures. There were no constraints of space; there were no corporeal bounds; and digital countercultures began to emerge. Just as hippies, punks or clubbers might align their fashions with their beliefs, individuals who participate in online countercultures create their own online existence. According to Kitchen, developments in digital technology offer a space of deviancy: 'cyberspace is creating a new space of deviancy, a space that provides a social context where the socially alienated can occupy and play out their fantasies.'[15]

As I have noted in my discussion so far, music has always been a marker of identity for the countercultures. Within the development of online communities, music and dance now take on a digital form and can be shared within seconds. Flash mob dance is a quintessential example of this; a group of dancers hijack a public space in which dance is performed and people going about their daily lives suddenly become spectators of a spontaneous performance in a random space. Although there is an element of randomness to the spectators and the space, the dance itself and its performance in this area is clearly choreographed, rehearsed and planned. Within flash mob dance, not only do the members of the public become impromptu spectators, they also become documenters of the performance,

often recording it on the latest hand-held technological devices and promoting it on social media within seconds. This transfer of dance from traditional settings to alternative sites (similar to the X6 processes) certainly has a countercultural objective, and

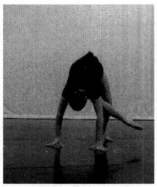

the trajectory of countercultural dance will align with new technologies from now on. Popat[16] has already explored the possibilities of dance making within internet communities from a performing arts discipline, acknowledging the extensive opportunities now available between performers and viewers.

Mark Edward in one of his contemporary dance works

The body has always been a political and countercultural space as it adopts the markers of resistance and anarchy in relation to the dominant mainstream movements of the time. This chapter has observed how movement marks powerful experiences of states which unify mind and body. Just as yoga is about movement which energises the mind and body, dance is a universal form which has associations for overall human wellbeing: the flesh, the mind, feelings, sexuality, sensuality and spirituality. It is not only individualised, but relational to others who share the experience. The effects of such subjective feelings have been well-documented in terms of their relation to countercultural movements, from hippies to punks to club ravers. Arguably, it is this embodied dimension of counterculture which has fuelled the success of various movements. As we move forward digitally, and communicate virtually rather than in physical time and space, I fear we are at risk of losing the embodied countercultural catalyst of dance.

DISABILITY ARTS AND ACTIVISM

Subversion within the Excluded
– A Personal Journey

Penny Pepper

Penny Pepper, shown here at the 2014 DWP blockade

Triton Square 2011 in London's Euston, with its soulless modern blocks is not a cheery place on a cold, February morning. There are about a hundred of us here to demonstrate against the much hated ATOS – Tory government lackeys, a private company hired to carry out vile assessment tests designed to identify so-called illegitimate disability welfare claimants (which, as history would show, included people in comas and people with terminal illnesses).

Besides us, there's the police and ATOS security. They won't let us in to hand in a petition. People take turns on the megaphone and soon it's time to read my poem:

Fraud

You poke and prod my pocket
As servants clear your moat
While I'm wheeling and I'm walking
In a ragged shabby coat

COUNTERCULTURE UK

You snatch and crush our wages
As servants shine your Rolls,
While we're shouting and we're swaying
In sparse seven-hand clothes.

You cling onto your rule book
Like a brat with a dummy
While we scrape in our honest gutter
For a glimmer of some honey

Granddad struggles in the morning
Whimpers gently towards the night
Sitting in his own hot shit
'Cause his care scheme's not paid right

What kind of warped out world
Is this one I see unfolding?
Our rulers fudging porno, second homes
And any chi-chi small holding

Independent Living Fund
It helped us live full lives
But cripples, never seen or heard
Cut our freedom with your knives.

Hypocrisy, it is on trend
And avarice shouts proud,
Bankers greed, bloats leaders dreams
Tax dodgers milk our skinny cow.

We're scratching and we're whining
At food banks for a crumb.
Recession, we're heaped with the blame –
While our leaders shoot the guilty gun.

There are cheers and I grin. We chant: '*No ifs, no buts, no disability cuts!*' The police move in with barriers and we, the raggle-taggle group of disabled people, including wheelchair users and allies, find ourselves kettled.

Freezing my tits off, nearby Starbucks beckons with its warmth, its accessible toilet and accessible entrance. Any quarrel I may otherwise have with this allegedly tax-dodging multinational

company flies off into the icy wind. This is the reality for many of us; we do not have the freedom, or the equality, to always make ethical choices about where we have a pee.

Why was I there? Why the poem? Because I am proud to call myself a disabled activist – and an activist who has for many long years used my words, poetry and performance to push our cause, to bear witness and highlight our oppression.

Disability Arts occupies a strange place in the social history of creativity and the UK's counterculture scene. For a start, anything we do means tackling multiple physical barriers, which non-disabled artists don't have to think about. Access remains one of the biggest issues for disabled people and mainstream disability charities still campaign for improvements. However, progress has been slow and for disabled activists organisations such as Scope, Leonard Cheshire Disability and the RNIB, to name a few, do not always reflect the genuine concerns of disabled people. Understanding this is crucial to understanding the grass roots development of disability arts as a counterculture movement. Overwhelmingly, our organisations are 'of disabled people, for disabled people', in which the old style charity model is replaced with autonomy. Then there is our invisibility, a result of being consigned to institutions and hindered by societal definitions as pitiful invalids and not much else – if we are thought of at all.

Path to Activism

February 1979: I was a seriously depressed young woman. There was nothing great in the world for me. However one might imagine the life of a nineteen-year-old then, mine had only a fragile relationship to teen culture. Yes, I was introverted, fuelled with the silent angsty fervour of youth but I had no boyfriends and a negligible social life. This was not uncommon for many disabled people during that time, at least for those from a small nowhere town and from a working class background. I had no direct exposure to gigs, cooped up in my bedroom, on a semi-rural Chiltern Hills council estate, with my family in dull and struggling poverty. Writing was my escape – poetry and grim little stories of existential horror sustained me.

There was also music from my tiny blue transistor radio. This

delivered messages from God, and God was John Peel. Through His word I slowly immersed myself in punk and the indie music scene, the experience broadened through my baby brother Ant, who went to gigs: the Sex Pistols, Penetration, Siouxsie and the Banshees, the Skids, Ian Dury and the Blockheads. Ant's reports on the energy and excitement of live gigs steered me towards the exploding indie fanzine scene, at first as a reader, my substitute to seeing bands, then as a contributor.

I had the *NME*, John Peel and my brother. There was no transport, no support worker and no real friends.

But rebellion against injustice took hold from a young age, and I aligned with political causes such as feminism and animal welfare before I was sixteen. It was a natural progression to move towards campaigning for equality issues, especially as a burgeoning writer and poet. The attitudes of creative DIY and the anti-establishment punk ethos twinned with my rage at the unfairness of life.

Penny Pepper, publicity shot for her *Lost in Spaces* show

I was also restless living outside the metropolis in the wasteland of suburbia; I was deemed unfit for work, an 'invalid' on 'invalidity allowance', yet I craved excitement, and I had to find a way out. Eventually, I won the fight to live independently, in London, despite howls of disparaging protest from social workers and their ilk. This began in early 1980, when I met Kay in the unlikely setting of a hospital. She was also a poet, also angry, also disabled. Burning with anti-establishment rage, we planned and plotted, joined anarchist collectives and immersed ourselves in the blossoming arts scene, which was breaking away from the old ideas.

Disabled artists have always been part of the disability activism movement, which began in earnest in the 1970s. This was the time when disabled people fought back against that patrician idea of being 'looked after'. There was a growing realisation that we

knew what was best for us – not others. We took much of our inspiration from the Black Civil Rights and Feminist movements. 'Nothing about Us, Without Us' became our mantra.

It was a call to arms to meet other disabled people – creatives – with a similar outlook, aligning ourselves to a counterculture scene. In artistic terms, being disabled and a creative was about as countercultural as it could get. After moving to London, an act of defiance in itself, I continued scratching around writing poems and songs and anything I could, ripe with a radical sensibility and a desire for more.

In terms of output, our art was as broad as it was new and sometimes unformed. We are still loathe to set boundaries on what disability art is or can be. Many of us had no access to educational arts institutions, to networking opportunities or to venues – we had to reroute and rewrite rules at each progression. But like other groups who have experienced oppression, our art comes from a unique understanding of the human condition, whether the art created is disability explicit or not.

New Platforms

Flowering in the 80s and 90s, disability arts forums (DAFs), saw the scene operate at grass roots level and this is where I made my shy entrance as a professional practitioner. Initially there were DAFs in Manchester and Liverpool; and soon the London DAF was set up in 1986. The latter founded the magazine *Disability Arts in London (DAIL)* – for its time and insights – a revolutionary publication.

DAIL magazine was first published in November 1986. It ran for over twenty years, and was the most widely read disability arts magazine in Europe. I was a regular contributor and found a natural home on its pages. As a movement we cooperated, sometimes argued, but above all we connected on *DAIL*'s pages, and we began to make noise within the broader arts movement. Disability Arts Online (DAO) is the natural successor to *DAIL*; run by long-serving disability arts stalwart

Colin Hambrook, it still operates with a countercultural sensibility.

The explosion of disability arts flourished in tandem with growing political awareness. Under the boot of Margaret Thatcher, disabled people were seen as little more than people to pity, rather than empower. Much of our art railed against this idea and it took our fight forward at the same time as our comrades in Disability Action Network (DAN) took to the frontline.

DAN could be said to be the frontline of disability activism. We were a tiny, loose collective of activists who would take the fight to where it mattered. Basing our approach on the non-violent direct action methods used by Gandhi and the Black Civil Rights movement, our actions included the regular blocking of London traffic, often by laying in the road helped out of wheelchairs by non-disabled allies, in protest against inaccessible public transport. We also handcuffed ourselves to buses and, on one occasion, smoke-bombed a grossly expensive Leonard Cheshire Foundation junket to which no disabled people were invited. DAN often raged against large corporate charities which made vast profits on the backs of the disabled population, including those involved in the running of care institutions.

While small in number – recognising that not every disabled person was physically able to attend an action – DAN were exemplary role models for many of the protest groups that exist today, and showed that disabled people – many of whom were from the arts sector – had a presence outside of the existing negative labels. We suddenly became visible, protesting against the inequalities and prejudice we faced.

Much of the arts discourse explored the barriers society put in our way. Barriers that could be removed, attitudes that could be changed, information that could be made accessible, to disseminate, to create equality; this redefining of our fight is known as 'the social model'. Developed by disabled activists and academics in the 70s, this positioned disabled people firmly as a group who experience oppression; our identity as artists was strengthened by the circulation of this idea, and on a personal level it informed my work, just as feminism had, some years earlier.

We are a disparate bunch, but however contrary our output,

the social model – and a sense of being a loose community of creative practitioners that experience oppression – binds us together under the kaleidoscope that is disability arts.

Celebration?

Some of the early key arts organisations have now achieved a rise in their reputation and a level of mainstream success. For many years Graeae Theatre Company, founded in 1980 by disabled actor/activist Nabil Shaban and Richard Tomlinson, was the only theatre company of professional disabled actors. Their first production was significantly called *Sideshow*.

Graeae reached what some may see as its pinnacle in 2012 – its prime involvement in the opening of the London Paralympic Games. Jenny Sealey, Graeae's Artistic Director, was given the job of co-directing the opening ceremony with Bradley Hemmings. Jenny Sealey, who has achieved international recognition for her work as a director, remains committed to taking disability arts into the mainstream. Some of Graeae's acting alumni have moved into the mainstream, including Liz Carr, who is now in BBC's *Silent Witness*. Yet even now, the need for rebellion remains; the mainstream still insists on effectively the equivalent of 'blacking-up', casting non-disabled actors in 'disabled' roles (for example Oscar-winning Eddie Redmayne in *The Theory of Everything*, 2014.)

As far as the Paralympics goes, it has had some positive effect but it has also caused a polarisation in how disabled people are judged. I was interviewed on radio and TV a year after the Games to look at their so-called legacy on the back of various national surveys, which showed no vast improvement to attitudes and access. There is also a massive increase in incidents of hate crime towards disabled people, and sometimes the Paralympics can be used as a reason to attack us: 'If they can do that, why can't you work?' – and much worse.

Access is Still the Key

It must be remembered that The Disability Discrimination Act (DDA) didn't stagger into life until 1995, with the aim (according to the government website) of giving people with disabilities rights in the areas of:

- employment
- education
- access to goods, facilities and services, including larger private clubs and transport services
- buying or renting land or property, including making it easier for people with disabilities to rent property and for tenants to make disability-related adaptations
- functions of public bodies, for example issuing of licences.[1]

It has always been a weak piece of legislation, with no compliance executive, relying on individuals who have the energy and commitment to sue those who appear to be breaking it. The law is now part of the Equality Act (2010)[2] which many activists and academics believe is even weaker. (This act aims to legally protect people from discrimination 'in the workplace and in wider society. It replaced previous anti-discrimination laws with a single Act, making the law easier to understand and strengthening protection in some situations. It sets out the different ways in which it's unlawful to treat someone.') So if I come across a venue that has no access nor an accessible loo, technically I can sue them. This is pointless (and morally heartless) if they are an independent with little money, but even if they are not so small they can utilise the term 'reasonable adjustment' as a cop out, using it to say 'we can't make any appropriate changes because we are poor.' Once a major department store claimed this; they were challenged, lost the case and had to make all their inaccessible men's departments accessible.

Apart from loose links between the major charity-based organisations I've already mentioned and specific local initiatives by user-run groups, there is no formal approach pushing for increased access across the whole of society. In terms of access to the arts in the broadest sense, that is access to opportunities

for disabled writers, arts practitioners and producers across impairment groups, it is down to major players to support ways in which the mainstream creative sector can dismantle some of the most immediate and nonsensical barriers. Organisations such as Graeae, Shape, Dada International, Artsline/Attitude is Everything and Unlimited have taken the lead in this area.

Founded in 1981, *Artsline* is an organisation and online resource offering disability access information about events across the arts and entertainment industry. I remember going to their tiny office in Camden, circa 1985, sitting at the back as vibrant speakers espoused change. It is also the progenitor of the influential Attitude is Everything. AiE improves access to live music for deaf and disabled people by implementing a Charter of Best Practice at music venues, clubs, festivals and tours across the UK.

Artsline and AiE are the key points of information for access to entertainment venues, with AiE focusing on accessible participation in the music scene. However, *Artsline* is London focused – access issues in other parts of the UK tend to be addressed by local Disabled People's Organisations (DPOs). Their level of success depends on how well they are valued by their local authority and how they are funded. So, despite some significant improvement, access is still piecemeal in the creative sector.

It's a long way back to my miserable days of never attending a concert, of being considered part of an alien race to even dare to want to go. But my seditious self remains. The number of venues – theatres big and small and beyond – with access for disabled performers (as well as audiences) stays low, and I regularly lose out on work because of this fact.

Shape Arts, formed in 1977, continues to play a major role in the development of disabled artists, with guidance and mentoring by and for disabled creatives. It is one of the current Unlimited partners, a funding programme that supports disabled artists emerging at the top of their game with a level of mainstream exposure once scarcely dreamed of – including ground-breaking shows at the Royal Festival Hall on London's South Bank.

Now one of the largest arts festivals in the world of its kind,

DaDaFest International, based in Liverpool, is a huge force of change. Grown from humble beginnings in 1984, DaDa – Disability and Deaf Arts, the company behind DaDaFest – has

been delivering high calibre international disability arts projects from the beginning.

Even now in 2015 Disability Arts still occupies a unique and often inadvertently subversive place, despite the nod towards mainstream acceptance for some. Our actual presence is subversive as we

Dadafest (YouTube still)

struggle under a government obsessed with austerity measures. These cuts threaten progress for everyone, including Graeae, as reported in the *Guardian* in July 2014:

> '... just two years after the euphoria of the London 2012 Paralympics and the marker for change it laid down, many disabled artists are finding it increasingly difficult to get the support that they need to make work because of cuts to the Access to Work scheme. At Graeae, key members of staff face losing up to 70% of their support which means they will be unable to create the projects that in turn enable other disabled people to work.'

These attacks have implicitly demonised disabled people. The young crip rebels are now the old crip rebels, coaxing the young'uns to protest, to remind them they have a voice and that they need to feel confident taking on this legacy.

In contrast to the scapegoating of disabled people, there is now, remarkably, the National Disability Arts Collection and Archive (NDACA), 'home to the heritage and rich history of the Disability Arts Movement' – to whom I shall leave my own thirty year archive of work – if they want it!

Our protest continues. I am still banging on, still pushing for more writing opportunities for disabled people – including my own – work which is beyond the so-called misery memoir and triumph over tragedy pot-boiler. And you will still see me on many protests, ready with a word, knowing where my arts roots lie and where my strength comes from.

And because many battles have been won, but the war for equality wages on, I will always, always be ready with a bolshie poem:

Scrounger

I'm a sponger, a scrounger
A lazy-arsed lounger
A raspberry[3] in rainbow
I pose you no danger.
I'm the bottomless pit
Of your pity and debt
On the sick since John Major
I'm still on it yet!

I'm the latest cheap target,
Tabloids' dark darling
Draining the markets –
The unit of measure
Economic displeasure.

I'm a blamed useless-eater
A foul fraud repeater
Do I make it all up?
They say that I suck
The money from purses
Of rich bloated bastards,
The kicks and the curses
Fall from our leaders
On us liars and bleeders,
We're pariahs and feeders
Gorged on too much –
From the big nanny state.
You've condemned us already
There is no debate.

We can't be sustained
Because bankers are greedy
We're lazy, we're rank
we're targets of hate
To e-rad-icate!

COUNTERCULTURE UK

But I'm a rouser with words
To shout and to hit,
Saying who are the Nazis
Raking over this shit?

I shout and I spin
At the string of their lies,
I'm a new Boadicea
Together we rise!

They have no compassion
Yet we have rebellion,
and rage with our passion.
As time it is rushing
defiance it chimes!

We dare to fight back
We dare to fight loud.

WE
DARE
WE
DARE
WE
DARE

ENVIRONMENTALISM

A Way of Life

Paul Quinn

The Story So Far...

Would you call yourself an environmentalist? There was a report in the *Guardian* in 2013 that said one in ten adults in the UK is either a member or a supporter of an environmental group.[1] Mostly the 'be nice to animals' variety. But there's also an increasing awareness that the environment isn't just the place where 'nature' lives. It's where we all live.

There are hundreds of environmental groups in Britain today, ranging from those that focus on looking after specific types of wildlife (like the Bat Conservation Trust or Buglife) to those trying to improve the way the world operates on a bigger scale – including Stop Climate Chaos, Transition Network and the New Economics Foundation ('economics as if people and the planet matters').

We do tend to think of environmentalism as a fairly modern concept – it's true that almost all the world's environmental groups have appeared in the past fifty years. But even though the word itself wasn't used until the late 20th century, there are examples of what we'd call environmentally conscious behaviour going well back into history, from all around the world.

For instance you might be surprised to know the roots of the phrase 'tree-hugger'. Used as a term of abuse at times by critics of environmentalism, but subversively 'embraced' by some greenies (not least on the website of the same name), tree-hugging can

actually be traced back to early 18th century India – and may well have existed long before that.

The story goes that some villagers in India, determined to protect sacred trees that were about to be cut down on order of the maharaja, got together and literally hugged the trees – putting their bodies in the way of the axes. The Hindi word for these huggers, '*chipko*', was revived in 1973 when groups of women in Himalayan forests recreated the ancient story, heroically preventing trees being felled by linking arms around them.

So the idea of protecting the natural world isn't new – it's just become more urgent as the damage being inflicted has accelerated.

You could look back to ancient Greek times too. The Greeks weren't averse to clearing forests – not just for timber, but also as a general 'civilising' process of subduing or dominating nature. But even then they became aware that removing trees could cause disastrous soil erosion. The newly exposed earth was just flushed away by the wind and rain. In the same way as happens today. But this didn't (and still doesn't) seem to stop people cutting down forests.

Horrifyingly, in the days of the Roman Empire, it got to the stage where there was such an insatiable demand for wild animals – usually for bloodthirsty public entertainment spectacles – that several populations of tigers, elephants, bears, hippos and other species were apparently pushed to the brink of extinction in parts of the empire. (That list of species will sound all too depressingly familiar to modern-day conservationists too!)

Most people's views about the natural world and other species seemed to change very slowly, if at all, over the next 1500 years or so. At various times there were also moral or religious concerns that anything too 'natural' was dangerously close to being 'savage' and 'uncontrollable' – an obvious worry for the church and ruling classes, so best preached against.

We owe a lot to particular pioneering individuals and organisations who were brave enough to speak up in defence of nature and other creatures, despite public indifference or ridicule, and slowly started changing attitudes.

Environmental Trailblazers:
Early Pioneers and Inspirations

When the Society for the Prevention of Cruelty to Animals (later the RSPCA) was founded in 1824, it was, as they now admit, 'a challenge to get the British public to recognise animals as sentient beings – and not just commodities for food, transport or sport.'

Probably the first person to talk about 'animal rights', as opposed to 'animal welfare', was Henry Salt (1851–1939) (left), the British social reformer, conservationist and evangelical vegetarian. His 1890 book *A Plea for Vegetarianism* was later quoted as 'inspiring and influential' by Mahatma Gandhi, who read it while a student in London.

And some people were willing to point out that 'progress' could have unintended consequences. Since the industrial revolution had brought new levels of river pollution and smoke-belching chimneys, there was a growing suspicion (among a few) that the quality of the air or water people were exposed to could affect their health or spread disease.

At the same time there was a feeling that 'nature' and the 'wild' could and should be antidotes to increasingly fast-paced, stressful, polluted modern living. In the words of Henry David Thoreau, the American naturalist, reformer and pioneer of civil disobedience: 'We need the tonic of wildness.'

Scottish-born John Muir, who moved to America as a child, did a huge amount to promote the idea that we need 'wild' places – and that those places wouldn't stay wild unless we deliberately protected them and kept them that way.

Victorian writer and artist John Ruskin was particularly vocal about protecting the beauties of nature – and he also became very worried about the effect that industrialisation was already starting to have on landscapes and people.

Likewise William Morris, whose 1890 book *News from Nowhere*

imagined a future 'eco-utopia,' where 'people live in harmony with nature' – coincidentally the same words used by the World Wildlife Fund when it launched seventy years later.

For the most part, if there was a concern about 'the environment' it was still predominantly about human health and wellbeing in relation to the natural world, rather than about extinctions of other species, or threats to the planet as a whole.

The common idea persisted right up the mid-20th century that it was beyond the ability of people, either deliberately or accidentally, to do any significant damage to our planet. Mainly because the Earth – including the oceans and skies – just seemed so big and resilient that it could withstand anything that one puny species could throw at it.

That feeling suddenly changed in 1945 with the dropping of the first atomic bombs on Japan, followed by the development of the much more powerful hydrogen bomb and the subsequent nuclear arms race. There was a dramatic shift in public awareness of the potential damage our puny species could actually do to our one and only planet.

It also marked the start of a new age of environmentalism.

Green Revolutionaries: The Soil Association, CND, WWF, Greenpeace, Friends of the Earth

The Soil Association

Most environmentalists would probably talk about Rachel Carson's 1962 book *Silent Spring* as being the birth of the modern 'green' movement. Her eloquent exposure of the dangers of pesticides, specifically the widely-used DDT, became a best-seller and woke the world up to a serious environmental menace.

But here in the UK there had been concerns about increasingly intensive and chemical-led farming since the end of World War II. A group of biologists and farmers got together to form the Soil Association in 1946 to tackle the problems they could

see, including a decrease in the quality of soil, and of food, and the exploitation of animals in the new breed of 'factory farms' (which have grown exponentially since, despite those concerns).

Set up originally as a research body – which might partly explain why they landed themselves with such a non-public-friendly name! – the Soil Association believed farmers should be working with nature rather than against it, and that biology, not chemistry, was the key to solving agricultural problems.

The Soil Association came in for criticism right from the start from the chemical-led farming lobby (which has somehow become known as 'conventional' farming, as if it was in some way the traditional or natural option). They particularly liked to seize on the fact that one of the association's co-founders, Lady Eve Balfour, was also from a family of spiritualists, and supported 'new-age' ideas.

The post-World War II period in agriculture became known (rather confusingly from a modern perspective) as the 'green revolution'. This was a reference to the verdant growth induced by copious application of nitrogen-based, fossil-fuel-derived chemical fertilisers, which governments in the UK and elsewhere had started promoting and subsidising in order to boost food production in the post-war years.

The Soil Association's championing of strictly 'organic' farming – avoiding or at least minimising any chemical treatment of soil, plants or animals – was laid down in a set of standards that are now widely followed and respected.

Growing concern and revulsion about conditions on intensive conventional farms – which came to a head when BSE/'mad cow disease' was linked with feeding sheep brains to vegetarian cattle – considerably boosted sales of organic products in the late 20th and early 21st century.

Campaign for Nuclear Disarmament (CND)

The dominant environmental issue of the 1950s, of course, was the nuclear threat. Although it was ostensibly more of a 'people for peace' issue, it obviously had serious implications for the natural world too, and quite a lot of the world's modern-day environmental activism was kickstarted by the anti-nuclear

movement of the 1950s and 1960s.

Formed in London in 1957 by pacifist philosopher Bertrand Russell, Canon John Collins and MP Michael Foot, among others, CND's simple, enigmatic logo and 'Ban the Bomb' slogan soon became iconic shorthand for the peace movement. (The equally famous 'Nuclear Power: No Thanks' badge, with the smiling sun, wasn't actually a CND concept – it was produced by Danish activist Anne Lund for her small anti-nuclear group in 1975, but was soon widely copied across the world.)

In its early years, CND organised very well-supported annual Easter marches at the Aldermaston Atomic Weapons Research Establishment in Berkshire – at least up until 1963, when a nuclear test ban treaty was signed. After that CND faded off the scene a bit – until the 1980s, when the nuclear proliferation of the Cold War, and the talk of 'mutually assured destruction' (MAD), re-energised the whole disarmament and peace movements.

The heroic women of Greenham Common, many of them CND supporters, first arrived at the US military base in Berkshire in September 1981 to protest against it being used to house nuclear missiles. Some stayed for years – the longest for nineteen years – despite frequent police raids, harassment, eviction and imprisonment. The missiles were removed in 1991, but the camp remained as a protest site until 2000.

The founders of CND had lots of internal debates about how they should protest – about the extent of their use of non-violent direct action (NVDA), mass civil disobedience actions, including blockades and sit-ins, and whether it was ever justified to break the law. Co-founder Bertrand Russell, who led from the front, was arrested and imprisoned for a week in 1961 at the age of eighty-nine. The feeling was that in some cases the state itself can act illegally, so resisting it was justified – and at times it might be necessary 'to commit a lesser crime in order to prevent the greater one of nuclear war.' This was another way in which CND was very influential on later activist groups.

The nuclear threat had become quite high-profile, thanks to

footage of nuclear tests, science fiction tales of atomic disasters and the constant news of the cold war. But the persistent ongoing destruction of wild places and wild animals still wasn't widely known about by the start of the 1960s.

The World Wildlife Fund

Launched in 1961, the World Wildlife Fund (later just called WWF) grew out of the International Union for the Conservation of Nature (IUCN). The IUCN had been set up by the United Nations in 1948 to help put wildlife and nature protection on the global agenda – but it had limited finances to carry out research or hands-on conservation. WWF was set up mainly to be the IUCN's fundraising arm.

WWF co-founder Julian Huxley had recently visited East Africa and been horrified by the rampant killing of wildlife and habitat destruction that he saw. So when he got back to the UK he set about putting together a group of experts, including bird specialists Peter Scott and Max Nicholson, to take action.

To help promote the newly-launched WWF, the *Daily Mirror* ran a front-page appeal – focusing on the endangered African rhino in particular – and readers responded by sending in £60,000 within a week. WWF soon spread its operations around the world. In its first three years, the organisation raised and donated nearly $2m to conservation projects.

WWF has spent the past five decades finding ways to work with local communities, politicians and businesses around the world to save endangered animals and stop the destruction of important wild places, including rainforests, oceans and wetlands.

It hasn't been without its critics though. With its UN connections, high-profile friends, and princes as presidents, WWF has faced accusations of being an establishment-led, elitist organisation. The thousands of ordinary, dedicated environmentalists that have worked passionately for WWF around the world over the decades may disagree.

Another controversy that dogged the group was the fact that co-founder Julian Huxley happened to be a staunch eugenicist –

he believed that selective human breeding was the way ahead for a better world. Not, to be fair to him, based on Nazi-like ideas of racial superiority or purity. He just felt anyone with 'desirable traits' should be encouraged to breed more than those without. Let's leave that there.

Huxley was also a nuclear fan, and believed the power of the atom bomb could be deliberately used to melt the polar ice caps – which he argued would free up extra land for agriculture, as well as nicely warming the chillier parts of the planet. Yes, it would no doubt flood places like India and Holland, but he seemed to imply that might be a price worth paying…

Thankfully, WWF doesn't share those views, and is campaigning hard to tackle global climate change and find fair solutions to environmental problems. But the legacy of a slightly patriarchal view of the world is still pounced on by conspiracy theorists and climate deniers alike, hoping to spread the slightly bizarre notion that environmentalists are either 'new world order' fascists or else just care more about 'nature' than they do about people.

So, five decades on, has WWF managed to save every single endangered animal on the planet? No. Would even more animals be dead or endangered without WWF and other conservation groups? Undoubtedly yes. The challenges are increasing all the time. Economic development in countries like China has been feeding the demand for 'luxury' wildlife products (from elephant ivory and rhino horn to tiger skins and exotic pets), and sophisticated poaching and smuggling syndicates make the job harder. And of course climate change makes all the other problems even more complicated. As Sir David Attenborough said on WWF's 50th anniversary: 'The job of WWF is more important that it has ever been…'[2]

Rachel Carson

It seems incredible now, but before Rachel Carson's *Silent Spring* came out in 1962, no governments anywhere had departments for the environment. For most people in the post-war West, industrial, agricultural and social progress seemed like a one-way street – an unstoppable superhighway moving forward. Carson

successfully inserted a much-needed speed bump, pointing out:

'For the first time in the history of the world, every human being is now subjected to contact with dangerous chemicals, from the moment of conception until death.'[3]

She publicly rejected the notion that science could (or should) conquer the natural world – saying:

'The "control of nature" is a phrase conceived in arrogance, born of the Neanderthal age of biology and philosophy, when it was supposed that nature exists for the convenience of man.'

Carson died of cancer in 1964, but thanks to her research and campaigning, DDT was gradually banned around the world. That's not to say DDT hasn't been replaced by plenty of other harmful chemicals, but at least the precedent was now set for better scientific testing, and for effective protests to achieve bans of harmful substances.

Similar concerns are also being expressed nowadays about the genetic modification of food. Just like Rachel Carson, GM protesters are being accused of being anti-science and anti-progress – but it's really about caution in the face of any powerful new environmental 'genies' that may be unleashed and then hard to control. It may turn out that some good things can come from genetic modification – but that doesn't mean all genetic modification is justified, useful or even safe. Most people aren't convinced we know enough about the long-term impacts on the soil, on wildlife or on human health, despite what the vested interests tell us.

Environmental Threats at Sea

If it was a shock to some people that the soil or air could be poisoned, it was even harder to imagine that we could harm the world's vast, unchartable oceans. We thought there would always be 'plenty more fish in the sea', as the old saying went.

Then in 1967, the huge oil tanker Torrey Canyon ran aground off Land's End, spilling all of its 120,000 tonnes of crude oil into the Atlantic. It was the world's worst ever oil spill at the time – the first involving the new 'supertankers'. Around 15,000 seabirds

and countless other sea creatures were killed, with damage done not just by the oil but also the toxic chemicals used to disperse it. The RSPCA, RSPB and WWF got together to raise funds to rescue birds and promote research. But despite environmental protests and some regulation changes, worse oil disasters were to come.

Overfishing was starting to be seen as a problem. Fishing fleets had been expanding, and bottom-dredging technology meant there was little escape for most sea life. For instance, Atlantic cod catches increased dramatically in the 1960s but the level was unsustainable, and they dropped dramatically from the 1970s, until the whole 500-year-old Newfoundland cod industry collapsed completely in 1992.

Now, a few decades on, most of the world's fish stocks are overfished and in serious decline. Huge campaigns have been launched, in the UK and around the world, to end overfishing and 'bycatch' (lots of other sea creatures are accidentally killed by fishing boats too) – but time could be running out for the world's seas.

Back in the late 1960s, whaling was still a big issue too. Despite the fact that only two countries, Russia and Japan, were doing most of it (the UK was whaling up until 1963), they still caught almost 35,000 whales between them in 1969, more than half of them sperm whales.

Ah, if only there had been some environmentalists with a ship who could sail out and try to stop them. Well, we didn't have to wait long for that...

Greenpeace

Greenpeace began around 1970 as a loose but committed collective of peaceniks, Quakers, journalists and ecologists. They included Robert Hunter, Bill Darnell, Irving and Dorothy Stowe, Jim and Marie Bohlen, Paul Cote, Ben Metcalfe and Paul Watson, among others.

They first met up in Vancouver, Canada, and they did indeed acquire an old boat... but despite what they soon become famous for, their earliest sea outings weren't actually to save whales. Their first actions were trying to disrupt US and French nuclear

bomb tests in the Pacific – the 'peace' part of their name was as important as the 'green' part in the early days particularly.

Greenpeace was influenced by the Quaker idea of 'bearing witness' – which didn't just mean watching an event, but making a statement by being there and protesting non-violently. Their goal ever since has been to hold big corporations and governments to account for any planet-damaging actions, whether it's dumping toxic waste at sea or drilling for oil in the pristine Arctic.

The group's passion for whales came to the fore in 1975, and after just over a decade of high profile, daredevil actions to hinder and publicise the actions of whaling ships, they helped achieve a worldwide commercial whaling ban in 1986.

Activities like this create a clear distinction in most people's minds between the hands-on radical activism of Greenpeace and the more measured, 'safer' approach of a group like WWF. The difference highlights a dilemma for some environmentalists – the question is, is it best to be allowed inside the boardrooms of big corporations and governments, speaking with them directly, and meeting with powerful political leaders – in other words arguing for change from within? Or is it better to stay more removed, agitating and protesting from outside, deliberately making life difficult, even embarrassing, for transgressing companies and short-sighted politicians, until the pressure makes them 'do the right thing' for the environment? Both approaches have their merits and drawbacks.

Despite their differing tactics, the aims of Greenpeace and WWF have a lot in common, and they do regularly campaign together on big issues. In fact, it's not widely realised that WWF helped Greenpeace UK get off the ground (and into the oceans) by funding their first Rainbow Warrior ship in 1977.

Paul Watson, one of the younger members in the original Greenpeace group, left them in the late 1970s – because he didn't feel they were being radical or aggressive enough – and he formed the Sea Shepherd Conservation Society to better suit his aims.

Friends of the Earth (FOE)

This organisation was established in the UK in 1971, a couple of years after it was first founded in San Francisco by David

Brower. FOE was originally set up as an anti-nuclear group, and was initially largely funded by a US oil magnate – which of course seems slightly ironic in hindsight, given what we now know about oil's role in environmental damage. But these were different times.

FOE's first UK action in 1971 was placing thousands of non-returnable bottles (normally thrown away at the time) outside the offices of Cadbury Schweppes, to promote reuse of resources. And its most high profile and successful action to date was probably the Big Ask in 2005,[4] which aimed to get the UK government to introduce a climate change bill that would set carbon reduction targets. It included celebrity concerts, political lobbying, a big online petition (before such things were commonplace), and DIY video messages. Three-and-a-half years later, MPs voted in favour of introducing a climate change law.

One of their most recent campaigns is the 'The Bee Cause'. FOE say what they stand for is: 'A beautiful world, a good life, and a positive relationship with the environment.'

Green Politics and Social Change

The early 1970s also saw the launch of a new environmentally-focused political party in Britain – probably the first of its kind in the world. Originally called the People Party, they changed their name in 1975 to the Ecology Party (one of their leading lights at the time was Jonathon Porritt). Then in 1985 they became the Green Party, inspired by the success of the German Greens led by Petra Kelly (who created the much-copied mantra: 'Think globally, act locally'). By the end of the 1980s almost every country in western and northern Europe had some kind of 'green' political party. In 2010 the Greens got their first MP in the British parliament, Caroline Lucas.

Another popular movement that kicked off in the 1970s was self-sufficiency. This was partly prompted by the global energy crisis of 1973, when war in the Middle East cut off oil supplies to much of the world and made some people think about changing their lifestyles to be less reliant on external resources.

E.F. Schumacher's book *Small is Beautiful*[5] came out the same year, and suggested that the world's constant and insatiable drive for growth – bigger cities, bigger businesses, more stuff – was

unsustainable, and not what's needed to create happy people and a healthy environment. Sadly, not enough people have taken his message to heart.

As Schumacher said: 'Any intelligent fool can make things bigger, more complex, and more violent. It takes a touch of genius – and a lot of courage – to move in the opposite direction.'

Also in 1973, former businessman Gerard Morgan-Grenville opened the very influential Centre for Alternative Technology in Wales, offering courses to anyone on renewable energy and sustainable building techniques. (It's still running today, although Morgan-Grenville died in 2009.)

John and Sally Seymour's ground-breaking and incredibly comprehensive guide to *Self-Sufficiency* in 1976[6] did exactly what it said on the cover, and was a huge inspiration for a whole generation of 'downshifters' (alongside the slightly less serious 1970s BBC sitcom on the same theme, *The Good Life*.)

Recycling had pretty much fallen out of favour since World War II – we were now meant to have a modern, plastic-based 'disposable' society, where people no longer needed to 'make do and mend' like their parents had. But the energy crisis in the 1970s did have the effect of making governments and businesses realise that recycling could save energy too – so for the first time we saw public recycling banks for glass bottles, tin cans and paper.

Television had also become the main way for most people to see and hear about the natural world, especially in distant places. And no one was better at showing it than much-loved naturalist and broadcaster David Attenborough. He'd been making 'natural history' programmes since the 1950s, but it was particularly his work from the late 1970s onwards, starting with the series *Life on Earth*, that showed huge TV audiences wild creatures and wild places they'd never seen before.

The inspirational lifework of David Attenborough and his colleagues makes you wonder if one of the most important inventions in the history of environmentalism (particularly conservation), might well be the camera. Before the dawn of photography in the mid-19th century, pretty much the only way most people could see wild animals was either captive in unnatural

and cramped zoos, or as dead specimens displayed in a museum or art gallery.

Back in the 19th century, Henry David Thoreau made the point that he couldn't understand the desire to study nature by killing it. Surely, he argued, all you're studying then is just 'dead matter', without the essential character and spirit of a living creature.

In particular, you could argue that developments like the zoom lens, video and remote control cameras have made it possible to see previously unimaginable close-up images of wild animals in their natural habitats, with minimum disturbance from people. And brought great advances in scientific research and knowledge too.

It was a boom time for new age spirituality too, and James Lovelock's 1979 book *Gaia: A New Look at Life on Earth*,[7] seemed to neatly combine science and spirituality. Lovelock expressed the radical view (for the time) that our whole planet acts like one giant living organism, and will regulate its environment to keep it suitable for life – albeit over long timescales – and not necessarily keeping it suitable for human life. Lovelock, a scientist and inventor who'd worked with NASA at one point and helped detect CFCs in the atmosphere in the late 1960s/early 1970s, has often been a controversial figure. He was an early predictor of climate change, but he's since gone against the environmental mainstream by claiming he'd been over-alarmist on climate (or at least on the timing), as well as backing nuclear power as the best low-carbon energy option – dismissing the worries over nuclear waste as exaggerated.

Lovelock's earlier scientific work had helped identify another potential global disaster. It had been known since the 1970s that man-made chlorofluorocarbon (CFC) gases – the type used regularly in fridges and aerosol sprays – could destroy ozone. But it wasn't until the mid-1980s that it was discovered there was a significant 'hole' in the ozone layer above Antarctica – enough to let through potentially dangerous levels of the sun's ultraviolet light. Another example, if we needed one, that people's actions really could alter the way the planet functions.

Environmentalism on the Streets

Edward Abbey, the American writer and godfather of radical environmental activism, once said: 'Human society is like a stew – if you don't keep it stirred up you get a lot of scum on top. Agitate!'[8] His influential 1975 novel *The Monkey Wrench Gang*[9] is about a group of misfits who use vandalism and sabotage to stop developers damaging the environment. It was said to be an influence on Dave Foreman, founder of Earth First!, described as the first 'mainstream' environmental extremist group, which spread to the UK in time for the road-building protests of the early 1990s.

Anti-road-building protests weren't new – they're almost as old as the car itself – but the Tory government's huge road expansion policy in the early 1990s produced some of the most dramatic protests ever seen in Britain. From Twyford Down in Hampshire and Newbury in Berkshire to the outskirts of London, Glasgow and elsewhere, the protests attracted people of all ages and backgrounds to take part in mass civil disobedience and direct action on the streets (and up in trees, and in tunnels under the ground).

After weeks and months of sometimes violent attempts to remove protesters, most of the road schemes were eventually pushed through, though often with concessions about new natural spaces being created nearby. The incoming Labour government cancelled the remaining road-building plans. The protesters also achieved a few moral victories. Lord Justice Hoffman, the judge at an appeal by Twyford Down protesters, said: 'Civil disobedience on grounds of conscience is an honourable tradition in this country, and those who take part in it may well be vindicated by history.'[10]

These actions coalesced into the 'Reclaim the Streets' movement in the mid-1990s, sometimes called 'Reclaim Your Environment' – in part a reaction against the government's new Criminal Justice Bill, which threatened everyone's right to peaceful protest by limiting group sizes and movements.

'Reclaim the Streets' promoted community-ownership of public spaces, and rejected the car as the dominant form of transport.

It also had links with anti-consumerist movements ('Buy nothing/ no shop' days). The *Daily Mail* (among others) almost inevitably labelled the protesters as 'militant environmental activists'. By 1998 Reclaim the Streets had spread across the world.

Protesters' tents from the Occupy London movement

It has echoes in the more recent anti-capitalist 'Occupy' movements in New York, London and elsewhere. Although some might argue Occupy is more of an economic than an environmental protest, for a lot of people the two are increasingly closely linked nowadays. It's about the sharing and consumption of the planet's resources, and how environmental protection and improvements (climate action for instance) are being delayed by vested business interests.

Climate change has clearly become the big environmental issue of recent decades. At first the battle was to persuade sceptics and global warming deniers that climate change was real, that it was being caused by human behaviour – and that we could and should do something about it. Now those arguments are pretty much won, the pressing problem is how to put the words and deals into action.

The dangers of burning fossil fuels hasn't just prompted some creative new low-carbon technologies and lifestyles (see 'Low-carbon, low-energy living' below), it's also spurred a lot of imaginative and passionate environmental campaigning. Whether it's Greenpeace activists climbing London's tallest building, or the widespread anti-fracking protests, or the 'Divest' movement, aimed at dissuading people, businesses and governments from

investing in fossil fuels and persuading oil companies to 'Keep It In The Ground'.

It's not all about big global issues though. The 'act local' ethos is strong in movements like the Transition Network, which relies on local skill-sharing, community co-operation and sometimes local currencies to improve environmental and social situations.

Another non-confrontational environmental activity is guerrilla gardening – a form of non-violent direct action where activists unexpectedly descend (sometimes under cover of darkness) on abandoned or neglected land and turn it into vegetable plots or flower gardens.

Less energetic environmentalists might prefer armchair activism – sometimes rather unfairly referred to as 'slacktivism' or 'clicktivism'. That need is also well catered for, with the growth of online petitioning groups like 38 Degrees, 350.org, Avaaz etc.

Environmental Differences

There have always been differing ideas on how people should relate to and/or look after the environment. You might break them down into six different views...

1) The literal biblical notion that we've been put in charge of everything else in 'creation', so we need to exert control (which can also unfortunately be used to excuse some mistreatment of animals or landscapes).

2) The view that, because we're a 'superior' species, we have a duty to dispense compassion and look after the poor helpless animals, plants etc.

3) We're inherently compassionate and caring and we love every living thing (the 'hippy' view).

4) We're urban and civilised and have moved beyond wild and savage 'nature'. We don't need it. It's not really our bag.

5) We have no choice – it's in our own self-interest as a species to protect the natural world, because we rely on it for our own survival.

6) It doesn't matter whether or not we 'like' nature, or need it for our survival, we should look after it just because it's the 'right thing' to do.

Or perhaps in some cases a combination of these.

Back in 1973, Norwegian philosopher Arne Næss came up with the concept of 'deep ecology', which basically put forward the inherent moral case for environmental protection. He argued that we shouldn't be green just because it's in our own long-term interest, or because there's any economic or social imperative, or even that we can make it work within an existing capitalist or industrial system. Instead we should be green simply because it's the right thing to do.[11]

A similar argument is used in the more recent Common Cause movement (led by Dr Tom Crompton, formerly of WWF), with its conviction that our more selfless 'intrinsic' values should be nurtured more than our 'extrinsic' or self-enhancing values.

It's a complex, philosophical field of argument, and hotly contested in both camps. On one side there are those who argue that environmentalists need to live in the 'real world' and adapt their green agenda to the way the world is, whether we like it or not. As against those who believe that's entirely the wrong approach, and is actually pandering to the 'consumerist' or profit-driven values and lifestyles that have created our environmental problems in the first place.

The idea of putting a monetary value on nature is at the heart of the topical debate over 'payments for ecosystem services'. The original reasoning behind this was to make the protection of nature something that can generate income – and can therefore compete with the destruction of nature. For example, making a forest worth as much left standing as it is chopped down. But opponents of this idea argue that what can happen in reality is that large corporations can muscle in and dominate the system, acquiring land cheaply ('land-grabbing'), and then profit from that land's newly attributed financial eco-value. The challenge is to make sure the payments for ecosystem services are made fairly, and go to the people who need and deserve them.

Conclusions

So, if you'd call yourself an environmentalist, which type would you be? I'd suggest that a real environmentalist would want to protect both nature and people. Because as we've seen, we're all connected.

In the end, of course, despite the old environmental clichés about 'Saving the Earth', the planet itself will probably be fine, in the long term. It's really the living species on the planet right now – including us – that we need to worry about.

That's why environmentalism isn't, or shouldn't be, some slightly idealised minority pursuit. It's vital for everyone. So whether or not you call yourself an environmentalist doesn't really matter. We're all involved. And what you do is more important than any label you might have.

Environmentalism may have started with lone, pioneering voices, or small, determined groups, but the big changes really happen when the majority of people join in. When change comes from the bottom up, and reaches a critical mass, a movement no longer needs a name – it just becomes the way we live.

Low-carbon, Low-energy Living

So, we know climate change is happening, we know it's caused by greenhouse gases warming the planet, and we know the biggest source is burning fossil fuels in our homes, cars and workplaces. But how do we change that? How do we break our addiction to fossil fuels?

The easy stuff is things like loft insulation, turning down your heating a couple of degrees, taking quick showers rather than deep baths, boiling less water in the kettle... But those won't be enough. In order to meet the carbon-cutting targets the world needs (and even to meet the levels the UK government has committed to) we will need far more severe cuts in fossil fuel use than most energy-saving websites will suggest.

This is what very few people are talking about – especially not politicians, as it's not a vote-winner for them, because it sounds too much like a drastic lifestyle change for most people. And it will be. The problem is that we've all got used to the amazing energy boom provided by fossil fuels. But the changes are very achievable, and it won't mean the end of the world. (It might be the end of the world if we don't change.)

Again there's more than one possible approach. Do we replace the current set of fossil-fuel-based technologies and consumer goods in our home with the latest low-carbon alternatives? Or do

we try to do without some or all of them altogether?

Greener Homes

Most homes in the UK, especially the older, draughtier buildings, but even some relatively new ones, are built to pretty low energy-efficiency standards. Some serious retro-fitting would be needed to bring them up to an acceptable standard in terms of insulation and energy use. The government has dabbled in this area, offering a slightly half-hearted 'green deal', but it'll need to get serious and probably make these improvements compulsory before long (and offer grants or loans to householders to carry them out).

And all new homes will need to be built to much higher energy-efficiency and zero-carbon standards. The technology and techniques exist already – highly energy-efficient houses were being constructed in Germany and Scandinavia a quarter of a century ago (using the *'passivhaus'* system).[12] So why isn't it more widely adopted here by now?

The ideal low-carbon, low-energy home is built with high levels of attention to details like design, materials, insulation and air quality. The idea is that by spending about 10%–15% extra on construction costs you could cut running costs by 90%.

New building technologies and terms we'll all become familiar with in coming decades will include things like thermal mass (the ability of building materials to absorb and release heat), and ground/air source heat pumps – which can convert small amounts of heat drawn from the air or from underground into usable energy for central heating and hot water. And of course all suitable roofs should have solar panels fitted as standard. There might even be see-through solar panels in windows before long (new technologies are making this a possibility).

Homes don't need to be built in the conventional form either. The Cube Project offers a 3×4×3 metre kit-built energy-efficient, zero-carbon home for around £10,000,[13] and this would make a cosy but affordable first home for a single person or close couple.

Another building option is using straw bales as a construction material. A straw-bale house might sound like something that could be blown down by a malicious wolf in a children's story, but actually they're incredibly strong, if built properly, highly

insulated, low-cost and very low-carbon.[14]

Reinventing the Wheel

Transport fuel will be another big consideration for a low-carbon lifestyle in the near future. The oil is probably going to run out some time this century anyway, but even if they find more, we can't burn it. If we did, we'd doom ourselves to even more disastrous climate change.

So there will need to be a phase-out of petrol-powered vehicles (sorry, Jeremy Clarkson) and a huge scaling-up of the electric car-charging network. The electricity used for the charging will have to be from renewable sources too of course – ideally from the solar panels on the roof of your home or workplace.

Batteries are getting more powerful and more lightweight all the time, and cars themselves will almost certainly be made of strong-but-light composite materials, rather than metal. It makes no sense to fuel a ton of steel just to carry one or two people around.

We'd need to make sure some of the new alternative technologies don't use equally damaging or unsustainable resources as the old ones. It already seems like the whole biofuels 'turning crops into energy' idea was an over-hasty bandwagon jump (is it a good idea to be burning food?). But there are promising alternatives like algae, which are sustainable and low (even negative) carbon.

The encouraging thought is that the sooner fossil fuels are phased out, and no longer allowed to be so extravagantly and damagingly burned, the sooner we'll see new and better alternative sources of energy coming into the mainstream. They've been held back for decades by the dominance and financial clout of the oil industry.

Governments should obviously lead the way, and help with advice and incentives where possible. But we can't rely on politicians to be forward thinking and altruistic enough to make career-risking choices. So we need to start making some of these changes ourselves, and let the 'leaders' catch up.

FEMINISM

Feminist Activism and its Achievements So Far

Hayley Foster Da Silva

There is an aspect of counterculture, a form of activism, that has been going on for decades but still hasn't fully been embraced by the mainstream: feminism. There are a lot of people who seem to think there is no need for feminism any more. They think that women have the vote now and can do many things that fifty years ago would have been frowned upon and this must mean that equality has been achieved. While yes, there has been much progress, there is still a lot of work to do before we can truly say we all have equal rights in terms of gender. Not only here in the UK but across the globe. Despite the stereotyped public image that feminism still carries (feminists continue to be portrayed as bra-burning, man-hating butch women), there are many campaigners and activists who continue to fly the feminist flag with pride and their goals and achievements are the focus of this chapter.

Origins of the Feminist Movement

To look at the earliest pioneers of the cause, the first wave of feminism happened during the 19th and early 20th century and the issues at the time focused on legal rights, in particular the vote. This was the time of the Suffragettes, who campaigned tirelessly to gain women the vote, sometimes using life-threatening methods such as hunger strikes. Their work began to pay off in 1918, when they succeeded in getting the vote for property-owning women over thirty years of age, and in 1928 the Equal

Franchise Act finally gave women voting rights on the same terms as men. However, women were seen as second class citizens for a long time, regarded as little more than their husband's property.[1]

Second Wave Feminism

The second wave of feminism began in the 1960s and feminists started focusing on wider issues, fighting to protect their rights in the workplace and within society more generally.

One of the first major breakthroughs of this era, as far as women were concerned, was the combined contraceptive pill which was approved for use by the Food and Drug Administration in 1961. This made it easier for women to have careers as they could plan their families. Discrimination in the workplace against pregnant women has reduced but still exists as a recent report from Maternity Action has highlighted.

Prominent feminist Betty Friedan released her classic feminist text *The Feminine Mystique* in 1963 in which she argued women were not being treated equally to men, and were being denied opportunities because of their sex. In the book she says:

> 'In almost every professional field, in business and in the arts and sciences, women are still treated as second class citizens. It would be a great service to tell girls who plan to work in society to expect this subtle, uncomfortable discrimination – tell them not to be quiet, and hope it will go away, but fight it. A girl should not expect special privileges because of her sex, but neither should she "adjust" to prejudice and discrimination.'

Friedan's influential book contributed towards helping the Equal Pay Act come into existence.

Campaigns for Today: Anti-rape, Lose the Lads' Mags and No More Page Three

One of the main campaigns of recent years for feminists has been the fight against rape culture. Rape culture is the culture of acceptance that emerges when rape is normalised by mainstream attitudes to gender and sexuality. For example, in one aspect of rape culture known as 'victim blaming', a woman may be blamed for being raped because she wore a short skirt; or drank an

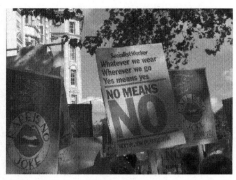

alcoholic drink, actions considered inappropriate for a 'decent woman'. Many argue that the victim somehow 'got what she deserves' instead of asking why the perpetrator would commit such a violent act. The conviction rate for the small percentage of rape cases which do reach court in the UK actually fell in 2014 to 60%, leading the Director of Public Prosecutions, Alison Saunders to demand that the decline in successful rape convictions be addressed immediately. She said:

> 'Myths and stereotypes still pervade throughout society and have the potential to influence jurors too. We have a part to play in fighting any pre-conceptions through the way we handle and present our cases to those juries.'[2]

Another campaign targeted the increasing appearance of jokes involving rape and domestic abuse on social media sites. Groups like the Everyday Sexism site and Women, Action and the Media (WAM) pulled together to highlight this problem and wrote an open letter to Facebook asking that they specifically remove groups and pages on the site that explicitly encourage rape or domestic violence, presenting such activities as subjects of fun rather than the serious abuse that they really are. When this letter was published online, fifteen companies pulled Facebook adverts from their sites including automaker Nissan and website hosting company WestHost. There was an additional petition to Facebook which got more than 224,000 signatures. To begin with, Facebook stated that the pages in question with names like 'Violently raping your friend for fun' did not technically go against their policies

but later released a statement saying that their system to rid the site of hate speech was obviously failing, particularly in relation to gender hate and that they would be working hard to change this.

An ongoing problem that has often been in the news the last few years is gang rape. It seems to be becoming increasingly common that teenage males in particular will take part in gang rapes in order to raise their status within their group. With currently no discussion of the issue of consent as part of schools' sexual education curriculum and as a result of the media's portrayal of sex, it seems many of the younger generation of males have warped ideas about what qualifies as consent. That's not to say it's only younger boys that take part in such crimes, as this behaviour has been rife amongst older men too, particularly amongst football players. Many high profile cases of rape have been in the media over the last few years.

In recent years there have been changes in the law regarding rape, including adjustments to our definition of rape. Originally considered 'the unlawful carnal knowledge of another person' where 'the elements of force and resistance were determinative'[3] this definition has been interpreted in many different ways and now means forced sexual contact towards a female or male. It was originally law that victims needed to report the crime as soon as possible, but now you can still report a rape many years later, as seen in the last few years with historical sex crimes being in the news fairly often. Unfortunately, despite these changes, according to Rape Crisis, approximately 85,000 women are raped on average every year in England and Wales. A quote from the book *Sluts* (2013) written by Christine Stockon sums up the virtual acceptance our culture exhibits towards rape:

> 'I am not sure if we are numbed to the reality of rape, but here's the sad irony. While the word rape can add an edginess to your language, talking about actual rape is taboo. I didn't know this until one of my friends was raped. Then I knew this, because I didn't want to tell anyone. If she were mugged, I would have told everyone and raged.'

Many feminists consider 'lads' mags' such as *Nuts* and *Zoo*, to

contribute significantly to rape culture by objectifying women and then labelling it as a bit of 'fun'. In 2013, feminist campaign groups UK Feminista and Object began their nationwide campaign against this type of magazine, 'The Lose the Lad Mags' campaign. Significantly, the campaign didn't aim to ban such magazines but to stop them being sold in high street shops and newsagents, where people can see them displayed on the shelves. Even if we aren't looking for this kind of thing or don't want to see it, images of semi-naked women are commonplace and have a desensitizing effect. Charities including Women's Aid who help victims of abuse have supported this campaign.

Since the beginning of the campaign there have been a few successes. The Co-operative supermarket decided to ask the publishers of such magazines to deliver them in sealed bags. When their request was refused, the Co-op didn't give in and announced that unless the publishers agreed to use sealed bags they would no longer sell their magazines. In a triumph for the campaign, this was a contributing factor to the closure of both *Nuts* and *Front* magazines in 2014 due to lack of sales after being pulled from the shelves of supermarkets like the Co-op. You can read more about the campaign on their website www.losetheladsmags.org.uk.

Another ongoing feminist campaign has been 'No More Page 3' which was started by Lucy Ann Holmes as a petition for the *Sun* newspaper to stop printing the photos of topless women on its notorious 'page 3'. The campaign has grown and grown with the current figure at time of writing being 216,539 signatures. There has been lots of support from other organisations for this campaign, including from Girlguiding UK, Mums Net, Women's Aid and Unison amongst others. At the start of 2015, the *Sun* newspaper managed to convince even their own sister newspaper the *Times* that they had quietly stopped publishing the offending page. Campaigners were cautiously optimistic, and as it turned out that caution was correct when the *Sun* then published a topless woman on Page 3 again and passed the whole thing off as some sort of joke. (Though the real joke is that UK law hasn't prohibited this ridiculous practice already.) Undeterred, the campaigners carry on with a renewed vigour. If you haven't

signed the petition yourself yet, or would like to read more about the campaign, you can find it on www.nomorepage3.org.

Other recent feminist campaigns included the design on the £10 note. Tireless feminist campaigner Caroline Perez-Criado successfully campaigned for the UK Government to go back on their decision to ditch the social reformer Elizabeth Fry in favour of Winston Churchill on the note, and now the new note will have the famous writer Jane Austen. Unfortunately, Caroline also experienced a lot of backlash on Twitter for her hard work, receiving abusive tweets and even death threats. Later on, the police did arrest a man who made the most damaging of the threats.

There was the campaign against sexist T-shirts on the website Amazon too. The T-shirts that caused most offence had the slogans 'Keep Calm and Hit Her' and the completely horrifying 'Keep Calm and Rape A Lot'. After the news spread around Twitter, the outrage came pouring in and Amazon were persuaded to remove the offending T-shirts from their site.

Online Campaigns: Everyday Sexism and the Twitter Youth Feminist Army

Another recent popular feminist campaign is the 'Everyday Sexism Project' (www.everydaysexism.com) which has both a popular website and Twitter account. Started by a woman called Laura Bates, anyone can write in (male or female) and contribute their stories of the everyday sexism they come across in their lives. This can be something as simple as a rude catcall up to more serious tales such as rape. The website is designed to highlight how much sexism is still rampant in our society, and reading through it can seriously cause some rage and sadness. At times I've considered unfollowing the Twitter page as the stories make me feel so angry and/or emotional. The website also provides a list of useful links that may provide support for people experiencing similar issues, from rape crisis, to legal support and minority support. As an example, the latest story to be submitted at the time of writing is from a thirteen-year-old girl who says she has heard more than ten rape jokes at school today from boys and that her sex education hasn't once covered the issue of consent.

On a more positive note, this also shows that there are girls out there who are identifying as feminists and understanding the implications of sexism from an early age. An excellent example of a young feminist is Lily Evans who started the 'Twitter Youth Feminist Army' (TYFA). She started the Twitter account after getting angry with reports on the news, and she wanted to meet other feminists the same age as her. Eventually, this led to an online community being built, which has now expanded to include a website and a Facebook page. Lily is an excellent campaigner, even starting projects to get consent included on the national curriculum for sexual education. You can find out more about the Twitter Youth Feminist Army and their projects at www.tyfa.co.uk

Fifty Shades of Feminism: Different Guises

One thing I have found as a feminist activist, is that there is not just one type of feminism, in fact there are many. A quick search on the internet can throw up a list of at least twenty types and I'm sure that there are more. Due to the nature of the varying types of feminism, even within the movement there are a lot of different viewpoints on the core feminist issues, and I have witnessed this first hand at feminist events I have attended. One issue which divides feminists and has recently come to the fore is that concerning transgender people. Many feminists are supportive of transgender people but there is a branch of feminism often labelled 'radical feminism' which does not accept these people within the feminist community. They believe that a man could never fully understand what a woman has gone through so therefore has no right to identify as one.

Famous feminist writer Germaine Greer (left) has said:

'Nowadays we are all likely to meet people who think they are women, have women's names, and feminine clothes and lots of eyeshadow, who seem to us to be some kind of ghastly parody, though it isn't polite to say so. We pretend that all the people passing for female

really are. Other delusions may be challenged, but not a man's delusion that he is female.'[4]

Feminist writer and activist Laurie Penny has often written on her blog at laurie-penny.com/blog and for the *New Statesman* newspaper in support of transgender rights. A quote from one of her articles is: 'Feminism calls for gender revolution, and gender revolution needs the trans movement.'[5] Liberal feminists believe that gender is not binary, and we can't all be categorised as simply male or female. There are even people who identify as 'genderqueer' who don't identify with one gender or another, but feel they are more androgynous.

Some feminists also disagree about the validity of 'female only spaces'. Some believe that only cisgender women (those born as women) can work and campaign on feminist issues as they feel any men or transgender people will always try to 'overpower' the females with their 'male' perspectives. There have even been events in recent years, such as the Radfem 2012 conference that were organised by radical feminists that stated beforehand that only 'women born women' could attend. This caused a lot of outrage and the venue involved with the intended conference Conway Hall in London actually pulled out of putting on the event, as the owners didn't feel this would fit in with their policy of equality and inclusion. I have been to some feminist conferences that were only for people who identified as women, and some where both men and women could attend. To be honest, in both circumstances the attendees have mostly been women but I found the atmosphere to be overly positive in both types of events.

The topic of sex work is another that divides opinion within the feminist movement. Some feminists are completely against it (such as the radical feminists, who believe that we need a complete reconstruction of society to achieve equality) whereas other feminists (like the liberals) would like to see sex work legalised, as they believe the safety and health of the women involved could be improved if sex work was regulated. Others believe that sex work is just another way of undermining women and puts the focus on their sexualisation and commodification once again.

Other types of feminism include anarchist, socialist, and environmentalist feminism, amongst many, many others; which shows how diverse the various factions are compared to the limited concept that many people have of the movement. The one thing almost all types of feminists can agree on is that the main aim is to achieve equality for men and women. As a liberal feminist myself, I don't want women to have any more rights than men, but I want us both to be on an equal footing, as sexism can affect both genders. My feminism also goes beyond gender, I believe in equal rights for everyone, so that means my feminism includes people of colour, lesbians, gays, bisexuals and more.

Perceptions of the F-word Today

Feminism still seems to divide both men and women. There are a lot of women who don't want to call themselves feminist as they see feminism as an outdated concept or believe it's about women getting more rights than men. There has even been debate about the word itself, with some people preferring the word 'humanist' or 'equalist.' The truth is that feminism isn't about one gender being better than the other. In fact it's now about much more than gender. Feminism today is usually about gaining equal rights for EVERYONE, yes the obvious battle is to achieve this for those born male and female, but also transgender, straight, gay, lesbian, bisexual, white, queer, black, white and all of the other 'labels' in between.

In many ways, feminism is more widely accepted today with governments, corporations, unions, schools and sports clubs encouraging girls in the 21st century to excel and become leaders. There's also a campaign for more women to take up positions on the boards of big companies. Statistics show that companies with more than 25% of women on the board outperform those with less.

In the 90s, The Spice Girls espoused 'Girl Power' and became the best-selling female pop group of all time. Their message of empowerment appealed to young women and girls, suggesting that loyalty to female friends was an important quality in life. The tabloid press hounded them and frequent stories in the media concerning in-fighting between Geri Halliwell and Melanie

Brown ran counter to their lyrics which advocated female unity. In a UK poll taken a decade later, their brand of 'Girl Power' was considered to have defined the 90s, making them the most popular cultural icons of the decade. The popularity of the Spice Girls was in evidence when they performed at the closing ceremony of the Olympics in London 2012, dancing on top of black taxis, to a rapturous crowd.

More recently, singer Beyoncé Knowles performed with a giant screen blazoned with the word 'Feminist' behind her during the 2014 MTV Video Music Awards, and she has an all-female backing band (Suga Mama). She sampled a speech about feminism in her music and has even written an article about equal pay. In the UK, singer-songwriter Kate Nash is very open about her feminism and mentions it frequently throughout her 2013 album *Girl Talk*. She has run a 'Rock n Roll After School Rock Club for Girls' which helped young women to pursue their musical dreams and makes a point of only hiring female sound engineers and as many female crew members as she can to help with her work. Writer Caitlin Moran also identifies as a feminist and on a recent tour to promote her novel *How to Build a Girl* (2014), sold tea towels, T-shirts and other feminist merchandise to raise funds for the charity Refuge. In her popular feminist book *How to be a Woman* (2012) she mocks anyone who doesn't identify themselves as feminist:

> 'We need to reclaim the word "feminism". We need the word "feminism" back real bad. When statistics come in saying that only 29% of American women would describe themselves as feminist – and only 42% of British women – I used to think, What do you think feminism IS, ladies? What part of "liberation for women" is not for you? Is it freedom to vote? The right not to be owned by the man you marry? The campaign for equal pay? "Vogue" by Madonna? Jeans? Did all that good shit GET ON YOUR NERVES? Or were you just DRUNK AT THE TIME OF THE SURVEY?'

Another high profile feminist is musician Amanda Palmer. Palmer has been anything but quiet when it comes to her

feminism. From challenging beauty standards to singing songs about the joy of pubic hair. She wrote on her blog:

> 'As far as I'm concerned, the most powerful feminist can do WHATEVER SHE WANTS, THAT IS WHAT DEFINES A TRUE FEMINIST.'[6]

Spreading the Word: Community Contact

It's not just the celebrity world and the media that attests to the rise of feminism in the UK. There are also quite a few feminist conferences which take place each year. I have personally attended two, one back in 2011 called 'FEM 11' (a female identified only conference) and one in 2013 called 'Feminism in London' (a mixed gender conference) which has been running successfully for around five years. At such events there are many talks, events and stalls that not only promote feminist-minded charities but also often have women selling their homemade crafts. (Feminists have been doing this since the time of the suffragettes.) FEM 11 was organised by feminist organisation UK Feminista and I attended talks from The Fawcett Society (who campaign for equal pay and other such rights) and from Object about the sexualisation of women. There was also a feminist Question Time with some prime writers from the media, and even a pre-election debate with those who were the candidates to be the mayor of London at the time – including Boris Johnson, who was the only candidate who decided not to show.

At Feminism in London there were some fascinating talks from people as diverse as Caroline Lucas from the Green Party and Shabina Begum, who did a talk about acid attack violence. I went to a workshop that tried to explore how the differing types of feminism could work together to overcome oppression, and I also attended a 'red tent' which was a quiet spiritual space where only a few women gathered and we discussed our menstrual cycles and how they could relate to the seasons of the year.

The Red Tent is another feminist-minded project. Red Tents are a global movement started by women for women to gather to share, and meet other women. There are Red Tent events and groups all over the world. Some meetings are held in a physical red tent but others are just held in people's houses.

Feminist Arts

Other wonderful feminist events are *Ladyfests*. These can be held by anyone, anywhere, but they originally started in the year 2000, with the first one taking place in Olympia, Washington. The idea of a Ladyfest is that it is a non-profit festival promoting women in the arts, and often these festivals will be raising money for charities such as Rape Crisis. I have been lucky enough to attend two London-based ones, and I have organised one myself in my hometown of Southend-on-Sea, in Essex. The ones I attended had fantastic music with bands like Lilies on Mars and MEN. They also had great workshops. I've attended a panel discussion on Women in the Media, done a dance class, made feminist bunting and even more. My particular event was an all-dayer of independent female-fronted music such as Candy Panic Attack and Death of the Elephant plus some spoken word poetry from a local arts group Sundown Multimedia, with the money going to the domestic abuse charity Refuge.

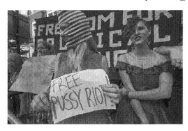

Feminist arts also had a place in the news during the Pussy Riot trial. Pussy Riot is a feminist activist band based in Russia. They hit the headlines when they performed an anti-government song in a church. Three of the band members were sentenced to two-year jail sentences for 'hooliganism' which led to an international uproar and opened up the debate once again about freedom of speech. The song that caused such a commotion was called 'Punk Prayer – Mother of God, Chase

Putin Away'. The band members had a lot of support from all over the world and from major artists like Madonna and Lady Gaga. I attended a demo outside the Russian Embassy in London at the time of the trial, and I was inspired by how much support was being shown. There were women, men and even children in attendance, wearing either brightly-coloured clothing or balaclavas (as often sported by Pussy Riot themselves) in solidarity.

Feminism and Film

In the past few years, more films and books have been produced with strong, powerful women as the protagonist. Consider *The Hunger Games* book series and subsequently the blockbuster films. The main character is Katniss Everdeen, a girl who is very intelligent, and knows how to survive through hunting and negotiating (and is not sexualised, unlike some other 'strong' leading female characters.) We also had Stieg Larsson's *The Girl With the Dragon Tattoo*, the first of the *Millennium* book trilogy. All three books were made into films by a Swedish film company, and the first was also remade by Hollywood. Although the lead character Lisbeth goes through horrendous abuse and rape, she emerges as a powerful, strong character.

But the absence of female characters in TV and feature films is an ongoing subject of debate with many actors calling for change. Louise Jameson, an actress from BBC TV's long-running soap *Eastenders* called for better representation of women on screen:

'It is shocking that in 2009 we are still debating this issue of equal representation and equal pay for equal work. Only by unionising, only by putting our collective voices with, for and behind each other will anything move forward. I urge everyone, male and female, to join this campaign for the sake of the craft we are all so in love with.'

The UK Actors' Union Equity has created a petition which has garnered over 10,000 names so far, calling on TV companies in the UK to redress the imbalance:

'Over half the viewing public is female, yet in TV drama for every female character, there are two male characters – (35.3% female roles to 63.5% male roles). Whilst leading

parts are frequently played by male actors over 45, women in this age group start to disappear from our screens. The message this sends to viewers is distorted and distorting. We call on all the major UK television channels to take action to correct this imbalance.'

The petition URL is www.gopetition.com/petition/24658.html

The *Bechdel test* is a very simple test for evaluating whether a film or TV drama has a bias towards male characters. It consists of three questions that need to be asked of any film under scrutiny. Firstly, is there more than one female character? Secondly, do the female characters talk to each other? And thirdly do they talk about something other than a man? When you start applying this test you will notice that most films, even some of the biggest-selling ones, don't pass these simple criteria. For example, *Harry Potter and the Deathly Hallows Part 3* fails, as does *Avatar* and the original *Star Wars* trilogy. The test is named after the cartoonist Alison Bechdel who in 1985 had a character in her comic *Dykes to Watch Out For* discuss the idea.

In 2014, the Bath Film Festival came up with the idea of 'F-rated' films. Inspired by the Bechdel test, the producer of the festival, Holly Tarquini, wanted to highlight the lack of females in the film industry. The films with the 'F-rating' would be 'female friendly/feminist' so would have female protagonists or even a female director. At the festival, seventeen of the forty-two films showing received the rating. Some people questioned the decision to apply the 'F-rating', asking whether this was really necessary, but at the very least it might encourage scriptwriters to think about how they portray female characters. On the New York Film Academy's website they list some statistics about women in the top 500 films of all time, which include the fact that only 30.8% of speaking characters in these films are female and that 26.2% of women characters get partially naked compared to only 9.4% of male characters.

A very interesting documentary that was made by Jennifer Siebel Newsom and released in 2011 is *Miss Representation*, that you can buy on the filmmakers' website www.representationproject.org or at the time of writing is available on Netflix. The documentary

explores the lack of representation for women not just in the media but also in politics, and it also critiques the way women are often presented, usually in a sexual way or at the very least in a mode determined by their looks. For instance, in one part of the film there is a discussion concerning how the few women in politics are represented by the media. Often the media will talk about the clothes they wear, their hairstyles or what they look like, rather than what their policies are or what they have achieved in terms of their careers. Some of the shocking statistics unearthed by this documentary include the following: only 35 women have served as US Governors compared to 2,319 men and in 2011 only 11% of protagonists in films were female. Women only own 5.8% of all television stations and 6% of all radio stations.

Public Protest: Reclaim the Night and SlutWalks

The annual 'Million Women Rise' march, London

There are still many regular protest marches organised by feminist groups as they play a pivotal role in drawing attention to particular causes. One regular event is the Million Women Rise march which takes place every year on International Women's Day (which is the 8th March or the closest Saturday) in London. The march is an all-female march, and is a protest against male violence to women. The march has been going since 2008, and regularly sees thousands of women and girls take part.

It's not the only annual march. There is also 'Reclaim the Night' which is another all-female march against violence to women. The origins of this event can be traced back to the 70s but it is

now a regular event organised by the London Feminist Network which has sister marches all across the country. The event takes place in the evening, to represent the women 'taking back the night', as we shouldn't have to fear going out in the darker hours just because we are female.

More recently conceived, we have the 'SlutWalk' marches which started in 2011 in Canada, in response to a policeman who said 'women should stop dressing as sluts' as rape prevention advice. On this march, women often wear revealing clothing and have banners with such slogans as 'my skirt is not consent'. Since then it has gained momentum, happening in several countries including two that took place in London. It has proved to be controversial, however, as even within the feminist community there has been disagreement over the approach taken by this particular march. Some women who participate in the SlutWalk also use it as a way of 'reclaiming' the word 'slut', saying that women can eradicate the derogatory meaning of this word by claiming it for themselves and attaching a more positive meaning. However, other women disagree, and hate the use of the word 'slut' in any context. I have taken part in one of the SlutWalks that took place in London and though I don't have any desire to reclaim the word 'slut' neither do I have a problem with women who do want to claim the word back. Kathleen Hanna of the 90s Riot Grrrl band Bikini Kill furthered the cause at the height of her fame. She often performed on stage with just a T-shirt and knickers, with words like 'slut' scrawled over her skin. Theatre company Scary Little Girls (www.scarylittlegirls.co.uk) often perform feminist-inspired shows, and performed a radical storytelling event in London's Stoke Newington to celebrate International Women's Day 2015.

In the Home and the Workplace: Where Did the Promise of Equality Go?

Oscar-winning actor Patricia Arquette recently used her televised acceptance speech to highlight the continuing issue of women not receiving equal pay to men. The Fawcett Society, a campaign group for women's rights in the UK, recently released a report on equal pay. In the report, it says there is still a significant pay gap between men and women that has worryingly actually widened in

2013. The gap as detailed in the report stands at 19.1 %, meaning that for every pound that a man earns, a women only earns 81p. Why is there still this gap? The Fawcett Society believes that is partly down to a 'motherhood penalty' as having children will often affect a mother's working hours, and some workplaces are not very willing to fit in with a mother's needs for lifestyle changes such as flexi-working. The report also discusses what can be done to tackle this problem of non-equal pay, including changing the minimum wage to a living wage, which would help decrease the pay gap. You can read the full reports and their findings on their website www.thefawcettsociety.org.uk

Even in the home, we are still not finding equality between men and women. In 2014, the Bureau of Labour Statistics released a report which indicated that although things have improved over time, women are still doing the majority of the housework. Some of the statistics they found included the following: on an average day 49% of women would do housework like washing, compared to only 19% of men, and that women would spend up to one hour physically caring for a young child (things like bathing etc.) compared to an average of 26 minutes for men.

Educating the Next Generation

To gain some insight into why sexism still exists, it is worth looking at how the world is portrayed to young children. You only have to go into a toy shop to see the difference in marketing to boys and girls. In a lot of toy shops you will probably find a separate department for 'girls' and another department for 'boys'. In a typical boys' section, you can find all sorts of fun toys like science sets and cool costumes like Batman and a Pirate. Over in the girls' section, you typically wouldn't find toys that encourage the mind such as science sets, but instead are greeted with an array of pink toys, dolls, replicas of household cleaning objects and costumes such as Nurse or Fairy.

This starts an early trend in a child's life that girls are destined to be mothers (you can even get dolls that urinate/cry etc.) and boys are destined to drive cars and use their minds.

There is a campaign called 'Pink Stinks' that targets these gender-stereotyped toys, saying that they are limiting to both girls

and boys. It also promotes good female role models, self-esteem and positive body image, in the hope that by encouraging these things from a young age, later generations will have less of the issues associated with the representation of their gender in the media, and less body-related disorders like body dysmorphia or anorexia nervosa.

Weirdly, it's not even just children's toys that are affected by 'pinkification.' Other products that have been marketed as pink and for women even include Bic pens! In 2012, the stationery company released a range of pink and purple pens designed for 'her'. There was no real difference in the pen itself although in the advertising on their website they say that it has a 'fun comfort grip'. This led to outrage and ridicule on the product's Amazon website reviews with hundreds of women (and men) writing their own reviews to mock the silliness of the product. For example one part of one of the reviews reads:

> 'My husband has never allowed me to write as he didn't want me touching men's pens. However when I saw this product I had to buy it (using my pocket money) and it's fabulous! Once I learnt to write, the feminine colour and the soft grip (which was much more suited for my delicate hands) has allowed me to vent my thoughts about knitting, cooking…'

and so on.

In late 2014, the children's book publisher Ladybird changed the branding of some of their books from 'For Boys' and 'For Girls' to 'For Children' instead. They said they didn't want to be seen to be limiting children in any way, and that books that specified gender in the past will in future be published as gender-neutral. This was applauded by the campaign group 'Let Toys Be Toys' who seek to get the gender labels off toys and have a sub-campaign called 'Let Books Be Books'. They believe that gender-labelling toys and books is old fashioned and sets restrictions on play and a child's imagination. Not only did they have success with Ladybird but also Parragon, Chad Valley, Dorling Kindersley and Miles Kelly Publishing, and they also convinced the company Paperchase to stop selling gendered activity books.

A Feminist Future

So in conclusion, feminism is still very much alive, and is still very much needed, despite the mainstream media's tendency to largely brush it under the carpet or make it into an object of ridicule. There are still many feminists working hard to try and make the world a better place for everyone.

What you can do to challenge sexism:

• If you overhear a sexist remark, challenge it.

• If you see sexist advertising, send a complaint to the relevant authorities.

• If a particular company's portrayal of the sexes is seriously stereotyped boycott the company and do not buy anything from it again.

• Volunteer at a relevant charity such as a domestic abuse shelter or a helpline for vulnerable women.

• Share domestic work and responsibilities at home equally.

• Don't buy gendered toys or clothing for children.

• Speak out about feminism and advocate equality in society.

• Attend feminist conferences and marches.

• Sign petitions which protest inequality or discrimination.

• Use social media to promote a more equal society.

• Vote for politicians with policies that advocate equality and challenge discrimination.

FILM

Beyond the Mainstream: Counterculture Cinema

Ellen Cheshire

Young People Had Nothing to Do and Nowhere to Go

With the new freedoms experienced by many young people in the 60s, the decade has become synonymous with 'sex, drugs and rock 'n' roll.' Although this was true for some, this was not true for all. Vanessa Redgrave recalling the period, reminds us to '... picture an England where young people had nothing to do and nowhere to go... Nothing resonated with them, nothing.'[1] Here we will be exploring how film reflected this 1960s power shift from one generation to the next, and how over the subsequent decades this has inspired filmmakers to challenge the mainstream.

We will highlight the films and filmmakers that showcased contemporary changes in society; these may not have been as commercially successful as other films of the time i.e. *Carry On...*, *Hammer...* et al, but they have left an indelible record of the seismic shifts in British Society in the 1960s and beyond. These films explored alternative visions of British life, ones that are perhaps more truthful, more challenging or more poetic, created by filmmakers who are driven by a desire to explore the limits of filmmaking and to create art without the restraints of commercial expectations.

Although the phrases 'British life' and 'British filmmaking' are used it is worth noting that there isn't just one British cinema – the countries that make up Britain all have very different cultures

and film industries. The reality is that the film production has been, and still is, largely concentrated in England, hence the films we'll be looking at and discovering are essentially 'English'. It is important to remember that labels such as 'swinging sixties' or 'kitchen sink dramas' are only categories, not the films themselves. These labels are often given retrospectively as a means of easy-identification and linking the work of differing directors at a particular point in time, and place.

As Much Glamour in the Muck as in the Brass

Changes in film techniques, styles and use of sexuality do not happen overnight. No one woke up one morning on January 1st 1960 and said 'The sixties is going to be a decade of "social realist dramas" followed by "swinging sixties films".' The styles and uses of sexuality evolved over the years. The 'social realist drama' commonly known as the 'kitchen sink drama' started to be introduced to British audiences as early as 1957. The genre then evolved over the next six years as a period of profound social and cultural revolution in the British film industry. This style of filmmaking was taken from the Italian Neo-Realist film style and proved very popular on stage, television and in film.

In 1956 a new wave of young writers, directors and actors formed. They were rebelling against the popular films released in the aftermath of World War II, which were largely classy literary adaptations (*Great Expectations*, 1946 and *The Importance of Being Earnest*, 1946), heroic war escapades (*The Dam Busters*, 1954 and *The Colditz Story*, 1954) or encouraged people to settle down and get on with it (*Brief Encounter*, 1945 and *Passport to Pimlico*, 1949).

The principal directors of this new wave were Karel Reisz, Lindsay Anderson and Tony Richardson. They founded the 'Free Cinema' documentary film movement. In its 1956 statement it was asserted that, 'No film can be too personal. The image speaks. Sound amplifies and comments. Size is irrelevant. Perfection is not an aim. An attitude means a style. A style means an attitude.' Anderson was particularly dismissive of the commercial film industry, and the 'free' referred to them being made outside of commercial cinema. They received funding from the British Film Institute's (BFI) Experimental Film Fund (which had been

launched in 1952), independent funding or business sponsorship. The first series of three short documentaries was screened at the National Film Theatre in February 1956 and over the next few years five programmes were screened under the 'Free Cinema' heading. The series ended in 1959, as by that point many of the directors had moved to feature films, which retained a documentary-style to them.

These feature films, often based on popular novels or plays, were gritty interpretations of everyday life, usually within domestic situations and have subsequently become known as 'social realist', 'kitchen sink' or 'angry young men' films. Typical themes were of alienation, frustration, fighting the system and ambitions for a better life. The men in these films were young, working class and angry at the world.

Saturday Night and Sunday Morning DVD cover

They included *Woman in a Dressing Gown* (J. Lee Thompson, 1957), *Room at the Top* (Jack Clayton, 1959), *Look Back in Anger* (Tony Richardson, 1959), *Saturday Night and Sunday Morning* (Karel Reisz, 1960), *A Taste of Honey* (Tony Richardson, 1961), *A Kind of Loving* (John Schlesinger, 1962), *The Loneliness of the Long Distance Runner* (Tony Richardson, 1962) and *This Sporting Life* (Lindsay Anderson, 1963). The films all share common themes that reflected working class (usually northern) culture and life, the films' narratives were strongly sexual and often violent; they showed strong men trapped in their environment unable to escape because of education, societal pressures and family life.

Clive James recalls viewing *Saturday Night and Sunday Morning* for the first time:

'Out there in Sydney I copied Finney's libidinous smirk the same way that I had previously copied Marlon Brando's

sneer. It was a portent: there was as much glamour in the muck as in the brass.'[2]

It is worth remembering that this was a period in time before the arrival of motorways and fast trains, which limited movement from the North to the South. The films were shot in black and white, using natural light, genuine locations of working class slums and rubble-filled streets that would have become familiar through documentary photographs of the *Picture Post*. Make-up and hair-styling was kept to a minimum, and costumes were bought from high-street stores such as the Co-op and C&A.

The Anti-Establishment Emerges

By 1963 Britain had started to 'swing' and the release of Anderson's *This Sporting Life* did not achieve the same commercial or critical successes as its predecessors. *Billy Liar* (John Schlesinger, 1963) was already in production, and can be seen as a film that bridges the shift from one period to the next. In its promotion the fantasy elements were accentuated and the social realism downplayed.

As this book highlights the early 1960s brought a new vitality and impetus for change across a number of artists and societal movements, and with that a series of films that were characterised by themes of rebellion, fun, pleasure, promiscuity, adventure and escape including *Dr No* (Terence Young, 1962), *A Hard Day's Night* (Richard Lester, 1964), *Darling* (John Schlesinger, 1965), *The Knack… and How to Get It* (Richard Lester, 1965), *Catch Us If You Can* (John Boorman, 1965), *Georgy Girl* (Silvio Narizzano, 1966) and *Alfie* (Lewis Gilbert, 1966).

A Hard Day's Night (Richard Lester, 1964) was the Beatles' first foray into film, and focuses on several days in the life of the fab four. London was considered the epicentre of Swingin' Britain, and many films depicted young people from the North dreaming of/or

Still from *A Hard Day's Night*

flocking to London to participate, and the Liverpool band was no exception. On arrival they greet London with a heavy dose of cynicism, constantly criticising, challenging and undermining

figures of authority particularly the police, their 'elders and betters', the upper class and the bowler-hatted city gents. This mocking of the old national identity is one of American born Lester's themes; in 2014 he recalled filming with the Beatles.

> 'There was something extraordinary about the four of them and we knew that if we could get that quality across to an audience, then it would work. They treated almost everything with a healthy disrespect. Their sniffiness for the establishment radiated from them. You could feel their awareness that you shouldn't be too beguiled.'[3]

In the guise of a fun film starring Britain's biggest band, the film explores issues of national and regional identity, class representation, the rise of youth, and the desire for freedom. The Beatles' star image was to be both cool and working class, and this is mirrored in the film's visual style. The film is heralded now for its use of hand-held camera, jump cuts, sped-up shots, unusual camera angles and playing with the fictional boundaries of the film – which blurred the lines between reality and fantasy with dream-like/surreal sequences. This filmmaking style captures the youthful irreverent attitude of the band at the height of their fame, and also served as a vehicle for promoting their album of the same name. Despite the element of rebellion, the band and the film are a commodity for consumption, and ripe for exploitation.

By the mid-60s the Americans had re-discovered the British film industry and were pouring money into it, in an attempt to capitalise on this new youth market. The style of the films changed; they were made in colour and appealed more to the American and overseas market.

In many respects *Alfie* (Lewis Gilbert, 1966) epitomises 1960s British Cinema more than any other. Through its portrayal of sexual promiscuity and its use of contemporary pop music, the film explores issues of sexuality, gender and class, occasionally underpinned by strong moral messages.

Alfie was Michael Caine's break-out film and focuses on this larger-than-life character and his sexual exploits. He is not in search of social mobility, but in enjoying the benefits of the

changing attitudes towards sexuality. The film opens with him revelling in his promiscuous lifestyle and the fun he enjoys moving from woman to woman. Now that women had access to the pill, it shifted the burden of pregnancy from the man to the woman, and yet this film was released prior to the changes in abortion legislation, and the film reveals the repercussions of this sexual liberation for the women, including a brutal back-street abortion. By the film's end, Alfie is portrayed as a friendless, isolated man who has no meaningful relationships.

Over the next few years, further changes in legislation would allow more explicit and challenging material to be introduced. In 1967 the Abortion Act was introduced, making it legal and free to obtain an abortion; in 1967 homosexuality was decriminalised, in 1968 there was an end to the censorship in theatre, which in turn affected film production. In 1969 the Divorce Reform Act made it easier for couples to divorce. Known as the 'Casanova's Charter', it opened the door for an increase in male promiscuity and in 1970 the Matrimonial Property Act was introduced.

But this desire for more provocative stories was coupled with the dramatic demise in the fortunes of the British Film Industry which necessitated new funding models, modes of distribution and the development of underground/art/experimental cinema.

How dramatic was this demise? In 1946 when audiences were enjoying historical costume dramas, war movies and comedies, 1,650,000,000 cinema tickets were sold in the UK. In 1945 it was reported that there were only 15,000 television sets in Britain. When commercial television started in 1955, there were now 5 million sets across the country and over the next 6 years this more than doubled, so by 1961 there were 11 million sets and cinema admissions had fallen by 75%.[4] By the 1960s the grand cinemas, that had been built thirty to forty years earlier, were falling into disrepair. Mainstream commercial filmmakers tried to fight back by employing techniques that could not be copied on television such as Technicolor, CinemaScope and 3D.

In Britain, and similarly in the US, the late 1960s saw filmmakers tackling material that moved further from the mainstream. These films tackled head-on issues around violence, drug use,

homosexuality and extra-marital affairs. In the US, these included *The Graduate* (Mike Nichols, 1967), *Bonnie and Clyde* (Arthur Penn, 1967), *Midnight Cowboy* (John Schlesinger, 1969) and *Easy Rider* (Dennis Hopper, 1969).

Following the mixed reviews and poor box office Anderson's *This Sporting Life* had received in 1963, he returned to the theatre to direct a series of plays at the Royal Court, as well as at the Old Vic and Chichester Festival Theatre. With the May 1968 French student protests taking place across the Channel, Anderson was working on his own contribution to the anti-establishment protests that were occurring across Europe and the US. *If...* (Anderson, 1968) is a satire starring Malcolm McDowell in his first screen role, and established for both star and director an association with civil disobedience and creative extremes. The ground-breaking film is about class, homoeroticism, sexual repression and violent revolution in an English public school; and is lauded for its messages of freedom and rebellion. These messages are mirrored in the film's visual and narrative style which continually shifts from the realities of the institutional hell to bizarre fantasy sequences. Its shift from colour to black and white film stock was both a budgetary necessity and a reinforcement of the shift from surrealism to social realism. The film was released as students in Britain, Europe and the US were taking to the streets in protest of social inequalities.

In 1968, Donald Cammell and Nicolas Roeg where working on *Performance* (Donald Cammell and Nicolas Roeg, 1970) written by Cammell and starring James Fox and Mick Jagger. Jagger with other members of the Rolling Stones had made headlines the previous year with the now infamous drugs bust at Keith Richard's home near Chichester, West Sussex. The image of the Rolling Stones was a far cry from that of the Beatles. American commentator and novelist Tom Wolfe said, 'The Beatles want to hold your hand, the Stones want to burn your town.'[5]

The tagline for *Performance* was: 'This film is about madness. And sanity. Fantasy. And reality. Death. And life. Vice. And versa.' The film blends the lives of two men from two opposing worlds: Chas (James Fox) is a London gangster who has to hide out following

a conflict with a gang-land boss; he hides out in the drug-fuelled bohemian home of rock star Turner (Mick Jagger). The structure and visual style of the film replicates the slow disintegration of Chas's personality as he is drawn into Turner's world of cross dressing, drug-taking, casual sex and discussions of Eastern poetry. Turner takes on some of Chas's traits by dropping his flower-child persona, and becomes more aggressive and out of control. This is shown through the film's editing style, visual effects, jump cutting, shifting and confusing points of view and the blurring of the lines between reality and hallucination. The film was financed by Warner Brothers who were so troubled by the film's content that they delayed the release until 1970.

In an interview with Simon Hattenstone, James Fox said making the film was 'traumatic';[6] it led him to give up acting at the age of thirty and turn to evangelical Christianity for many years.

There were increasing levels of sexual and violent content in films as the 1960s progressed, and the pressure of special interest groups meant that in 1970 the British Board of Film Classification recognised that teenagers had specific concerns of their own which ought to be reflected in the ratings system. The introduction of the AA rating which permitted admission to children of fourteen years or over and raising of the minimum age for X certificate films from sixteen to eighteen was finally approved by local

Stanley Kubrick, during the filming of *A Clockwork Orange*

authorities and the industry in 1970. With it a series of films that increasingly pushed the boundaries of filmmaking style and content including *Straw Dogs* (Sam Peckinpah, 1971), *A Clockwork Orange* (Stanley Kubrick, 1971), *Get Carter* (Mike Hodges, 1971), *The Devils* (Ken Russell, 1971), the *Monty Python* films (Terry Gilliam, 1971, 1975, 1979), *Don't Look Now* (Nicholas Roeg, 1973) and *The Wicker Man* (Robin Hardy, 1973).

The British Film Industry Seemed to Keel Over and Die

With most of the major studios suffering at the sudden withdrawal of American funding, and the decreasing cinema attendance (193 million admissions in 1970 down to 110 million in 1980)[7] a very different cinematic landscape in Britain was created from the early 70s to 80s. As John Patterson wrote in a 2008 *Guardian* feature on 1970s forgotten film gems:

> 'The British film industry appeared to keel over and die… When the American studio money that had largely underwritten the "British" new wave throughout the 1960s dried up in 1970, British cinema experienced a body-blow from which it took almost a decade to recover.'[8]

The 'forgotten' films were those funded by the BFI Production Board which received a much needed injection of funding in 1971–2. The funding came from a large increase in the BFI's government grant, and income from the Eady levy, a tax on box office receipts which was introduced in 1957 and terminated in 1985. Some of this money was specifically intended for the BFI to fund low-budget feature-length films on a regular basis as well as a series of featurettes (under one hour), which included Bill Douglas' *My Childhood* (1972) and *My Ain Folk* (1973) and Terence Davies' debut *Children* (1976).

This scheme saw the release of a cycle of new feature films: *Winstanley* (Kevin Brownlow and Andrew Mollo, 1975), a historical drama about social reform, *Moon Over the Alley* (Joseph Despins, 1975), an exploration of the problems of the multicultural residents in a Notting Hill boarding house, *Requiem for a Village* (David Gladwell, 1975), a poetic meditation on how the modern world was effecting those in rural England, the openly avant-garde *Central Bazaar* (Stephen Dwoskin, 1973), the first British Black film *Pressure* (Horace Ove, 1975) and the first British Asian feature film *A Private Enterprise* (Peter K. Smith, 1974).

This investment in emerging filmmakers helped them transition into feature film production. Many had come to filmmaking through art school and short film initiatives such as the London Film-Makers' Co-op (1966–1999), Cinema Action (1968–1986) and the Newcastle-based Amber Films (1968–present), London

Women's Film Group (1972–1976), the Sheffield Film Co-op (1975–1991) and Leeds Animation Workshop (1976–present).

What emerged was a group of directors whose 'art' films combined innovative visual styles with narrative structures and plots which were deliberately provocative and demanded more from the viewer. This group made clear that a single individual is integral to the film's vision, and films are marketed on the back of the director's name, not the genre or the star. The narratives and characters can appear to drift along with no real motivation and the films often make a conscious attempt to resist the mainstream through their narrative, visual style, marketing and distribution. These filmmakers may deliberately reject the classical narrative model, be politically motivated and reject ideologies associated with 'film as entertainment'; they would draw on previous innovations in experiential or marginal filmmaking techniques.

Derek Jarman and Sally Potter were near contemporaries whose artistic output spans film (experimental shorts to feature films), performance art, theatre direction and music. Both are outspoken about their atheism, and used their work as a form of anarchy.

Derek Jarman

In 1963 Derek Jarman began a four-year degree at the prestigious Slade School of Fine Art in London, and then set up his own studio. He was outspoken about homosexuality and a key advocate for gay rights. His first job within the film industry was as a designer for Ken Russell's *The Devils*. In 1976 Jarman made the move from his own Super-8 shorts into feature films with *Sebastiane* (1976). An early film depicting positive images of

homosexuality, it was also entirely in Latin. He followed this up with *Jubilee* in 1978, an apocalyptic punk film and an unconventional adaptation of *The Tempest* (1979) which featured nudity (mostly male, but some female) and saw the punk singer Toyah Wilcox cast as Miranda. In the 1980s he became a key campaigner in the fight against

Clause 28 and to raise awareness of AIDS. This was reflected in his work including in *The Angelic Conversation* (1985). His biggest commercial success was due in part to the involvement of Channel 4 in the financing and distribution of *Caravaggio* (1986), a fictionalised re-telling of the life of the 15th century painter, which also received funding from the BFI.

Frustrated by the limitations of 35mm, and the bureaucracy that came with working with institutions, he returned to 8mm to create a series of films which abandoned traditional narratives in favour of personal poetic mediations on contemporary Britain. These included *The Last of England* (1987) on the loss of British culture in the 1980s and *The Garden* (1990) which offers bleak depictions on homosexuality and Christianity. *Blue* (1993) was broadcast on Channel 4/BBC Radio 3 in September 1993, with Channel 4 providing half of the £90,000 budget. *Blue* consisted of a single shot of saturated bright blue; and was accompanied by a soundtrack of Jarman talking on his life and artistic vision, with new music compositions by Simon Fisher Turner and other artists. When he was interviewed about the film for the *Guardian* Jarman was in hospital, losing his sight and dying of AIDS-related complications. But he was still passionate about advocacy and the creative process:

> 'A lot of these [AIDS] slogans are ludicrous. I wish you were living with AIDS, but it's the opposite, only dying, dying with AIDS. It's much better to face the facts. I'm still surviving, but I don't think I'm going to survive... [On *Blue*] I thought that it would turn out to be an interesting experimental film, but it's bizarre that the film just became a film, rather than an experimental film... I think it will be my last. There are no plans to do another one. It's a good end film, so I'm not too worried about that. In fact I've made quite a lot of films now, about 11 or 12 of them, and enough is enough. I don't feel shortchanged. I've done everything I can do.'[9]

Jarman had been diagnosed as HIV positive in December 1986, a condition he discussed openly.

'I have never been happier than in the last two years,

entering into all these public debates. My aggressive stance, with all my public work is to do with keeping alive. If you go into a corner, and shut yourself up, like Freddie Mercury did…God, I wish I'd known Freddie, because it would have been great to say to him "come on, let's go on an Outrage demonstration."'[10]

He died in February 1994, six months after the transmission of *Blue*, but he did have time for one last work, *Glitterbug* (1994) a one-hour compilation film of various Super-8 shorts he had filmed over the years, accompanied by music from Brian Eno for BBC's *Arena* arts series. When David Rooney reviewed it for *Variety* he said that it is

> 'a pristine techno creation built to house a lifetime of reflections… London remains an omnipresent factor… [and it] eloquently captures the city's physical presence, from moody, gray Thames scenes to orderly parks and gardens to starkly ugly housing estates. It glances back at the pre-AIDS days of parties, drugs and drag. Brian Eno's score constitutes a breathless journey taking in the director's films, friends and favoured stomping grounds.'[11]

Music had always played an important part in Jarman's personal and professional life as he directed the music videos from all the major singers in the British counterculture music scene including the Sex Pistols, The Smiths, Marc Almond, Bryan Ferry, Bob Geldof and the Pet Shop Boys.

Sally Potter OBE

Potter began making amateur films when she was fourteen, and was given an 8mm camera from her uncle. She dropped out of school at sixteen (1965) to pursue a career in filmmaking. She

Sally Potter, with her OBE for services to film, 1992.

became a member of the London Film-Makers' Co-op and made a series of short experimental films, including *Jerk* (1969) and *Play* (1970). She returned to education and trained as a dancer and choreographer at the London School of Contemporary Dance. In

1972 she founded Limited Dance Company with Jacky Lansley and focused on creating performance-based art and directing theatre productions.

She returned to filmmaking in 1979 with a short film, *Thriller*. Her first feature film was *The Gold Diggers* (Sally Potter, 1983) starring Julie Christie. She continued making short films and new work for television including *The London Story* (1986); a documentary series for Channel 4, *Tears, Laughter, Fear and Rage* (1986); and *I am an Ox, I am a Horse, I am a Man, I am a Woman* (1988), a film about women in Soviet cinema. She won international acclaim in 1992 with an adaptation of Virginia Woolf's *Orlando* starring Tilda Swinton, which revels in the themes of gender as a social construct.

Although Potter's film output is not prolific, it always offers the viewer something challenging. The dialogue in her 2004 film *Yes*, written in response to 9/11, is all in iambic pentameter, the majority of it in rhyme. Potter reported that: 'People were much more afraid of the iambic pentameters than the politics which are relatively oblique, because there is deliberately no overt message or actual event.'[12]

The film's budget was £1m, with almost half coming from the UK Film Council and with the cast and crew working on deferred payments. Potter confirmed that:

> 'The film was shot fast (a six week shoot, including travel between the countries). It was shot on Super 16mm (a 35 mm negative was generated in post-production). The crew was very small and very committed. We worked with what we could find or afford or invent.'[13]
>
> She added, 'I've always travelled with the films because I want the audience to be my teacher so that I can learn for the next one. But I have never had the sort of feedback that I've had with *Yes*. In Turkey, which was the first place where the audience was predominantly Muslim, the fact that there was a sympathetic Middle Eastern man in a main part was a news story, because it was such a rarity. The response there was very much more populist than in America – we were even in the Turkish *Hello!*'[14]

Her subsequent film, *Rage* (2009) is told from the point of view

of a blogger working at a New York fashion house, who shoots behind-the-scenes interviews on his mobile phone. The film was the first film to be debuted on mobile phones; the film was shown in seven episodes, beginning on September 21, 2009.

Like Jarman, Potter was also embedded in the British counterculture music scene. She was in various music bands including Feminist Improvising Group (formed in 1977) and The Film Music Orchestra. She collaborated (as a singer-songwriter) with composer/oboist Lindsay Cooper on the song cycle *Oh Moscow* which toured widely in the 1980s. Potter collaborated on the scores for *Orlando*, *The Tango Lesson*, *Yes* and *Rage*.

Art Cinema Seems Increasingly Fragile

Brian McFarlane writing in The British Cinema Book said, 'The 80s art cinema luminaries [Jarman, Davies, Greenaway, Potter] do not appear to have any clear successors and the audience or art cinema seems increasingly fragile.'[15]

Both Jarman and Potter benefited from the launch of Channel 4 in 1982, which brought a change in relationship between British cinema and television. Channel 4's remit was to commission original work rather than producing the programmes themselves, and to experiment and innovate and cater for audiences not previously addressed. With this is in mind 'Film on Four' was established, commissioning films for television from independent producers, with the anticipation that they would have a limited theatrical release before being transmitted. By entering into partnerships with the BFI Production Board or British Screen, or investing in (continental) European films, this system became a viable form of funding low to medium-budget feature films. Initial films funded this way included, *The Draughtsman's Contract* (Peter Greenaway, 1982), *A Letter to Brezhnev* (Chris Bernard, 1985) and *My Beautiful Laundrette* (Stephen Frears, 1985).

At its outset Channel 4 provided funding for films that could be termed as medium-budget art cinema, ensuring that they were creating diversity of access to film production, and through its films focusing on those who had previously been marginalised – finding new audiences. Government legislation in 1991 made Channel 4 more independent and reliant on advertising revenue.

This meant that they were now looking for films that could potentially draw in a wider audience at cinemas. In the mid-90s the company's fortunes were at their peak, with films like *The Crying Game* (Neil Jordan, 1992), *Four Weddings and a Funeral* (Mike Newell, 1994) and *Trainspotting* (Danny Boyle, 1996) earning both critical and public acclaim.

Now in its fourth decade it has supported over 500 films and helped to launch or further the careers of Derek Jarman, Ken Loach, Peter Greenaway, Alan Clarke, Neil Jordan, Mike Leigh, Danny Boyle, Steve McQueen, Shane Meadows, Jonathan Glazer, Andrea Arnold, Asif Kapadia, Michael Winterbottom, Paddy Considine, Richard Ayoade, Roger Michell, Kevin Macdonald, Martin McDonagh and Ben Wheatley.

With the pressures on commercial cinema greater than ever, cinemas are increasingly showing Hollywood blockbusters. The British film industry is currently investing heavily in safe dramas featuring a series of Dames, so alternative films are increasingly seen only in art galleries and specialist cinema societies. Artist filmmakers such as Tacita Dean, Andrew Kötting, Steve McQueen, Sam Taylor-Johnson (*née* Taylor-Wood) have reached out to audiences beyond these confines. But for many, the lack of support could endanger a future where filmmakers are able to create films that do not pander to the mainstream. For example, Luxonline is a web resource for exploring British based artists' film and video in-depth. It has an archive that stretches back to 1900 and collates articles and films for free streaming, and yet through lack of funding it has not been updated since 2009.

In 2012 the BFI launched its five-year 'Film Forever' strategy. Aware that its resources are a relatively modest part of the overall film finance landscape, it determined to focus on three priority areas only: Expanding education and learning and boosting audience choice; supporting the future success of British film; and unlocking our film heritage.[16]

Within this strategy there is modest funding for supporting the production of shorts and feature films through its Film Fund, the largest public film fund in the UK. It currently invests over £26m of Lottery funds to support film development, production

and distribution activity in the UK, with the budget set to increase to £30m by 2017. There is also funding through the BFI Film Audience Network to encourage cinema exhibitors to programme specialist film content; which in this context includes: Independent British film; Foreign language/world cinema with subtitles; Documentaries; Work with stories and subjects relating to diversity, for example Black, Asian and Minority Ethnic, disability and LGBTQ; Archive/Classic film (any films made from 1895 until about ten to twenty years ago); Short film programmes; Artists Film/Experimental.[17]

With new technologies making filmmaking cheaper and easier than ever, the future of film production looks more promising. But what of film exhibition and distribution? Stephen Follows, writer and producer, wrote in 2014 "We are currently in a boom for feature film production, with more films made in the UK in 2013 than ever before. However, the size of movie audiences and the rate at which we watch films is not growing at the same speed. This means the 'pressure point' in the filmmaking process has shifted from "Will I get it made?" to "Will anyone see it?""[18]

The introduction of digital film exhibition has helped lower costs, allowing smaller distributors to get their films into cinemas. The increase in people watching films on demand via sites such as BFIplayer, Curzon Home Cinema and Netflix has offered new ways of film distribution, allowing for a greater mix of films to be seen, as has the proliferation of film festivals around the world. So let's hope that Follows' "Will anyone see it?" soon becomes "Have you seen it?"

Subversive Cinema:
Cult Film and the Rise of Film Fan Communities

Dr K. Charlie Oughton

A ragtag group of people gather in the cinema lobby. Some are chattering wildly, some are silent; a few are rather pink in the cheeks and several hold a prized poster, still rolled-up above the crowd and have grins as wide as Glasgow smiles. Their ages range from fresh-faced youngsters to... those who... have seen. This is FrightFest and for a few days at the height of summer, people of all genders, ages and an impressive range of nationalities travel to London to watch horror films one after the other in a darkened cinema. Some of these films will go on to wide release in cinemas across the UK while others such as *The Samurai* (2014, Till Kleinert) will be loved yet go straight to DVD, to be enjoyed and discussed online by communities such as the FrightFest Revisited – Rewatch & Catchup Facebook group, long after the event.

FrightFest is a key example of how counterculture film is thriving in the UK and this chapter will chart its rise. Featuring interviews with key industry insiders from iconic cult film actress Emily Booth through to the managers of film festivals and subversive cinemas, it will examine how genres including fantasy, sci-fi, psychotronic, action films and horror are consumed outside of the mainstream. Owing to the quantity of material associated with subversive cinema, not to mention the academic study of the phenomenon, we will explore horror cinema in particular and other genres where crossovers are particularly culturally significant. Beginning with a note on the definitions of cult cinema, and focus on its roots, the chapter will chart the history of today's cinematic counterculture with particular reference to

its relationship with the punk and art movements of the 1970s and 1980s as a determiner for practices and ethos and at the same time a decidedly intellectual style of fan appreciation. The punks and supposed reprobates would, after all, go on to become the vendors and organisers of today's scene. It will then allude to the so-called Smith Report in a discussion about the increasing problems of monetising cinema. The chapter will then examine some of the films' fan cultures, from film festivals through to specialist film clubs and independent cinemas events such as the Prince Charles Cinema in London's Leicester Square. It will examine their differences in ethos and what they offer, from events to developing a network of cine-literate fans who keep the film cultures alive. Finally, it will look at how the films alter the fans' identities in their day-to-day lives through fashion and socialisation. Indeed, the advent of social media, in particular, has enabled these people to become filmmakers themselves and as will be shown, reinvigorate genres intended for specialist audiences, thus changing the taboo that was cult film.

So What Is Cult Cinema
– and How Is It Countercultural?

It is firstly necessary to situate what we mean by 'cult' cinema and explain why this type of filmmaking fits so well in the countercultural vein. In its broadest British sense, the cult films which began to appear in the 60s saw the move away from the classic standards of Hollywood cinema and more towards less fairytale-like appreciations of the cultural landscape.

One example of a film which gained a cult following is *Jubilee* by Derek Jarman. Intended for a niche audience, such films often had avant garde or experimental filming styles that actively sought to challenge the viewer. Such films created a shift towards a notion of film as something that could be appreciated by a new cinema-literate audience.

A key aspect of horror film appreciation is the culture and indeed industry that surrounds it. While films such as the *Saw* franchise have appealed to a mainstream market, they are reflections of what is happening within the genre. While the definition of cult entertainment has been discussed at length

(see Mathijs and Sexton 2011 and Jancovich and Reboll 2013 in particular), it is probably most readily summed-up by scream queen Emily Booth as 'something that grows. It's something that becomes cool. It's underground and it becomes "word of mouth". It becomes its own vehicle.' The notion of 'cult' is a somewhat nebulous term. It is intrinsic to its cultural importance.

'Turning Rebellion into Money'

The new wave of cult appreciation of the horror film began in and around the 1980s in England. Its beginning and development owed a lot to its integration with other forms of counterculture, most notably popular (and not so popular) music and the fashion industry. Artists came from across the spectrum guided by the attraction of other artistic forms to participate in this new culture of appreciation, notably film critic and music journalist Alan Jones. It did not end there, however, and renowned genre artist Graham Humphreys has stated that he also owed a lot of his sensibility to the punk movement, while Siouxsie and the Banshees' roadie Billy Chainsaw would go on to be a respected journalist for publications including *Bizarre* magazine. Similar can be said of a number of the lead traders in the modern scene such as Marc Morris of Nucleus Films. Morris was collecting videos at the time punk broke in the 1980s and that counterculture momentum fuelled a scandal involving so-called 'video nasties', wherein horror films saw censure for fear that they could damage the minds of those who watched them, much to the genre buffs' indignant discontent.

Cult, Cine-literacy and the Smith Report

But times have changed for filmmaking. 'A Future for British Film: It Begins with the Audience...' is a report on the home industry commissioned by The Department for Culture, Media and Sport, chaired by Lord Chris Smith and published in 2012. The report followed the success of mainstream films including *The King's Speech* (Tom Hooper 2010) and sought a strategy to support future development. It acknowledges some of the challenges and opportunities facing modern filmmaking, such as the ease of production offered by the advent of digital and

micro budget filmmaking as well as the opportunities presented by multi-platform viewing, even if the latter also contributes to the rise in a piracy culture that even the non-IT whizz can access with minimal effort. The report's cultural importance, however, was to highlight and recognise the importance of cine-literacy – the notion that to make films succeed, both as cultural artefacts and as profit-generating ventures that filmmakers can afford to make, the audience for them should be nurtured. Aside from funding proposals, the report suggests the development of inter-curricular film studies programmes in schools as well as the fostering of several film networks to spread education about the enjoyment, creation and distribution of films throughout the land.[19] Critically, it states that, 'The panel also recognises the huge opportunities presented by social media for both industry and audiences.'[20]

Only good old-fashioned human communication rather beat the panel to this realisation and there was already a wealth of such networks in place, both in terms of audience appreciation and the filmmakers themselves.

Cine-literacy and Film Criticism

Vertigo poster, 1958

It is vital to contextualise cine-literacy in order to understand how the modern cult film landscape functions. Cine-literacy, and by extension film appreciation, can be understood as a spectrum that masquerades as a polarity. To use the polarity metaphor, on one side there is the critical tradition exemplified by film journalist and theorist Andrew Sarris and that found a voice through highbrow, relatively academic publications such as *Cahiers du Cinéma* and *Sight and Sound*, as has been discussed by Sanjek. The tradition focused on the technical creation of film as well as film as a product of its

culture. The worldwide knowledge base that these publications covered ensured those productions that were particularly praised were considered the great filmic texts. This is shown by *Sight and Sound*'s famous 'Greatest Films of All Time' poll, in which critics have argued for works ranging from Hitchcock's *Vertigo* (1958) through to Yasujirō Ozu's *Tokyo Story* (1953). On the other end of the supposed polarity are the 'fanzines' (fan-made, DIY magazines) and 'prozines' (magazines created by professionals) that discuss and indeed catalogue genre publications, often exhibiting a certain relish at the subversive nature of the different types of films in question. The highbrow films might not be the type of art one might associate with your typical cult cinema fan. One might be wrong. The film criticism culture in England is thriving, if perhaps in intent rather than profit and what's more important, the critical cultures meet. Academic writers including Calum Waddell and Shelagh Rowan-Legg have come through the university film system as fans of the genre and are published in mainstream as well as genre and academic periodicals. Similar can be said of Kim Newman, who has covered mainstream film as well as focusing on the niche of subversive film. They mix academic rigour (and theory, where appropriate) with a love of films that some would consider to be trash. Therefore, rather than film criticism being a polarity of filmic respectability married to detailed academic analysis and simple story appreciation attached to cult cinema, there is a huge crossover. This is also reflected by audiences, with amateur and semi-professional journalists such as Kat Ellinger contributing light academic criticism and in-depth cinema knowledge to a range of publications that are in turn consumed by more fans. But how did this come about?

VHS, Film Clubs and Fan Fetishisation

In the UK, the mainstream film scene was changed by the medium and style of product release. Historically, films could only be seen via theatrical release in cinemas until they were scheduled on television. The film festival market as we know it could not have developed were it not for the advent of home entertainment in 1979. Rather than having to venture outside of

the house and into a public space to see films with other people, film fans could purchase a VHS player and tape and watch at home, and they did not need to live in an urban centre to do this. It meant that the film as object could be far more easily fetishised, not merely through the previously possible appropriation of a poster (which would take up a lot of space on your wall) but by holding something that was not much larger than your hand. VHS tapes (or videos) were therefore collectable and a collection could be amassed to suit individuals' tastes, as has been described in documentaries such as *VHS Forever: Psychotronic People* (2014). That said, it would be incorrect to assume that this was an entirely solo pursuit, as part of this process involved becoming aware of the videos themselves. While this was sometimes achieved via the press (as has been discussed in *Video Nasties: Moral Panic, Censorship and Videotape* (2010)) it was also achieved through a variety of conventions, clubs and film screenings.

A number of film clubs and special screenings sprang up. Infamously, these included those at the Scala, a legendary cinema in London's King's Cross that was renowned for its late night showings of both classics and lesser known gems such as German writer/director Jörg Buttgereit's *NEKRomantik*. The screenings themselves were sometimes reported on by journalists including Newman. There were also a number of collectors' fairs whose sole purpose was to enable film fans to access more material commercially, the difference being that at places such as these specialist conventions and shops such as The Psychotronic Store in London, enthusiasts could share their tastes as well as pay for product, rather than simply renting videos from local convenience shops.

Today's Horror Film Clubs

It is from this culture that the modern horror community has bloomed. This is owing to a high level of diversification in terms of the films as well as their fans. One of the chief reasons for this flourishing community is who the fans were in the first place. Genre geeks such as Iain Robert Smith, Julian Petley, Marc Morris and Xavier Mendik became the journalists, academics and distributors who talked about and promoted the films. As a

result, the film market has also diversified to the extent that both the extreme low brow and extreme high brow end of film culture are celebrated, albeit in differing ways.

(Cult)ural Importance Across England

Cult is now recognised as increasingly culturally important. Horror programming is now also increasingly part of other institutions, such as the British Film Institute and the British Museum, traditionally considered as the spaces associated with educated, high brow culture. From August 2013 to January 2014, the British Museum ran a specialised Gothic season of outdoor films curated by The University of Aberystwyth featuring introductions presented by Kim Newman and others. There has also been additional programming at The Barbican by curators such as Cigarette Burns, who has staged screenings of obscurities such as *Cool It Carol!* (1970), complete with filmmaker introductions. As the title of this film may suggest, some of these films are not those publicly associated with excellence or indeed mainstream cultural importance, but instead recognise the undercurrents of other, more widely-known cultural sensibilities.

This is in addition to the regular film clubs that exist across the country. The scene in London is marked by its sheer diversity, though there is an emphasis on the appreciation of older cult cinema. Its film fan community can attend numerous styles of club, from events such as the sci-fi and horror shown by the West London Fantastic Film Society through to those run by The Duke Mitchell Film Club. The latter is a particularly interesting case as they represent a perfect clash of cultures. The club is heavily associated with presenting lesser known film content focusing on genres from martial arts through to horror and yet has moved from its original venue in the upper room in a public house in King's Cross through to being hosted by the legendary Phoenix Artists' private members' Club in London's Soho. Furthermore, it has expanded to curate events for other venues including

the FrightFest film festival and the Prince Charles Cinema. Furthermore, organisers such as Evrim Ersoy are journalists and (Ersoy in particular) have since become programmers at other major film festivals.

Note that this listing does include a few defunct clubs. The Classic Horror Campaign, formerly based in London, and which the author used to co-present, had shut down, but it was recently re-established in Brighton. Clubs vary widely in style, from high camp intermission skits, as favoured by the Classic Horror Campaign to the formal, academic introductions used at Filmbar70. A few clubs exist outside London, such as CULTural Babylon, and horror events are also held at Brighton's Komedia. It has been reported that some of these clubs struggle owing to a lack of attendees. (This may be down to the film and audience cultures in place in those areas.) Typically relatively low key, the events run by such clubs feature anything from single screenings and 'afterwards-in-the-pub' discussion through to incorporating talks featuring either film experts or the filmmakers themselves. Attendees at these screenings often include those who have been involved with particular productions, as film directors, festival organisers, journalists or other creative talent.

Film Festivals

Festivals, too, have gained a form of club mentality despite their varying sizes. This is partly due to their increasing number and the fact that it is usually easy to travel to them. A key attraction is that many show pre-theatrical or DVD release films and are open to both the press (free with accreditation) and to the public for a standard ticket fee. There is also an increasingly strong showing for further niche development. Owing largely to the availability of recording technology and the increase in people with access to

Bram Stoker International Film Festival 2013, Whitby

education in film and media studies, the topics covered by genre film have begun to diversify, leading to an increase in new films and subgenres. Many film festivals are run as profit-making businesses; one business model is to charge filmmakers for submitting their films for potential inclusion in the programme. Other festivals use a free submission model to expand the diversity of submissions, in the hope of developing prestige and increasing ticket sales. Festivals can also be classed by content: some aim to represent a cross section of a chosen genre, while others specialise in particular subgenres or have a particular focus, such as the indie and retrospective programming seen at FrightFest's Discovery screen. There are also general film festivals that show genre content as special screenings amongst their main programme, as exemplified by the Raindance Film Festival's showing of the zombie porn mashup of Euro-auteur Bruce LaBruce's *L.A. Zombie* (2010) and their special showing of *A Serbian Film* (2010) to selected audiences.

Case Study: FrightFest

FrightFest merits a more detailed analysis owing to its position as what is arguably the UK's premiere genre film festival. Specialising in horror, it has also branched out into thriller (showing films such as Adam Wingard's *The Guest*, 2014), sci-fi (*Shockwave Darkside*, Jay Weisman, 2014) and fantasy (*Pan's Labyrinth*, Guillermo del Toro, 2006) over the years. FrightFest's co-director and publicist is Greg Day, owner of Clout Communications, a public relations firm

that represents acts such as magician Derren Brown. Day has been involved with the festival since its inception in 2000 when his long-time friend and festival co-founder, Alan Jones, asked for his help to promote the first event at the Prince Charles Cinema in London.

Day argues that the key features that distinguish FrightFest from some of the other film festivals associated with London in particular are its *raison d'être* and audience. It is at the centre of the country's historical cultural and business resources and yet, unlike the London Film Festival, for example, not only is FrightFest a thoroughly public event where critics and audiences share the same screening, it also has a somewhat contradictory feeling of togetherness, as Day points out. This is partly because the festival is so much at odds with the national mainstream owing to its delicate dance with censorship, which has resulted in one of Day's few regrets – the shelved screening of *A Serbian Film* (Srđan Spasojević, 2010) owing to the film's controversial content. However, he feels that at the same time FrightFest actually provides an environment in which fans are able to get together and discuss their concerns and their love of the films. Several fans, such as Michael Hewitt and Ailsa and Catriona Scott (the latter two known as part of The FrightFest Lovelies) found the festival to be a platform that fostered their dedication to the extent that they all now work within the film industry themselves. Indeed, FrightFest has a strong community ethos that features heavily in Day's most cherished memory of the events:

> 'It was kind of weird being at the first one because no one kind of knew who I was and it was very much fans at the event and I felt very much a wallflower – I didn't feel like I was part of it at all. I loved horror films and I'd been watching horror films since I was about eight or nine years old, but I hadn't really thought of a place where all these people who liked horror would all converge – it was all very weird to me [laughing]... So for the first two or three years I was kind of Mr Invisible. I was kind of there, but I kind of didn't talk to anyone apart from the guests who needed to do interviews...
> Then I think it was 2006 when the [festival's co-directors]

said "You know, you'd better come on stage with us at the beginning of the festival". It was weird because when I went on stage everyone just kind of started clapping it was almost as if they had already accepted me as a FrightFest family member, but I didn't know... I hadn't really accepted that and that sort of endorsed me in a way and that brought me out of my shell because I thought, well, if they're accepting me as part of the FrightFest clan and I do what I do, which isn't as warming to the fans, then that's great.'[21]

These are, after all, fans who travel across the country and indeed across the world to attend the festival, considering it as their key holiday and who, as a result, become the community Day talks about. It is a community bonded physically, often for just one week in the year, yet the bond appears to be one of communal agreement.

Indeed, a notional civility appears to be what marks these 'fear fans' out from other entertainment consumers, as Day recalls of market research carried out a number of years ago:

'Interestingly enough, when we first got approached by advertisers – Volkswagen posed the question – what is a FrightFester? How do we know they're going to buy our car? Who is the horror fan? Who are they? Volkswagen actually did their own research that year and they found [the fans] were surprisingly affluent, very well spoken, well-educated on the whole and had disposable income and were more likely to buy a Volkswagen than rock fans.'

These are not the type of individuals who sound ripe for 'corruptibility' caused by a horror film as censorship legislation suggests. Indeed, the research discovered that these horror film fans live stable lives far removed from the tabloid stereotype. Day jokes it would be difficult to pitch stories to even left-leaning newspapers such as the *Guardian* because it's impossible to specify a fan 'type'. These fans are not just the angry teens we might imagine, many are adults who will head back to their jobs when the festival is over and some of the excesses, such as the horror memorabilia T-shirt, go straight into the back of the wardrobe.

Furthermore, FrightFesters, according to Volkswagen's research, are a discerning and discriminating audience and FrightFest is a business in an increasingly crowded market. The festival must therefore maintain its relevance and this requires inspiring projects rather than pure promotion. Day states that it has been a conscious choice to form an exclusive partnership with magazine *Total Film* for specific packages only, as to do otherwise would alienate alternative media outlets. As a result, the key is finding suitable new enterprises. This is reflected by the events the festival stages. Indeed, the other directors, Ian Rattray, Alan Jones and Paul McEvoy travel the globe finding new films and ideas for events that they feel will cater to this home market. These finds have included the Hebrew Horror film that appeals, according to Day, because of its use of allegory, through to the quizzes and 'In Conversation With' interview series (some of which were inspired by a visit to Fantastic Fest). The key, according to Day, is to offer the audiences mental stimulation as well as fun:

> 'We have the main screen and the Discovery screen [that shows retrospective and independent films] and we'll probably always stick to that. If anything, the growth will be in events rather than films – theatre events rather than having 100 films instead of 66 or whatever.'

Examples of this include the expansion into FrightFest's now annual satellite event in Glasgow in February and other excursions to cities such as Bournemouth and Leeds with events ranging from all-night programmes through to one-offs, such as the tours promoting key releases such as *American Mary* (2012).

By mounting such one-off events, the festival and its organisers are able to re-establish the connection with fans in other major urban centres and develop business links across the country. This adds to the notion of the event as a community, which now of course comes complete with souvenir material for sale online such as the FrightFest Originals wall hangings and other memorabilia.

Rather than simply providing entertainment, Day suggests that the expansion of the enterprise also offers an important psychological safety valve. He states, 'Horror fans tend to be ritualistic and there are correlations between compulsion to lose

control in their lives and an event that balances the OCD through the format they know', with the people they feel comfortable with. Just as the monsters the films celebrate are in turn celebrated by the fans and become key parts of their cultural identity, so too are the festival directors – immortalised in cartoon form every year on posters and the annual booklet as the monsters who offer threat, but one salved by the knowing hand of a friend.

Specialist Cinemas

Of course, the notion of a community is historically most rooted to geography. An entirely different style of fandom is offered by the legendary Prince Charles Cinema in London, tucked away behind the red-carpet cinemas of Leicester Square. This venue offers screenings with question and answer sessions with the filmmakers themselves, and also fan experiences more akin to those of US cinema cultures, such as sing-along screenings, movie marathons and events where fans come dressed in homage to the characters. It is not the only venue to mount such events, but these activities form a specific part of their remit, or rather their service to the fan community.

Wayne's World poster, 1992

The programme is run by Paul Vickery, a man who swears he is older than he looks and it is likely his mindset contributes to both his appearance and the cinema's profile. After beginning work with the organisation as a weekend assistant, he describes the programme's genesis as follows:

'My role grew when I watched *Wayne's World*. I was watching the first one and I noticed how people were quoting along to their friends. I'd had a couple of beers with my friend and I said, "this needs to be my generation's singalonga". *The Sound of Music*, *Grease* and *Dirty Dancing* – they're fun nights out but I don't want

to go to those. I want to go to watch *Wayne's World* on a Saturday night. I want to go and watch *The Big Lebowski* on a Saturday night. That must have been like five years ago that I did the first *Wayne's World* event. It sold out and I did it a couple more times. And they asked me what else I was going to do so we did *The Big Lebowski* and we did *The Princess Bride* and just all of those really obvious cult movies... It was effectively taking what we'd done on a Monday without any bells and whistles and putting it on a Friday and making it fun for people. And just from being a cinema that had the odd singalonga to a cinema that was like an event cinema. While Secret Cinema was around at that time we were the only place in the UK playing with that idea of cinema and this was before a lot of the pop up venues were around.'[22]

His development beyond the quote-along format came courtesy of his sister, whose teenage, girly sleepovers were sadly beyond his reach:

'I was like, I've got a sister and I want to recreate what you had with your friends with 300 people in a cinema. I couldn't be part of that growing up so I now have somewhere where I can put that on and I can be part of the fun and I can instigate that, [so] we had all-night movie marathons and I think the first one we did was about 10 teen movies. It was insanely long – it was far too many films. It was all teen movies and everyone wore pyjamas and everyone got free sweets and it was like a sleepover.'

Suffice to say, Vickery's enthusiasm is entirely infectious, with the notion of the cult seeming subversive precisely because it offers adults (particularly the reserved English) the chance to interact with each other in a public space in a manner that is comparatively unrestrained and childlike, a direct defiance of the notional authority normally connoted by cultural and arts spaces. Yet in a delightful twist, this behavioural subversion also becomes key to the challenges of maintaining the development of film and recalls the notion of the cult film fan not simply as the curator of the unusual, but instead as the exemplar of the completist

cinephile. This is directly related to the Prince Charles Cinema's business plan, as Vickery states:

'As a cinema we have a responsibility to the form itself and everything it covers. Film is our medium and to just show cult movies would be to do a disservice to the medium. As a film fan, I'd be bored of repeating the same thing but the fact we put *The Big Lebowski* on and sell it out means we can put a couple of things on that won't sell out… Every month we have strands, from female directors to sections where a percentage of films shown must be in their original foreign language and must have subtitles. I try and strike a balance that I think is representative of people who like film.'

Vickery's statement here is indicative. In collapsing the notional boundaries between cult film and the mainstream by reframing the texts and behaviour processes of their audiences within the context of this very central cinema space, the entire definition of cult and indeed the avant garde becomes blurred. The stability of the experience comes from the permission the audience is given to become cinephiles and enjoy the cinematic experience, particularly when they become part of the film's very intertextuality as a result of their participation.

Fan Identification via Clothing and Culture

Of course, being a film fan isn't just about watching the films anymore. Any parent who has ever seen a group of small children let rip with 'Let It Go' during a screening of *Frozen* (Chris Buck and Jennifer Lee, 2013) will know that films are increasingly acknowledged to offer audiences a sense of identification with their characters and situations (King: 1991). This is particularly prevalent among the horror community owing to the content of the films and the ideologies behind them.

Horror film culture strongly harks back to its punk-appreciation history and as a result cinema spaces embrace the visual representation of that counterculture through some of the enduring fashion trends, such as a persuasive penchant for black-backed memorabilia T-shirts. That said, more mainstream ideation such as sexuality and gender normativity also feeds into

the current horror scene. This is in part through the deference paid to the gendering of classic horror films, including those famously made by Hammer, which also have a key position at many festivals. In such representations (and though a generalisation), men are seen as assertive plot motivators while women are heavily sexualised and often submissive. It is a trend that values an ideology of rough capitalism and normativity.

More recent films have attempted to update this representation, though aspects of historical normativity remain. There is still often the focus on the monstrous male characters (having moved from classics such as Frankenstein's Creature to the downtrodden Martin from Tom Six's *The Human Centipede* franchise). Female characters can increasingly be seen as embodying Carol Clover's famous 'final girl' trope (1992), wherein they emerge from the horrific plotline as the victor or at least in control of their own destiny, as has been seen in films from *Alien* (Ridley Scott, 1979) through to *American Mary* (Jen and Sylvia Soska, 2012), though they will often retain aesthetically pleasing qualities. Female filmmakers and indeed fans are thus increasingly likely to take on similar personas (Oughton: 2014). As a result of this gender critique, as well as the film scenes' association with independent endeavour and its fights against legislative censorship, horror is often seen as having somewhat of an overarching leftist politic.

Of course, this notional 'leftism' requires qualification. Punk is a movement which is often associated with anti-capitalism – evinced by the Sex Pistols' refrain of having 'No future' and the notion that no one outside of the middle classes could have a stable socio-economic background to build on. However, a number of key players within the horror scene (and punk, too) have had both the education and background to be able to develop a successful future. Furthermore, as the gender biases here demonstrate, it is not simply a case of libertarianism, but instead something far more akin to a notional and generalised anti-establishment ethos that is best expressed by questioning the mechanisms of power rather than their outputs.

This is, however, a dramatic over-simplification as I have discussed previously (Oughton: 2014). There is still a heavy

reliance on traditional norms within the horror scene, evident from the capitalist business models of some distributors and outlets through to modes of personal presentation. That said, there is also a movement promoting acceptance of different body types within the horror community, with particular figures such as the *Axwound* fanzine's founder, Hannah Gorman and the Soska Sisters actively calling for body positivity whether in terms of weight, gender identity and disability. As a result, there is a marked emphasis within the community on the importance of personal authenticity as part of a celebration of imperfection. Indeed, when author, journalist, actress and presenter Lianne MacDougall was found to have plagiarised a number of her works, several influential publications ran articles focusing as much on MacDougall's brand as a horror-loving beauty as on her actual misdemeanour (see Oughton: 2014). She was castigated for performing the tropes the community expected and indeed arguably demanded from her.

The (Fan)tastic Emily Booth

The problem of achieving a balance between authenticity and the need to comply with stereotypes has been discussed by actress, glamour model, presenter, producer and all-around scream queen, Emily Booth (left). Booth categorises her career as owing to the smallness and interpersonal nature of the scene in which 'nearly everyone's connected', stating that, 'after [I did] *Pervirella* I met Eileen Daly and I met Jake West and did lots of weird horror films and a lot of presenting.' There is a very strong notion of a scene frameworked by authentic friendship groups as much as by talent. However, Booth's perspectives on the thorny issue of women in horror are illuminating. She states:

> 'Women have been the driving force in the stories themselves. They've been chased, chopped up, screamed; they've really been punished… I think they've really gone through the mill in terms of how we've been depicted in horror… Now I think women are the driving force

behind horror themselves in directing and producing.'[23]

This obviously indicates the key assumption that placing a woman within the centre of a narrative in terms of how the characters relate to her – a reversal of the Bechdel test – is seen in some ways as a progressive viewpoint. Yet as Booth also comments, this very fetishisation can be problematic, literally seeing women and men being boiled down to body parts. Indeed, she goes on to state:

> 'There have been films that I've turned down. I mean, I'm not dead against nudity but it would have to be the right project. Recently I've had like, "Oh, you're the victim and you're in the film for about five minutes and you have sex and someone comes and gets you". I don't want to just do a cameo – I don't want to just be tits again. When I do do a film, I do want it to be quite a good role for a director that I respect.'

Indeed, while her career was something of an accident, based on a successful, one-off audition while still at university, Booth has long held an academic interest in horror. She states: 'My dissertation was on women in horror and so I'd read up on Carol Clover and Barbara Creed, *Men Women and Chainsaws*, *The Monstrous Feminine* and I did read up about castration theory, vagina dentata and the Male Gaze.' This notion of the woman as victorious monster led to the production of her first self-produced short, *Selkie* (2014), the story of a captured mermaid-like creature. She states:

> 'One of my favourite things is Medusa. I love the whole storyline of Medusa. It's kind of what got me wanting to do *Selkie* because I wanted to do a female creature from ancient mythology but within reality – to recreate and realise it.'

The short itself moves between being an incredibly sombre piece focusing on the selkie, played by Booth, enslaved physically and sexually by a fisherman, to being the selkie's own celebration of her sexuality. It incorporates narratives on actual slavery and entitlement owing in no small part to a camera that focuses in mid-shot on the actress' eyes as she goes about her chores. However,

towards the film's end there is a segment in which the understated realism of the period piece moves towards an expression of the creature's very physical joy when it is able to rediscover its own body. While not strictly speaking 'sexy', the piece reaffirms not only the notion of enjoyment of the sexualised female body (particularly as the audience knows it is Emily Booth), but also the fantasised dialogues of overthrowing dictatorial expectation – the key aspects of the horror scene at large. The text as a whole is therefore something of a direct reflection of Booth's career and the horror set at large – something that simultaneously challenges and confirms convention.

Horror's Increasing Circles

There is a notable, new wave of people within the horror community who also increasingly reiterate models of traditional horror's continual and evolving cycles. These people, such as Dani Thompson, often participate as models, presenters and journalists as part of their appreciation of the genre. In this context the notion of authenticity becomes difficult. Some players' fan-indentities are very important to them; they may seek to replicate the representations they admire on screen, not just to demonstrate their devotion to particular films or characters, but also as a part of their personal identity and to earn attention from other fans. This veneration has several reasons, among them validation of their acceptance among the community on a personal basis as people who properly appreciate horror, acceptance on a fan-productive basis that sees them as appropriate trustees and indeed ambassadors of horror's traditions. It finally also equates on a professional basis as their acknowledgement of horror's traditions are used to generate backing from the fan community to enable their own endeavours. This may be in the form of basic appreciation such as Facebook 'likes' through to financial support such as contribution to crowd-funding campaigns for their own projects. These can range from gaining personnel and finance for short and feature film productions such as *The Tour* by Alex Mathieson and Damon Rickard (2014) and indeed the Soska Sisters' new graphic novel project, *Kill-Crazy Nymphos Attack*, through to reinterpretation art. This latter

can be seen through the increase in the practice of 'cosplay', particularly as exemplified by film fan Markosi Gonzarelli, who attends film and memorabilia conventions in full character dress and characterisation in the guise of the likes of the Joker character from Batman lore. While the main focus of such players is undoubtedly to attract personal attention (Gonzarelli has appeared in several mass-distribution newspapers), it is also very much about sharing and exploring the character both as a performer and with other fans, essentially bringing the text to life. As a consequence, this complex notion of personal authenticity becomes linked to social validation of what has passed, and can also become an incitement to the unending circle of consumption.

Rorschach cosplay (from *The Watchmen*) by Markosi Gonzarelli

Indeed, there is often an overlap between the types of art and culture that horror fans produce and which leads directly to the development of the horror celebration market which is now an industry in itself. This from free-to-view online news, reviews and gossip publications such as *Haunted After Dark* to blogs too numerous to mention. In addition to these there are a number of fan-run, specialist home entertainment distributors who provide packaging for cinema and non-cinema releases often incorporating filmmaker commentaries and production notes, such as Arrow Distributing and Network Distributing. The market has also diversified further in recent years, from Mondo Tees' Death Waltz Recording Co.'s collectors' packaging of horror film soundtracks through to the lifestyle products, such as David Flint and Daz Lawrence's development of the Gods and Monsters line of collectors' items, which included 'Top Trumps'-style cards with information about the horror films caught up in the video nasties scandal. The purpose of all this is to sell products, but to

do so by increasing awareness and appreciation of the artistry of the films themselves as a result of the vendors being genre fans themselves. Indeed, it is a credit to the sometimes deranged beauty that is the films that so many of the people who enjoyed them initially as viewers have since devoted their working lives to their appreciation. As a result of this, and undoubtedly owing to the communication with industry insiders now offered by social media as well as meet-and-greet sessions at film festivals and memorabilia fairs such as The London Film Convention, these people can now easily facilitate interaction between the stars and their fans.

Counterculture?

Aspects of counterculture are now becoming mainstream texts. In the past, so-called cult items such as some horror films and even comic books could be difficult to discover and consume, particularly if you did not live in an urban centre that catered for diverse tastes. Now the advent of the internet has made much media widely available (legally or illegally) while social media has spread knowledge of its existence. What's more, the ability to hold a product digitally requires no physical storage space and avoids the packing and postage costs associated with physical products. Users can consume a far wider range of material without having to dedicate the same time and diligence to securing each specific package. Furthermore, cyber transactions allow anonymity for the newbie who may just be delving into new interest areas, thus encouraging further exploration without pressure to prove the knowledge required to be admitted to particular fan peer communities. As a result of this, counterculture is now encroaching on mainstream culture, with independent horror films such as *American Mary* (2012) being championed by leading mainstream magazine *Total Film* (although its primary support remained within the genre community).

Moreover, the changes are also reflected in subtle shifts within the texts. Superhero films, based as they are on the height of geekery that is comic books, have moved from the overarching, wholesome Americana of focusing on Superman through to productions such as the far less politically correct stories of

original side characters such as *The Suicide Squad* (2016). The Joker, described in *The Dark Knight* (2008) as a man who 'want[ed] to watch the world burn' and as played with Oscar-winning menace by Heath Ledger, adorns a million mass-produced T-shirts. It is now cool to have and investigate a notional dark side, even if such indicators actually evince cultural awareness rather than being a reflection of identification with a particular social group. We shape our identities through icons that we may hope will become symbolic enough to guarantee instant interpretation but on the most generalised level. At the same time, as Will Brooker (2009) has pointed out, even limited understanding of those texts become intertextual as a result of what he terms 'overflow', wherein the viewer's experience of the film is affected by other information and media they may be accessing via personal information technology. Even though the notion of being a 'true fan' may now be open to interpretation, it is at least far easier for us to become part of a fan culture.

This naturally contributes to some of the challenges and opportunities faced by today's English subversive cultures. On the positive side, this diversification of audience base ensures there is increasing demand for more product and more diversity within that product. At the same time, however, it would be wrong to assume that all audiences would carry the same respect for either the medium or the message of the products, leading to problems of increases in piracy. However, as independent London-based film producer Jennifer Handorf has stated, the key concern for the subversive arts community may actually be within the diversification that new technology has offered. In an era when a movie such as Gareth Edwards' *Monsters* (2014) can be created by little more than one man with a laptop, practically anyone can make a product and find distribution for it either through external means or self-distribution. As a result, as Handorf has stated, not only is there no formal marker of quality, there is also a flooding effect as more and more product is released. Simply put, the market may become flooded with sub-standard films which could hide the truly creative pieces.

Indeed, as Farren Blackburn, British director of *Hammer of the*

Gods (2013) has acknowledged, there is increasing pressure simply to produce in the hope of being able to develop a stable career:

> 'When you've come from film school and you've got a short film or two to your name, it's really cutthroat and [there] are the shows where you show that you can work the actors, tell a story and, most importantly, prove to producers that you can deliver to a schedule and are not a risk. You have to fit into a house style. What I did was to continue making short films along the way. I maintained a voice in the way I go about things. You can prove you're not a risk and provide a body of work that's more personal.'[24]

Hammer of the Gods poster

This has a knock-on impact for the rest of the subversive cinema scene in that it creates a new standard of normativity. Indeed, Emily Booth, whose *Selkie* was one of two rare additions to cinematic mermaid lore, has stated her belief that 'It's going to be very hard to be completely, completely original' and that creating her short was a difficult process despite the wealth of personal and professional support at her disposal as an icon of the cinema scene. Funders will financially support concepts that they know will sell based on prior sales figures, which discourages them from taking financial risks and can in turn discourage filmmakers from experimenting with new concepts.

This also has ramifications in relation to the legislative standing of the industry. There have been recent concerns about a return to the censorship seen during the height of the aforementioned video nasties scandal, when the Thatcher government introduced additional censorship legislation. The criminalisation of certain sexual acts within adult cinema has been seen as evidence of this, as has the removal of sequences involving suicide from Axelle

Carolyn's *Soulmate* (2013) in order to receive the desired age-restriction rating. Of course, subversion is used as a marketing tool in and of itself. An exemplar of this is James Cullen Bressack's film *Hate Crime* (2013), which has been denied certification that could have led to distribution and profit owing to the BBFC's concerns regarding its prolonged depiction of violence.[25]

Courtesy of Clout Communications, the film gained publicity as a result of the BBFC's decision and has won a number of awards at film festivals. But it has been suggested that the entire escapade was a simple publicity stunt as the film was already freely and legally available on the director's website, suggesting that profit for that particular title was not the motive. In one respect, this episode may appear subversive for so ably demonstrating the weaknesses of English censorship law, but in doing so it also earned censure from genre journalists such as Anton Bitel for being a product that achieved its effect simply by baiting that law and lacking originality. Its perceived lack of subversive authenticity was enough to earn its censure. The challenge for the future will be how to continue to be genuinely subversive.

Conclusion

The alternative film scene has changed a lot since the early days of the Scala and VHS collecting. The punks are now the industry stalwarts and while self-delighting trash is still very much around, it is now celebrated alongside the classics that will be screened by the BFI. Secret Cinema screenings are the hipster's hot ticket (with prices to match) and the delights of The Duke Mitchell Film Club are run by film festival organisers. Rather than being something studied as part of sociologies of 'the other', subversive film in its own right is now part of university syllabi from Bournemouth to Brunel. Genre cinema now has respectability even though issues such as increasing censorship and piracy threaten its development. The challenge now is to see whether the films can evolve in any meaningful way.

GAMING AND THE INTERNET

Online Culture Leaking Offline

Simon Smith

Game graphics from *Snake* and *No Man's Sky*

Modern gaming is a multi-multi billion dollar industry. A single game for PC or console may have a larger budget than a Hollywood blockbuster. In addition, mobile phones outnumber people, and even old, basic phones usually have some simple games installed. So 10–20% of all living humans have probably played a computer or mobile game at some point. Despite this, the culture of gaming is still not taken particularly seriously compared to 'worthier' pursuits like art, music or sculpture.

While only the larger studios can produce a big-budget game, game development is a very flexible discipline, and it can scale right down to a lone programmer working in their spare time. With the world-wide reach of the internet it is possible, with luck, for a micro-budget indie title to catch on and become a global phenomenon. *Flappy Bird*, *Angry Birds* and *Minecraft* are three cases where this has happened. Pre-internet, the odds of any single product gaining sales of many tens of millions of units were negligible. This potential ability for anyone to reach

a global audience of tens of millions (and ultimately billions, if language is not a barrier) is new to the internet age, and it offers channels for the creation of entirely new subcultures. Given the extraordinary speed at which the internet can spread information, new countercultural material can be assimilated into the mainstream – or forgotten – extremely quickly, so discussions of gaming culture are likely to cross the boundaries between 'culture' and 'counterculture' repeatedly.

Gaming History and the Cultural Framework it Helped Create

One of the first notable computer games was the seminal *Colossal Cave Adventure*, written in FORTRAN in 1975/6 for the PDP-10 minicomputer. This was a 'text-based adventure game' (a genre whose established term is now 'Interactive Fiction'). In a text adventure, the computer starts by describing a scene in words, and accepts simple commands such as 'NORTH' or 'N' to go North, 'GET KEYS', 'LIGHT FIRE' and so on. As the player enters commands, the game describes the outcome, and new clues, locations, items and actions became available. The object of the game might be to collect treasure, perform a quest, escape a dangerous situation, or similar. As the output is text-only, game writers have similar freedoms to the writers of radio plays; if it can be portrayed well in words, it can probably be done in-game.

Affordable home computers started to appear in the 1980s, and each quickly gained its own collection of games. The text adventure became one game type among many. Gaming 'culture' at this stage was vestigial; those playing the same games could share tips, reviews and cheats directly with one another or via the same computer magazines. Game programmers played the same games as everyone else, and whenever a popular new game type arose on one computer, it would soon be widely reproduced on all the others. With time, new programming tricks and the availability of more powerful computers made entire new genres of games feasible. Where the same game tactics appeared, they would tend to have been discovered by many different players independently, and information flow between players was comparatively slow.

At the same time, Bulletin Board Services (BBSes) were

beginning to spread. A bulletin board requires a computer server running custom software that allows users to connect to it using a terminal program. Once logged in, users can upload and download software and data, read news and bulletins, and exchange messages with other users by various means. BBSes could also offer online games, allowing users to compete with one another, and BBSes with multiple phone lines could even provide chat rooms, allowing users to interact directly. In fact, many of the same features the World Wide Web offers today eventually became available. Bandwidth was limited, and so were the capabilities of the computers, and text-based material tended to dominate. Still, a BBS with online chat could be a useful place to get game hints and hacks, perhaps sooner than from a magazine. From a cultural perspective, because BBSes allowed multiple users to interact in a new way – electronically – and because bandwidth was limited, practical considerations began to induce new modes of behaviour in the users.

In 1980, Usenet appeared. Usenet has no central server nor dedicated administrator, and is inherently more scalable than any BBS. Usenet is also distributed, amongst a large and constantly changing global network of servers that store and forward messages to one another. It took some years for Usenet to grow to a significant size, but as it did it began to supplant some of the services offered by BBSes. Furthermore, Usenet could connect people on a far larger scale, so its users too gradually developed consistent patterns of online behaviour – culture, in other words. As Usenet became global, its specialised culture also became global, albeit amongst a widely-dispersed minority of technically-inclined users. Idiosyncratic jargon, if useful, could easily spread and become established terminology; fads and early memes could also propagate via the same channels. Before the internet, office humour, for example, used to spread via blurry tenth- and twelfth-generation photocopies which would be retyped once they got too degraded to read; now thanks to BBSes, email, Usenet and the early World Wide Web, the same jokes could spread far farther far more quickly. So too could health scares, hoaxes, rumours and gossip of all kinds; the internet was beginning to accelerate the

dissemination of all aspects of culture.

By the early 90s, home computers were more powerful still, and had started to gain basic networking capabilities. And as soon as networking became feasible, networked games appeared. Thus the same people who as children might have carried their non-networked 80s computer to a neighbour's house to play games together, now as teens or young adults might load their (much heavier!) PC into a car and take it to a 'LAN party', where several computers would be set up as an ad-hoc network in order to play a particular game. With several players playing the same game, but perhaps spread across different rooms in a house, practical concerns would cause simple gameplay conventions to arise, and the more useful conventions would tend to be re-invented repeatedly among different groups of players.

Universities of this time also had more powerful computers, often networked, and were largely populated by the same students who had played their first games on 80s home computers. Games like *Colossal Cave* had spawned many descendants, of which one class was the Multi-User Dungeon, or 'MUD'. These were text-based, as *Colossal Cave* had been, but could now handle many players at once. MUD players often developed their own specialised behaviours, jargon and in-jokes, any of which could spread to other games. For example, many games had a 'whisper' command of some kind, allowing a player to send a private message to another player. There might also be a 'shout' command, where a message would be seen by all players in a given area, and perhaps a 'farshout' command, seen by everyone playing at the same time. But as soon as a command like 'shout' or 'farshout' becomes available, players could abuse it, whether through malice or ignorance, so cultural rules for its use would arise.

A typical MMORPG character (during character creation)

MUDs continued to evolve throughout the 90s. As computer graphics improved, 'graphical MUDs' started to appear. Better techniques for clustering servers allowed large number of players to play in one shared environment,

and in the late 1990s the term MMORPG (Massively Multiplayer Online Role-Playing Game) appeared. Early MMORPGs included *Ultima Online*, *EverQuest*, *Dark Age of Camelot*, then later *World of Warcraft*, *Second Life*, *Eve Online* and more. Each game brought its own specialised jargon, more ways to interact, and ever richer online behaviour. For example, over time, MMORPG characters gained animations, called *emotes*, allowing them to dance, taunt, bow, wave, laugh, shrug and so forth. Each requires programming and artistic effort and yet none, taken individually, is particularly important to gameplay. But emotes have a social and cultural use and games with fewer emotes feel 'poorer' than those more.

So here we have an extremely truncated history of forty years of networked computing and gaming. It has been covered because the cultural behaviour of modern gamers (and particularly game programmers, whose shared background influences are often apparent in the new games they make), is affected on many levels by what has gone before. Whenever gaming moved online, players could import tactics, jargon or behaviours from their 80s games or their 90s LAN parties, and as new players came online they would adopt whatever customs they encountered.

On top of this, the internet continues to develop, sometimes in unsavory ways. *Darknets* and the '*deep web*' are related terms for those parts of the internet and web that are invisible to search engines and casual browsing. They do have legitimate uses, for security, for privacy, to restrict access to a particular audience, or simply because the content stored has no value outside its highly specialised arena. Darknets include corporate intranets, friend-to-friend networks, Tor, raw data dumps and feeds from internet-connected devices, but the term also covers illegal peer to peer file sharing services and online markets for software exploits, weapons, drugs and other illegal services.

Abbreviations like IIRC, LOL, ROTFL, TTBOMK, BBL, AFK and so forth have been useful shortcuts for people interacting online for many years, and game-specific jargon like 'kiting', 'tanking', 'camping', 'farming', 'spamming', 'turtling', 'levelling', 'DPS', 'aggro' and more describes tactics or behaviours which are nearly as old. Acceptable behaviour in chat, how to interact

in-game with other players, dealing with 'newbies', effective team play, in-jokes, game-related memes and more are all informed by what has worked in the past, in previous games written by that programmer or played by that player. And those old games were influenced by their progenitors; echoes and shout-outs all the way back to *Colossal Cave Adventure* persist to this day.

For example, many influential MMORPG designers were involved with early MUDs, as developers and/or players. Programmers whose early gaming experiences were with *Wolfenstein 3D* or *Doom* may well now be working on any of a plethora of 3D first-person shooters. Others were doubtless inspired by *Elite*, *Sim City*, *Tomb Raider* or any of a thousand other possibilities, and there can be few game developers who would not cite some 'great game' they played in their childhood that helped influence them to choose their current career. All of gaming culture is pervaded by behaviours that can be traced back to the first MUDs, Usenet, and even the BBSes and the sometimes surprisingly addictive 8-bit games of the 80s. The roots of computer gaming are growing deep. In another 20 years, programmers and gamers whose formative computing experiences have been shaped by the *Minecraft* game will be widespread.

Text-speak, Geek-speak and Lolcats, Oh My!

As already mentioned, abbreviations like IIRC, LOL and more have existed online for many years. Some even pre-date the internet; the first known use of 'OMG' (Oh My God) was in 1917, in a letter to Winston Churchill. Online culture initially tended to be computer-geek culture, and 'geeks' and 'nerds' have varied and obscure interests, with many overlaps. To operate online at all required a reasonable level of technical skill, including problem-solving abilities, and the same creativity that was applied to programming problems was also applied to language. New abbreviations and re-purposing of technical terms was just the start; even typographical mistakes were fair game for subversion.

As a later example, the term 'pwn' was first seen around the mid-2000s. If a person was guilty of poor computer security, their computer could be compromised by another. One term for this was 'being owned.' But from there the term's meaning rapidly

expanded to include situations like being completely outmatched by an opponent in a computer game. However, when typing at an opponent during a game, speed is of the essence and errors become more common. Thus a taunt intended to be 'Ha, I owned you!' would tend to be shortened, perhaps to 'HA, OWNED' or similar, and mistyping 'own' as 'pwn' or 'owned' as 'pwned' was a mistake made frequently enough to be distinguishable and become a notable term in its own right. Then at some point soon after people began to use the mistyped form intentionally.

Similarly, one may encounter exclamations such as 'ROTFL!11!ONE1'. (ROTFL – 'Rolling on the Floor Laughing' – a phrase that's already an exaggeration; how often is something really that funny?) The digits and exclamation marks are interchangeable, as this represents a person fumbling the shift key and inadvertently typing some exclamation marks as the number 1. But the 'ONE' – typing the number one as a word – is something even the most exuberant typist would not do by accident, and the result is an ironic mockery of this over-excitable behaviour.

With the rise of the mobile phone, especially for modern teens and young adults who have grown up in the internet era, these practices became accelerated; youngsters will bend the language to their needs just as readily as 'geeks' do (especially if primed to do so by geek parents) and they use text communications with their peers constantly, and largely unsupervised. This gives enormous scope both for invention and serendipitous coinages. Early mobiles did not have predictive text capabilities, and text messages were limited to a few dozen characters (besides, only 30–50 characters might be visible on-screen at once anyway), so there was a strong incentive to abbreviate, and yet another new communications medium arose with, initially, few cultural rules for how it might be used. The result has been another explosion in linguistic creativity, still ongoing: just take the same habits of language subversion exhibited by older geeks, combine that with the modern availability of smileys, emojis, abbreviations, unicode text (which gives a vastly expanded range of available characters compared to the A–Z, a–z, 0–9 and basic punctuation and currency symbols that older phones had), 'leet speak' (which

substitutes numbers and sometimes other symbols for similarly-shaped letters), modern slang, words or phrases from internet memes or even other languages, and then add predictive text and auto-correct facilities that don't always get things right, and apply just some of those to the text of a single message. The result may be barely comprehensible unless one is familiar with the cultural elements that have been combined. Consequently modern youths have a cryptic shorthand at their disposal that changes so rapidly even internet- and meme-savvy parents struggle to understand it.

The 'lolcat' meme was another craze which has now slowed down, but which made its own contribution to popular culture. The core idea is just a cat picture with a humorous caption, but the lolcat conceit was to write the caption from the cat's point of view in creatively bad English, because cats – obviously – are less literate than humans. In very short time, a lolcat 'language' became established and suddenly pictures of cats with funny captions in mangled English were everywhere. Furthermore, popular internet culture thrives on reinventing old material with a new twist, and while lolcats are no longer quite so ubiquitous, they have spawned successors such as the 'doge' dog, which has its own distinct style of broken language. No doubt there are endless new variants yet to come. Internet memes represent a tangled network of jokes, animations, catchphrases and other forms of media which spread and mutate extremely quickly. The successful ones can become very widespread before vanishing into obscurity in just a few years; in hindsight it can be hard to understand how some of them became so popular, but sometimes they leave behind a more permanent trace in the form of some new phrase or idiom.

Machinima, Let's Play! Videos, and Gaming As a Spectator Sport

Eventually, games began to offer 'record' and 'replay' facilities. Football and racing games were obvious places for such a feature; a slow-motion replay of a goal – or a crash – would be quite

in keeping with what might be shown for the same sport on TV. But as soon as a multiplayer game has a 'record gameplay' tool (which doesn't necessarily even need to be built in to the game), a new broadcast platform becomes available: instead of playing the game, players can be given a script to follow, and the record tool can capture what happens. The computer game has become a virtual studio. The recording can use cheat modes, in-game pyrotechnics, character emotes and so on, and the resultant digital video file can easily be manipulated further. Voice-overs and sound effects can be added, and then, thanks to YouTube, the results can be uploaded and shared.

YouTube still of Jonathan Coulton's 'Code Monkey'; machinima by Spiffworld

This new genre was called *machinima*. It covers a wide range of subjects; *Red vs Blue*,[1] which first appeared in April 2003, used the *Halo* game to parody first-person shooter (FPS) games, military life, and science fiction films. *World of Warcraft* has been used by fans to re-enact and even create music videos, from Queen's We Will Rock You to Jonathan Coulton's Re: Your Brains.[2] *Alice and Kev* is the touching story of a homeless family modelled using *The Sims 3*,[3] although that is a photo-story (or perhaps a 'screen-grab story') rather than a machinima animation.

'Let's play' videos seem to have become popular with the recent crop of sandbox games such as *Minecraft* and *Kerbal Space Program*. Possibly this is because in a sandbox game players can do whatever they please, but that means some players will seek inspiration for what *to* do. Meanwhile other players may be curious as to what their peers get up to in the same environment. There are recordings of older single-player games, before the current crop of sandbox releases, where players showcase bugs, demonstrate perfect playthroughs and so on, but their viewer numbers are tiny compared to the viewerships for YouTube's many 'let's play' series. Advertising revenues for the more popular of these are sufficient for the channel owners to play professionally.

In parallel with the many 'let's play' series, multiplayer video games are becoming a very lucrative spectator sport. Ace players at *Call of Duty*, *League of Legends*, *Defense of the Ancients (DotA)*, *Starcraft* and many more can command large audiences, and the best video games players also earn enough to play professionally; top prizes are often $25,000–$50,000 per tournament, with hundreds of tournaments per year worldwide.

Cosplay and Steampunk, Makers and Conventions

Cosplay was also briefly mentioned in the Film chapter, and films are an obvious source of inspiration for cosplayers. But they may not even be the main source, because there is a lot of reference material in TV series, comic strips, computer games, anime (both film and print) and subcultures such as steampunk.

Approaches to cosplay vary. For many, the object is to recreate a given character concept as faithfully as possible, and any deviation from that is a departure from the ideal. But for many others, adding their own creative twist is part of the appeal. One may find opposite-gender versions of favorite characters (a male version of Disney's Ariel, the Little Mermaid, for example), or mashups of several different characters, which can be most unexpected: 'Master Chef', for example, combined the *Muppet Show*'s Swedish Chef with Master Chief from the enormously popular *Halo* sci-fi game franchise. Conversely, a 'steampunk gender-bent Joker in a Willy Wonka hat' turned out to be a strikingly accurate cosplay of a lesser-known character that even many comic geeks had not heard of.

'*Steampunk*' is related to the cyberpunk genre, although the latter tends to have a grimmer and more dystopian feel.

Steampunk cosplay by 'Qasiel'

Steampunk uses anachronistic technologies and retro-futuristic inventions as people in the 19th century might have envisioned them. It is pervaded by a 19th century perspective on art, culture, fashion and architectural style. It is a larger and more popular genre than cyberpunk, perhaps because of its optimistic tone and greater creative flexibility, and it has grown to encompass a very wide variety of material. It seems almost anything can be given a steampunk twist, and unlike with 'accurate' cosplay, where the ideal is to recreate the subject perfectly, every steampunk 'take' on a character is distinct.

All of these subcultural threads feed in to one another. There are steampunk conventions, comic conventions, game conventions such as Gencon, and there are many overlaps between them.[4] Many notable computer RPGs and wargames were inspired by – or even developed from – older pencil-and-paper role-playing games and wargames, so there has long been two-way cultural traffic between gaming online and off. The greater size of the US makes it the centre of the convention scene, but the UK has its proportional share. And even if one doesn't attend a con in person, the internet ensures images and videos of the best material are disseminated worldwide, to be seen by comic-book writers, game designers, amateur and professional artists, other cosplayers, authors and so on. This forms a cultural feedback loop whose boundaries are impossible to identify. Some of this material will surely influence our future computer games, comics, films, science fiction stories and so on, perhaps even mainstream fashions, but there's no way to predict what.

Another source of countercultural material is the 'maker community'.[5] Thanks to the invention of – and rapid improvements in – 3D printers, it is possible for people to create

Lego robot with a camera
smartphone for a face
www.droidscript.org

prototypes with an ease not possible even five years ago. Makers may be interested in electronics, robotics, 3D printing, sculpture or many other related areas ranging from the practical to the artistic. People with the maker mindset have always existed, but in the past they tended to need considerable space for a workshop, and what they could make was limited by their tools and their own skills with them. The idea of 'maker communities' arose with 3D printing, but as maker workshops began to appear they would also have had space for older wood- or metal-working tools such as lathes and table saws as well as the new 3D printers. Such communities have helped connect people with a very wide range of practical and creative skills, from wood-turning and sewing to 3D computer modelling and electronics, and the combined possibilities are endless. Lego bricks (including Lego Technics and the Lego Mindstorm controllers) have also become a very useful maker tool, especially when combined with cheap, micro-sized but powerful computers such as the Raspberry Pi.

The extraordinary creative flexibility given by combining 3D printing, robotics, cheap computing, Lego and more is difficult to overstate. Makers immediately saw many 'obvious' things to try, starting with 3D printed artificial limbs, art and sculpture of immense variety, cosplayers using 3D printing to make props, 3D printing of working guns, teachers making 3D printed models for their students in subjects from maths and geography to chemistry and engineering, frustrated DIYers making replacements for broken parts and repairing gadgets that would have otherwise have been junk, and even 3D printing of 3D printers.

Makers take full advantage of the ability to custom-create just what they need. Prototyping and small production runs are cheap, and large-scale and distributed production are readily feasible for successful designs. These things appeal to many different people for many reasons, and hence 'makers' cover a very broad cultural

spectrum, from artists, designers, engineers and teachers wishing to create, to anti-consumerists who are dismayed by our modern culture of waste and can (finally!) make their own widgets which can be repaired or recreated when they break. Makers can even share their designs freely with others so inclined. It is regrettable that disliking needless waste and taking steps to do something about it labels one countercultural, but in our modern throw-away society that label does seem to fit.

What's to Come?

Is online culture merely beginning to 'leak' offline, or is it more true to say 'online culture' is no longer separate from offline culture, but intermixed with it? When going online required sitting at home in front of a PC, it was not unreasonable to consider those activities separate from one's offline behaviour. But when every smartphone can connect to the internet from almost anywhere in the country, people can transmit almost anything they see live, whether a party, an arrest, a UFO, a flash-mob, an animal behaving entertainingly, an image of a medical emergency or whatever else. At this point the distinction between being online and off no longer has much use, so it should be discarded. This modern ease of communication has many good and bad points; freedom of speech is enhanced, but privacy invasions become ever easier, and getting the best balance between good and bad is a major cultural challenge society still needs to address.

Online culture (of which gaming is just a large subset) can help people connect with one another, even when they are physically isolated, and the more like-minded people are able to connect and share, the more chances for collaboration and creativity will arise. All kinds of friendships, employment opportunities, chances for mutual profit, new contacts and more may arise from these connections. At some point, 'internet famous' should become as accepted a form of fame as any other.

We will know 'online culture' has become fully mainstream when the term disappears except when used as a technical description. By then 'online culture' should be accepted as just another facet of human cultural life, and the internet will probably be the dominant channel by which culture propagates.

LGBT CULTURE

What's So Wrong with Being a Freak Anyway?

Jack Bright

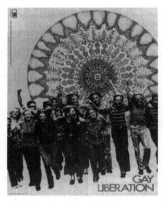

In post-war Britain homosexuality was seen as both immoral and socially unacceptable which led to tremendous suffering among those who were unable to openly express their feelings and others who were criminalised for same-sex relationships, such as code-breaking genius and father of the computer Alan Turing whose incredible life was recently filmed as *The Imitation Game* (2014). Screenwriter Glenn Moore, who picked up an Oscar for his adaptation of Andrew Hodges' book *Enigma*, said at the award ceremony:

> 'When I was sixteen years old, I tried to kill myself because I felt weird and I felt different and I felt I did not belong. And now I'm standing here I would like this moment to be for that kid out there who feels she's weird or she's different or she doesn't fit in anywhere – yes, you do. I promise you do.
> Stay weird, stay different and when it's your turn, and you are standing on this stage, please pass the message on to the next person who comes along.'[1]

Dirk Bogarde's brave film *Victim* in 1961 was the first British

film in which the word 'homosexual' was mentioned and during the sexual revolution of the 1960s the closeted gay scene created a market for gay art and photography, most apparent in the emergence of magazines displaying the male physique. Artists like David Hockney made sensual paintings of gay relationships and male nudes and writers such as Christopher Isherwood pushed the boundaries by writing about a day in the life of a gay professor in his novel *A Single Man* (1964), which was adapted for film in 2009 with Colin Firth in the title role. But for the moral majority, non-conformism to strict gender roles was still considered a threat to society.

The riots which broke out on June 27th 1969 at the Stonewall Inn in New York were the beginning of the gay community's fight back against the persecution of its members by the police in America, and it led to the founding of the Gay Liberation Front.

A year later Aubrey Walter and Bob Mellor founded the UK Gay Liberation Front at the LSE in London with around seventeen people who met in a basement. Later that year, they went on to organise the first public demonstration in the UK by lesbians and gays, protesting against the police practice of entrapping gay men into performing acts of gross indecency, usually in public toilets.

By 1971 there were hundreds of gay activists regularly attending meetings all over the country. In one well-planned protest, a group of GLF members staged a dramatic invasion of the opening of the Festival of Light, a Christian celebration organised by Mary Whitehouse at the Methodist Central Hall, where gays and lesbians kissed publicly and symbolically let mice go free from their cages, before turning out the lights.

Peter Tatchell was an early member of the group:

> 'GLF was a glorious, enthusiastic and often chaotic mix of anarchists, hippies, left-wingers, feminists, liberals and counterculturalists. Despite our differences, we shared a radical idealism – a dream of what the world could and should be – free from not just homophobia but the whole sex-shame culture, which oppressed straights as much as LGBTs. We were sexual liberationists and social revolutionaries, out to turn the world upside down.'[2]

Into the Age of Same-sex Marriage: The LGBT Community Is Divided

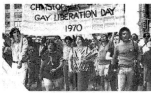

Gay Liberation Day protest,
Christopher Street, 1970

Despite the Marriage (Same-Sex Couples) Act having been elevated into law in early 2014,[3] and perhaps lulling some into a sense of security not achieved by civil partnerships, LGBT people are still disproportionately affected by a number of issues not affecting their straight or gender-confirming counterparts. Moreover, with a number of legal rights having been afforded to LGBT Britons in a relatively short space of time since the decriminalisation of homosexuality in 1967, there appears to be a tension between those who celebrate being able to fit into the 'norm' (whether achieving the archetypal traits of straight or gender-confirming people or carving out their own space within it) and those who still want to rebel against it and stand apart.

Brendan O'Neill writing in the *Telegraph* reminds us that the original members of the Gay Liberation Front were against marriage, which they thought was an oppressive institution. They were far more revolutionary in their aims than today's campaigners, wanting to transform society, not conform to it:

> 'The Stonewall radicals wanted liberation, not equality, and they wanted to destroy marriage, not buy into it. The Gay Liberation Front that emerged out of the Stonewall riot insisted that "sexual liberation for all people cannot come about unless existing social institutions are abolished."'[4]

There is no doubt that marriage, and the enshrining of legal protections for LGBT people into law, has irreversibly affected the way the LGBT community sees itself, and has started a dialogue concerning where we find ourselves in this new chapter. Having taken strides towards equality, and though coming far from where we began to achieve the recognition of our rights in 1967, there is still much room for progress.

One definition of counterculture that might apply to the LGBT sphere reads: 'a subculture whose values and norms of behaviour

differ substantially from those of mainstream society, often in opposition to mainstream cultural mores.'[5]

While some members of the LBGT community in the UK feel they are becoming more accepted by the mainstream, hate crime and homophobia are still commonly experienced by many.

London Life: LGBT Culture in the Capital

Having arrived in London from Newcastle almost ten years ago in 2006, and having stayed in the capital almost solidly since then (aside from a brief stint in Paris), it is possible that I have become sucked into the more LGBT-friendly bubble of our country's greatest city. Of course, I cannot speak for the entire LGBT community (if any of it), but I write this exploration of LGBT culture in a personal capacity. Further than that, I attempt to do so from a UK-centric, rather than London-centric standpoint.

There are often articles published in the gay media from those outside of the capital or other metropolitan areas, who don't relate to the portrayal of gay people on screen and in the mainstream media, and disagree with the widely accepted notion that gay rights have been more-or-less achieved.

While, aside from a couple of minor assaults over my sexuality, my first experience of the LGBT scene was in some ways reminiscent of the TV series *Sugar Rush* or *Queer as Folk* (albeit more confusing), it is still, in my late 20s, full of mystery and wonder, and also remains something of an enigma.

I have been lucky, but LGBT experiences are not always positive. Typical problems faced by LGBT people include having to deal with public attitudes out of metropolitan areas which may not be nearly as accepting as those in inner-cities, homophobic, biphobic and transphobic bullying, particularly in schools, anti-LGBT crimes and healthcare issues such as lack of training on trans issues, or the argument that gay men should receive bespoke health care compared to straight men, and the same for women, non-gendered, trans and intersex people, and so on.

Crossovers: Blurring the Lines between What Was Considered 'Counterculture' and the Norm?

In 2014, Sir Terry Wogan commented on the triumph of

Eurovision star Conchita Wurst. He said the bearded drag star had reduced the notoriously camp competition to a 'freak show'. I wrote an article for the *Independent* in defence of Wurst, and criticising Wogan for using language which appeared to marginalise the drag star. Having written more extensively on the topic, if I were confronting Wogan now I would pose the question – 'What is wrong with being a freak show?'

Conchita tore up the rule-book of what is acceptable and yet was propelled to fame, becoming an international symbol against bullying and marginalisation, performing at the UN headquarters in Vienna, releasing an album and being invited back to host a segment at the Eurovision Song Contest in Austria in May 2015.

Clubs and Bars: Continued Discrimination

When I grew up in Newcastle there was quite a large gay scene, considering the relatively small population. While there were the typical dance-music driven and 'alt' indie clubs and bars, the most interesting venues to me were those dubbed 'gay friendly'. One venue, now closed, contained a mixed crowd of gay, bisexual and straight people, all happy to co-exist harmoniously without judgement. For a northern city in the early noughties, this was a godsend, as far as I was concerned. It allowed me to explore my sexuality in a safe setting, away from the often judgmental crowd.

Fast-forward over a decade, and the idea that a public venue should cater for anyone, regardless of their sexuality, and allow them to be themselves, still seems to me like a vision from the distant future. While 99% of clientele and staff in pubs and clubs up and down the country probably wouldn't bat an eyelid at a gay couple popping in for a quiet drink, the media often reports on people being thrown out of venues, cabs and the like, for simply sharing a kiss with their same-sex partner.

In fact, an alarming number of stories appear each week reflecting the fact that, no, LGBT people can't feel comfortable anywhere they choose, and don't yet have the freedom to be themselves in public without ridicule, rejection or worse.

Possibly the worst aspect of these news articles is the reaction from within the LGBT community. Following a story in the *Evening Standard*[6] about a gay couple who were kicked out of

one of London's Uber cabs for kissing, the reactions from some gay people were not of outrage at the way the couple had been treated, but agreement with the actions of the driver who had kicked them out. Many responded by saying that they probably were doing more than kissing, or saying that they disagree with any public displays of affection (PDAs). Even if everyone is entitled to their viewpoint, it still seems very odd that the gay community does not stand by its own, and will even see past an incident which is clearly motivated by a rejection of same-sex relationships, and comment on the fact that it's a PDA. I've personally never heard of a straight couple being kicked out of a cab for kissing.

Perhaps the negative aspects of memories fade with time, or perhaps I was just fortunate enough to have a fairly positive experience of the gay scene growing up, (aside from the 'standard' couple of gay-bashings – although the fact that being assaulted more than once is to be expected is probably worrying). In any case, when members of the LGBT community want to be recognised as equal, and want to be respected and accepted on these terms, but want all of that as well as the recognition that they are different – well, is that really too much to ask?

Ten years after leaving Newcastle the names and club nights of each venue on the northern city's 'pink triangle' have inevitably changed, and they appear to also have been diluted, ending up with less character, and less variety. In fact, this seems to have been occurring up and down the UK. One of the first club nights I ever went to in London, 'Popstarz', which started in 1995 and was intended as an alternative to the pop and house music-filled clubs already on the gay scene, closed its doors for the last time in November 2014. This was a haven for many friends and friends of friends who were in the process of coming-out or about to; a place where anyone, gay and straight, could feel comfortable. It will be sadly missed. To say the least, the number of club venues offering gay-friendly nights seems to be diminishing.

The Demise of Classic LGBT-friendly Spaces

It's not just particular clubs or bars that are under threat.

A campaign to 'Save Soho', the most notoriously gay-

friendly area of the capital, backed by the likes of Stephen Fry and Benedict Cumberbatch, aims to work with landlords and developers in the area in order to be included in the planning of its performing arts and entertainment venues. Going as far as meeting with Westminster Council, Fry battled against plans to redevelop a number of Soho venues into flats.

Speaking on Soho Radio, Fry said: 'Save Soho is not about shaming landowners, it is hoping to work with them and be given a small consultation role in their plans.'[7]

In the months leading up to January 2015, famous Soho venues such as the Yard (self-styled as 'Soho's most unique gay venue') faced proposed plans for redevelopment and the Green Carnation (calling itself 'a lavish place full of decadent pleasures' dedicated to Oscar Wilde) also closed its doors to make way for another venue. Manbar closed for the last time in late 2014, and looking further back, the news is littered with reports about further venue closures. Like it or loathe it, the iconic Astoria in Tottenham Court Road gave way in 2009 to Crossrail, and was torn down. While G-A-Y fled to Heaven, it was, in my opinion, never quite the same.

Speaking at the closure of Manbar, Chris Amos, the venue's owner, faced a legal battle in 2014 with Westminster Council which investigated noise complaints. Management said they feared the venue would have to close as it geared up for a legal challenge following a licensing review, after one resident living above the premises complained about noise.

He said:

> 'I am extremely saddened to have to announce Manbar has closed down. December and New Year's revenue was considerably less than we expected.
> We had been counting on good takings from the festive season to help... but it never eventuated.
> I sincerely believe had we not had to spend a considerable amount of time and money fighting Westminster City Council to keep our entertainment license, Manbar would still be open today.'[8]

Looking further afield, the Black Cap in Camden, which was

built in 1889, and is one of London's oldest LGBT venues, had faced similar proposals to The Yard to redevelop its upstairs rooms into accommodation, which would have drastically reduced its floor space. The Black Cap unexpectedly closed at Easter 2015 after its owners battled for planning permission to partially turn it into flats. The historic Royal Vauxhall Tavern is also in the midst of a battle to save it from a similar fate.

The Joiner's Arms in Shoreditch – one of London's 'most anarchic LGBT venues' according to *Vice* magazine – is yet another club which has recently faced closure as in January 2015 the management were told their lease would not be renewed. Again, this was to make way for a block of flats. The venue doors remain open at the time of writing, but for how long?

From holding charity fund-raisers to local artist exhibitions, and recently hosting a debate about LGBT sex and drugs, the Joiner's Arms battles political correctness at full throttle.

Undoubtedly there is a desperate need for affordable housing in London, given the rising cost of property. For most people living in the capital, the idea of buying a house is laughable, and I have certainly felt the sting of rising rents, and I have no doubt that other non-LGBT have too, but these venues are an essential part of London's colourful LGBT history. More importantly, venues like The Joiners give a visible presence and a loud voice to a section of the community that chooses to boldly defy the stereotypes that may be prescribed to them and chooses to remain actively different to the 'norm'. Reporting on its threatened closure in 2014, Vice magazine quotes writer Paul Flynn, a long-term local resident who 'captures its spirit perfectly':

> 'The Joiners' was a social space that symbolised a decade of gay counterculture which felt at joyful war with gay assimilation. It represented a little assault against Civil Partnerships, gaybies, It Gets Better, Lady Gaga and *Glee*. You need that tension when social and political change is moving at such a swift pace.'[9]

The Fight Against Demolition

Sweets Way Resists is a campaign led by residents of the Sweets Way Estate in Barnet and their supporters, to prevent the social

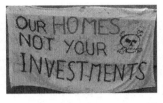

cleansing of the North London community there by developers who want to build more profitable executive flats. Russell Brand's support has helped the protest gain publicity and momentum. Campaigns and petitions like these are often organised by local people to prevent shiny new flats replacing some much-loved estate or venue, but the LGBT community often fails to stand up collectively to protect its cherished venues from developers.

I have heard among gay friends the argument that there is a need for redevelopment in areas such as Soho, and that planning permission should be granted to those seeking to alter or take over gay venues which are allegedly past their best. While areas like this, which have housed the LGBT community for generations may need a bit of TLC, it is an outrage that property developers, whose main motive is of course profit, should be allowed to decide how any 'area' like Soho should be remodelled. Once the LBGT community is driven out of the area by high rents and designer shops, where will it go?

TV and Film:
Representing LGBT Culture in the Media

In 2014 and 2015 there appeared to be a shift in the way directors and producers tackled gay issues on TV and in film. Examples of this included the critically-acclaimed film *Pride* (2014) which semi-historically told the tumultuous but heart-warming story of Lesbians and Gays Support the Miners (LGSM), who teamed up with a Welsh mining village during the famed strikes of the 1980s, and the mutual support they found in return.

The film had a fairly widespread release and I was surprised to hear from my mother (among others who I assumed would not watch a 'gay' film without recommendation) that she had gone to watch the film with my even less-likely stepfather. Another remarkably widely-received example of directors pushing LGBT issues into the mainstream is Amazon's TV series *Transparent* (first aired in 2014 and ongoing). Despite some criticism over the choice of cisgendered actor Jeffrey Tambor to play trans mother

Pride poster, 2014

Maura Pfefferman, the series was widely and warmly received.

ABC Family's *The Fosters* in March 2015 featured what was considered to be the youngest ever same-sex kiss to air on US TV. The kiss was shared between thirteen-year-olds Jude and Connor – but the moment drove anti-gay activists to complain about 'gay propaganda'. Classic UK examples of onscreen gay romance include actress Anna Friel's character sharing a kiss in the hit series *Brookside* (in 1994 this was radical for being the first lesbian kiss in a UK soap). *Queer as Folk* was a huge hit in 1999, portraying the lives of three young gay men in Manchester, and more recently, *Lipservice* (2013) was a BBC drama following the lives of lesbians in Glasgow. *Doctor Who* writer Russell T. Davies has also recently produced *Cucumber* for Channel 4, a series about middle-aged gay men in the Manchester gay scene; as well as *Banana*, an E4 series about young LGBT people in the *Cucumber* universe; and *Tofu*, an associated online documentary series available on 4oD discussing issues surrounding contemporary sex and sexuality.

There are, of course, more examples of how the media in the UK and USA is reflecting a more accepting society where sexuality and gender identity are irrelevant – but we aren't there yet – and opposition to such a world is still strong in traditional communities and even in developed countries such as Russia, where Putin has even reintroduced laws against homosexuality.[10]

Saunas, Sex Clubs and Dark Rooms

Saunas remain a big part of LGBT culture, even though there is a more widespread acceptance of same-sex relationships, non-

gender conforming people, gender reassignment etc.

Former soldier-turned-author James Wharton caused a PR nightmare in March 2014 when he declared that saunas are the 'thorns in our side that mark our community as different for the wrong reasons'. He subsequently spent a lot of time apologising, and has since retracted this statement. Without going into detail, Wharton said that after the breakdown of his civil partnership he visited Berlin and had an epiphany about casual sex.

But isn't the sexual liberation of the gay scene being taken up by straight people, as something to celebrate rather than something to be ashamed of? Many would argue so, and an increasingly vocal group of gays wants to highlight the fact that gay men are different, not the same as straight people. They want to draw attention to the differences, while pushing for acceptance, rather than becoming 'the same' as straight couples.

This minority raises a number of issues, healthcare to name one, noting that HIV continues to ravage the gay community, given the disproportionate number of new infections each year. A report published by Public Health England in November 2014 showed 6% of gay and bisexual men were living with HIV, rising to 13% in London.

It is difficult to object to the argument that because of HIV, among a number of other factors, the LGBT community shouldn't try to blend in, and instead should be recognised for its differences, and simply accepted. However, this runs contrary to the idea that we are all the same, in marriage and in society.

Grindr, Tinder, etc...

Apps such as Grindr were created mainly for gays, and were arguably borne out of the need to be able to meet discreetly from the age of 'gross indecency' (age fourteen – according to the 1960 UK act) and a lack of acceptance for gay men looking for sexual meet-ups. Nevertheless, these apps, including Tinder, were very quickly adopted by the straight community.

British pop and soul singer-songwriter Sam Smith, who speaks out on LGBT issues and sometimes puts his foot in his mouth, criticised hook-up apps Grindr and Tinder for 'ruining romance'.

'We're losing the art of conversation and being able to

go and speak to people and half the time we are just "swiping people" who we might get on really well with. From my experience the most beautiful people I've been on dates with are the dumbest, so why would I swipe people who are "unattractive" when I could potentially fall in love with them?'

Smith has since vowed to set up a LGBT charity.

To my joy, in recent years, a plethora of more niche apps catering to those with less mainstream tastes have popped up. These allow for those perhaps disheartened by the adonis-dominated world of Grindr and Tinder.

Are they borne out of the necessity of days gone by to meet discreetly with cruising partners? Perhaps, partly. But if non-LGBT adventurous types are using such apps then why shouldn't the LGBT scene enjoy them too?

'Straight Acting for Similar'

Out gay actor Russell Tovey (left) caused outrage recently when he told an interviewer for the *Observer* that he was 'glad' his father didn't send him to drama school where he could have become 'really effeminate'. He went on to say that his father suspected he would become a 'tap dancing freak', and that he was pleased he never went to Sylvia Young, because it gave him the 'unique quality' he is famed for.

This, however, appeared to many as the press interview equivalent of writing 'straight acting' on a Grindr profile, and Tovey later apologised for these comments.

From the interview came calls for the whole gay (and LGBT) community to be protected and celebrated, not just those who can pass for straight or cisgender or fit into such communities.

Whereas Tovey obviously meant no offence with his misplaced comments, many suggested it was a more in-depth way of saying 'straight acting' or 'masc4masc', as seen on gay dating apps all

over. A friend has a brilliant response to those asking if he is 'masc' on Grindr: he replies, 'No. I'm gay as fuck.'

Health: HIV, Suicide and Mental Health

Mental health issues are another area where the LGBT community loses out. In a world where the community is not yet sufficiently protected against discrimination, there aren't always adequate support systems in place to help victims of depression or bullying as a result of their sexuality.

One poignant and somewhat alarming issue is the fact that LGBT people are disproportionately affected by suicide. Earlier in 2015, trans girl Leelah Alcorn from the US state of Ohio scheduled a suicide note to publish on her Tumblr blogging page, before taking her own life.

She wrote: 'The life I would've lived isn't worth living in… because I'm transgender.' Going on, she said she had an idea that she was trans from age four, but that she 'cried with happiness' when she 'learned what transgender meant', but that her parents rejected her right to self-identify.

This right to self-identify is a key part of some major issues affecting the LGBT community. From my experience many otherwise liberal and accepting individuals still have a problem with assigning labels to do with gender, sexuality or otherwise, to people who may not have made up their minds.

Peter Tatchell considers that the battle has been partially won:

> 'Male and female roles are, today, less prescribed and inflexible than in 1970. There's greater fluidity and gender variance is more accepted. Butch women and fem men – whether homo or hetero – are still rarely social icons but they are also less likely to be demonised and outcast.'[11]

With legal equality, and the option of fitting into a more conventional stereotype becoming more viable, it is unsurprising that a portion of the LGBT community feel different, are different, and want it to be recognised they are different.

Conclusion

The LGBT community undoubtedly still faces acceptance issues, and despite great strides forward in terms of legislation, there is

still a way to go in terms of changing society's attitudes.

While dialogue and debate are certainly key components of a functioning and united LGBT community, and crucial in moving forward on issues, infighting and criticism could certainly be said to have had a damaging effect on the ability of the LBGT community to cohere sufficiently to achieve its goals.

Whether it should be called 'counterculture' or something else, I just wish the LGBT community could understand the need for solidarity around key issues and live by the idea that 'divided we fall'. Apathy is also hugely prevalent and probably more damaging than in-fighting between groups. Finally, while members of the LBGT community in other less liberal countries look on hopefully at what has been achieved in the UK, it's important to remember that civil liberties can be eroded and the clock turned back, whenever those in positions of power seek to win the popular vote through homophobia and attacks on 'otherness'.

LITERATURE

Blast and Bless:
A Selective History of Underground Publishing

Ben Graham

To attempt an authoritative history of DIY/underground publishing in the UK is impossible and self-defeating. Underground publishing, by its nature, resists such fixed histories; resists easy cataloguing, hierarchies and the idea that some voices and moments are more important than others. This galaxy of political broadsheets, little magazines, pamphlets, chapbooks, fanzines, alternative newspapers and small press books constitutes a multitude of voices, all raging (or quietly musing) from the margins, and all of equal importance. These voices may be contradictory, angry, self-indulgent, obscure, offensive, enthusiastic or just plain weird; they are also often experimental in the truest sense, where failure is just as valid as success.

History is written by the victors, but underground publishing, if it has any value, must provide a voice too for history's losers. This is where the disenfranchised and the dispossessed can also be heard; those oppressed, alienated or dissenting voices that are too often lost in the collective roar of mass opinion and historical certainty. As such, this overview is unapologetically subjective and idiosyncratic. I've written about many writers who did indeed go on to mainstream success, but I've passed over publications that have been well-documented elsewhere, and which are too often presented as the be-all and end-all of the underground publishing phenomenon. I've spoken to a small selection of people who've been involved in zines or self-publishing over the past twenty or

thirty years, with no pretence that these are the definitive voices on the subject; but they are voices, drawn from life, and their opinions and experiences are as relevant as anyone else's, and are hopefully to some degree representative. If you disagree, then perhaps this chapter will at least inspire you to crack open your laptop, your typewriter, pen and ink or somebody else's photocopier, and in the best underground publishing tradition: Do It Yourself.

A Song of Liberty: The English Dissenting Tradition

If it's impossible to catalogue the British publishing underground, then it's just as impossible to definitively pinpoint its beginnings. Before the European discovery of the printing press, religious and political dissidents would circulate their controversial ideas via handwritten tracts, and these only increased in number after William Caxton established the first British press in 1476. A century later, a clampdown on dissenters within the Church of England led to all of the country's printing equipment being placed under the strict control of the Archbishop of Canterbury, John Whitgift. Shortly afterwards, seven illegal tracts, credited to the pseudonymous Martin Marprelate, were secretly printed on a small press that was moved around the country to escape detection. These Puritan pamphlets were widely read and mixed virulent attacks on the establishment with savage satire and an ironclad self-righteousness: qualities (apart, maybe, from being widely read) that have remained characteristic of the underground press ever since. As their notoriety grew, the church hired literary stooges like Thomas Nashe to produce pamphlets that aped Marprelate's attention-grabbing, proto-punk style, but supported the establishment point of view. This tactic, of the mainstream quashing a radical underground by imitating its style, while distorting its content to maintain the status quo, also recurs throughout the UK's countercultural history.

Two hundred odd years later, Thomas Paine and William Blake were friends who also happened to be two of the most radical and influential visionaries of the late 18th and early 19th centuries. Though considered an obscure crank in his lifetime, Blake can now be seen as the towering archetype in British underground

publishing, an anti-establishment poet and artist who was fiercely independent in his views, practices and cosmology, printing his own work in beautiful, lovingly crafted editions where the media and the message were inextricably entwined. Paine on the other hand enjoyed widespread success and notoriety, inspiring the American Revolution and publishing *The Rights of Man* (1791) while remaining deeply controversial for his attacks on monarchy, religion and government.

By the 1890s, scandalously exquisite magazines like the *Yellow Book* and the *Savoy* represented the decadent aesthete movement in London and elsewhere. Though the *Yellow Book* is most notorious, the short-lived *Savoy* was more innovative and self-consciously decadent, and also more independent. It was published by the sensitive pornographer Leonard Smithers, in association with two renegades from the increasingly conformist *Yellow Book*: Aubrey Beardsley (who had just been sacked as art editor) and Arthur Symons. Contrary to popular belief, Oscar Wilde never wrote for either publication, though he was closely associated with those who did, including Max Beerbohm, W.B. Yeats and Ernest Dowson. It was Yeats who described the *Savoy*'s writers as 'outlaws... waging war on the British public when all were against us,'[1] and the *Savoy* was immediately banned from UK newsvendor WH Smith on publication for its assumed obscenity.

The turn of the century would see a brief but lively vogue for small magazines and proto-fanzines known as chapbooks or, quite charmingly, 'ephemeral bibelots'. This craze would be best documented in America, but Frederick Winthrop Faxon's *Bibliography of the Modern Chap-Books and their Imitators* (Boston Book Company, 1903) lists several London-based bibelots, including *The Anti-Philistine* ('a monthly magazine and review of Belles Lettres; also a periodical of protest'), the *Butterfly*,

the *Elf* and, coming perhaps full circle, the *Protest* ('a journal for philistines,' published out of Eden Bridge in Kent). These often whimsical small-run publications were soon joined by a swathe of more high-minded literary and artistic journals such as John Middleton Murry's *Rhythm* (1911–1913), a youthful and iconoclastic alternative to Ford Madox Ford's rather stuffy *English Review* (1908–1912) that saw itself as the *Yellow Book* of the modernist movement. Though it did indeed hark back somewhat to the decadent 1890s, *Rhythm* celebrated modern art in all its forms and ran for 14 issues, each with an average circulation of about 250 copies. Fauvist, and later Cubist (it was the first English magazine to publish Picasso's work), *Rhythm* described itself as anti-academic and celebrated the savage, the primitive and the brutal, alongside the uninhibited self-expression and movement suggested by its title. Obviously anticipating rock 'n' roll, it had less long to wait for the arrival of England's only home-grown modernist art movement: Vorticism.

Many of the contributors to *Rhythm* became Vorticists overnight, and would reappear in the movement's most celebrated journal. Though it only ran for two issues in 1914 and '15, Wyndham Lewis's *Blast* is probably the most influential and infamous little magazine of its day. It inspired generations of British malcontents, from Malcolm McLaren and Jamie Reid's punk manifestos for the Sex Pistols (arguably more than the commonly cited Situationism), Billy Childish's Hangman Books and Stuckist art movement, *Vague* fanzine, the lyrics of the Fall's Mark E Smith, and the indie-noise record label Blast First. The hard, unadorned lines and harsh diagonals of *Blast* were a decisive break from the soft curves and flowing fripperies of the 90s' aesthetes, and the writing too was deliberately confrontational, aggressive, jarring and unsentimental. Most influential were the thrillingly arranged manifestos that

opened the first issue, blasting and cursing all that English society held dear, especially the proud achievements of the previous generation; but they also contained blessings, praising all that was deemed most quixotic and contrarian in the national character.

If any of these little magazines can be said to be forerunners of the later underground press, however, then I would nominate those under the editorship of the astonishing anarcho-feminist, mystical visionary and prototype Riot Grrrl Dora Marsden (left, portrait by G.C. Beresford). In contrast to the above decadent aesthetes and upper middle class intellectuals, Dora Marsden (b. 1882) was a working class Yorkshirewoman who, after winning a scholarship to the University of Manchester, became a teacher and an early member of Emmeline Pankhurst's Women's Social and Political Union (WSPU). In 1909 she resigned her headmistress post to become a paid organiser for the WSPU, and was arrested and imprisoned twice that same year, on the second occasion serving two months in Strangeways. Here she went naked rather than wear the prison uniform, and when the wardens tried to put her in a straitjacket she was able to squirm free due to her tiny, child-like build.

The WSPU was embarrassed by Marsden's militancy, while she in turn was critical of their apparent bias towards serving the interests of middle class women only. Marsden expressed a broader sense of feminism than the WSPU allowed; for her, it was not just about the vote, but about women's social and economic standing in society in general. She also wanted to go beyond politics to discuss questions of sexuality, which were completely taboo when the official suffragette movement was determined to maintain a chaste and respectable image in order to achieve its ends. Marsden resigned at the beginning of 1911, and briefly joined the non-violent Women's Freedom League, hoping they would fund a feminist magazine under her editorship. When they

refused she joined up with Grace Jardine and Mary Gawthorpe – another feisty Yorkshirewoman and refugee from the WSPU – and found a willing publisher for their venture in Charles Granville of Stephen Swift & Co.

The first issue of the *Freewoman* appeared on November 23rd 1911 and caused an immediate scandal. Denounced as 'the dark and dangerous side of the women's movement,' over the next few months this 'Weekly Feminist Review' published articles advocating communal childcare and shared housekeeping duties, criticising monogamy and marriage, and discussing homosexuality, prostitution and free love in open, non-judgemental terms that generated opprobrium from pro- and anti-suffragettes alike. The *Freewoman* advocated sexual freedom and sexual enjoyment for women, while arguing that true equality was impossible within the economic bind of conventional marriage. In September 1912 WH Smith banned the *Freewoman* as they had the *Savoy*, supposedly for its sexual content, though Marsden felt the ban was political: 'the opposition of the capitalist press only broke out when we began to make it clear that the way out of the sex problem was through the economic problem.'[2]

In June 1913 the magazine was re-launched as the *New Freewoman*, an independent publication paid for by subscriptions and by several wealthy patrons, notably Harriet Weaver. The *New Freewoman* moved away from socialism and feminism towards individualism, as Marsden fell under the spell of the individualist/anarchist philosopher Max Stirner (1806–1856), and in November the name changed again to the *Egoist*, and continued as such for the next five years. The *Egoist* is probably best remembered for serialising James Joyce's *Portrait of the Artist as a Young Man* over twenty-four issues, and it had begun printing excerpts from the unpublished *Ulysses* shortly before its demise. Wyndham Lewis, D.H. Lawrence and T.S. Eliot also contributed, but by 1919 the magazine's readership had dwindled to just 400, and Harriet Weaver pulled the plug.

Dora Marsden moved to the Lake District and dedicated herself to writing a seven volume philosophical work that would explain Christian theology in terms of contemporary physics.

Against her better judgement, Harriet Weaver revived the Egoist Press to publish the first volume of Marsden's work, *The Definition of the Godhead*, in 1928; it sold just six copies. Volume two, *The Mysteries of Christianity*, fared little better in 1930, and there were no further volumes. In 1935 Marsden suffered a mental breakdown and was confined indefinitely to the Crichton Royal Hospital in Dumfries, suffering from 'Deep Melancholia'. Harriet Weaver paid her hospital bills, and Marsden withdrew completely, living at Crichton for another fifteen years before dying of a heart attack in December 1960.

The Rise of the Fanzines: SF and Beyond

It's widely believed that fanzines first appeared in Britain in the late 70s' punk rock explosion, but they actually emerged from the science fiction fan community over forty years earlier. The first British fanzine is believed to have been *Novae Terrae*, launched in March 1936 by editors Maurice Hanson and Dennis Jacques from the Nuneaton chapter of the newly-formed Science Fiction League (SFL). Other early zines included Walter Gittings' *Scientifiction* and the Leeds-based *Science Fiction Gazette* and *Tomorrow*. These were notoriously serious and earnest, perhaps because the writers and editors were desperate to prove that their enthusiasms were legitimate and respectable. SF fans from the period would later recall 1930s fanzines as pompous and ludicrously self-important, full of pretentious, pipe-waggling articles on the future of mankind and the coming age of technological progress. Concerned perhaps more with science than with fiction, these magazines exhibited a very British middle class certainty and stolidity, and seemed over-keen to establish a top-down bureaucracy whereby the BNFs (Big Name Fans) appointed themselves secretaries, treasurers and chairmen and dictated policy to the hoi polloi of 'passive' fandom. Accordingly, the magazines were often filled with dreary meeting reports; minutes, votes, edicts and resolutions to be solemnly observed.

Early science fiction fandom was, politically engaged, with a strong pacifist and socialist streak. The November 1937 issue of *Novae Terrae* (now based in London under the joint editorship of Maurice Hanson, John 'Ted' Carnell and an aspiring writer and

rocketry buff called Arthur C. Clarke) included copies of the 'Peace Pledge Folder' on behalf of the Peace Pledge Union, a pacifist campaigning group led by 'radio parson' Dick Sheppard. The official organ of the PPU turned out to be Britain's longest running 'alternative' magazine, *Peace News*, founded by Quaker Humphrey Moore in June 1936 and still going strong (incidentally in 1940 the editorship passed to *Rhythm* magazine's John Middleton Murry). Perhaps this pacifism among early SF fans is not so surprising; many were also science enthusiasts who thought technological advances meant another major war would mark the end of civilisation, or life itself. In 1958, many of the earliest members of CND were drawn from the SF community.

The final issue of *Novae Terrae* (number 29) was published in January 1939; Ted Carnell took over and anglicised the name, publishing four issues of *New Worlds* before that too folded. The old world was slipping into the abyss of war, and many pacifist SF fans applied for conscientious objector status. Others tended to end up in the RAF or the army signals corps, where SF clubs flourished on military bases. A few new SF zines appeared at the start of the war, but paper shortages and other pressures soon made their existence untenable. The only amateur SF publication to last the duration was the *Futurian*, a late 30s zine renamed *Futurian War Digest* in October 1940. Known affectionately as *FIDO* it ran for thirty-nine issues till March 1945, and was the work of Leeds' Mike Rosenblum, working on a farm as a conscientious objector by day and producing *FIDO* during air raids by night. It was a Herculean labour, further hampered by the unwanted attention of the authorities, who suspected him of publishing seditious material and of gathering illicit supplies of paper and ink, and put him under police observation. American fans helped their limey counterparts by sending over unwanted paper, often with a misprinted page of a US zine on the other side that could be reused. Other British fans produced single sheet zines that would be distributed alongside *FIDO*, and which inevitably became known as '*FIDO*'s litter'.

Once the war was over, in June 1946 Ted Carnell re-launched *New Worlds* as a professional magazine in association with

Pendulum Publications, but this lasted only three issues before Pendulum went out of business. *New Worlds* was re-launched yet again in February 1949 under the auspices of Nova Publications, a fan-financed incorporated company that had writer John Wyndham as its president. Nova was taken over by Maclaren & Sons in March 1954, ending the company's brief status as a fan-owned, independent venture, but *New Worlds* continued as a pioneering SF magazine under Carnell's editorial control.

The 50s saw a post-war boom in SF and other fanzines, usually produced with stencils on a hand-powered Roneo or Mimeograph duplicator. A south London teenager named Michael Moorcock took his first steps into primitive zine publishing with *Book Collector's News* (1955–56), followed by *Burroughsiana* (dedicated to the work of Edgar Rice Burroughs, from 1956 to 1958) and *Fantasy and Jazz Fan*, which also started in 1956, but changed its name to just *Jazz Fan* after four issues. As Moorcock explained, 'I think fantasy is sufficiently dealt with in my other two zines.'[3] An early example of a British music fanzine, *Jazz Fan* actually focussed on skiffle, with digressions into blues, folk and early rock 'n' roll (Elvis Presley was dismissed as 'talentless'). Perhaps with this in mind, as of its tenth issue in January 1958 the name changed once again, becoming the *Rambler* until its demise after #14. Contributors included SF author John Brunner, artist Jim Cawthorn and, as art editor, Liverpudlian art student Bill Harry.

Harry had published SF fanzines like *Biped* throughout the 1950s, and contributed artwork to most of the major zines of the day, including *Burroughsiana* as well as *Jazz Fan/ Rambler*. At Liverpool College of Art he became friends with Stuart Sutcliffe and John Lennon, and began going to see Lennon's various skiffle bands, as well as (in 1958) producing his own duplicated music fanzine, *Jazz*. By 1961 Harry was so enthused by the local music scene

he decided to start a fortnightly newspaper dedicated to it, which he named *Mersey Beat*. More ambitious than a fanzine, *Mersey Beat* was still independently produced and printed by Harry, and was a labour of love rather than a commercial venture. The first issue came out on July 6th 1961; John Lennon would become a regular columnist, while local shopkeeper Brian Epstein took out advertising and later contributed record reviews. Eventually Harry convinced Epstein to check out Lennon's latest band; the 1960s had arrived.

A Tasty World: The Counterculture's Rise and Fall

It began with poetry. Oxford university undergraduate Mike Horovitz had turned on to dope, jazz and William Blake, and decided to start a small press poetry magazine. *New Departures* was influenced by the politicised alternative community that found itself on the first CND marches as well as the American beat generation; issue 1 in 1959 featured the first excerpts from William Burroughs' *Naked Lunch* to appear in Britain, and Horovitz accidentally made the first Burroughs cut-up by printing them in the wrong order. Other early *New Departures* contributors included Adrian Mitchell, Pete Brown, Spike Hawkins and Johnny Byrne. Byrne and Hawkins would produce a series of small literary and poetry magazines, the most well-known of which was *Night Train*, with Barry Miles, whose mimeographed beat poetry fanzine Tree published new work by Allen Ginsberg and Gregory Corso for the first time in 1960.

Scottish poet Gael Turnbull had founded Migrant Press and magazine in the late 50s following an American trip, and subsequently published a pioneering mix of American and British poets; in 1961 Tom Raworth's *Outburst* magazine also premiered much important British and American poetry, and what would become known as the British Poetry Revival fostered a transatlantic exchange of ideas and energy mostly through small press publications throughout the 1960s and 70s. Bob Cobbings' *Writer's Forum* published hundreds of mimeographed and later photocopied poetry collections; in 1964 Andrew Crozier started Ferry Press, and later in 1966 in Cambridge he and J.H. Prynne published the irreverent mimeographed poetry magazine the

English Intelligencer. Deirdre and Stuart Montgomery's Fulcrum Press published Basil Bunting's *Briggflats* in 1966, arguably rescuing this seminal British poet from obscurity; there was also Tom Raworth's Matrix and later Goliard Press, Bill Griffiths' Pirate Press, Iain Sinclair's Albion Village Press, Asa Benveniste's Trigram Press and many others.

The underground press proper is generally held to have started in New York with the first issue of the *Village Voice*, in 1955. Yet the *Voice* was founded by a Yorkshireman, John Wilcock, who had worked his way from the *Sheffield Telegraph* to the Big Apple via freelancing for magazines in Canada, and who fell in love with Beat-era Greenwich Village but felt that the alternative community there needed a newspaper of its own. Ten years later, Wilcock was still the *Voice*'s news editor and an influential columnist, but felt the paper he'd started was getting square, so quit to found the more underground *East Village Other* (*EVO*).

Back in London, Barry Miles and John 'Hoppy' Hopkins had been publishing a small magazine called *Longhair Times*; Miles and the *New Departures* gang had also organised the famous International Poetry Incarnation at the Royal Albert Hall on June 11th 1965, featuring Allen Ginsberg and Gregory Corso alongside many of the British Poetry Revival's leading lights, and which was seen as a key event in the founding of UK 1960s counterculture.

The International Times No 8 Feb 13-26 1967/1s
ginsberg • townshend (who) • snyder • mandrake root

Seven thousand people came to the reading, and seeing the potential of the emerging scene Miles and Hoppy decided to start an underground paper that would also have a mass appeal: *International Times*, or *IT*. Tom McGrath, then editor of *Peace News*, was persuaded to come over to *IT* as its first editor, and initially *IT* was heavily influenced by John Wilcock's *EVO* while still very much rooted in the CND, post-beat era. There was very little music coverage until a firebrand ex-art student named Mick

Farren talked his way into a gig on the paper. Farren also ran the door at London's first psychedelic nightclub, UFO, which was another part of the *IT* empire, and as his influence on the paper grew, it swiftly went from being seen as a bewildering but accepted emblem of 'Swinging London' to being lambasted as a dangerous influence produced by a community of druggy freaks intent on destabilising society.

In 1967 *IT* was joined by *Oz*, when Richard Neville and art editor Martin Sharp decided to import their Sydney-based satirical magazine to London and take on *Private Eye* (which had been started in 1961 by Richard Ingrams, Paul Foot, Christopher Brooker and Willie Rushton as a professional version of their old public school magazine). *Oz* soon changed tack and jumped on the psychedelic bandwagon, and Sharp's dazzling graphics, radical layouts and lysergic, fluorescent-coloured artwork – made possible by the advantages of offset lithographic printing – made *IT* look dowdy by comparison.

When *Nasty Tales* folded in 1972 *Ogoth and Ugly Boot* got a comic of their own.

IT and *Oz* also reprinted American underground comix[4] by artists like Robert Crumb and Gilbert Shelton, and soon *IT* began running original UK-based comic strips, most notably Mal Dean and Michael Moorcock's 'The Adventures of Jerry Cornelius' and the work of Edward Barker. This led in 1970 to the brief (four issues) appearance of *Cyclops*: 'The first English adult comic paper', which featured work by Dean, Barker, Sharp, future *NME* cartoonist Ray Lowry and 'The Unspeakable Mr Hart' written by William Burroughs and drawn by Malcolm McNeill. This was followed in 1971 by *Nasty Tales*, which combined US reprints with original work. Unfortunately the graphic nature of the American strips, combined with the British assumption that comic books were aimed at children,

swiftly led to *Nasty Tales*' publishing team – Mick and Joy Farren, Edward Barker and Paul Lewis – being prosecuted for obscenity. This was in the wake of the more famous *Oz* trial (also caused by a reprinted Robert Crumb cartoon, onto which one of the schoolchildren invited to guest edit that particular issue had pasted the head of Rupert Bear). Farren chose to defend himself against the obscenity charges at the Old Bailey, and without the aid of expensive lawyers won an unexpected and precedent-setting victory against the establishment.

New Worlds No. 213 – one of the very last issues

Meanwhile, back at the beginning of 1964, publishers Roberts & Vinter bought *New Worlds* from Maclaren, and Ted Carnell recommended the twenty-three-year-old Michael Moorcock as the new editor. The first Moorcock-helmed *New Worlds* was published in May 1964, and the magazine went on to become the most ground-breaking science fiction publication of all time, spearheading the 'New Wave' of writers like J.G. Ballard, Brian Aldiss, Charles Platt, Samuel Delany, Thomas Disch and Norman Spinrad. Spinrad's serialised novel *Bug Jack Barron* was considered scandalous enough for *New Worlds* to lose its art council funding, as well as causing it to join the honourable list of magazines banned by WH Smith. Moorcock was forced to underwrite the magazine with his own money, made by knocking out short fantasy novels in a period of days in between editing, more serious writing and numerous extra-curricular activities, including appearing on stage with the psychedelic rock band Hawkwind. In April 1970, #200 was the last in the classic format; *New Worlds* resurfaced the following year as a ten-volume paperback anthology series, and in 1978 Moorcock revived *New Worlds* as a semi-fanzine, publishing a further five issues over the next two years.

Savoy Books, founded in Manchester in 1976, was directly inspired by *New Worlds*, where co-editor Mike Butterworth had first seen his fiction published in the mid-60s. Returning to Manchester from Ladbroke Grove, Butterworth produced lit zines *Concentrate*, *Corridor* and *Wordworks* before hooking up with artist Dave Britton of *Crucified Toad* and *Weird Fantasy*, AKA *Bognor Regis*. Britton's art style paid explicit homage to Aubrey Beardsley, but updated to a post-hippie, post-industrial sci-fi setting, with the deviant sex and violence ramped up accordingly. It was natural that when the pair decided to start an independent publishing house to continue and extend *New Worlds'* radical blend of SF and the avant-garde, they should name it after Beardsley's daring *fin-de-siècle* magazine: *Savoy*.

The Savoy Book, named after the 'scandalously exquisite' 19th century *Savoy* magazine

Like Beardsley's magazine, *Savoy* was partly funded by pornography. Butterworth and Britton co-owned a number of SF and fantasy bookshops across Manchester, but the books they loved didn't sell enough to keep the shops open. Accordingly they also stocked the kind of soft porn novels and magazines that could be found in most high street bookstores and newsagents, which sold steadily enough to keep them afloat. Unfortunately for them, 1976 also saw James Anderton become chief constable of Greater Manchester police, and 'God's cop' immediately began a moral clean-up of the city, targeting drug addicts, prostitutes, the gay community and 'pornographers,' which increasingly came to mean alternative bookshops. Britton and Butterworth's shops were raided regularly, while other outlets selling the same material – or worse – were left alone, and thousands of pounds worth of stock was seized and destroyed without any formal charges being brought.

Savoy's early catalogue drew heavily on the *New Worlds* school, including Moorcock, M John Harrison, Harlan Ellison, Langdon Jones and the first UK-produced graphic novel, Jim Cawthorn's adaptation of Moorcock's *The Jewel in the Skull* (1967). A short-lived distribution deal with New English Library (NEL), kings of the 70s exploitation paperback, allowed *Savoy* to reprint overlooked authors like Jack Trevor Story and Henry Treece. In 1980 they acquired the rights to two classics of new wave SF erotica – Samuel Delany's *The Tides of Lust* (1973) and Charles Platt's *The Gas* (1970). These were seized by Anderton's vice squad and pulled from national distribution, though in fact the prosecution that bankrupted *Savoy* and landed Britton in Strangeways for twenty-eight days hinged on the seizure of some fairly tame, remaindered Grove Press erotica that had been gathering dust on their bookshop shelves for some time.

When Britton claimed that most of *Savoy*'s books were closer to rock 'n' roll than to literature, he was talking about their anti-establishment attitude, rebelliousness and willingness to experiment as well as their cultural roots. *Savoy* obsessively returned to a small pantheon of outsider musical heroes including Captain Beefheart, the Cramps, Adam Ant and, especially, faded 60s pop crooner P.J. Proby. 1985 saw Savoy Records release Proby's astonishing auto-destruction of New Order's 'Blue Monday' as a 12" single, clad in an Anderton-baiting sleeve that ensured no distributor would touch it, and credited to the 'Savoy-Hitler Youth Band' with vocals by 'Lord Horror'.

Britton's Lord Horror would be the most notorious creation *Savoy* shepherded into the world. Originally a combination of wartime traitor Lord Haw-Haw and Moorcock's amoral albino Elric, the character of Lord Horror first appeared in an eponymous 1989 novel (co-authored with Butterworth) which explored how the terrible shadow of the Holocaust has defiled the entire 20th century, while also delving into the dark underbelly of modernist literature and art. Necessarily shocking, often stomach-turningly so, the book was also informed by Britton's experience in Strangeways, when he was nearly burned alive in his cell during a prison riot, and his bitterness towards an

increasingly homophobic and messianic Anderton. Indeed, Lord Horror featured a strikingly familiar supporting character named Appleton, whose dialogue quoted the Chief Constable's speeches, replacing the word 'Homosexuals' with 'Jews'. All copies of the book were seized, and despite the obvious satirical intent Britton was convicted of anti-Semitism in 1991 and returned to jail for two months. *Lord Horror* was banned and all copies destroyed; though the ban was lifted on appeal in 1992, the original novel has not been reprinted. Lord Horror's adventures would continue in two sequels and in a series of graphic novels, alongside the almost as controversial *Meng & Ecker*.

The examples of *IT*, *Oz* and *Black Dwarf* (a Marxist alternative newspaper founded in 1968 by Tariq Ali and Sheila Rowbotham) and the possibilities offered by offset litho printing led to the founding of scores of local alternative papers across the UK in the 70s and 80s. These left wing, community-based 'free press' publications tried to reflect the concerns and experiences of ordinary working (or unemployed) people, as well as the growing tensions and anxieties of the Cold War, 'Protect-and-Survive' era. In May 1979, Rochdale Alternative Press (RAP) led with a cover story on how local MP Cyril Smith had abused a succession of young boys at a children's home he'd founded. The story was thoroughly researched and backed up with affidavits from five victims. But as soon as the story broke, Smith issued a gagging writ and, although the case never came to court, the accusations were buried for the next 31 years till after Smith's death. The corpulent MP was returned with an increased majority in the 1979 election that also saw Margaret Thatcher become Prime Minister. Her government would progressively grind down the community that supported the Free Press movement until, even before the internet changed everything in the late 90s, very little survived.

Voices from the Underground

The zine explosion that appeared in the wake of punk was watched with bemusement by many in fandom's old guard. John Ingham was a science fiction fan from the West Coast of America who'd found a job as a journalist for UK music paper *Sounds* just as punk was kicking off. He applauded the energy and

attitude of punk zines like *Sniffin Glue*, *Ripped and Torn*, *London's Outrage*, *48 Thrills* etc., but bemoaned their ignorance of the basic principles on which the 40-year-old fanzine culture operated. Punk had declared itself Year Zero, and ignorance, like youth, was a virtue: breaking free from the underground's own conventions allowed new generations to find their voice without worrying about the censure or approval of BNFs or self-appointed leagues, associations and committees. Ingham shrugged and jumped in, starting his own punk zine, *London's Burning*. As cheap photocopying displaced mimeograph duplicators a massive zine subculture proliferated during the 1980s, the familiar collaged, cut n' pasted, closely typed and overprinted format encompassing alternative music, occultism, conspiracy theories, role-playing games, feminism, football, personal confessions, comics, political radicalism, sexual experimentation and pretty much everything an increasingly conservative mainstream refused to touch. The Riot Grrrl era of the early 90s was in many respects the last hurrah of this golden age of UK DIY culture, when a post-post-punk generation of girls and boys realised, like Dora Marsden, that gender-based stereotypes and assumptions were the first barriers that had to be torn down in the search for true personal freedom, and the next step was snapping yourself awake from the capitalist-consumerist coma and creating your own realities instead.

GirlFrenzy magazine

Erica Smith published *GirlFrenzy* from 1991 to 1998. It was an influential zine that was often lumped in with Riot Grrrl but which actually drew inspiration from the new wave of independent

comics. 'I started working on *GirlFrenzy* in 1990,' Erica says.

> 'I thought of the name and decided it was so good I
> had to do something with it. I'd recently discovered
> small press comics, and decided it would be great to
> create a publication that promoted small press comics by
> women creators.'[5]

Aged twenty-seven in 1990, Erica considered herself too old
to be a Riot Grrrl, and wasn't aware of the movement until
GirlFrenzy hit issue 3. Informed more by punk and the broader
political and feminist struggles of the 1980s, she describes
GirlFrenzy as a 'parallel development'. 'I wanted to create a zine
which reflected my interests – ones that didn't seem to be covered
by "mainstream" media,' she says.

> 'The motto was always "Articles, strips and no make-up
> tips" and "By women for people". I didn't want to pay
> Poll Tax, so I put the amount I should have paid into
> a bank account every month and used it to print the
> first copy.'

Erica's major influence was the Hernandez Brothers' *Love &
Rockets*, an American independent comic that, though created
by males, focussed on a cast of strong, well-characterised and
realistically drawn female characters. She says:

> 'I was surprised how few women seemed to be involved
> in the comics industry. I was kicking against the male
> domination within the comics industry, but also the lack
> of publications I wanted to read as a woman. On one
> hand, the glossy mags were full of make-up tips and
> diets. On the other, publications like *Spare Rib* were very
> anti-pornography/pro-censorship. I wanted a space that
> would explore feminism and sexuality.'

Erica fondly recalls tropes of the era such as writing handwritten
letters on the back of smudged photocopies and smearing stamps
with soap so that they could be re-used by the receiver; classic
post-punk zine kid tactics.

> 'When I started *GirlFrenzy* I was working in what I thought
> was a vacuum, but as soon as I started putting out flyers
> about it, and going to events like the Small Press Fair in

London, I started meeting like-minded people. Through the zine world, I met the Woozy gang from Melbourne – they came over to stay with us in Brighton, and we went over to Australia. Likewise, Fly from NYC came over, and when I finally visited New York in 2001, I met up with her again. We did a *GirlFrenzy* tour (two spoken word nights in two venues – Blue Stockings and Dumbar). It was great that *GirlFrenzy* created all these opportunities.

The downside to the zine world is that I do think there is a tendency to refuse to grow up. That's partly a good thing, but I did feel there was a reluctance from some people, particularly men, to take on adult responsibilities. That's fine, except it does impact on the women in the scene who can end up being mothers to the kidult males. I did get tired of that, and it's really why I stopped being so active in zine world.'

Erica considers that to some extent blogs and social media have replaced the zine culture of the 80s and 90s.

'I guess blogs are used as a confessional space as many zines were/are. It is great that they are free, and internationally accessible. No need for endless trips to the post office and sending zines and dollar bills over the world for exchange or payment! It's much quicker and more ecological too – but it's not the same as the whole process of zine production.'

Tim Wells, who founded the poetry zine *Rising* in 1993, is more dismissive of the internet's much vaunted accessibility. He says:

'I've deliberately avoided the interweb. If you can find a zine easily then it's not underground, is it? When I started *Rising* it was paper, scissors, glue, Letraset. These days I do the zine on a computer, so that is the big change. Twenty-two years on I'm still using the same printer, who still charges me the same rates!'

Still going strong, *Rising* holds itself apart from passing literary trends, whether academic or media driven. 'Tough on poetry, tough on the causes of poetry,' the slim A5 zine is irreverent, unpretentious, cheeky but lovable; a tart with a heart of gold. Distributed freely by Tim at gigs and readings, for over twenty

Rising, poetry magazine

years, *Rising* has been the street-level voice of London poetry.

'As a teenager I was reading loads of reggae and skinhead zines,' Tim says. 'This was before the interweb, way before. The music I liked wasn't on the radio and the main way we got information about records and music was home-made zines.'

After writing for a few music fanzines, Tim started up his own poetry mag.

'I was sick of not seeing the writing I liked, and a general lack of humour, in poetry magazines. I'm from a "do it yourself" background so I started publishing the kind of writing I liked and I knew would annoy the po-faced.

I've always favoured working class writers. They're not guaranteed publication 'cos they're still as capable of turning out drek as anyone else but working class anger is something I want to see more of in the world. *Rising* has always had the zine aesthetic. Where other magazines have been getting glossy and acceptable we've deliberately gone the other way. We're a free zine. One of our tag lines is "it may be free, but it ain't cheap".'

Typically, Tim avoids any suggestion that *Rising* is part of a supportive poetry underground, and instead prides himself on annoying as many people as possible. 'Skinhead zines like *Hard As Nails* were a big influence,' he admits.

'The sheer miserablism of so many poetry magazines is also a spur. One highlight for me was when an aesthete defaced the cover of a Poetry Library copy of *Rising* with the words "Is it poetry? Shame on you". Even better, it was done in pencil.

'I think we're a distinct voice at *Rising*, as any good zine should be. I'm pleased that some excellent poets send me

poems that they know no one else would publish. There is a bit of a DIY "scene" but I'm happily not part of it. The zine I've most in common with these days is *Push*, a lit zine sold at West Ham (and recently Orient – about time!). Both of us are happy not being the kewl kids I think.'[6]

Ultimately, Tim is happiest as an outsider. 'I don't see *Rising* as part of the canon,' he says. 'It's more of a belch: immediate, loud and entertaining.' Asked what his main difficulties publishing the zine have been, his answer is succinct and to the point: 'Twats.'

Ablaze! issue 7

'The only reason I was able to know that making your own magazine was a thing you could do and print and show to people was that other people were doing it,' says Karren Ablaze, who published one of the most important music zines of the late 80s and early 90s, the Leeds-based *Ablaze!* As she explains:

'There were thousands of zines around in the 80s, and I was encouraged by a radio show that preached the message of DIY in relation to zines, which gave me both permission and the imperative to do it. I imagine that this huge wave of zines emerged from the influence of *Sniffin Glue*. The zines that influenced me the most to begin with were John Robb's Rox and Mark Williams' *Shine* and *Lemonade* titles.'

Karren agrees with Erica that the internet has made the whole process of production much easier.

'In the 80s you would get on a bus, meet a band, do an interview, record it, go home and transcribe it, and write up the piece on a typewriter using Tippex for any reconsiderations. A photographer would take pictures of the band, develop them, and you would then take them to a reprographics place for them to be dot screened. You

would rely on a photocopier, located maybe a mile away, to create graphics and to reduce or enlarge text, and if you were rich you might use Letraset for headings. You would stick everything down onto paper or card and carry it to the printers like a baby. All contact would be made over the phone or by going to see people. Now you can do the whole thing on a laptop without leaving your bedroom.'[7]

In 2012 Karren started independent book publishers Mitten On. Their first publication was a huge *Ablaze!* anthology, titled *The City Is Ablaze!* (2012). They followed it up with *View from a Hill* (2014), the autobiography of Chameleons' singer Mark Burgess; more titles are pending.

'I went back into independent publishing 'cos I loved doing zines so much, and books are the new zines for me due to the challenging nature of their production and the awesome things you end up with... In terms of the industry I have some great distributors, but my experience is generally the one you would expect, of determination and persistence in order to push past the obstacles that inevitably appear in the face of any large project.

The main advantage is that indie publishing is all about love – passion (a word much misused by corporations) for the subject matter, and hopefully a respect for all the people involved. And it is an area in which adventures take place. Mainstream publishing puts money first; Indies are there for the thrill of the ride. DIY ain't dead!'

Another independent publisher, Tariq Goddard co-founded Zero Books in 2009 to combat what he saw as a prevailing anti-intellectual trend in contemporary culture:

'I became involved in publishing because I feared, literally and slightly messianically, that if I did not, then works that I thought should be published never would be. The proliferation of blogs had shown me that there was a generational wave of authors, working between the boundaries, that were being ignored by mainstream publishing, and needed to get into print. John Hunt, at JHP publishing, agreed, and backed me to begin Zero Books.'[8]

Perhaps unusually for a small press moving in what could be considered academic and esoteric areas, Tariq identified Zero's audience via the music press. He says:

'The existence of a once vibrant UK music press told me that there was a potentially large and un-catered for mainstream audience for subject matter and concerns that had wrongly been pushed towards the margins. The culture industry meanwhile, "appeared content to reheat and recycle the same names indefinitely, in effect sustaining a closed shop".'

Once Zero was up and running Tariq found the independent publishing sector surprisingly supportive.

'Those publishers who you might have thought would be our closest rivals have opened the door and welcomed us in, particularly Verso. To our happy surprise there were even more people open to what we were doing than we thought, and their support was enthusiastic and instantaneous. Of course, the proliferation of small publishers does mean that there is greater competition for authors, and if a publisher isn't clear about what differentiates him/her from others working in a roughly similar area, their success will be short lived.'

While Tariq cites flexibility, a faster responsiveness, an open mind and a far greater willingness to take risks as the main advantages to independent publishing, he admits that:

'Very creative people are not always excited by or particularly interested in the practical aspects, logistics, number crunching or infrastructural aspects of making a publishing company work... most of the people I work with, myself included, have been authors in their own right, so an indifference to nuts and bolts issues is something we have had to all collectively overcome.'

In 2014 Tariq and several other Zero staff left to found a new imprint, Repeater Books. Repeater continue Zero's original mission to publish radical books for a wide readership and to move alternative thinking out of the margins, and can be found at repeaterbooks.com and www.facebook.com/repeaterbooks.

Zero also continues to publish exciting and challenging work as part of John Hunt Publications.

Conclusion: The Children of the Vortex

The virtual vortex may be upon us, but Karren Ablaze is right when she says 'DIY ain't dead'. In some ways underground publishing is healthier than ever. Not only does the ease and profusion of blogging mean that more individuals than ever have a platform from which to create and communicate, but desktop publishing, digital printing and print-on-demand services mean it's now ridiculously easy to produce a professional-looking independent small press magazine, newspaper or book. Whether these newly empowered voices have anything to say of course, remains another matter; the number of original thinkers is probably statistically the same as it ever was, but the babble around them has grown.

These are not undramatic times, however. A battle continues to rage between a mass media revealed as increasingly avaricious, corporate-controlled and corrupt, and a decentralised network of dissenting voices, many as influential, for good or ill, as publishing empires and TV channels with billions of pounds of public or private money behind them. At one end of the scale an anonymous Amazon review can have more impact on sales of a new e-book or music download than a lengthy article by a respected national newspaper critic; at the other, a whistle-blowing blogger can expose the machinations of the rich and powerful and potentially bring down governments. And this, surely, is what we all wanted; the ultimate democratisation of communication, the underground publishing utopia made real on earth. Within the babbling vortex, the fiercely independent website the *Quietus* continues to publish high quality, thoughtful and challenging writing on music, film and all aspects of culture. Indie book publishers like Zero, Repeater, Headpress, Strange Attractor and Aurora Metro still scour the margins for original voices and flickers of genius. Small poetry presses proliferate. And as no one can make a living out of writing or journalism these days anyway, the temptation to sell out should surely be less strong. But at the same time, this makes the 'underground'

more than ever a playground for fakers, dilettantes, careerists and bohemian bandwagon hunters.

To remain vital, underground publishing must amount to more than just artisan, hand-crafted small press editions to amuse a middle class hipster elite. It should be a voice of resistance, or at least a voice; the genuine voice of an individual human being writing because they must, or for the love of it, but not primarily for money or acclaim. It is the voices that count, and we should resist making a fetish of Tippex and Pritt Stick, staples and Letraset. Instead we must mutate to survive, using any means necessary to stay one step ahead and outside of the mainstream, to blast and to bless. And blessedly, this is happening.

All across the UK underground, the secret presses of Martin Marprelate are still on the move.

MUSIC

Mainstream Countercultures:
The Ultimate Mix

Em Ayson

Introduction

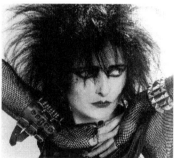

Unknown male punks, Siouxsie Sue, 1970s

'Subcultures', 'countercultures', 'the underground' – such terminology conjures up images of rebellious teenagers and social misfits; goths, punks, hippies and ravers; with such groups frequently seen as somehow different to the rest of society. But is the barrier between the mainstream and the countercultural perhaps more permeable than is often perceived? Since the 1960s, British culture has seen the rise of a series of iconic countercultures, but just how socially subversive were they? This chapter constitutes a celebration of the British underground, but also draws attention to the fact that despite its separatist *raison d'être*, it is intertwined with and dependent upon mainstream culture. The result:

mainstream countercultures.

When the music of a counterculture infiltrates the mainstream, it uses it as a conduit through which to both disseminate its values to a wider audience and to garner more supportive members. In discussing this, I will begin with a whistle-stop tour of some of the most recognisable British musical cultures and discuss how members of these groups ardently strove to differentiate themselves from the rest of society through their sounds and practices. I will then progress onto the impact that changing technology has had on underground music production and enjoyment and how this shift has played a fundamental role in perpetuating the beneficial amalgamation of the countercultural into the mainstream. My final section presents a case study of what may be one of the major mainstream countercultures in Britain: Lady Gaga fandom.

A Countercultural Chronology

As with all societies, British culture has never been homogenous, it has always been divided along certain lines; gender, ethnicity, class and religion to name a few. Consequently, an individual's choice to affiliate themselves with any particular identity or lifestyle ultimately places them in a position wherein they are perceived by themselves and others as belonging to either the cultural majority or the minority, engendering great tension between groups such as the mods and rockers in the early 60s. A phenomenon that has also divided the population of Britain is music, not just in terms of taste preferences, but also in terms of the perceptions about certain musical groups that come to be held by wider society. For example, widespread opinion often suggests that all punks are anarchists, all goths worship the Devil or that those who listen to dance music at raves take drugs. Consequently on the one hand, these groups often consider their music and musical practices as progressive challenges to the hegemony. On the other hand, those outside of such factions frequently come to feel baffled by or even threatened by the unconventional and the unfamiliar. This point is particularly relevant when musical distinctions are involved, for as will be seen, music constitutes a potent force through which countercultural presence and power can manifest.

If one subscribes to Hans Christian Andersen's sentiment that 'where words fail, music speaks,' then music can perhaps be considered as the ultimate channel through which people are able to freely express their values, beliefs and identities. In turn, the power of music to affect our everyday lives, thoughts and activities is immeasurable, for music 'affords a kind of auditory device on to which one can latch in some way or another, in relation to some other bodily activity or process.'[1] In essence, listening to or creating music can offer us escapism, a chance to de-stress, rekindle forgotten memories, energise ourselves or induce certain moods. Similarly, where people are unable to articulate their thoughts due to social constraints, music can communicate for them. You do not need to be a trained professional to make music that can touch other people in some way; from simply whistling a tune to drumming a beat on your desk, anybody has the ability to create their own aural delights. For instance, Skiffle groups of the 1950s such as The Vipers and The Bluegrass Boys made music from everyday objects such as washboards, jugs, boxes and combs. British musical history is teeming with people and groups that created their own music, under their own rules, for their own purposes and as the influence of one musical phase diminished, another rose to take its place in a cycle that continues today.

Rock, Roll and Rebellion

The Yardbirds, 1966

Our journey into the archives of British counterculture begins in the 1960s, with the rise of British rock. Whilst rock had been a staple of British musical culture since the 1950s, with US artists such as Bill Haley and his Comets, Elvis Presley and Buddy Holly gaining popularity, it was not until the 60s that the iconic genre of British rock truly found its footing as pioneered by the Beatles, the Yardbirds, the Animals and the Rolling Stones. As detailed by Osgerby, the years after World War II signalled a new dawn for working class British youth; more employment opportunities, enhanced incomes and increased amounts of

leisure time meant that young people could spend their time and money on the wares of an ever growing youth market.[2] Fuelled by the post-war pursuit of leisure, British rock became the music of a generation of newly affluent baby boomers with access to new methods of decent contraception. Less impeded by the restraints of parenthood, notions of what it meant to be young were reconfigured, for youth was no longer viewed as merely a fleeting stage on the path to adulthood. Instead, it was perceived as the ultimate desirable condition which should be exploited and prolonged for as long as possible.[3] The social revolution which followed unleashed a raucous repertoire of rebellious music that spread messages of fun, frivolity and freedom. Songs such as the Who's 'My Generation', the Rolling Stones' 'I Can't Get No Satisfaction' and Led Zeppelin's 'Whole Lotta Love' became anthems for a generation who were searching for something more than material security through experimentation with sex, drugs and eastern mysticism. Thus, rock appeared to be the catalyst for a stringent generational divide in which young people rebelled against the values of their parents, who naturally wanted their children to work hard and build 'decent' lives for themselves, rather than frittering away resources on faddish leisure pursuits.

British rock was heavily influenced by the rhythm and blues aesthetic of Black American artists such as Muddy Waters and B.B. King,[4] signalling arguably the first emphatic fusion of black and white music into one cohesive genre, while music produced by the large corporations was viewed by rock fans as unintelligent, banal and lacking artistic merit and sincerity.[5] In contrast, rock was perceived as the sound of raw, human feeling and through the music young people were able to physically feel and directly relate to the sense of youthful exuberance that was infused into it.[6] In this respect, rock music derived much from the traditions of folk music which has long been considered as the epitome of authentic and sincere human expression. As Parry wonderfully states, such music involves 'no sham, no got up glitter, and no vulgarity,'[7] something many artists of all genres still strive to emulate today. In turn, rock music fostered a community of young people who were united in their rebellion against their elders and

the established order. A particularly iconic venue in London that became synonymous with the development of British rock as a musical form is the Eel Pie Island Hotel in Twickenham. Located on a small island in the Thames, the run-down hotel offered young people an edgy place where they could hang out, drink and dance then step up onstage to experiment musically. Originally home to British jazz acts in the 1950s, including Ken Colyer, Acker Bilk and George Melly,[8] the venue went on to be at the forefront of the British rock revolution. The dwindling popularity of jazz in the 1960s meant that burgeoning British rock bands were added to the roster in order to keep people coming through the doors. By supplying British youth with what they desired, The Eel Pie Island Hotel was packed to capacity most Wednesdays and the venue boasted an impressive back catalogue of acts who have performed there, including John Mayall's Bluesbreakers (featuring Eric Clapton), the Tridents (with Jeff Beck), the Rolling Stones, Pink Floyd, David Bowie and The Who.[9, 10]

Turn On, Tune In, Drop Out

British rock is a heavily splintered form, with many offshoots including blues rock, progressive rock and, later, heavy metal. One further iconic branch that particularly adheres to the genre's anti-mainstream, emotionally-laden position is psychedelic rock, often the music of choice for those who were part of hippy culture. Incorporating sounds and instruments previously unheard of in British music, bands from this movement such as Cream, Pink Floyd and Hawkwind utilised devices such as long instrumental sections and guitar solos, combined with synthesisers and echo machines. Similarly, musicians also pulled influences from other cultures into their compositions and it was not uncommon to hear the tinny tones of a sitar within the already eclectic mixture of sounds.[11] Furthermore, the impetus behind the creation of such compositions was to mimic in musical form the experience of hallucinogenic drugs which were becoming increasingly available.[12]

With the influence of Timothy Leary's books *The Psychedelic Experience* (1964) and *The Politics of Ecstasy* (1970), young people were encouraged to believe that it was possible to reach new

realms of consciousness through drug use, particularly with the use of LSD. There was not only a rejection of mainstream society in this philosophy, but a rejection of all social norms which were seen as manufactured by 'straight' society for social cohesion. Pink Floyd's 'See Emily Play', Jefferson Airplane's 'White Rabbit' and the Doors' 'Break On Through to the Other Side' were a few examples of songs which hinted that drugs could open the doors of perception to a higher state of awareness.

The Beatles' enjoyment of cannabis was expressed in a number of songs, including 'Got To Get You Into My Life' and 'With A Little Help From My Friends' while LSD is said to have inspired 'Day Tripper' and 'Lucy in the Sky with Diamonds'. Lennon became addicted to heroin and wrote about it in the songs 'Happiness is a Warm Gun' and 'Cold Turkey' which McCartney rejected as a single and so Lennon later recorded it with the Plastic Ono Band. The Small Faces' 60s song 'Itchycoo Park' was banned by the BBC for its references to getting 'high' until the band insisted the song was about nothing more than going to a children's playground. But as the 70s progressed, drug use destroyed the creativity of many of the former rock rebels. They were no longer seeking any kind of revolution but simply trying to manage serious addictions. Eric Clapton's 'Cocaine', Hendrix's 'Purple Haze' and the Velvet Underground's 'Heroin' all testify to the centrality of drugs at this time.

British rock of the 1960s constituted a revolution against the restraints and responsibilities of aging and the mainstream music industry. The music preached youthful liberty and pleasure and thus the 1960s era signals the first instance of youthful awareness that they did not have to accept the status quo; a notion also vehemently taken up by young people in the following decade.

Anarchy in the UK

In the 1970s, Britain witnessed the advent of a new breed of countercultural agents: punks. Borne out of social and economic unrest, antipathy towards the increasingly inaccessible mainstream music industry and a general desire to shock and shake up the country, punks 'signified chaos at every level'.[13] With their aurally assaulting music, unconventional fashion sense and aggressive

ways of being, punks actively challenged and disrupted the mainstream through multiple avenues, firmly cementing their place in the echelons of British counterculture.

The Sex Pistols performing at Paradiso in Amsterdam, 1977

The 'official story' is that punk reached British shores in 1976, with the seeds of the scene, or at least the style, carried in the mind of one man across an ocean and sown in London. Alongside fledgling clothing designer Vivienne Westwood, Malcolm McLaren owned a boutique with a reputation for specialising in apparel for Britain's 'anti-fashion' communities.[14, 15]

It was this very shop which was to become the originating hub for punk, not only the place to purchase all the necessary accoutrements, but also the meeting place of members of what was to become perhaps the most iconic punk band in the world – the Sex Pistols. A world away in New York, garage rock and glam rock were slowly being dissected and reconstituted into the musical genre now known as punk, with the emergence of bands such as the Ramones and Dead Boy. It was in The City That Never Sleeps that McLaren encountered these new sounds and simultaneously found his inspiration for an exciting new line of garments. Television's Richard Hell was spotted adorned in one of McLaren's shirts, torn to shreds and precariously held together with safety pins. Returning home, McLaren poached Hell's customisations and melded them with Westwood's bondage-style designs, rebranding his shop under the name 'Sex'.[16] Upholding the tenet of being patently 'anti-fashion', the ragged, sadomasochistic aesthetic of the clothes was so shocking that they

required a special kind of marketing, so McLaren recruited some real life mannequins. Members of a struggling band, the Strand, one of his salesmen and a regular customer of Sex were enlisted to form a living, breathing advertisement: the Sex Pistols.[17] Thus, Pandora's Box was opened and punk fashion was unleashed upon Britain, flaunted in the face of mainstream couture as an open declaration of punk's ethos of disruption and chaos. But it was also through music that punk made its loudest statements.

Johnny Rotten on stage, 1977

Punk music represented an active challenge to the commercial music world, which was seen as a monolithic force that denied entry to those who could not deliver the studio-perfected, money-making sounds that helped line the pockets of label bosses.[18] Punks with little musical experience began to form their own bands, write their own songs and organise their own shows; their 'do it yourself' approach signalled total rejection of the conventional logistics of the music business. It is well known that when John 'Johnny Rotten' Lydon was recruited into the Sex Pistols, he had never sung a note in his life.[19] As such, the music and lyrics of punk were abrasive, amateurish and unpolished. For instance as Laing argues, the singing voice is the focal point of identification for listeners in music[20] and so conventionally vocals are supposed to be distinguishable in order to have resonance. But in punk, the voice is used to produce 'a mixture of speech, recitative, chanting or wordless cries and mutterings',[21] completely inverting expected musical standards and foregrounding punk's socially disruptive ethos. One only has to listen to the Sex Pistols' anti-authority anthem, 'Anarchy in the UK' to witness the musical and lyrical subversion of punk.

Furthermore, as another proverbial middle finger to the mainstream music industry, the punk community became

accustomed to arranging their own live music events, rather than relying on the marginal chance that a promoter would do so for them. This reinforced the DIY ethic of this culture, with bands taking control of their musical careers, exercising group solidarity and not denying access to the musical limelight for those who wished to share it. Interestingly, punks drew a stringent semantic distinction between a 'concert' and a 'show', wherein the former was a large affair associated with the profit-driven mainstream acts they strove to so ardently differentiate themselves from. At punk 'shows', there was rarely a barrier between the stage and the floor, allowing artist and audience to often have physical contact; a fitting metaphor for the punk belief that 'musicians are fans and fans could be musicians'.[22]

Punks ripped apart dominant conventions surrounding fashion and music and in doing so achieved their desired purposes: to shock society and make their own kind of music on their own terms. During the punk reign, Britain spawned a slew of iconic bands; the Clash, the Damned, the Buzzcocks, X-Ray Spex, UK Subs, Siouxsie and the Banshees, the Subway Sect, the Vibrators and the Slits, to name just a few; and indeed several landmark venues are often attributed to the punk scene including the 100 Club and The Roxy. Yet, as the 1970s ebbed away into the 1980s, the prominence of punk began to diminish, making way for Britain's next generation of countercultural crusaders.

Drugs, Dance and Decadence

In the late 1980s, morale in Thatcher's Britain was all but disappearing. With soaring unemployment rates, poverty and a loss of community spirit as the 'every man for himself' mentality began to take hold, feelings of social anomie were endemic. For British youth, the future appeared bleak and attempts to counteract their dire situations seemed futile. Many desperately sought utopian escapism, solace that would be offered to them in the arms of a new breed of musical counterculture; the rave scene.[23] A cacophonous cocktail of thumping electronic music, neon lights, gyrating bodies and euphoria inducing substances, the hedonistic ethos of this scene allowed British youth to disassociate themselves from the troubled real world – at least

until the clubs closed and the effects of the drugs subsided. In her canonical book on club culture, Thornton magnificently parallels the club scene with the rabbit hole from *Alice in Wonderland*, taking members 'from the mundane world to wonderworld'.[24] Yet, like Alice, clubbers inevitably had to make the return journey back to reality and at the end of the night, Britain was still broken.

1988 is often cited as the year of inception of this scene in Britain. Returning home from a trip to Ibizian clubbing mecca, Amnesia, pioneer DJs Paul Oakenfold and Danny Rampling sought to inject life back into the moribund British club circuit and give British youth the escapism they craved. The duo brought the drugs, dance and decadence of the Spanish scene to London, founding the first dedicated rave clubs, Shoom[25, 26] and Future.[27]

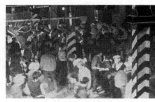
Inside the Haçienda

More clubs began to spring forth in the capital and other locales around the country, particularly in Manchester where the hub for rave was the Haçienda club, formerly the stomping ground for indie rock bands of the 'Madchester' period such as the Stone Roses and the Happy Mondays.[28, 29] Inevitably, events were not limited to the legal, with many illegal events organised in order to combat stringent licensing laws and prolong the euphoric escape of the rave, if only for a few more hours.[30] Unlike its musical sibling, hip-hop, the dance music scene may not have often appeared visibly political, but rave culture was often about forming communities which were anti-establishment, with many people who were organising illegal raves and squat parties living in squats or on-site within new traveller communities. In contrast, hip-hop was largely geared towards being overtly anti-authority and anti-status quo, with membership to this culture often synonymous with violence, gangs and hard drug use.[31] Although, no discussion of rave culture would be complete without mentioning acid-house duo, The KLF, who gained notoriety at the 1992 Brit Awards for firing machine gun blanks into the crowd and depositing a dead sheep at the after-show party; most definitely

anti-establishment behaviour![32]

As the successor to disco music and discotheque dancing culture, the music of this counterculture encapsulates many genres; acid house, techno, trance, jungle and drum 'n' bass to name a few, and DJs are both the composers of the sounds and the conductors of the crowds. A skilful DJ is able to not only produce the latest club classic, but is also able to manipulate the crowd until they physically cannot dance any harder,[33] something enabled by the ubiquity of energising psychoactive drugs such as cocaine and MDMA. These musical puppeteers clearly had a great deal of responsibility for maintaining the vibe of the club scene, but they also had a duty to not let their powerful status cause them to be seduced by the mainstream music industry. As Thornton notes, many clubbers felt a sense of disdain when their music appeared on the radio, for this signalled that their culture was being exploited by the mainstream music industry for capital gain.[34] Similarly, many members of rave culture were suspicious of the mainstream media in general, for it was viewed as a damning force which had the power to expose the whole scene and its secrets to those that sought to destroy it or enter it without the correct credentials.[35] Although the numbers within club culture were gradually swelling, as with most countercultures, members did their best to fiercely protect their environment to prevent 'them' from becoming involved. This is reflected in how events were publicised, or rather how they were not. Most communication was achieved via word of mouth or by sending members of clubs private invitations. Even when flyers were distributed they were often only handed out to those that 'looked like' they belong and rarely had full addresses printed on them; it was assumed that if you were die-hard, you would know where to go.[36] Interestingly, under the mandate of the Department of Trade and Industry it was illegal to license radio stations purely dedicated to rave, resulting in the establishment of many pirate radio stations, most notably KISS FM. Whilst giving ravers musical access in situations outside of the clubs, the countercultural platform ensured that the 'romance of the underground' was maintained[37] and rave music kept from the ears

of those external to the scene. Furthermore, this counterculture faced even more adversity, for under the Criminal Justice and Public Order Act (1994) police had the power to break up raves and arrest those in attendance. So, alongside the drugs, dance and decadence of the scene, there was also danger.

From the Margins to the Centre

So far in this chapter, readers have been introduced to some of the main contenders that constitute Britain's countercultural musical history. All deliberately anti-mainstream, these groups gained notoriety for the fact that they overtly revelled in their 'Othered' social status. However, as will now be seen, these communities have never truly been able to remain completely independent from the mainstream. The sentiment within this section is that rather than being completely antithetical, the countercultural and the mainstream are in fact inherently intertwined. As such, the mixing of these two spheres has culminated in what I have decided to call 'mainstream countercultures'.

According to Negus, 'the music industry frequently appears as a villain: a ruthless corporate "machine" that continually attempts to control creativity, compromises aesthetic practices and offers audiences little real choice.'[38] Similar thoughts can be traced back to Adorno, who argued that the advent of mass media created a purely profit-driven 'culture industry'.[39] For Adorno, such an industry is one of 'anti-enlightenment' and 'a means for fettering consciousness... imped[ing] the development of autonomous, independent individuals who judge and decide consciously for themselves.'[40] His assertion is that although the cultural artefacts we are offered appear to be artistically meritorious and innovative, what consumers are actually paying for is formulaic, cultural detritus which serves to sedate our minds.

For instance, the development and production of affordable technologies of storage such as the robust 7" single meant that bands could get their music and messages heard on a much wider scale, yet on a more intimate format, than ever before.[41] Between 1955 and 1975, the British record industry tripled its output and it is fair to suggest that much of the music on offer was of the rock or punk genres. Similarly, increased affluence meant that not only

could more people afford record players, but they were also able to purchase other musical technologies such as tape recorders and transistor radios.[42, 43] With modern broadcasting and pop music radio stations, you did not even need to leave the house to hear the latest songs.

The significance of radio is particularly important, for this market is undeniably competitive and broadcasters must strive to attract listeners. For one, the audience of a given radio programme or station will inevitably become static or shrink if the desires of listeners are left unsated and so there is an oscillation between musical diversity and concentration to be found on the radio.[44] During periods of diversity, broadcasters often depart from playing music that is considered as popular or *à la mode*, exposing listeners to new sounds and messages. In contrast, specialised illegal pirate radio already caters to the niche, but must be actively sought out.[45] KISS FM, once a pirate radio station solely dedicated to playing dance and rave music (then illegal in Britain), obtained a license in 1991 and its popularity even usurped Radio One, exposing the mainstream to the delights of club music.[46] This wider exposure to club music may have inspired people to make their own, akin to the DIY ethic of punk. According to Hesmondhalgh, soon after the mainstream popularity of dance music increased, so did home production, engendering a flourishing 'bedroom culture' in which individuals could make their own tunes rather than only being able to access music in the clubs.[47]

Evidently, changes in technology have greatly contributed to the amalgamation of the countercultural and the mainstream and this is a process which is still very much occurring today. The advent of cassette tapes and then compact discs meant that music fans only had to venture into their nearest record store to be able to access an even more vast array of music from all different eras and locales than vinyl had enabled. More recently, the rise of the internet and online technologies has also reconfigured the distribution and exposure of music. Digital MP3 files can now be uploaded and downloaded in an instant and so a whole world of music is literally at the fingertips of anybody with access to

a computer. Dedicated music streaming services such as Spotify and iTunes and video websites such as YouTube allow exposure to every music category ever to exist. Furthermore, BBC radio offers dozens of stations and broadcasts aimed at niche audiences including the Asian Network and 1Xtra which is solely dedicated to hip-hop and grime. Consequently, one can begin to see that the mainstream music industry is perhaps not so much the villainous figure that it is often perceived to be. It provides many public platforms, affording artists and groups the possibility of having a louder voice both at the height of their popularity and posthumously. A most notable instance of this occurred in 2009, when Rage Against The Machine's political anthem 'Killing in the Name' reached number one as a direct result of fan retaliation against mainstream popular music.

Thus, with their utilisation of mainstream culture, countercultural clusters can in some instances actually be considered as 'mainstream countercultures' and one contemporary example of such a grouping is Lady Gaga fans.

British Lady Gaga Fandom

Lady Gaga with fans, London

Lady Gaga is one of the most famous and successful American recording artists of the contemporary age, so what place does she have in a book about UK counterculture? Well for one thing, akin to US rock and punk and Spanish rave, her wares have been welcomingly imported and assimilated into British culture. Secondly, although undoubtedly mainstream in terms of commercial success, her background as a performance artist on the New York fringe has informed her music and values and so it can be argued that she has a distinctly countercultural voice. Third and finally, most scholarly work has focussed on the global impact of Gaga rather than honing her influence down to a single locale and so this book constitutes a prime opportunity to instigate discussion into the microcosm of British Gaga fandom. What follows is a discussion of Gaga's status as a mainstream

artist, progressing onto how her music, values and fans are also inherently countercultural, engendering the existence of a quintessential mainstream counterculture.

At the age of twenty-eight, Gaga is already one of the most successful recording artists of all time, selling over 23 million albums and 64 million singles worldwide[48] and having a ubiquitous presence on most media platforms. Indeed, this profitability and popularity is highly admirable, yet Lady Gaga's detractors may argue that such commercial success is purely driven by the need to generate capital rather than produce culturally enriching music. For example, Gaffney finds that many of her songs adhere to the expected conventions of pop music in terms of duration and structure and so seemingly lack musical innovation or originality.[49] In a similar vein, Lady Gaga-inspired merchandise constitutes a mind-blowingly huge revenue stream for the singer – one can purchase books, clothing, cosmetics and everything else in between. Furthermore, Gaga fans are amongst some of the most passionate in the world and Huba has dedicated an entire book to discussing how such devotion is the result of a highly successful profit-focussed business plan.

Regardless of such accusations, fans still flock to Gaga in their millions and a closer look at the woman herself and her fans paints a different picture than the one suggested by Huba. Regardless of her commercial success, at times even the mainstream media is unsure how to take her; from the infamous meat dress[50] and her arrival at the 2011 Grammys in a giant egg,[51] to a recent stage performance which saw the singer seemingly doused with lurid 'vomit',[52] Lady Gaga frequently courts controversy. Her past is coloured with instances of drug abuse and burlesque dancing and she is hailed as the ultimate postmodern figure, constantly amalgamating her experiences and influences and reconfiguring

her identity.[53, 54] Furthermore in an article featured in *Rolling Stone*, Lady Gaga is referred to as 'a pop star for misfits and outcasts',[55] an analogy that fans themselves openly agree with.

Lady Gaga with a fan

For example, fans have adopted the moniker of 'Little Monsters' and the immediate connotations of this title appear to uphold the notion that these fans are different to the rest of society. In her discussion of the semantics of the Little Monster name, Davisson argues that 'the monster figure teaches us about the boundaries of a civilised society by illuminating where such boundaries lie and functioning as an example of what happens when they are crossed.'[56] Thus, under the guise of the 'monster', the dominant ideology surrounding Gaga fans renders them as figures that should be contained or regarded with trepidation.

However, the monster title simultaneously refers to the fact that many fans already belong to marginalised social groups, such as the bullied and those of alternative sexualities that do not adhere to heteronormativity. The high proportion of fans that fit into these categories attests to how Gaga supports and welcomes into her community those who feel like social outcasts, for she has revealed that she shares similar experiences of feeling socially lost and isolated. Not only does Gaga herself identify as bisexual,[57] but she has also been incredibly open about how she suffered at the hands of bullies, who targeted her for looking and behaving differently to them.[58] As a result, many fans are drawn to her because they feel a sense of identification, and enjoy belonging to a group outside of the norm which helps them strengthen themselves and challenge the world. One only has to listen to songs such as 'Born This Way' and 'Hair' to realise that although commercially catchy, her music carries messages of empowerment and pride in individuality, sentiments British fans have ardently taken up. Gaga's popularity in Britain is phenomenal; she has sold out some of the country's largest venues, has performed with

some of the UK's biggest stars and has even met the Queen.

In looking at statistics collected from my previous research,[59] many British Lady Gaga fans indeed appear to be members of already existing marginalised social groups. The multiple choice survey questioned fans on a variety of topics, including their sexual orientation and reasons they were fans of Gaga and her music. Of the 200 respondents to the survey posted on Lady Gaga's official social network, www.littlemonsters.com, 65 (32.5%) hail from these shores, a particularly high proportion considering the fact that the website has a global audience.

Of these 12% identified as members of the LGBTQ community. This number is particularly interesting, for according to recent official government statistics, only 6% of Britons openly identify as such.[60] As such, the high concentration of members of this community alludes to the largely countercultural make up of this group in terms of marginalised sexuality.

Amongst the group, 16 participants (24.6%) stated that one of the reasons that they liked Gaga is that she made them feel proud to be themselves, resonating with Gaga's active promotion of self-love and pride in difference. Furthermore, 22 respondents (33.8%) were fans because they considered Gaga a creative genius, recalling to mind the argument that countercultural music challenges the banalities and lack of authenticity of standardised popular music; it is considered more complex, more textured and infused with emotion. One participant specifically drew attention to the fact that Lady Gaga is a classically trained pianist, implying that this aspect of her musical education is part of her appeal. Another fan described how they simply do not consider Gaga part of the 'pop machine'. Thus for these fans at least, Gaga is emphatically not the same as all the other blonde-haired singers currently topping the charts throughout the world.

On these shores, Gaga's profitability and popularity is evident, but what is more striking is her propensity for articulating the experiences and desires of her fans through her music, creating a solid, devoted community of fans who are united by their shared experiences of feeling like social outcasts. Furthermore, according to the opinion of British fans, her particular brand of

music stands apart from the banality and vapidity produced by other musical megastars, both in terms of its message and of her high level of creativity and musical skill. Through using her performance as a way to celebrate her 'otherness', Lady Gaga has created a following of 'Little Monsters' which is both within the mainstream yet sits in countercultural opposition to the attitudes and social norms which characterise mainstream society.

Conclusion

'Subcultures', 'countercultures', 'the underground' – are they really so easily separated from the rest of society and from the mainstream? Apparently not, as this chapter has attempted to demonstrate. In discussing some of the most iconic countercultures that Britain has borne witness to, it is evident that historically there seemingly has been the presence of a stringent 'us versus them' divide between these groups and the rest of society. The rockers, punks and clubbers have all in their own ways engaged in practices and promulgated beliefs that challenged the social status quo. But despite attempts by these groups to disassociate themselves from mainstream culture, the music through which they spread their subversive messages has still found its way into mainstream consciousness via commercialisation and technological change. Importantly, this has not entirely been to the their detriment. Rather than diluting or perverting their anti-hegemonic styles and stances the amalgamation with mainstream cultures has given them a louder voice and a wider audience. Thus, the voices of these groups are no longer restricted by a lack of exposure and the change or challenge they call for may actually be realised when enough people learn about their wants and desires. For rock fans, the wish was to prolong the exuberances of youth, punks wanted to shake up and shock British society and ravers wanted to escape. In the contemporary age, socially marginalised Gaga fans long for acceptance and personal pride, solace that they have discovered and can share through the music of their mainstream Lady. So, instead of maintaining a strict separation between 'mainstream' and 'countercultural', we should accept that they are not so antithetical at all, and that mainstream counterculture does exist.

NEGATIVE SPACE

Subculture in Boom-Time London

Tim Burrows

The plight of London's autonomous, perhaps underground spaces has received much attention in recent years – and for good reason. For many in this voracious city, it is as if a purge of a certain shade of London – the London that they had come here for – has been taking place around them, and a new city formed in its place, one in which the young might get pissed together watching *The X-Factor* on TV instead of going to a community hub such as the local music venue, because it's not there. London has become a shiny shopping precinct where something more radical once stood

The developers have moved in across the city, nowhere more than Soho, which is in the process of being remade due to Tottenham Court Road station's renovation as part of the £20bn Crossrail transport link that is being built to connect London's outer areas with its centre. The 12 Bar Club, which in its own way held the candle for London's Tin Pan Alley and the rich songwriting tradition attached to it, has been forced out of Denmark Street. Madame Jojo's on Brewer St, less fabled but still an important part of London's cabaret, drag

and indie scenes, has also been closed down. (In December 2014 the club lost its license after some reported violence. This set many tongues wagging, as it appeared to be a pretty draconian measure in the face of the violence of a single staff member.)

Plastic People, the club credited with incubating grime and dubstep and a centre of bass music since it opened on Oxford Street in 1994, and moving to Shoreditch in 2000, has also ceased to operate, choosing to bow out gracefully after years of wrangling with Hackney Council. The gentrification of Dalston and Hackney is spreading south to Deptford, New Cross and Peckham and anyone left looking for a radical, thrilling, or truly unexpected cultural experience will find it much harder today than a decade ago.

To chart London's change you might equally look at what has happened to *Time Out*, formerly the countercultural organ of the capital, which has in recent years become an uncritical supporter of property-boom London's increasingly middle-of-the-road culture. Founded in the radical apex of 1968, the magazine was once admired for its attention to countercultural happenings and literate approach to decoding the myriad events that were the DNA of London. But more recently, the print and online publication has devoted much space to the new London of PR-driven gimmicks and endless pop-ups – recent examples include coverage of Annie the Owl, 'London's first owl bar' and the opening of the Cereal Killer Café on Brick Lane, the capital's first cafe specialising in children's cereals such as Lucky Charms.

The publication therefore speaks to the unthreatening, consumerist, infantilised London that has come into being. But even *Time Out* is concerned now: in early 2015, its free-sheet print magazine splashed with a cover that read: 'Save London: Is the writing on the wall?' Inside, its editorial asked:

> 'Whatever happened to that filthy, perverse, sticky-floored city we used to stay up all night in? Recently the fun, the music, even the extraordinary ordinary people have been edged further out… a bonkers property market wants to turn the whole place into a piggy bank for overseas investors.'[1]

To which you might reply: too little, too late. But it is significant that even the new *Time Out*, which until now has largely seemed in support of Boris Johnson's vision for London as the financial hub of Europe, has voiced concern. It shows how far along the road we are. So far that it has become passé to suggest that the London that earned such kudos for its subcultural depth, its radical flavourings and the perpetual tension that its underground infused, has suffered under the financial centre's success. London's moneyed centre, the City, has been left apparently unaffected by the crash that was blamed on its bankers – more than that, it is booming, dictating the logic of the London that surges around it, while other towns and cities around the country languish in comparison in terms of unemployment and upward mobility.

The current state of things begs the question: how might counterculture be expected to survive when the requisite clubs, venues, galleries, bookshops, independent cinemas, community cafes and other locations needed to help it thrive dwindle all around us?

Endgame?

'The underground is DEAD,' my friend Justyna, a veteran of squat parties during the noughties, wrote to me when I put a call-out on social media for people's thoughts on London today.

> 'There are a few squat parties and events but they're run by people off their faces and charging too much money on the door ... the most interesting people are moving out of London because it's too expensive.'

Justyna has her ear to the ground but can't be bothered to go out as much as she used to:

> 'Everything is retrograde. Property developers have screwed London, the conservative culture – I know also that I am totally jaded and less up for trying things out – there are still cool things on in regards to grime and "urban" music that's the most real, but they're chasing paper too ... you have to if you live here I guess.'

Justyna and her boyfriend Robert are both active musicians and zinemakers, but feel London is not the place for them any

more. Like many others looking to participate in some kind of countercultural community, London has ceased to work for them. They are looking to move out in the next few years, perhaps leave the country and start afresh.

East London is an interesting case study. In 2012, I wrote an editorial for *Dazed & Confused* magazine. I pitched the piece as a look at the changing face of east London, at a time in which the area was changing in front of our eyes. The people looking to live in east London enclaves such as Dalston or Shoreditch were now brought in by chauffeured car, with hair coiffured for double figures. Reuters had reported that Shoreditch was on course to become a 'mini Bond Street" that would welcome luxury retailers eager to capitalise on its 'edgy image'. Property values in areas such as the gallery-strewn Redchurch Street had doubled in a decade, and high-end retail was moving in.

I talked to Pauline Forster, landlady of one of the oldest pubs in London, the George Tavern on Commercial Road, Stepney, who is still fighting the planners who want to build flats adjacent to the venue three years later. The battle is a common one, not just in London but in cities all over the world as apartments trump venues in the battle for space.

The culture we are living with is numbingly conservative: it isn't just the spaces disappearing, the looser strands of a culture that fosters the playful, antagonistic, intelligent discourse that comes with such spaces is in danger too.

The Stratford Rex (RIP)

Perhaps the last truly exciting musical genre to be birthed in these parts was grime – and one of its homes was the Rex down the road in Stratford, which has now closed down. The Rex was where MCs like Dizzee Rascal did the hard work before they got noticed. 'Before grime crossed over and everybody in the suburbs or Hoxton got into it, the Rex was really street with a proper council-estate buzz,' Diz said in 2007. But the venue has had a troubled life since its grime days, and closed in

2010. In recent years, cultural and racial profiling has impinged on grime and other shows that attract an audience deemed too much trouble by London authorities.

Supply and Demand: Inventing a Tribe

It might be said that demand outweighs supply these days when it comes to visible youth subculture. Style definitely still plays a big role in the life of young London, but it could be said that subcultural signifiers have become divorced from what was once their primary aim: to reject social values, the legal system, prevailing morality and the rest – see: teddy boys, mods, punks, mod revivalists, casuals, acid house ravers, grime crews. Tribes that did much to divide but which also gave Britain's urban and suburban kids a way of relating to each other and the wider world.

But not so much now. During a conversation I had in 2012 with Mark Fisher, the academic and cultural critic who blogs under the moniker K-Punk and who wrote the influential 2009 book *Capitalist Realism*, he observed that today, commercial sportswear has replaced the détourned and defaced stylistic appropriations of warring youth tribes:

> 'There has been a detribalisation of youth I think… There are no subcultures any more in a serious way. There are the older ones like goth, which is kind of residual, but you look around you and almost everyone wears a form of sportswear – you can have quite subtle and nuanced forms of identification.'

The history of subculture still appears in curated form on bodies traversing the fashionable drags of the capital. A brothel creeper here, a mod-era bob there, perhaps offset by a hyper-modern synthetic rain mac. It speaks to fashion's dominance over music in terms of cultural production.

You can't dance to a pair of Louboutins but then again you also can't download them either, which is why we see fashion move in to replace music as our generation's subcultural fuel.

The popularity of certain styles of clothing as visible signifiers of cultural leanings has fostered a constant need within the fashion industry to invent new forms. The latest to surface in the press is the 'nu lad', which riffs on the working class sportswear

fashions, that Fisher mentioned: all shaved hair and Reebok classics, that have been a hallmark of British culture for at least two decades.

The nu lad was at first given the unfortunate name 'chivster' by self-styled trend forecaster, LSN (Lifestyle News Network). 'With the chivster we started to notice a new aesthetic coming through blogs, niche magazines, graduate fashion shows and of course on the streets,' Peter Firth, a former journalist and now LSN's 'Insight Editor', told me. 'Right now sports and performance wear is on the rise, and we're reaching what I think is the first wave of nostalgia for the "chav" look of the mid-noughties.'

If the nu lad or 'chivster' ever did take off, it wouldn't be the first time that middle class kids have looked to the working class they feel estranged from in a kind of fascination (and maybe jealousy) for a supposed wantonness that cannot thrive among the strictures and etiquettes of Middle England. For LSN's Firth, it's this that fuels it. 'We are frequently shown a life through social media and mainstream media that is inaccessible to most of us,' he says. 'Maybe we need more angry young men and fewer people who are willing to roll over and accept things as they are so long as they can still afford to live in Dalston.'

The new London has played its own part in the need to create media personas such as the 'chivster'. The city has less and less room for those communal spaces in which genuine, often music-related subcultures have germinated in the past – abandoned warehouses, former cinemas, makeshift shebeens inside residential properties, fields: spaces that have inspired a kind of cross-class unity, last seen in its most intense form during the rave era. These are the places where real lives are lived away from the diktats of the mainstream media. Places where individuals can bask in a shared sense of freedom, knowing they have helped create a space or event of the kind they desire, not one that has been sold to them by someone else. The freedom of Eel Pie Island and the Roundhouse when it was an incubator of avant-rock and punk; the makeshift acid house venues such as Dalston's Four Aces club, a reggae club that evolved out of a former theatre, and Clink Street, housed on the site of the famous prison. When you

don't have those spaces, you don't have music-based subcultures, which has left the media and people like Firth filling the gap in ever more spurious ways.

You can't design a subculture from scratch, which results in the uncomfortable truth of what subculture is now becoming: a linguistically confused non-event dreamed up to persuade masses of people to prefix their social media posts with: 'So apparently this is a thing.'

Ours is an age in which new editorial ideas are served up by meetings cobbled together from statistics and so-called media trends. Guests attend 'Trend Briefings' in places such as the Future Laboratory in Spitalfields – a fortress in a flattened media topography, where LSN is based. There, aspiring brands and writers are served canapés of franken-words with a side order of pseudo-intellectual concept. Take your pick from 'fear marketing', 'the polarity paradox', 'the U-turn society', 'the sharded self' or the 'me-conomy', if you can stomach it.

Consider the etymology of the word 'hipster' compared with that of the 'chav'. The 'hipster' evolved out of the jazz age, 'hepcat' evolving into 'hepster', which in turn became 'hipster'. It was always allied with connotations of superiority in terms of cultural capital, evolving until the word was immortalised by Norman Mailer, who defined it as an 'American existentialist' bent on 'setting out on that uncharted journey into the rebellious imperatives of the self.'[2] The phrase was reappropriated around fifteen years ago to variously describe the perhaps more self-conscious but no less astute subcultures of Shoreditch, Williamsburg and beyond.

It's why the fusion of 'chav' and 'hipster' is a problematic one. The obvious way for the hipster to view the chav is from a lofty height. Where the disdain for the hipster may carry some kind of affection – we were all pretentious twats once, right! – the hatred of chavs is a mutated, 21st-century form of old-fashioned class snobbery. For me, the chivster, and now the nu lad, represent the triumph of the fashion industry over grass roots culture, something all those interested in any form of culture should lament.

Dissipation, Not Disappearance

The artist Laura Oldfield Ford has documented the decline of radical London since she started her zine *Savage Messiah* in 2005. Laura's work in her zines and on show in places such as Hackney's Space gallery was once inseparable from her east London surroundings, a protracted dream set to paper of the area's subcultural wilderness – a wilderness in the process of being cleared for London Olympics 2012. But more recently she has wandered the further reaches of London's edges – suburban enclaves such as Croydon, Hounslow, Surbiton and Kingston – to take another look at London, away from the aggression of the inner-city property boom.

Oldfield Ford thinks the spirit of countercultural, radical London hasn't disappeared entirely – it might be better to say that it has dissipated, and often in quite surprising ways:

> 'In the areas that I have been spending a lot of time in like Hounslow and Croydon, and all the way round London – Edmonton, Barking, Lewisham – religion is at the forefront. The big African church communities, the mosques, the Catholic church with the Eastern European populations. A lot of it is to do with the absence of the left; a lot of these places are standing in where the left would have once had a robust community, it would have been there to support people, fight for people and create a sense of solidarity and support.'

Oldfield Ford points to the dwindling number of radical bookshops that were once small but vital hubs of countercultural and left-wing life in London as just one example of the absence of critical, creative space in the capital:

> 'There used to be those radical bookshops all around

London – now there's only Housmans [in Kings Cross]. There used to be loads around Brixton, Dalston. They're not there now. There are more Christian bookshops. But there is an emancipatory potential in spirituality. It can transcend the very individualistic, Darwinian nature of capitalism. The feral nature of it. Religious sects form the kernel of a lot of radical movements … People shouldn't despair just because people are articulating these things through religion – it's not always such a big leap.'

The point is an interesting one: once, religion would not have occurred to Laura as something young people might be interested in, but in seeing the truly democratic, fertile squat, rave and punk scenes recede around her, she's recognised similarly enriching qualities in other areas that she might have once avoided.

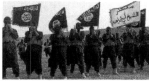

An extreme example of how religious fervour might be said to have attracted the attention of a young fanbase are the scores of teenagers leaving the UK to fight for ISIS, which former chief crown prosecutor of the Crown Prosecution Service Nazir Afzal recently labelled, 'Jihadimania', saying, 'The boys want to be like them and the girls want to be with them. That's what they used to say about the Beatles and more recently One Direction and Justin Bieber.'[3]

Islamic State insurgents in Iraq

But of course there is a crucial difference. ISIS is offering an opportunity for those who view themselves as outside the mainstream and at odds with contemporary Western values, to join an apparently exciting movement and with a clear purpose – the defeat of Western imperialism and supposed decadence through violence justified by religious extremism. Although seen as subversive by Western governments and the Arab League of Nations, fundamentalist religious groups such as ISIS are often highly regulated organisations, with strict rules of behaviour. It goes without saying that whatever ISIS actually is, the opportunity for glory in bloodshed it offers disaffected youth is the opposite of the kind of expansive freedom that you might have once

felt within a radical, Western subculture. But the root of this impulse is bound to be similar: the desire for transformation, for communality, and perhaps above all, for danger.

Risk-aversion and Riots

In the UK, music venues are fewer and further between and when they do exist, more tightly controlled. Mark Ellicott, general manager at London's much-loved LGBT nightspot and medium-sized music venue, Heaven, and former manager of the Astoria, which closed in 2009, says:

> 'Venue operators now alas have almost exclusively turned live music venues into this antiseptic, polished thing where you are watched over by a phalanx of stewards and door supervisors so it's almost like being in a school assembly,'

Ellicott himself was a veteran of Cramps gigs at the Hammersmith Palais, and he despairs at the onset of polite concerts in venues where you are expected to sit down and be quiet.

> 'It's not so easy to be yourself when there are dozens of eyes monitoring your every move and where CCTV cameras are mounted all over. Operators, so fearful of any risk however improbable, have just taken the fun out of gig going. They've forgotten what being young is all about. Sometimes it needs to be a bit dangerous!'[4]

With a dwindling in countercultural space, the home has absorbed much of our late-night frivolity now. But the YouTube-fuelled shebeen back home after the pub should not be discounted. It's often a site for furious, energetic conversation and dance. But it is not usually a situation that offers the happenstance of the chance conversation and the mixing of people from different backgrounds. Smartphone-fuelled social media offers freeing aspects to the individual, but could be said to narrow the web of people we engage with to include only those we have handpicked. The advent of internet choice means that different groups move ever more separately.

At no event in recent times has the potential for smartphones to unite people been so evident as in the London riots in 2011,

when Blackberry Messenger played a key role in communication between potential looters. It was suggested shortly after the riots happened that a lack of places for kids to go was a contributing factor in what happened, but only by a minority of commentators. For possible causes some pointed to the decline of spaces such as music venues and youth centres where young people could get together and let off steam, dance and get high or just do what they liked in a designated environment. Even if you (somewhat cynically) deemed the riots to be a pure articulation of greed riding on the back of the shooting of Mark Duggan, the looting of chain stores told its own graphic story of how youth might articulate themselves in the future. In many ways, it was an indicator of how the articulation of dissent can't be separated from consumerism any more.

But that doesn't mean to say that you can't articulate a spirit of resistance within the tight confines of our product-swamped age. There are indications that the reclamation of commercial space might spur new forms of subculture in future, inviting improvisation in the face of adversity.

Westfield, Shepherd's Bush

If you live in London for any other reason than to make money, in the last ten years you will have seen the city redesigned around you, for people who aren't you. Of course by now we know the culprits well: London 2012, offshore property developers, a Mayor who posits the consumer industry as the solution to all the city's ills. Indicative of this New London are its two Westfield poles. The one at Shepherd's Bush in the west, and the bigger, even more popular one at Stratford City in the east.

The sleek interiors, mood lighting, ease of access and hundreds of boutique shopping experiences on offer at Westfield Stratford City attract thousands daily. Three years after it opened, the scale of the place remains daunting. To wander round the vast, empty landscape that surrounds the mall is to be within an archetype of dystopia so overblown you almost cringe at the barefaced

nature of it. Tellingly, though there are signs directing you from the shopping centre to places further afield – central London, Leytonstone, Leyton, Stansted airport – there are none pointing you towards the older end of Stratford, towards the old town hall or the 1970s-built Stratford Centre. It is as if turbo-charged, 21st-century London would rather not know about the old Stratford, because it has invented an entirely new one.

Reclaiming the Stratford Centre

Walk into the Stratford Centre and the old shopping precinct is a world apart from Westfield. People predicted that it would close as soon as the giant opened, but it has survived, and has become a 24-hour hub of the community since. Through the evening and into the night, it houses a community of skaters, dancers and body-poppers. It's like being in an 80s version of the future, a reclaimed space next to the over-managed Olympic Queen Elizabeth Park and the consumer security zone, Westfield. It tells a story of London that might not be told through the official channels, who have hyped up the new developments.

The central hub where everybody skates and dances looks like a miniature version of any British high street, with JD Sports, H. Samuel, Claire's Accessories, Dorothy Perkins, Thomas Cook, Carphone Warehouse, an independent jewellers, a pharmacy and a linen shop. Looking around at the livewire scene, it feels like The Warriors as imagined by JD Sports' marketing team.

At night, the space opens up. Skaters like Isaiah have been coming to the centre for over five years. As the centre is a public thoroughfare they're allowed to come and go as they please. 'I heard you could skate until one in the morning,' he says. 'Practice new stuff, just skate. It's 24 hours. Some skaters leave at 4am.'

The Stratford Centre at night

Isaiah and other skaters I talk to say that it's necessity that has brought them here, night after night.

'Most skate parks are more designed for BMX people. It's so smooth here and you are actually allowed to skate – it's

open, there's space, so it is so much easier for skaters in general to enjoy themselves.'

Isaiah comes from Catford in South East London. His tall, slinky mate in a sweater with the dog from US comedy *Family Guy* on it and matching grey joggers comes all the way from West Wickham in Bromley, Kent. 'All the skaters just come here to hang out and chill – it's the only place like it,' he says. 'This is nothing,' he continues, gesturing to the scene around him on a Monday evening. 'On a Friday, there's about sixty people. Skaters, dancers, people taking pictures…'

The Stratford Centre is like no shopping centre I've ever seen, in that security generally leave the skaters alone in a state of semi-tolerance. Such is the unexpected life of the place, the skaters receive a generally good reaction and regularly get people coming up to them, congratulating them, taking photos, shaking their hands. 'It happens all the time,' says Alex, from Romford.

'The majority of them are usually drunk. People come up to us and ask us about the place, ask why we skate here. They really appreciate it; some people stand there and will watch you for a good twenty minutes.'

You get the feeling that if there were a better place for these people to go and hang out, they would. This is making do, but they're still grateful. 'Skating is a passion for a lot of people,' says CJ, who until recently worked as a labourer but is now unemployed. 'Here it's covered. There's no rain. I come every day, I leave just before midnight. It's my passion.'

The skaters' presence does attract police attention. Says Alex:

'During the week, Monday to Thursday, they just bowl about. But on Fridays there are about twenty walking up and down. There was one guy who got arrested a few weeks ago for mouthing off to them. The police kicked him to the floor because they said he had a knife. He didn't have anything on him in the end.'

By the side of the entrance is a notice for the dispersal of groups and people under 16, reminding you that the centre is still being fought over. Anna Minton is the author of *Ground Control*, the 2009 book that did much to push the crisis of public

space into the forefront of the discussion about London. For her, Westfield represents the securitisation of land that has fast become the norm in cities over the world.

> 'What has really characterised a city like London over the last ten years or so is that every single pocket is now up for development. It's got a very high property value. The empty spaces in the city, which are always the creative spaces, are less and less.'

The existence of places like the Stratford Centre, then, is quite precarious. As Minton says, 'There is so little of the city left where people can express themselves and reclaim the space.'

There is a persistent lament regarding the lack of subcultures. We mourn the passing of legitimate street culture and music scenes. People say: 'It's gone – those days are never coming back.' But what is obvious is that the lack of public space or affordable property for music venues, youth clubs and the like, has been decisive – places in which young people felt safe from authority, in which community could foster, in which art is made, that encourage an organic creativity.

If youth is squeezed too forcefully, some will try and reclaim their territory. It's what has happened at Stratford. In a sense it was in part responsible for the ferocity of the London riots. The primacy of real estate over real-life experience is the story of London 2015, but it's hard not to pin some hope on the impulse of the Stratford kids. That they articulate their resistance in the midst of commercialism is thrilling, and yet somehow inevitable. This is a different city to the one in which a contiguity of subcultures nestled and burned from the 1950s. When punk happened, much of central London was an abandoned shell. The claustrophobia created by the over-fed city that has grown since has led to the appearance of less visible margins within its fabric. It's from here that the young might imagine another kind of world, where new ideas can live and breathe, and new subcultures might form.

THEATRE

A Radical Loosening of the Fabric of Drama: Countercultural Performance from the 1960s to Contemporary Experimental Theatre

Dr Tim Garrett

Classic *Punch* cover with Mr Punch and his dog Toby

Subversive theatre has always existed, or at least for as long as plays have been written about or transcribed. From satire in Ancient Greece to folk art, puppetry and carnival, there has always been a strand of performance that exists to question, challenge and poke fun at the status quo. The variety of trickster figures that emerged in travelling puppet shows across Europe attests to the need for a character and mode of performance that challenges the established narrative about the nature of humanity, about what is moral or immoral, about power structures, status and the place of the individual in society. But for much of European theatre history, these subversive figures – Guignol in France, Kasperl in Germany and Austria, Pulcinella in Italy and Mr. Punch in Britain,

271

among others – were consigned to 'low' folk entertainment, a world away from the 'high' art of the theatre. This all changed when a generation of modernist theatre makers and theorists adopted the puppet, along with other primitive or low culture practices and devices such as mask work and 'wild' dancing, and brought them into the theatre. Though experimentation was central to the practice of modernist theatre makers, this championing of the puppet was not just a shot in the dark: they were inspired by Heinrich von Kleist's seminal essay of 1810, 'On the Marionette Theatre', which, as Segel suggests, sought to '... explore the possible contribution of "low" or "popular" culture to a reanimation of "high" art.'[1] The project of the modernists was a remaking of art, music, literature and theatre. Behind this was a desire for access to deeper moral, personal, political and cultural truths, and to achieve this they returned to first principles of theatre, both Western (the Greeks) and 'primitive' (everywhere outside of Europe – a more positive continuation of the 19th century's Orientalism). Christopher Innes explicitly links the modernist avant-garde with the countercultural work of the 1960s as he furthers this concept:

> 'In avant-garde drama, as the widespread use of a term like "theatre laboratory" in the 1960s and 1970s indicates, primitivism goes hand in hand with aesthetic experimentation designed to advance the technical progress of the art itself by exploring fundamental questions.'

Here he quotes Peter Brook's programme notes from his 1968 production of *The Tempest* (which in turn draw upon the work of Grotowski):

> 'The questions are: What is a theatre? What is a play? What is an actor? What is a spectator? What is the relation between them all? What conditions serve this best?' On this level, the scientific ethos of the modern age parallels the return to "primal" forms, equally signalling an attempt to replace the dominant modes of drama – and by extension the society of which these are the expression – by rebuilding from first principles.'[2]

This chapter analyses the extent to which UK theatre makers were truly able to go back to first principles, and create a countercultural theatre worthy of the name.

The counterculture of the UK most closely mirrors that of the United States, and there has been a significant amount of cross-pollination, though the differences are pronounced enough that they must be judged as discrete cultural worlds. Within the UK scene, what exactly constitutes countercultural work is still contested; countercultural theatre can indeed be seen as a 'movement' in that it shares a number of key ideals and imperatives, but the methods by which the work has been produced are varied, most notably in how radical and avant-garde they are. For one strand of countercultural theatre practitioners, the constraints of 'traditional' theatre needed loosening; for others they needed to be completely revolutionised. At its most anti-authoritarian, the counterculture called into question the modes, practices and hierarchies of 'traditional' theatre, in particular the concept of the well-made play, the carefully constructed three-act, tightly-plotted form with the requisite number of twists and climaxes; the insistence on character, and specifically character in situation as the driving force of drama; the Stanislavskian focus on the process of creating and embodying that character; and the notion of a hierarchy within the creative process, beginning with the idea in the mind of the author and ending with the actors performing the director's vision of the text. Much of the work produced in the UK was countercultural in content if not in form.

In North America, the concept of a break with much of theatre's history was perhaps not so much of a wrench: in the UK, the land of Chaucer and Shakespeare, a culture whose greatest export has been the written word, a theatre which did not revolve around the text was harder to imagine. So in this country, the theatrical counterculture would express itself in two strands – those who practiced it from within the more traditional forms of theatre, and those who came to theatre and performance from more diverse backgrounds, and operated more on the fringes.

Beginnings

In 1955, Peter Hall had been given the Arts Theatre in central

London to run and his world premiere in English of Beckett's *Waiting for Godot* opened many people's eyes to a theatre beyond the naturalistic, well-argued pieces, beloved of Oscar Wilde, George Bernard Shaw (and even John Osborne). They were introduced to something looser and more reflective of the changing, disorientating modern world. The critics were largely negative about *Waiting for Godot*, but Kenneth Tynan[3] wrote that the play forced him to '... re-examine the rules which had hitherto governed the drama; and having done so, to pronounce them not elastic enough.' Beckett's plays inspired much of the innovative work that was produced in the 60s and 70s by writers such as Harold Pinter and Edward Bond.

Charles Marowitz was an American actor, critic and director who arrived in Britain in 1956 and introduced improvisation and method acting techniques from the New York Actors Studio to London. He wryly explained, 'Having proved myself a failure at drama schools both in New York and London, it seemed the most natural thing to set up an acting school of my own.'[4] His focus on new writing and deconstructing the classics, by editing and re-arranging the text, was instantly challenging to the traditional theatre of the well-made play and gained him a certain notoriety.

Marat/Sade cover picture, 2001 paperback edition

His provocative bent was further shown when he collaborated with Peter Brook in directing the Royal Shakespeare Company productions of Weiss' *Marat/Sade* and Genet's *The Screens*. Those led on to a 1964 Antonin Artaud-inspired Theatre of Cruelty season, an effort to rediscover theatre's savage roots and find new forms of expression.

In 1968 he became Artistic Director of the Open Space Theatre (with Thelma Holt) taking over a disused old people's home at 32, Tottenham Court Road in central London. He went on to produce

many plays there, remaining for over a decade, such as *Fortune and Men's Eyes*, in which he memorably created the experience of entering a prison by having the audience 'frisked' on arrival by actors playing prison guards. Other premieres included plays by Joe Orton, Samuel Beckett, Sam Shepherd and Howard Barker. In what are now seen as ground-breaking productions:

> '... he staged a "black power" *Othello*; a feminist *Taming of the Shrew*; a "Freudian" *Hedda Gabler* (in which Hedda rides her father around the stage, thrashing him with a whip), and a *Doctor Faustus* with the title character based on the atomic scientist Robert Oppenheimer.'[5]

Holt went on to run the Roundhouse, which became the London base for the Royal Shakespeare Company, the Lindsay Kemp Company and Manchester Royal Exchange among others.

Prior to teaming up with Marowitz, Peter Brook had been directing at the Royal Opera House in Covent Garden, staging a controversial 1949 production of *Salome* by Richard Strauss (1905) with sets designed by surrealist artist Salvador Dali. He directed many notable productions of Shakespeare's plays, including his landmark, Tony award-winning production of *A Midsummer Night's Dream* for the RSC (1970), which was set in a white box and included the novelty of actors doing circus tricks.

Brook is probably the most well-known of all those who began experimenting with theatre in the 1950s in Britain. However, his decision to base himself in Paris at the Bouffes du Nord Theatre in the 70s to develop a more international, multicultural and artist-based theatre laboratory, deprived the UK of the influence of one of the most imaginative directors of the 20th century. Brook's deconstruction of the process of theatre and imaginative visual imagery has led to continual experimentation during the several decades in which he has been exploring the craft, with celebrated productions such as *The Mahabharata* (1985), *The Man Who...* (1993) and most recently *The Valley of Astonishment* (2014).

> '... the most rewarding aspect of all theatre is when, in an extraordinary way, the audience also becomes more sensitive than it has been when it's in the foyer or the street. That is what, to me, the whole of the theatre

process is about. In big buildings, in small buildings, in the open air, in cellars – no matter where – with plays, without plays, with a script, with improvisation, no matter – it is about giving everyone who is together at the moment when there's a performance, a taste of being finer in their feelings, clearer in their way of seeing things, deeper in their understanding, than in their everyday isolation and solitude. That's all the theatre has to offer, and if it happens it's a great deal.'[6]

Brook's lasting influence on other theatremakers around the world, including the UK's Simon McBurney and Katie Mitchell to name but two, has been phenomenal. Even the critic, Michael Billington, not generally known for his championing of 'alternative' work, writes in the *Guardian* of Brook's astonishing legacy, that he:

'… helped us to banish everything from the stage that is physically superfluous and to embrace the exciting provocation of an empty space. He has also taught us that the theatre of the future depends on cheap seats, a shared experience, a communal joy. He has radically influenced the way we look at Shakespeare: after Brook's *Lear*, with its train of riotous knights, it became impossible to ever again see the play as a black-and-white affair about a good king driven mad by evil daughters.'[7]

First Flowerings

One of Peter Brook's major influences was the actor, writer and director Joan Littlewood. Perhaps the most radical of the alternative theatremakers of the 1950s, Littlewood's communist sympathies led to her being kept under surveillance by MI5 for over a decade. She toured the country with her company, Theatre Workshop, from 1945 to 1953. The idea of a workshop, a collaborative space where artists operate as equals and are given space and time to develop, goes back to the Arts and Crafts movement, and the swirl of socialist ideas of that period. The workshop continued to be associated with egalitarian ideals, and it was when Littlewood's company stopped touring in 1953, and took a lease on the Theatre Royal, Stratford East, in London, that

a recognisably countercultural ethos emerged. The theatre had been left derelict, and when the impoverished company moved in it became their home as well as their workplace. The performers and crew slept in the dressing rooms, cooked for each other on a rota and in the process of making shows, also renovated the theatre. Essentially, they lived as a commune: an idea that would gain traction as the 1960s dawned.

The Theatre Workshop is actually a very instructive case study to analyse, as its progress reveals much of the peculiarly British angle on the counterculture. First, it comes from a place that, if not quite the mainstream, still embodies a very traditional British form of theatre: text-based, in a traditional venue, a group of actors led by a director, performing plays. Where international and particularly American countercultural theatre-making seemed to leap in at the deep end, British sensibilities seem to be so rooted in language and tradition that there was not always a clear break between the theatrical establishment and the counterculture, the mainstream and the fringe. Companies working on the British stage in the 1960s also had to contend with some archaic legislation in the form of the Theatres Act 1843, which effectively prohibited improvisation, with all scripts having to be submitted for approval to the Lord Chamberlain's Office (the law was eventually repealed in 1968).

As Littlewood's process changed, and the working methods included more improvisation, the company began to fall foul of this regulation. They were twice prosecuted and fined for deviating from the approved script when members of the company improvised during a performance. The company had staged some countercultural plays, such as Brecht's *Mother Courage and her Children* (written with a fiercely pacifist message to counter the rise of Nazism and Fascism), which

Littlewood directed and (on the insistence of Brecht himself) starred in. Perhaps the high point, where subject matter and working method combined to greatest effect was *Oh! What a Lovely War!* in 1963.[8]

The company based its work on a radio musical broadcast by the BBC, but took the script and divided the scenes amongst cast members who, having learnt it, then had to return and perform the scene but in their own words. The cast also took it upon themselves to each learn about a different theme or event to do with the war, and then teach the rest of the company about it. This kind of engagement, with the performers exploring the dramaturgy for themselves, and the different sensibility this inevitably brought to the process and performance, was quietly revolutionary. Eyre and Wright contend that while Littlewood may have had a background in European and classical drama, and did not disrespect writers,

> '... she had a contempt for "text" – she hated the notion of what was said and done on stage being inert or fixed. She believed in "the chemistry in the actual event", which included encouraging the audience to interrupt the play and the actors to reply – an active form of the kind of alienation that Brecht argued for but never practised.'[9]

Littlewood's perception, about the 'chemistry in the actual event', above and beyond the words or characters that tended to form the foundation of most theatrical events, was mirrored in the thinking coming out of the counterculture companies in the United States. Arthur Sainer, describing Living Theatre's production *The Connection* of 1959, tells of how the show '... fluctuated, in the subtlest manner, between performers performing and performers not performing, between performers making character and performers being selves.' For the first time, the audience was given a performer 'offering self rather than character', and the crucial element was not so much the 'absentness of character but... the presentness of performer.'[10] As the 1960s progressed, this rejection of character-driven, text-based work, and the championing of something like Brecht's theory of alienation, but with echoes of eastern-influenced

attitudes to being-in-the-body and mindfulness, became integral to the ethos of the counterculture.

It is said that history is written by the victors, or perhaps it would be more accurate to say it is written by the survivors: Eyre and Wright put it even more starkly,

> 'History favours those who write things down. Why are the theories of Brecht and Stanislavsky so remorselessly picked over? Answer: because their ideas are codified and can be studied and set for exams. Littlewood's productions defied study: their legend lay in their spontaneity.'[11]

The study of any kind of theatre is more complicated than that of film or music, because of the kind of artefacts it leaves behind. For most of its history, the study of theatre has been the study of play texts, which is problematic because the text alone can never capture the theatrical experience, and also because the fact that historically the text is what has been studied gives the false impression that the text is the most important element to study. Much countercultural work was not based on a text, and produced no text. From this perspective, Littlewood was lucky to make it into histories of British theatre, even if what is left behind is a pale reflection of the original.

Though British theatre of the 1950s had seen interpreters and innovators such as Hall, Brook and Littlewood at the forefront of a movement that was pushing the boundaries of what theatre could be, the 1960s were to prove even more radical, both in form and in content. The makers of the 1960s counterculture were, by and large, drawn from the generation known as 'baby-boomers', and anyone with any knowledge of post-war social history is well aware of the ubiquitous narrative of a childhood in a rather colourless, conservative, conformist world, followed by an explosion of life and colour sometime around 1964.[12] With hindsight, one could also argue that the 1960s were in some sense a fulcrum between the modernism of the turn of the century, and the post-modernism that was fast approaching: Auslander (1997) posits the emergence of post-modernism, for theatre at least, as occurring sometime in the 1970s. Having thrown off the shackles of what came before, and not yet shackled to post-

modernism, the freedom of the 1960s could be attributed at least in part to this interregnum. It is well established by writers such as James Roose-Evans, Christopher Innes and Margaret Croyden that the countercultural work of the 1960s owed a great deal to the experimental theatre of the modernists, with influences both direct and indirect. We should also be mindful of Baz Kershaw's injunction to assess the radical theatre of the 1960s on its own merits, and not 'link some or all of the new theatre movements too forcefully to the historical avant-garde of the early twentieth century.'[13] However strongly one links the countercultural theatre of the 1960s to what came before, and to what it became in the decades that followed, it cannot be denied that there was something special about the 1960s – 'Something in the Air', as Thunderclap Newman had it.[14]

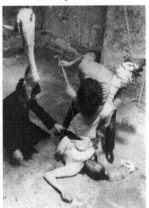

The People Show No. 1:
Syd Palmer, John Darling and
Mark Long.

The People Show No. 33:
Laura Gilbert and John Darling.
1969, photographer unknown

The leading light of the British theatrical countercultural scene of the 1960s was the People Show, founded in London in 1966 by Jeff Nuttall, John Darling, Laura Gilbert and Mark Long, and still going strong. As the name suggests, it puts the performer's self at the heart of the performance, and the subject matter comes from the dynamic of those assembled for the piece. Working with a selection of core company members, and often inviting associate artists to contribute to the mix, each show is assigned a number

rather than a name. They are now up to show number 128.

Their work initially resembled that of the Theatre Workshop in that the shows were scripted but with room for improvisation. Very soon the defining features became obvious:

> 'The space was of paramount importance to the creation of the show; the show came from the space. After the first year, abandoning scripts, the group started to improvise shows – image-based, visually structured shows – establishing a riskier, more dangerous relationship between performers and audience, and each other.'[15]

The People Show No. 53, 1974: Mark Long and Mike Figgis

It is interesting to note some similarities between the composition of, and inspirations behind the work of the People Show and that of the Artist's Cabarets that came about during the *fin-de-siècle*.[16] Both involved groups of people whose routes into performance were not via the theatre: performers, visual artists, musicians, writers, puppeteers and scenographers who wanted to make something, but outside the traditional boundaries and hierarchies. Whereas the Theatre Workshop had a strong director at its helm, the People Show was, like the Artist's Cabarets, intentionally non-autocratic. Another important element was the inter-disciplinary nature of the company: something was gained, not lost, by having a performer research like a dramaturg, or a scenographer perform a song. Finally the demotion of text from its exalted position, and the championing of the visual, marks out the People Show as a group as emblematic of the avant-

garde and experimental theatre in their founding era, as the Artist's Cabarets were in theirs. There are perhaps two important areas where they deviate, and these may illuminate something of what made the art that emerged in the 1960s counterculture unique. First, the question of improvisation. We do not know to what extent experimental theatre groups at the turn of the 20th century, such as the Artist's Cabarets, used improvisation. Though the ambience was intentionally sketchy, and no doubt many of the compère's remarks would have been off the cuff, there was an elemental structure to cabaret performance that is at odds with the kind of free-form work that originated in the 1960s. Secondly, and very importantly, the question of how the show was developed. In the countercultural theatre of the 1960s, the answer increasingly lay with the practice of devising as a means of generating performance.

The People Show No. 128: Founder member Mark Long and long-term member George Kahn

The practice of devising performance was initially taken up with more vigour in the United States. Starting with Julian Beck and Judith Malina's Living Theatre company (founded in 1947), collaborative creation – as it was called there – became the *modus operandi* of countercultural theatremaking. In this instance, the shorter theatrical history of the United States worked in its favour: new styles and working methods could spring up and find space to perform, without the oppressive weight of theatrical tradition. Even the innovations of the European modernists, which in so many ways prefigured what performance was going to become in

the 1960s, seemed remote and disconnected from the experience of many American theatremakers. As Sainer explains:

'Grotowski had just begun to happen in 1959, but he was in Poland and unknown to us. Artaud had happened in the 20s and 30s, but in the early 60s he was barely more than a name. Meyerhold had happened in Czarist and then post-revolutionary Russia some fifty years earlier, but he was encrusted in legend.'[17]

Andreas Huyssen corroborates the relative cultural isolation of artists in the US:

'Neither Dada nor surrealism ever met with much public success in the United States. Precisely this fact made Pop, Happenings, Concept, experimental music, surfiction and performance art of the 1960s and 1970s look more novel than they really were. The audience's expectation horizon in the United States was fundamentally different from what it was in Europe. Where Europeans might react with a sense of *déjà vu*, Americans could legitimately sustain a sense of novelty, excitement and breakthrough.'[18]

In the UK, the theatrical establishment remained much more powerful, both at the commissioning stage, and in its reception of revolutionary, countercultural work. Though critics eventually lauded shows such as *Oh! What a Lovely War!*, it was one of the few examples of countercultural work in the UK deemed worthy of serious critical appraisal. Celebrated poet and author Phyllis Hartnoll (writing in 1968) describes the situation of the new groups emerging onto the countercultural scene:

'... living from hand to mouth, exploring new techniques, providing their own scripts, working wherever they can find a roof over their heads, or even in the streets and parks. They can be found in cellars, disused chapels, warehouses, and, like the famous La Mama group, in cafes; in pubs, wine bars, and even, as at New End, London, in a converted mortuary. Through their combined efforts they are breaking the mould of the formal theatre, and, with improvisation and Collective Creation, lessening their dependence on the playwrights, to whom, and

to their audiences, they offer an entirely new concept of theatre.'[19]

One benefit of this was that it enabled these companies to 'side-step the disciplinary structures represented by the physical and social architecture of theatre buildings and other kinds of arts emporia.'[20] As the 1960s wore on and the 1970s dawned, it became increasingly obvious that the power centres of British theatre were not going to be infiltrated, and in this sense the theatrical status quo was not going to be seriously challenged. But in a way this just cemented the countercultural credentials of the work that was emerging – as a true opposition to the accepted notions of what constituted theatre. As Jeff Nuttall, one of the founders of the People Show, put it: 'All over Europe, America ... artists, creative people stepped aside into a deliberate sell-it-yourself amateurism. This was the beginning of the underground.'[21, 22]

Political Theatre

What in the 1960s had been called variously fringe theatre, experimental theatre, alternative theatre or underground theatre blossomed as the decade turned, and expanded into, as Baz Kershaw lists,

> '... a plethora of innovative practices [which] could be grouped around these broad headings, including community theatre, grass roots theatre, feminist theatre, women's theatre, lesbian theatre, gay theatre, queer theatre, black theatre, ethnic theatre, guerrilla theatre, theatre in education, theatre in prisons, disability theatre, reminiscence theatre, environmental theatre, celebratory theatre, performance art, physical theatre, visual theatre and so on.'[23]

Perhaps notable in its absence from Kershaw's list is one that many might think of, when asked for a defining theatrical trend of the 1960s/1970s – political theatre. There is a very good reason for this: Kershaw would argue (correctly, I think) that all these forms of theatre are political theatre. The 1960s was, after all, the decade when the personal became the political, and a common feature of all the work discussed so far has been

both an 'inward-looking' search for greater truth in performance, through the presence of the performer, and an 'outward' social conscience. As Eugenio Barba has it, 'Our craft is the possibility of changing ourselves, and thus changing society.'[24] Interestingly, there tends to be an implicit message contained in the term 'political theatre' – that the theatre so named will be left-wing. It has been argued that the propaganda, paraphernalia and pomp of the Nazi Party could constitute a form of right-wing political theatre, its aesthetic and methods a form of radical performance: 'radical performance encompasses left- and right-wing politics. Broadcasting the Aryan ideal to the masses... the 1934 Nuremberg Party rally is a paradigm of street theatre as media opportunity.'[25] In practice, 'political theatre' tends not to disassociate itself from its roots as an outsider's theatre – that is to say, a theatre for those outside the established power structures. From the subversive puppet show to the avant-garde's assault on what was perceived as the safe and self-congratulatory theatre of the bourgeoisie, political theatre has with greater or lesser openness challenged the political status quo. In Russia, agitprop theatre was used to further Marxist ideals; in Germany, Brecht developed Piscator's idea of the epic theatre into a means for shaking the audience out of its preconceived notions. Brecht was an inspiration for Augusto Boal, whose Theatre of the Oppressed became very influential in UK alternative theatre circles. The Living Theatre's production *The Connection*, discussed earlier, draws heavily on Brechtian ideas. Some of the aims and methods of political theatre can usefully be analysed through Bakhtin's notion of the carnivalesque. Mikhail Bakhtin, who was active in the 1920s but rediscovered in the 1960s, put forward the idea of the carnival as a counterculture archetype which embodied contradictory elements of comic, tragic and the grotesque, a 'dialogic' model which challenged classical, authoritarian 'monologism'. Innes argues that this Bakhtinian notion of the carnivalesque is central to avant-garde drama:

> '... in particular its emphasis on stage production as process in opposition to the fixed art-product of classical aesthetics; and the fusion of actors and audience,

breaking down the barriers between performance and
reality to create a communion [sic] of (in theory at least)
equal participants.'[26]

The most obvious UK company to mention here is Welfare
State International (founded in 1968 by John Fox and Sue Gill,
Roger Coleman and others) whose work encompassed site-
specific theatre, lantern processions, carnivals and festivals that
were artist led and engaged with communities in their native UK
and across the world. A statement on the company's philosophy,
issued in 1999, encapsulates this: 'We design and construct
performances that are specific to place, people and occasion.'
Welfare State bowed out in 2006, but its influence is still felt in
grass-roots and community-orientated and -originated political
work. The carnivalesque is also in evidence in the work of other
British companies such as the physical/visual/experimental
theatre group Forced Entertainment (founded in 1984 by
Tim Etchells).

Though the truly radical work was taking place outside traditional
venues, the traditional writer-led theatre was also addressing the
burning issues of the day, with the Royal Court Theatre in Sloane
Square the leading venue for work with a political edge. Plays
from new authors and old, with a left-wing political agenda have
included Edward Bond's *Saved* (1965),[27] Caryl Churchill's *Serious
Money* (1987) and Laura Wade's *Posh* (2010). The Royal Court
continues to champion emerging and alternative writers, and is
part of the current resurgence of political theatre, with its recent
season on revolution; a resurgence which has also seen a project
by the National Theatre of Wales exploring democracy, and plays
such as David Greig's *The Great Yes, No, Don't Know Five Minute
Theatre Show* (2014), Mike Bartlett's *King Charles III* (2014) and
James Graham's *The Vote* (2015).

Companies such as Red Ladder, 7:84, Women's Theatre
Group, Clean Break, Gay Sweatshop and Red Shift, and plays
such as Howard Brenton's *The Churchill Play* (1974), David Hare's
Plenty (1978), David Edgar's *The National Interest* (1971) and
State of Emergency (1972) (both very carnivalesque), and Sarah
Daniels' *Masterpieces* (1983) established the 1970s and 80s as the

quintessential eras of political theatre, though the 90s spawne
own mode of political theatre practice with verbatim theatre. As
an antidote to the spin of that decade, verbatim theatre set out to
use the words of real people to inform the audience about worlds
of which it knew little. Some significant examples of plays which
dealt with important topics and provided insights into hidden
worlds include: Robin Soans' *The Arab-Israeli Cookbook* (2004),
Gillian Slovo's *Guantanamo* (2005), David Hare's *Stuff Happens*
(2004) (about the Iraq war) and Amanda Stuart Fisher's *From
the Mouths of Mothers* (2007) about the failure of society to help
victims of sexual abuse.

Political theatre remains a staple of UK countercultural theatre
practice, though it can limit itself by simply staging left-wing
work in left-wing venues for left-wing audiences. Arguably, the
most intelligent work challenges the audience's preconceptions
either in an open, Brechtian, way, or much more subtly, by not
billing itself as overtly 'political' theatre. It was well recognised
by the political countercultural performers in the 1960s that the
personal and the political are inextricably linked: John Lennon
characterises the dilemma of the progressive regarding whether
to funnel energy into personal growth or political action in his
lyrics for the 1968 Beatles song 'Revolution': 'You say you'll
change the constitution/Well you know/We all want to change
your head/You tell me it's the institution/Well you know/You'd
better free your mind instead.'

John McGrath, co-founder (in 1971) of the Scottish left-wing
agitprop theatre company 7:84 has argued that:

'... the theatre can never "cause" a social change. It can
articulate pressure towards one, help people celebrate
their strengths and maybe build their self-confidence. It
can be a public emblem of inner, and outer, events, and
occasionally a reminder, an elbow-jogger, a perspective-
bringer. Above all, it can be the way people find their
voice, their solidarity and their collective determination.'[28]

Performance Art and Happenings
If the work in the UK most identified with the term 'political
theatre' tended to have a very clear message, and very obvious

(and almost exclusively left-wing) aims, there existed concurrently a countercultural performance strand that, if sometimes no less politically committed, was definitely more oblique in its style. Performance art and 'happenings' are, in some ways, the logical conclusions of the 'radical loosening of the fabric of drama' as Sainer[29] described the performance ethos that emerged in the 1960s: they are performance at its freest, and most immediate. Gone are the trappings of the theatre, sets, costumes, director, text and character. Taking the conceptual in visual art, as instigated by Marcel Duchamp and his *Fountain* of 1917,[30] and marrying it with performance, the counterculture in the UK (and throughout Europe and the US) sought to radically expand the limits of what constituted 'theatre'. As with other strands of countercultural production, the egalitarian, collective and inter-disciplinary ethos was central to the creation of the work. Like events staged by the Dadaists many years earlier, happenings integrated visual art and theatre – sometimes they were planned and even scripted, often not: the essential feature was that it was 'live' – that is to say, alive to the response of the audience, and the performers' spontaneity.

Allen Ginsberg at the International Poetry Incarnation, 1965

Though the first Happening in the UK is thought to have occurred in Liverpool in 1962, at the Merseyside Arts Festival,[31] the most influential was the International Poetry Incarnation, which took place on June 11th 1965 at the Royal Albert Hall in London. For Jeff Nuttall, one of the founders of the People Show, it was a revelation. With writers such as Alan Ginsberg[32] and Gregory Corso performing, and an audience (or participants) estimated at 7,000 with many more turned away at the door, it was soon understood to be a seminal event for countercultural performance.

As Nuttall later explained, 'The Underground was suddenly there on the surface.'[33] Happenings formed one half of the

emerging genre that came to be known as 'performance art'; distinct from Happenings but sharing a number of key motivations and sensibilities, not to mention practitioners, was the Fluxus movement. It shared a number of antecedents with Happenings, including the experimental music of John Cage, and the Duchamp and Dada connection. Fluxus-type work was being produced by a nexus of artists from the late 1950s onwards but the name was coined in 1962, and with its etymological reference to flow and change expressed the free-form nature of the movement. Fluxus drew artists from many nations, and staged events all over the world: in the UK the movement was most visibly represented by Yoko Ono, who was invited to stage a conceptual art exhibit at the Indica Gallery, London, in 1966.

John Lennon and Yoko Ono 'Bed-In for Peace', 1969

Her work caught the eye of John Lennon, who, like the other Beatles, was a good barometer of what the next countercultural 'thing' would be. Though most of the Fluxus artists came from the US or Asia, the UK was an important staging ground for experimental work: between 1966 and 1968, London was arguably the hippest place to be. At the close of the 1960s, the popularity of Happenings was waning, though Fluxus artists and performers continued to make work – arguably some of the most high profile being that of Yoko Ono and John Lennon, whose bed-ins for peace took the form of a Fluxus performance piece, or a Happening, and used it for mostly political ends.[34]

Minority Groups Take the Stage

Another broad grouping within the countercultural fragmentation could include feminist theatre, lesbian, gay and queer theatre, black theatre and disability theatre. 1968 saw the founding of Second Wave feminism, and 1969 the Gay Liberation Front; in the US the Black Arts Repertory Theatre had been formed in 1965 and the 1970s saw companies such as Black Theatre Co-operative, Carib Theatre and Temba Theatre formed in the UK. While remaining committed to a socialist/Marxist or at least egalitarian ideal, each

group came to the realisation that the broader left-wing groups were not adequately representing them, led, as they tended to be, by heterosexual white males. As Heddon and Milling put it,

'The glut of stereotypical, sexist or homophobic representations of women, gay men and lesbians on stage made the production of alternative representations an urgent necessity. This, combined with the cultural context of the time, suggested collaborative devising – a means of wrestling the mode of production from the grip of dominating institutions and dominant ideologies – as an appropriate model of agency for self-representation, and a process by which to make visible that which had been previously unseen and unspoken.'[35]

The move from the 1960s to the 1970s has been characterised as a shift from the politics of the group to the politics of the individual,[36] and though the 1960s collectivist response endured, the issue at the heart of many of these counterculture groups was identity politics. Though many of these companies survived for some decades, the 1970s were their heyday. Companies such as Gay Sweatshop Theatre Company, a leading Gay and Lesbian theatre collective (founded in 1974 in London) disbanded in 1997; Feminist group Monstrous Regiment Theatre Company, based in London, ran from 1975 until its funding, too, was cut in 1993; the Women's Theatre Group, a London-based touring group established 1974, ran until 2007. The next wave of counterculture companies organised by marginalised groups came as the 1970s gave way to the 1980s: the London-based Black Theatre Co-operative (now called Nitro) in 1979 (formed by Charlie Hanson and Mustapha Matura to produce the latter's play *Welcome Home Jacko*), the disability-myth dispelling Graeae Theatre Company (also London-based) in 1980, both still going strong in 2015.

The zeitgeist of the 1980s would seem to be quite at odds with that of the 1960s, at least in the UK, under Margaret Thatcher's Conservative government. Gone was the egalitarian dream of the 1960s: greed and conspicuous consumption were the order of the day, and the very idea of community, group action, even society was under threat. In such a context, the need for a counterculture

was greater than ever. The alternative theatre groups that had survived, and those that were still being formed, were well placed to challenge the accepted version of events in a way that many other media could not, their fragmentation and guerrilla nature a boon when companies attached to physical venues and reliant on government funding were having that funding viciously cut. The countercultural theatre of the 1980s was still able to implement Marcuse's notion of the Great Refusal: rejecting the 'rules of the game that is rigged against them.'[37]

To the Image and the Body

The 1990s allegedly ushered in a more caring era, with the harsher ideologies of Thatcher's Britain, if not reversed, then swept under the carpet, with an apparent stability settling over the country, and strange ideas like the 'end of history' being bandied about again. Post-Modernism was in full swing, with all its attendant notions of irony, parody, pastiche, collage and relativism: in this milieu, the idea of an end of history, or a Labour government that embraced big business more than the Conservatives, and said we're all middle class now, perhaps did not raise eyebrows as once it would have. So where did this leave the counterculture and its theatre artists? The avant-garde seemed to have achieved one of its aims of getting audiences to accept the mixing of 'high' art and 'low' culture, with cultural hybridisation one of the key practices of post-modernism. When the dominant culture is becoming more diverse, disconnected and at the same time more hybridised, the clear distinctions between what one is countering become harder to see. But of course there still existed many things to object to, many traps into which mainstream society seemed to be sleepwalking. If the idea that 'we're all middle class now' was meant to be a comforting thought, to a theatrical tradition that had historically tried to shake the bourgeoisie out of their complacency it was a red rag to a bull. Society, theatre and art would not be allowed to slip into a Baudrillardian detachment and passivity, lost in a post-modern stupor.

The initial 1990s answer to this was the theatre of writers such as Sarah Kane, Mark Ravenhill and Anthony Neilson, retrospectively branded by critic Aleks Sierz (in 2001) as 'In-yer-

face theatre'. Sierz claims the style has a lineage going back as far as Alfred Jarry and Antonin Artaud,[38] with, he says, a particular antecedent in the alternative theatre of the 1960s.[39] The labelling was not a flash-in-the-pan, and nor were a number of the writers so labelled, with some such as Ravenhill, Neilson, Patrick Marber and Jez Butterworth going from strength to strength. But if it is truly countercultural work then it is more Royal Court Theatre counterculture than Theatre Royal, Stratford East counterculture: that is to say, it is countercultural displays from within the theatrical establishment, from a writer-led process, rather than the collaborative, devised, company-led work that has largely been the defining element of countercultural theatre practice.

At the end of Kershaw's list of products of the explosion in alternative theatre in the 1960s and 1970s came two genres that have often been bracketed together, but are increasingly being seen as distinct, though connected, entities. As the 1980s waned, Physical/Visual Theatre began to appear more and more as a category in pieces of countercultural work that were trying to define where their interest lay. Referring back to Artaud, Grotowski, Barba, Brecht, as far back as Craig and the other modernist theatremakers, physical and visual theatre found a new fascination with a mode that put the performer's physicality at the centre of the creative process.

 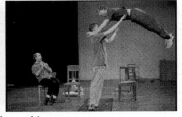

Complicite rehearsal images

Perhaps the most famous physical and visual theatre company originating in the UK is Théâtre de Complicité (founded in 1983, now known simply as Complicite), most of whom trained in Paris at the École Jacques Lecoq.

It is perhaps telling that it took performers with a continental training to act as a catalyst for British physical theatre to make

its mark. The influence of a renewed respect for Mime in France, and of a long line of European theatre theorists going back to Schlemmer, Meyerhold and Craig, informed Lecoq's teaching, and Complicite brought that sensibility to these shores.

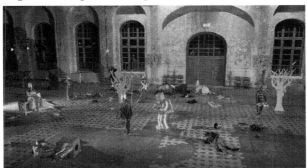

The Last Adventures publicity image; a Forced Entertainment production

Among many other collectives working in this manner we find Improbable Theatre (1996), Kneehigh Theatre (1980), Told by an Idiot (1993), Forced Entertainment (1984) and Trestle Theatre (1981), all founded in the 1980s and 90s and still going strong.

All these companies bear a relation to the historical counter-culture: they are artist-led, collaborative, devising companies, and perhaps inevitably (because of their construction) they are political to a greater or lesser degree. But there are also notable differences, the most obvious being, if not a hierarchy, then a stronger demarcation of roles within the company: each of the collectives mentioned has a director or directors at its helm. The political element of physical and visual theatre is also not as immediately apparent: it is not necessarily a 'stated aim' in the way that it was for much of the countercultural work that preceded it. Yet so much of its practice, and therefore its outcome, strongly connects to the ethos and methods of the historical avant-garde, and the countercultural flowering of the 1960s.

As Heddon and Milling note,

'The inspiration for much of the idea of "encounter" in the theatre was drawn from the gnostic imagination that haunts Artaud's *Theatre and Its Double*... the expressive breath and body of the performer, before and beyond the

text of any play, was increasingly significant, as Artaudian ideas inspired a generation of theatre makers.'[40]

These inspirations and impulses were always present in devised, collaborative work, but as the form has progressed, they have come to the forefront. If there has been a reluctance to begin with the body rather than the text, the growth of physical theatre has, since the 1980s, gone a long way to rectifying this hesitancy. Historically there has also been, in the UK at least, a distrust of the visual: a puritan suspicion that images are somehow vacuous or decadent in a way that text is not. Even from within the counterculture, visual theatre has had to contend with this idea that an enhancement of the visual or the aesthetic elements of a piece must be in opposition to, or even to the detriment of, the text – and therefore interfere with the 'message' of the work. Certainly the physical and visually-orientated aspects of contemporary experimental, collaborative and devised work are in many ways the most subversive things about them, and the mainstream, text-based theatre is still challenged by these countercultural practices and ideas.

Günter Berghaus suggests that:

> '... a central objective of the avant-garde has been fulfilled: rather than having been absorbed by the mainstream, it has widened the spectrum of Western culture and has compelled the conservative majority to give recognition to innovative and untested forms of expression.'[41]

Is this the ultimate aim of counterculture? To find its place and its audience – or even, as Berghaus suggests, to gain recognition from the mainstream? Or does it still harbour thoughts of revolution? (Can it still be classed 'counterculture' without them?)

Subversive theatre has always existed. But what is it to be subversive, to be countercultural, in UK theatre culture today? Part of the answer still lies in work emerging from previously (and still) under-represented groups: companies and individuals struggling against a theatre industry in which only 17% of the plays produced are by women, which is predominantly run by white, middle-aged men, sees celebrity casting as an inevitable part of raising funding and selling tickets and ignores disabled

actors even when a role demands one. Some actors such as David Oyelowo have publicly complained of the lack of opportunity for black actors in the UK and been attracted to work in the USA where more colour-blind casting operates (though the alternative theatre scene in the US is much less vibrant than that of the UK). Others, like director Phyllida Lloyd, have chosen not to work on plays which do not feature women characters centrally and to cast the classics with an all-female cast. Actors like Warwick Davis have sought to overcome the discrimination which persists by creating his own Reduced Height Theatre Company and producing a national touring production of *See How They Run*.

The counterculture that emerged in the 1960s paved the way for a radical shake-up of theatre, both in form and in content. Like the modernist avant-garde that preceded it by a hundred years, a key aspect was that it invited different groups into the theatre, both as performers and as audience: people who, previously, were simply not represented because they did not enter theatre through traditional routes. Indeed, the varieties of performance that emerged from the counterculture of the 1960s necessitated a whole new theatrical lexicon: what would previously have just been called 'acting' now broadened to become 'performance'; prior to the 1960s, theatres presented 'plays': now we speak of performances, events, even happenings; the word 'theatre' itself came to refer to a practice as much as a place.

In 1992, the avant-garde director and theorist Richard Schechner gave a speech for the American Association for Theatre in Higher Education in which he speculated:

> 'The fact is that theatre as we have known and practiced it
> – the staging of written dramas – will be the string quartet
> of the twenty-first century: a beloved but extremely
> limited genre, a subdivision of performance.'[42]

Schechner may have been being more provocative than prescient, but we can claim with certainty that the counterculture has made an indelible mark on the history and practice of theatre in the 20th century and beyond; and who can say what it might yet spawn?

YOUTUBE AND SOCIAL MEDIA

New Media: YouTube and Online Broadcasting – A Platform for All

Bella Qvist

Introduction

Jawed Karim at San Diego zoo, YouTube still

'The cool thing about these guys is that, is that they have really, really, really long, um, trunks, and that's, that's cool. And that's pretty much all there is to say,' says Jawed Karim, standing in San Diego Zoo and commenting on the elephants behind him. He's speaking to camera and on April 23rd 2005 the nineteen-second-long clip in which he utters these words became the first ever YouTube video to be uploaded onto the video-sharing website.

When the domain name youtube.com was registered on February 14th 2005 and this first video, called 'Me at the zoo', was uploaded, no one knew what an important forum and powerful media platform it would become.

296

YOUTUBE AND SOCIAL MEDIA

In 2005, Jawed Karim (the man in that first video), Chad Hurley and Steve Chen all worked at the money-sending service PayPal and they were trying to find online video clips of Janet Jackson's Super Bowl performance (the one where she had that wardrobe malfunction) as well as of the 2004 Indian Ocean tsunami. They wanted to see what it had looked like but couldn't – because mainstream media didn't offer a video search function. That's when the idea of creating a video-sharing site came to them.

The three set up as venture-funded technology start-up, working from an office above a pizzeria in California, and after six months of public beta testing,[1] YouTube officially launched. It was an instant hit and by July 2006 it was getting 100 million views every day.

In November 2006, Google bought YouTube for $1.65 billion and by 2007 it was estimated that the site was using as much bandwidth as the entire internet in 2000.

Ten years on from its launch, YouTube has exploded into being much more than a video service; it is a media library, a broadcast channel, a prime entertainment source and a means of communication used by media giants, underground movements and individuals alike. Moreover, it has been a catalyst for alternative and diverse conversation in the UK and worldwide, as voices that wouldn't otherwise have had such prevalence have been heard, shared and amplified.

From make-up tips for mature women who have been made invisible in traditional media to videos that politically engage first time voters, including also videos about mental health, sexuality and the most niche market games you could imagine, YouTube has it all. People have realised that they can create their own broadcast of whatever they are missing in mainstream media – and there is always someone somewhere who will watch.

It is the wide range of possibilities presented to anyone with a basic camera and access to the internet that has made YouTube so

popular, and ultimately successful. The simple nature of the site has made it possible for anyone to upload content and reach an audience, removing the barriers between the content creator and the consumer. Thanks to YouTube the idea of being restricted to broadcasts, opinions and entertainment chosen by someone else has pretty much been eradicated.

YouTube hasn't just filled the function of giving us the freedom to choose what media clips we want to consume, it has launched countless careers, it has become the go-to starting block for a new generation of musicians, filmmakers, trend setters, comedians, presenters, models, discussion drivers and celebrities and its potential is ever growing.

From Susan Boyle to David Cameron (and the Cassetteboy remixes of his speeches that went viral); everyone who is someone in 2015 is on YouTube. There is no doubt that the video platform has the power to engage.

YouTube has presented an equal playing field, a democratic video service if you will, and a platform where counterculture can thrive.

Vloggers, YouTubers and a Sense of Community

In 2015, ten years after the site was first registered, YouTube is localised in seventy-five countries, available in sixty-one languages and has more than one million YouTube partners – that is channels generating advertisement revenue from their creations. The online streaming site has more than one billion users – and at this point we're users, we're not just viewers, as our Google accounts connect with YouTube and we are able to use one login for all Google owned services. This simplification was very much not appreciated by everyone, as we will learn later in this chapter. YouTube is increasingly taking viewers from the traditional medium of television and it's easy to see why.

On YouTube we can comment on videos, 'favorite', 'like' or 'dislike' them, add them to playlists and share them with our friends. The control of what, how and when we consume media is ours, as is the freedom to produce endless amounts of content. You can't say the same for the BBC.

Just look at UK's biggest YouTube star, beauty blogger Zoe

Zoe Sugg (Zoella)

Sugg, also known as Zoella. She has set up her own series and broadcast schedule for fans to follow. And because the nature of YouTube is such that videos are saved on the channel and don't disappear once they've been broadcast (unless the creator chooses to delete them), those of us who haven't seen all her hundreds of videos already are able to tune into any of Zoella's videos at any one time.

Around 300 hours of video are uploaded to YouTube every minute and the platform has a dedicated team of experts helping the people creating the videos, the content creators, make the best videos possible.

With video comments and social media forming part of a conversation with the person uploading the video, often the filmmaker him or herself, the viewer experience becomes more interactive and a sense of a community emerges.

Girl Online cover image

In Zoella's case the sense of community reached new heights when she released her debut novel, *Girl Online* in November 2014. It became the fastest selling book of 2014 and also broke the record for highest first week sales for a debut author since records began.

YouTube is keen on creating that online bond also offline. There are even five centres, so-called YouTube Spaces, in Los Angeles, London, Tokyo, New York and Sao Paolo, offering workshops and resources free of charge to YouTubers. As video makers of all levels flock to these meetings, an online community becomes a real life community. YouTube meet-up events like Summer In The City, the UK's biggest YouTube

convention, brings together video creators and thousands of fans for a weekend of performances, talks and 'meet and greets'.

This sense of belonging is particularly noticeable when it comes to prominent videographers, called YouTubers or vloggers (video bloggers) such as Zoella. Here the audience influence becomes especially evident and the comments made by viewers often influence the topics covered in videos.

Many vloggers actively encourage their viewers to send them drawings, food or letters to feature in video content and YouTube Spaces put on workshops such as 'Get Started: Audience Building Essentials'. Viewer engagement is one of their top tips for success.

Prominent British vloggers in 2015 include Zoella, games commentator KsiOlajidebt, also known as KSI, *Minecraft* player Stampy Longhead, vloggers Joe Sugg, Caspar Lee and Alfie Deyes, and singer-songwriter/ vlogger Emma Blackery. Brighton-based Swedish gamer PewDiePie (left) is also notable; his channel is the most subscribed (since December 2013) and the most viewed (since July 2014).

Successful American vloggers include Grace Helbig and Hannah Hart, who as of 2015 have their own TV shows, as well as LGBT rights champion and One Direction superfan Tyler Oakley.

You may think there is nothing countercultural about a superfan site for One Direction – a product of Simon Cowells's mainstream TV show *The X Factor* – but all of the above are exciting precisely because they are examples of a medium that is countercultural. The fantastic thing about YouTube is that it offers all users independence from the dictates of mainstream media and prime time TV.

Talking about numbers is almost irrelevant when it comes to YouTubers because the amount of subscribers, views and followers constantly increase but in March 2015 in round figures,

Zoella had 7 million subscribers, Grace Helbig had 2 million subscribers and PewDiePie had 35 million subscribers and 8 billion views.

The appeal of YouTubers, or vloggers, is very individual but the very basic set-up, the fact that they can each be called a 'people's champion' brought to fame by our very own choice, is part of their attraction.

Have a Hart

Hannah Hart is a hugely influential American YouTuber who found fame when a video she made whilst flat-sitting for her sister went viral. By filming herself as she talked her friend through how to cook when drunk and uploading it to YouTube, she gained 100,000 views within a few days and people soon demanded she make more.

Two months later Hart left her 'day job' and moved to LA. Her channel My Drunk Kitchen was born and four years after that she's gone on to accumulate two million subscribers, write a best-selling recipe book, co-produce and star in a feature film and be cast in a TV show. President Barack Obama even invited her to the White House to take part in consultation ahead of his healthcare reform.

'I lucked out. I would still be a translator if I hadn't had a video go viral,' Hannah told *DIVA* magazine in 2014 about finding fame.

However, Hannah's efforts go further than just making drunken videos; she has used her newfound influence for a good cause. In 2014 Hannah went on a tour around America where she organised meet-ups that engaged people to volunteer at local food banks and other charity organisations in all the cities they travelled to.

'A lot of the time I think people have this idea about the internet being a very lonely, solitary thing but my bit is the opposite, it's about bringing people together,' she says in her tour documentary.[2]

Since then fans have continued the tradition, organising 'Have

A Hart' days around the world.

The fan-instigated website states that:

> 'It is our hope to continue to build Have A Hart Day around the globe, activating this community to reach out to local Food Banks and other non-profit volunteer based organisations to give our time and energy and resources. Hannah's H.A.H.D. aim is to motivate and contribute positively to our community. We hope to achieve this by helping feed and meet the needs of families around the world by offering our time, energy, and resources.'

Thanks to Hannah's initiative her fans challenge the political and socioeconomic status that they and their communities find themselves trapped under and, rejecting mainstream cultural norms of catering to the ego, they go out of their way to help those that have been failed by society and/or authorities. If that isn't counterculture then I don't know what is.

Tapping into the Taboo

The popularity of YouTubers has soared not just because of the charismatic, engaging and funny personalities of those who make the videos or the fact that they appear to be 'one of us', often making videos in their bedrooms. What has time and time again proved to engage viewers is people tapping into conversations, often about taboo or sensitive topics, that haven't sufficiently been dealt with in mainstream media.

These topics have notably included mental health, LGBT rights and the feeling of being alone or feeling like an outsider. Moreover, the fact that anyone can access this information anywhere, as Hart points out, is what makes it so special.

This is key, because as much as YouTube is a place for entertainment, it is also a site that has the potential of reaching out to people around the world about issues arguably more important than celebrity fashion or pop-culture trends. Anyone with a smartphone and internet access can tap into a well of knowledge and experience possibly similar to their own, making YouTube a place of refuge and companionship regardless of geographical location. This is a platform that has created entirely new global communities of like-minded individuals who will not

accept the lifestyles society may prescribe for them.

Coming Out Videos and the Importance of YouTube to Young LGBT People

'YouTube has played a very pivotal role in the coming out experience for this new, upcoming generation. You get to look online and see a whole bunch of people's stories and kind of relate to them on a different level, something that never even existed when I was, like, coming out.'

– Tyler Oakley[3]

From Team GB Olympic diver Tom Daley (left) coming out publicly with the help of a YouTube video to Hannah Hart's coming out video series, including her tear-filled statement about 'sticking around' which Oakley labelled 'lifesaving stuff', never before has such a catalogue of support, experience and first-hand accounts been available to those struggling to come to terms with their sexuality.

'In an ideal world, this shouldn't matter,' said British Olympic diver Tom Daley in the video called 'Tom Daley: Something I want to say', a video that went viral when it became clear that what he wanted to say was that he was gay – or bi, to begin with.

'It's gonna be, you know, big but I wanted to say something and I feel, like, now I am ready and... I couldn't be happier,' he said. The fact that Tom decided to make his announcement through a homemade video on YouTube shows not only what a big platform the site is but what a fantastic tool it is.

'Some said why don't you just do a statement, why don't you do a magazine cover, why don't you do a TV interview, but I don't want them to get my words twisted and I wanted to put an end to all the rumours and speculations and just say it, and just tell you guys... I just wanted to make sure that I got to tell you guys.'

News sites were instantly linking to the video and even if they could pull quotes from it, they couldn't do anything about the content – Tom got to tell his story his way and it put him in

control of a hugely sensitive situation.

With 44% of young LGBT people in the UK having considered suicide,[4] the support offered online is crucial and coming out videos, clips where people tell their personal coming out stories, have become an invaluable tool in many a young queer person's life.

Successful YouTuber and self-made filmmaker Lucy Sutcliffe from Hertfordshire in the UK was one of many to secretly Google for support when she was coming to terms with her sexuality.

> 'I was subscribed to the Ellen [DeGeneres] YouTube channel and I saw Chely Wright's [coming out] interview through that channel, which is what inspired me to go "I'm a lesbian." That was pretty much the turning point.'
> 'I grew up in a town where there were more sheep than people and I was so alone. There are thousands upon thousands of people who are just like that, who I think use YouTube as a way of connecting with people to make themselves feel better. And it is, it's like a support system online where anyone can click through. That's why it's so important that people still make coming out stories because they are helping god knows how many people by doing so.'[5]

Lucy is one half of YouTube couple Kaelyn and Lucy, a lesbian trans-Atlantic long distance couple who set out making videos for each other but became an internet phenomenon when people from around the world started tuning in to watch their videos.

> 'When we started our channel it was just so we could make videos for each other because obviously when you're long distance making that connection however you can is always helpful.'
> 'We didn't make ours public from the start, ours were private and I was like 'no one cares, no one's going to see them, let's just make them public!''

That was of course when everyone else started watching them.

Lucy has since moved to America to live with her partner, and her own coming out video has had well over 1.2 million views.

> 'Once I had come to terms with who I was and I was

comfortable in that and I had accepted it to the point where I no longer cared what the response was, [that's what when I decided to make my own coming out video]. I felt like because I had that confidence I was able to tell my story and share it with people who might not necessarily have it right then.

'I watched coming out stories before I had even accepted myself that I was gay. [I thought,] you know, I can just look at these videos and they'll make me feel better. And I feel like it's sort of a loop where one person makes it and it inspires another... and it just sort of creates, it has this big effect, like a snowball effect and I just want to help people.'

Anyone looking at the 6,000 comments and counting will see that Lucy has done just that.

The Emergence of New Role Models: Case Study – Rosweglyn and a London Meet-up

In April 2014, Kaelyn and Lucy was one of three well-known UK-based lesbian YouTube couples with a combined following of half a million subscribers. Realising they would all be in London at the same time, they arranged a 'meet and greet' with their fans and tickets for the event, called Rosweglyn, an amalgamation of their names, sold out in no time. On the day queues stretched around the block and many of the young fans who had come to meet Kaelyn, Lucy, Rosie and Rose and Whitney and Megan from as far away as Australia, Finland and Mexico had tears streaming down their faces. Although it took the girls by surprise, perhaps it shouldn't have.

The three couples were the brightest shining lesbian YouTube stars in the UK but they were also, really, the only realistic role models available to young queer girls looking for reassurance. Gay and bisexual women were (and in 2015 continue to be) close to invisible on mainstream TV, in film and on radio. Those who had come out were often of an older generation, not people that generation millennia would necessarily identify with.

In their own ways, the Rosweglyn girls put themselves out there and spoke about their everyday experiences of lesbian life.

Whether it was quarrelling over *Harry Potter* characters, eating sushi or planning their dream wedding, they normalised the idea of a happy lesbian relationship.

Rather than being seen frolicking half naked in order to obtain the attention of men, the girls were doing everyday things, talking about ordinary topics – and the internet loved it. Thanks to their videos, the lives they were leading seemed attainable for a whole generation of young girls and boys.

The girls had not planned on this outcome and they remained in control of what they put out there. Even if fans think they see the whole story, they often don't. YouTubers film, edit and publish their own content, meaning that they are in charge of their own stories.

A platform like this had never been available before and it made YouTube into a world beyond the ordinary with the freedom to promote different life-choices than those pedalled by the mainstream media.

The Geeks

It's not just gay kids who look for refuge from everyday life online. The Rosweglyn girls make a great example of LGBT-related counterculture but there are videos on every topic imaginable on YouTube. In a sense, YouTube is like the internet itself, endless and ever expanding.

Part of its core is the gaming community and in 2015 some of the most subscribed channels are those dedicated to game play commentary. One game that is particularly popular among viewers, and which transcends a vast number of age groups, is the gender-neutral *Minecraft*, where you build worlds from tiny building blocks.

To many the idea of spending hours on end watching someone play a game might seem crazy but around the world people tune in more often than ever before. The allure is clear; friendship and a sense of belonging, a shared interest and straightforward entertainment.

'Stampy Cat', the *Minecraft* avatar of Joseph Garrett

Joseph Garrett, 24, from Portsmouth is better known as Stampy Cat, a character playing *Minecraft*, and his channel was one of the ten most-watched YouTube channels in the world in 2014, getting more hits than the world's biggest boyband, One Direction. As Garret told the BBC in an interview in 2014,

> 'A lot of people view the television as a very passive thing now. It's in the corner, it's always just rolling 24/7... I think things on tablets, phones and laptops seem a lot more instant and probably just a bit more exciting.'[6]

Games developer Simon Lumb agrees. Appearing on *BBC Breakfast* he said,

> 'In other popular media there are not that many voices that the players can relate to, on television, radio and so forth, so YouTube is providing people like them who they can speak with, interact with, watch and get tips from, and it's directly there. It's showing them new things and they can get excited and get involved themselves.'

Brighton-based PewDiePie started out as someone commenting on the games he played and today he has the most subscribed channel in the world. His followers, or 'bros' as he calls them, are part of a community spanning the planet. Thanks to them, Felix Kjellberg, PewDiePie's real name, has managed to raise over a million US dollars for charity.

> 'I just love how we can turn this stupid channel, let's be honest here bros, it's pretty dumb, making these silly

videos every day and turn that into something that helps change the world into a better place,' he said in his video called '1 MILLION $ FOR CHARITY!'

It's interesting that individuals like Kjellberg, the geeky 'losers' some people may perceive as self-obsessed introverts with little interest outside their home computers, are redefining the gamer-image. The modern gamer may well change the world from the comfort of their sitting-room. Self-made filmmaker and YouTuber Lucy Sutcliffe says,

'They make so much money just from playing video games. They don't even leave their house, you wouldn't see them anywhere else. It's a chance to showcase stuff that we wouldn't see before, which is why they get so many clicks.'

Music Videos, Audition Tapes and the Power to Launch Pop Stars

'I think particularly the YouTube stuff is the equivalent of what was happening with rock 'n' roll in the 50s and 60s.

Particularly now that sort of the money has gone out of the music industry it's very difficult to get signed if you're working class any more and it's very difficult to become a writer if you're working class anymore but going online and doing stuff on YouTube and blogging and stuff is one of the few places that kids from any background can find an audience and it's that gold rush, the same gold rush that it was then, culturally.'

– British writer Caitlin Moran, appearing on Swedish/ Norwegian TV show *Skavlan* with PewDiePie

For many years, record labels profited from major, long-term deals with artists and from physical album sales but in 2015 the layers between content creator and consumer have been blurred. Fears of the 'dangers' of the internet associated with the Napster era have near vanished and in many cases so has the industry 'middleman', as musicians upload their own auditions, mix tapes and music videos onto YouTube, a site where anyone can tune in.

Emma Blackery from Basildon in Essex is a pop/rock-inspired

singer songwriter and she released an EP before setting up her main YouTube channel, Emma Blackery, in 2012. The channel sees her starring in mini sketches as well as singing and talking about issues that she cares about and in spring 2015 it had 930,000 subscribers.

In July 2013 Emma released her second EP, called 'Distance' and uploaded a music video for the title track 'Go the Distance' to YouTube. This song has accumulated 1.2 million views to date. The EP reached the first spot of the iTunes Rock chart within the first week of its release and on 11th November 2014 the title track from her third EP, 'Perfect' made it to number eight on the UK Rock & Metal Singles chart. The video for 'Perfect' features Emma's fans singing and dancing along to the lyrics in their own fan-made videos.

'You're perfect the way you are,' they all sing and the video captures UK youth culture very well.

Emma's most watched video is called 'My thoughts on Google+'. The video, with over 3 million views, sees Emma performing her own track about how much she hates Google+. (In an attempt to unify its social networking platform, Google had forced Google+ accounts upon all its YouTube users and vice versa. This move was widely unpopular, and the company relented in 2015.) Emma ends her video by saying that she anticipates it won't be allowed on the Google-owned site for much longer and so she encourages viewers to share, re-upload and cover the song as much as they like. A mini-rebellion or mutiny, you might say. Still, she remains on YouTube, today uploading to three different channels.

Another example of British music export benefiting from YouTube is Susan Boyle (left). She appeared on the UK TV show *Britain's Got Talent* in 2009 and thanks to her amazing performance of the song 'I Dreamed A Dream' from *Les Misérables*, the mezzo-soprano instantly became an overnight sensation here in the UK. However, it was the video of that performance uploaded to YouTube that made her an international star.

The video of her performance went viral and it became the (at the time) most watched video in the history of YouTube. Within nine days of the audition, videos of Boyle had been watched over 100 million times. Susan was soon appearing on TV shows around the world and went from being an unemployed 47-year old to earning more than £5 million in recording and advertising deals.

What has emerged thanks to YouTube is a chance for everyone and anyone to communicate a message and to audition to the masses, if you will. The popularity of radio continues and there were plenty of other music streaming sites before YouTube appeared, but the visual aspect of this site, and the fact that it is so easy to comment, list and share the content, has made it hugely popular among music fans.

YouTube still from Psy's 'Gangnam Style'

Some of the most watched videos on YouTube are music videos; in fact the top ten are all music-related. South Korean pop singer Psy's 'Gangnam Style' actually forced YouTube to rewrite its view counter code before it overflowed at 2,147,483,647 views, the largest number that can be stored in a 32-bit integer.

Many people use YouTube as a music player where they are their own VJ (it is perhaps unsurprising that MTV since the noughties has reduced its overall rotation of music videos; people want to choose) but it also presents an equal playing field, an opportunity.

In 2015, having a YouTube strategy is part of any record label's plan for success. There is even a touring music and social media festival, Digitour, which calls itself the 'world's first YouTube tour and music festival', an eight-hour event described as 'Coachella

for teens'.

And of course, looking further afield there's global pop-sensation Justin Bieber. You could hardly say his music was trying to push boundaries or attempting to be part of counterculture in any way, in fact, you could probably argue the opposite; that he wanted to be part of mainstream media from day one. But his success story might not have taken off had it not been for the fact that his mother posted videos of him singing at the age of eleven on YouTube.

YouTube as a Platform for Emerging Filmmakers

In a way, all YouTubers are filmmakers of a kind and I have already mentioned the YouTube Spaces around the world that run workshops to help content creators create better videos. For Lucy Sutcliffe her filmmaking career was amplified but not limited to YouTube. She had wanted to make films ever since she was little.

She went on to study filmmaking at university and it was at this point that she began making the videos discussed earlier in this chapter, of her time spent together with long-distance girlfriend Kaelyn.

Lucy was still at university when their fan base grew big and she graduated the summer following the Rosweglyn event. For her, the online following was a massive boost to her career.

> 'I have incorporated social media into my filmmaking in terms of like crowd funding and stuff strictly because I have that platform there that not many other people do so it sets me aside in a way from the rest, which again, is pretty beneficial.'
>
> 'I still wanted to be a filmmaker even before YouTube ever existed, I've wanted to be one since like eight and I feel like it's become very integral to my work. I would have definitely have gone about it the more old-fashioned route [had YouTube not existed]…which isn't bad, it's just different and I prefer this route.'[7]

In spring 2015, Lucy is just about to start working as a content creator at a US university, a job she got with the help of a fellow YouTuber.

311

Comedy

Alternative comedy thrives on YouTube and one of the UK's brightest shining YouTube comedy stars is Humza Arshad (left), who is reaching audiences with his comedy sketches about Pakistani life in the UK.

His most popular series, *Diary of a Bad Man*, was a comedy drama web series that he uploaded between 2010 and 2013, portraying a fictionalised version of himself as an exaggerated stereotype of Asian youth culture in the UK. In 2011 the fifth episode of the series was the seventh most viewed video on YouTube in the UK. More recently he has been working together with British police in order to combat Islamist extremism in schools.

In one video from 25th March 2015, called 'Badman's World 14 New Scotland yard', he pays a visit to New Scotland Yard.

'I don't like this place, it reminds me of the Illuminati,' he jokes but later on he gets more serious, talking about why he is thinking of going to the Muslim Youth Festival.

> 'It's hard being a Muslim in this day and age. Every day there is always something negative in the media about Islam and Muslims. Muslim this and terrorist that, evil Muslim dog attacks grass. Sometimes I feel that they single us out, pick on us and stereotype us because of a few misguided individuals who do not represent us. Yes, there are extremists out there who think that violence is the answer but you get extremists in nearly every single religion. Sometimes I'm even afraid of my identity but why should I be? I should be proud to be a Muslim and will stand up and show the world that Muslims are normal people and Islam is a peaceful, beautiful religion. We believe in Islam that if you kill one innocent person then that's like killing the whole of mankind but if you save an innocent person that is like saving the whole of mankind. That is Islam. So maybe I will go today, because

I am a Muslim and I am proud of who I am. And maybe
I just need to do my part. Insha'Allah.'

One month after airing the clip had 64,000 views, and many of
the comments are from children who have met him on one of his
many school visits, and who say they can't wait for the next video.

Going Mainstream

Thanks to the success of British YouTubers like Zoella and
Humza, traditional media channels too have cottoned on to
the extraordinary influence that YouTubers have. BBC Radio 1
has featured several of the UK's biggest YouTube stars in their
'Internet Takeover' sessions and in 2015 Zoella even appeared
on the BBC's *Comic Relief Bake Off* alongside other big celebrities.

The YouTube underdogs have in other words started to break
through into mainstream media. Traditional broadcasters are
beginning to understand that using voices that appeal to young
listeners is key and they will find them where this generation has
created them – on YouTube.

Since making it big on YouTube, many internet celebrities have
turned to one of the most traditional media formats; the book.

Zoella's aforementioned book *Girl Online* came out in
November 2014 and became the fastest selling debut book in the
UK, outselling J.K. Rowling's *Harry Potter*, but the success came
under scrutiny when the fans found out that she didn't write it
herself. Zoella had taken some creative help from the editorial
team at Penguin and some fans turned on her because of this.
Clearly this wasn't too much of a deterrent however and a follow-
up is set to be released in the summer of 2015.

Zoella's brother, another famous YouTuber based in London
and Brighton and who goes under the online name ThatcherJoe
has written a book, as has her boyfriend, Alfie, whose pseudonym
is PointlessBlog.

This, one might argue is a movement of counterculture
reaching a wider audience, a group of self-made comedians,
filmmakers and commentators providing an alternative to the
narrative chosen by those already in power. Not everyone agrees,
however, and there are those who claim these steps, paired with
the creation of sponsored content, videos aimed solely at selling

a product to viewers, are part of 'selling out'. Lucy Sutcliffe is one of them.

'I feel like especially the big YouTubers are losing their personable facade because it's now becoming a moneymaking thing… People are taking on brand deals to pay their bills, which is fine, but it shows how much YouTube is evolving from what it used to be.'

She continues to say that:

'I think companies and brands are seeing how effective YouTube is as a commercial platform as well which is why they contact YouTubers in the first place, it's just massive.'

YouTube and Social Media – for Good and Bad

We've established that YouTube's success lies in the possibilities of expressing yourself freely but with free speech comes good as well as bad. Throughout 2014 and 2015 terror network ISIS posted videos of beheadings on YouTube and experts say these videos may be brutalising society, making us accustomed to seeing acts of violence and even inspiring beheadings worldwide. It's a chilling effect brought on by the freedoms lent to us by the internet and in particular platforms such as YouTube.

Online abuse doesn't have to go as far as murder to be harmful – cyber bullying is a widespread issue and sometimes the lack of distance between consumer and creator can become too much for the person making the video. PewDiePie turned off the ability to comment on his videos for a month during 2014 after claiming spamming and negativity was dominating the conversations.

Lucy Sutcliffe says her and girlfriend Kaelyn too get a lot of hateful comments but that they just have to laugh at it. Like many others, including PewDiePie, they have made videos where they read out the hateful comments.

'That's the way we deal with it. People ask why we don't just ignore it but it's like if we ignored it then it would just keep going and it does keep going but I guess it's like getting one up on them, in a funny way and in a way that we found most comfortable. It's always the ones that spell bad, the funniest ones.'

YOUTUBE AND SOCIAL MEDIA

Despite their great success, including figuring on several magazine covers and speaking at a range of events as well as being approached by TV producers, Lucy says they've thought about ending their YouTube chapter.

> 'The benefits outweigh the negatives definitely [but] once we start feeling overwhelmed and pressured by it completely we'll probably ease it off, just slowly.'

And she doesn't think YouTube will last.

> 'I think in ten years, people who are popular now on YouTube won't be doing YouTube anymore. They may still be doing other things because they will realise that YouTube isn't a career that is long lasting. I don't personally think that it is long lasting. I think it can set you off somewhere… but I think it's not something you could do until you're like fifty-five… I feel like it's a very temporary thing. But it can launch you into other stuff.'

The pressure from the community to keep providing videos on a regular, often weekly basis if not more often, can get to anyone who is thrust into that situation without management around them and that lack of support for the creator is certainly a downside to many. And even though the filmmakers choose what they upload, the worry of providing engaging content in an increasingly competitive online environment is another concern.

> 'Sometimes I also think you're missing out a part of your life because you're either video-taping it and you're sharing these moments with people you don't know and so part of me just wants to live life without a camera. That's why vlogging is so difficult for us because we just want to have fun and not care about documenting it all the time, which is why we very rarely do vlogs. I actually want to be able to live this life and it takes away from that personal thing, for me anyway.'

The Future: Reaching New Audiences

YouTube's popularity remains greatest among teenagers and tweens but it is spreading to other demographic groups. Look Fabulous Forever is a British cosmetics brand with a range of

pro-age makeup products specifically aimed at women over the age of fifty-five and their YouTube channel is doing very well.

Tricia Cusden (left), who is sixty-seven and from Wimbledon, founded the business in October 2013 after becoming frustrated with the way in which the cosmetics industry addresses older women. She turned to YouTube to reach an audience she suspected was out there, but she never anticipated the overwhelming reaction she has had.

She launched the business in October 2013 and put videos of her explaining how to best apply make-up to aged skin onto YouTube straight away, but she says she was 'quite dismissive' about it. Tricia thought people might see them on the website, not search for them on YouTube.

> 'We had 20, 30, 40 views per day on the videos which at that stage I even thought was pretty good and then after Christmas, sort of January 2014, we suddenly started getting 10,000–15,000 views a day, it was staggering.'

Tricia soon realised the idea of the stereotypical YouTube viewer doesn't always apply.

> 'We are going against what you expect YouTube to be all about… before I did this in my head it was a platform for nerdy blokes and videos of cute kittens and it was a real eye-opener to me that so many older women were watching YouTube… and that was a surprise but a lovely surprise and it has absolutely driven our success.'

She also discovered that YouTube couldn't successfully be used for direct sales, like you might with a programme on a TV shopping channel, but that it connects people with subjects that they care about. She found that people connected with her because she was the 'real deal', telling her story and sharing advice.

> 'I'm the age that the audience is, or they're maybe a bit younger or older, but they're at that sort of age range that they identify with the idea of an older woman, and I

engage in a conversation with those people and it would appear that they like what I say.

I think that what's been so lovely for me is that I started it hoping against that hope that there would be a vast army of women who would be interested in this concept and there is.

I didn't do any market research at all, I took a chunk of money that I had and I risked it but at the same time I thought this isn't that much of a risk because there must be, there must be other women like me and there you go.'

YouTube as a pool of diverse voices is a fantastic medium and an unparalleled resource. It is a springboard and a platform and a way of paving a career, if you can stick your head above the ever-expanding ocean of content already available. It may be going down a more commercial route but its core concept still remains the same; if you see something missing in mainstream media then you can create it yourself. With Twitter and Facebook increasingly expanding their own video platforms, enticing people to post directly to their sites as well, the phenomenon of citizen journalism in broadcast form is spreading and traditional media will just have to keep up.

More than ten years have passed since Jawed Karim uploaded his first vlog to YouTube and it is clear now that his first YouTube statement was wrong. That wasn't all there was to say about elephants – or any other topic for that matter.

The amount of topics discussed on YouTube is ever expanding. This chapter barely scratches the surface of all the content available on YouTube today. Facts and figures change daily but one thing remains certain; YouTube, TwitchTV, Vimeo and other means of online broadcast, combined with social media channels such as Facebook, Twitter and more, have created multiple new platforms for culture and counterculture – and these new platforms are readily available to all.

Endnotes

For updates, errata, bibliographies, further reading, author bios and other information, please see http://www.supernovabooks.co.uk/counterculture.html

Introduction

1. https://www.findhorn.org/aboutus/vision/
2. *Financial Times*, 2nd January 2015.
3. *Guardian*, 12th July 2015.
4. Von Neumann worked on the Electronic Discrete Variable Automatic Computer (EDVAC), a contemporary of Turing's 'Ace' and another binary machine which pioneered the notion of a program stored in memory that would drive the operation of the machine. He can be considered one of the 'fathers of computing'.
5. In the 1930s Zuse created a machine called the 'Z1,' generally credited as 'the first freely programmable computer.' http://www.techland.time.com/2011/11/10/who-really-invented-the-computer
6. Torvalds developed the free Linux operating system, which has spawned many variants.
7. Developer of the C programming language.
8. Developer, with Ritchie, of the Unix operating system.
9. Inventor of the World Wide Web.
10. *Guardian*, 17th July 2015.

1. ART

1. From an interview for this book, 2015.
2. The Design and Artists Copyright Society, http://www.dacs.org.uk/
3. Sir John Cass Faculty of Art, Architecture and Design (the CASS), http://www.thecass.com/ – part of London Metropolitan University.
4. The ArtFund is the UK's national fundraising charity for art. See http://www.artfund.org/
5. *Guardian*, 29th May 2006.
6. Ryan Gander quotes from an interview for this book, 2015.
7. *Guardian*, 29th May 2006.
8. From an interview for this book, 2015.
9. Rich, Adrienne, *Later Poems Selected and New: 1971–2012*, W.W. Norton &

Company, New York, USA, 2013.

10. All Paul Kindersley quotes from an interview for this book in 2015.

11. *New York Times*, 31st October 1971.

2. BLACK AND MINORITY ETHNIC ARTS

1. *Guardian*, 4th August 2015, 'Controversial ISIS-related play cancelled two weeks before opening night.'

2. *Guardian*, 24th May 2015.

3. *The Globe and Mail*, Canada 5th August 2010, 'No terror glorification here, just an unfortunate Pollyannaism.'

4 *Guardian*, 11th August 2014, 'Edinburgh's most controversial show: *Exhibit B*, a human zoo.'

5. Change.org petition, 'Withdraw the racist exhibition – *Exhibit B*, the human zoo.', https://www.change.org/p/withdraw-the-racist-exhibition-exhibition-b-the-human-zoo (accessed 25th August 2015).

6. *Guardian*, 24th September 2014, open letter from Brett Bailey.

7. The 2011 Census put the percentage of BAME groups in the country at 11%.

8. The findings are included in the latest Taking Part survey results, which looks at participation in the cultural sectors. See also *The Stage*, 25th June 2015, 'BAME audiences less engaged with the arts – survey.' https://www.thestage.co.uk/news/2015/bame-audiences-less-engaged-arts-survey (accessed 25th August 2015).

9. *The Independent* (Blogs), 4th June 2013, 'Racial diversity in classical music.' http://blogs.independent.co.uk/2013/06/04/racial-diversity-in-classical-music-a-daunting-experience-for-non-white-professionals-working-in-the-industry-today (accessed 25th August 2015).

10. Kean, Danuta, The Writing the Future report, commissioned by writer development agency Spread the Word. http://www.spreadtheword.org.uk/resources/view/writing-the-future (accessed 25th August 2015).

11. *Evening Standard*, 9th February 2010.

12. *Guardian*, 17th July 2006, 'Local protests over Brick Lane film.'

13. *Guardian*, 15th April 2015.

14. *Guardian*, 10th April 2008.

3. COMEDY

1. All Steve Gribbin quotes from an interview for this book, 2015.

2. Cook, William, *The Comedy Store*, Little, Brown, London 2001.

3. Rob taught me stand-up and (at time of print) teaches stand-up at the City Lit Adult Education Centre in London.

4. http://www.comedianscomedian.com/about/ See also Stuart Goldsmith's podcasts at http://www.comedianscomedian.com which have nearly 150 great in-depth interviews with comedians.

5. Tony de Meur (aka Ronnie Golden), from an interview for this book, 2015.

6. *The Comic Strip – First on Four*, Channel 4 documentary, 1998.

7. *The Comic Strip – First on Four*.

8. Connor, John, *Ten Years of Comedy at the Assembly Rooms*, Papermac, London, 1990.

9. Cook, William, *Ha Bloody Ha: Comedians Talking*, Fourth Estate Classic House, London, 1994

10. Black, Stu, 'Tunnel Vision – The 80s Comedy Club Where Heckling Became an Art Form', http://londonist.com/2014/09/tunnel-vision-the-80s-comedy-club-where-heckling-became-an-art-form (accessed 18th Sepetember 2014)

11. Cook, 1994.

12. 'Bambi', *The Young Ones*, BBC 2, 1984

13. All quotes from Claire Muldoon, CAST, from an interview for this book, 2015.

14. From an interview for this book, 2015.

15. All quotes from Steve Bennett, editor of comedy website http://chortle.co.uk, from an interview for this book, 2015.

16. All quotes from Julia Chamberlain, producer of the 'So You Think You're Funny' new comedy act competition, from an interview for this book, 2015.

17. Richard Herring, from an interview for this book, 2015.

18. Cook, 1994.

19. From an interview for this book, 2015.

20. *Evening Standard*, 19th May 2009.

21. From an interview for this book, 2015.

22. From an interview for this book, 2015.

23. Al Murray, from an interview for this book, 2015.

24. http://manfordscomedyclub.com/about/

25. All Barry Cryer quotes from an interview for this book, 2015.

26. From an interview for this book, 2015.

27. From an interview for this book, 2015.

4. DANCE

1. Ashford, John, 'Choreography at the Crossroads' in *Performance Research, 1.1*, 1996, pp. 111, 110–113.

2. Carter, Alexandra, (ed.), *The Dance Studies Reader*, Routledge, London, 1998, p. 224.

3. For further discussion see Mackrell, Judith, *Out of Line: The Story of British New Dance*, Dance Books Ltd., London, 1992.

4. See Claid, Emilyn, *Yes? No! Maybe... Seductive Ambiguity in Dance*,

Routledge, London, 2006.

5. Mary and I first met in the 1990s at a dance improvisation workshop. I partnered with her in an improvisational duet and I could not help thinking about the dance history she embodies. She is a living archive, who shares her experiences to educate and empower the next generation of dancers and performers. The inclusion of her reflections on the countercultural nature of X6, and not those of the other founding members is only because she is a north-west based artist whom I see regularly.

6. These days the more common term for 'record' is *vinyl*. Records almost died out, supplanted by CDs, which in turn lost out to digital formats and then iTunes and other cloud music services, but they are presently enjoying a minor comeback.

7. Perone, James E., *Music of the Counterculture Era*, Greenwood Publishing, USA, 2004, p. 31.

8. Thornton, Sarah, *Club Cultures. Music, Media and Subcultural Capital*, Polity Press, Oxford, 1995, p. 70.

9. For further discussion see Wilson, Andrew, *Northern Soul: Music, Drugs and Subcultural Identity*, Willan Publishing, Devon, 2007.

10. Redhead, Steve, *Subculture to Clubcultures*, Blackwell, Oxford, 1997, p. 41.

11. For further work by Ogg, see Bestley, Russ and Ogg, Alex, *The Art of Punk*, Omnibus Press, London, 2012.

12. Redhead, p. 56.

13. Reynolds, Simon, 'Rave Culture: Living Dream of Living Death?' in Redhead, Steve (ed.), *The Clubcultures Reader*, Blackwell, Oxford, 1997, pp 89, 84–93.

14. Reynolds, Simon, *Generation Ecstasy: into the world of techno and rave culture*, Routledge, New York, 1999, p. 217.

15. Kitchen, Robert M., 'Towards Geographies of Cyberspace' in *Progress Human Geography, 22*, 1998, pp. 400–401, 385–406.

16. Popat, Sita, *Invisible Connections: Dance, Choreography and Internet Communities*, Routledge, Oxford, 2010.

5. DISABILITY ARTS AND ACTIVISM
1. http://www.nidirect.gov.uk/the-disability-discrimination-act-dda
2. http://www.gov.uk/equality-act-2010-guidance
3. raspberry, raspberry ripple, rhyming slang for cripple.

6. ENVIRONMENTALISM
1. http://www.greenfunders.org/wp-content/uploads/Passionate-Collaboration-Full-Report.pdf
2. https://www.youtube.com/watch?v=e-3ia_tmiVw
3. Carson, Rachel, *Silent Spring*, Houghton Mifflin, Boston, USA, 1962.
4. http://www.foe.co.uk/news/big_ask_history_15798

5. Schumacher, E.F., *Small is Beautiful: A Study of Economics as if People Mattered*, Vintage, London, 1993.

6. Seymour, John and Sally, *The Guide to Self-Sufficiency*. Faber & Faber, London, 1976.

7. Lovelock, James, *Gaia: A New Look at Life on Earth*, Oxford University Press, 1979.

8. http://www.barrypopik.com/index.php/new_york_city/entry/society_is_like_a_stew

9. Abbey, Edward, *The Monkey Wrench Gang*, Lippincott Williams & Wilkins, USA, 1975.

10. http://www.thegreenfuse.org/protest

11. http://www.schumachercollege.org.uk/learning-resources/what-is-deep-ecology

12. http://www.passivhaustrust.org.uk/what_is_passivhaus.php#2

13. http://cubeproject.org.uk

14. Jones, Barbera, *Building with Straw Bales: A Practical Guide for the UK and Ireland*, Green Books, UK, 2009.

7. FEMINISM

1. An exploration of this period was broadcast in the BBC series *Suffragettes Forever! – The Story of Women and Power* from 12th March to 4th April 2015.

2. BBC News UK, June 2014.

3. Degnan, Erin K. and Morikone, Cynthia A., 'Rape Fourth Annual Review of Gender and Sexuality Law: IV', *Georgetown Journal of Gender and the Law*, Washington, D.C, 2003.

4. http://www.theguardian.com/sport/2009/aug/20/germaine-greer-caster-semenya

5. http://www.thefword.org.uk/2009/12/cis_feminists_s

6. http://blog.amandapalmer.net

8. FILM

1. Bennett, Bruce, 'When England Waived the Rules', *The New York Sun*, 13th July 2007, http://www.nysun.com/arts/when-britain-waived-the-rules/58363

2. James, Clive, 'Made in Britain, More or Less', http://www.clivejames.com/british-films

3. O'Neill, Brendan, 'A Hard Day's Night: How Director Richard Lester Invented the Music Video', *The Big Issue*, 22nd July 2014, http://www.bigissue.com/features/4106/a-hard-day-s-night-how-director-richard-lester-invented-the-music-video

4. 'Local History', Film Education resource pack, http://www.filmeducation.org/resources/primary/topics/local_history/1946_-_modern_times/

ENDNOTES

5. As re-printed in Davies, High, 'Homecoming for the street fighting men', *Telegraph*, 15th June 2002, http://www.telegraph.co.uk/news/uknews/1397341/Homecoming-for-the-street-fighting-men.html?mobile=basic

6. Hattenstone, Simon, 'James Fox: I didn't take that much acid', *Guardian*, 3rd December 2013, http://www.theguardian.com/film/2013/dec/02/actor-james-fox

7. 'Local History', Film Education resource pack.

8. Patterson, John, 'Films we forgot to remember', *Guardian*, 16th May 2008, http://www.theguardian.com/film/2008/may/16/filmandmusic1.filmandmusic3

9. Garfield, Simon, 'Derek Jarman: into the blue', *Independent*, 14th August 1993, http://www.independent.co.uk/life-style/derek-jarman-into-the-blue-he-is-not-living-with-aids-he-says-but-dying-with-it-but-he-works-on-his-new-film-and-his-very-presence-are-reminders-of-how-in-him-radical-challenge-and-disarming-delight-go-hand-in-hand-simon-garfield-reports-1461014.html

10. Aston, Martin, 'Derek Jarman interview', *The Planet*, 1991, http://martinaston.co.uk/?p=449

11. Rooney, David, 'Review: *Glitterbug*,' *Variety*, 4th May 1994, http://variety.com/1994/film/reviews/glitterbug-1200437356/

12. 'People were more afraid of the poetry', *Guardian*, 28th July 2005 http://www.theguardian.com/film/2005/jul/29/2

13. 'Interview with Sally Potter', *Guernica* Magazine, 24th October 2005, https://www.guernicamag.com/interviews/yes/

14. *Guardian*, 28th July 2005.

15. MacFarlane, Brian, 'The More Things Change... British Cinema in the 1990s', *The British Cinema Book*, second edition, BFI, 2001, p. 277.

16. 'BFI Film Forever Policy Strategy', http://www.bfi.org.uk/about-bfi/policy-strategy/film-forever

17. 'Film Hub South East Programme Awards Guidelines' https://filmhubse.files.wordpress.com/2014/11/fhse-programme-awards-guidelines-2014.pdf

18. Follows, Stephen, 'Who dominates UK film distribution?', 4th August 2014, http://stephenfollows.com/who-dominates-uk-film-distribution/

19. 'A Future For British Film: "It begins with the audience..."', 12th March 2012, p. 6, https://www.gov.uk/government/uploads/system/uploads/attachment_data/file/78460/DCMS_film_policy_review_report-2012_update.pdf For alternative formats see https://www.gov.uk/government/publications/a-future-for-british-film-it-begins-with-the-audience-report-on-the-film-policy-review-survey

20. 'A Future For British Film: "It begins with the audience..."', p. 27.

21. All quotes from Greg Day from an interview for this book, 2015.
22. From an interview for this book, 2015.
23. All quotes from Emily Booth from an interview for this book, 2015.
24. http://www.aintitcool.com/node/63891
25. The BBFC statement regarding its decision was: 'Hate Crime focuses on the terrorisation, mutilation, physical and sexual abuse and murder of the members of a Jewish family by the Neo Nazi thugs who invade their home. The physical and sexual abuse and violence are accompanied by constant strong verbal racist abuse. Little context is provided for the violence beyond an on-screen statement at the end of the film that the two attackers who escaped were subsequently apprehended and that the one surviving family member was released from captivity. It is the Board's carefully considered conclusion that the unremitting manner in which Hate Crime focuses on physical and sexual abuse, aggravated by racist invective, means that to issue a classification to this work, even if confined to adults, would be inconsistent with the Board's Guidelines, would risk potential harm, and would be unacceptable to broad public opinion. The Board considered whether its concerns could be dealt with through cuts. However, given that the fact that unacceptable content runs throughout the work, cuts are not a viable option in this case and the work is therefore refused a classification.'

9. GAMING AND THE INTERNET

1. https://roosterteeth.com/show/red-vs-blue is notable for being one of the earlier machinima shows – and for still being online today.
2. Coulton's music uses a Creative Commons licence (see http://creativecommons.org), which makes all kinds of fan-made content including YouTube videos of his work permissible. http://www.jonathancoulton.com
3. https://aliceandkev.wordpress.com/
4. Sample links:
London ComicCon – http://www.mcmcomiccon.com/london
The Victorian Steampunk Society – http://www.britishsteampunk.org/
Team Neko, List of UK/Irish Conventions, Events and Expos – http://teamneko.co.uk/list-of-uk-conventions-events-and-expos/
5. Sample links:
http://www.hackspace.org.uk/wiki/Main_Page
http://www.makerfaireuk.com/about/
htttp://www.shapeways.com

10. LGBT CULTURE

1. *Independent*, 24th February 2015.
2. *Guardian*, 13th October 2010.
3. In England and Wales, with Scotland to follow soon afterwards.
4. *Telegraph*, 6th February 2013

ENDNOTES

5. This definition by the Merriam-Webster Online Dictionary (2008).

6. *The Evening Standard*, 6th January 2015.

7. Stephen Fry's interview of 18th December 2014.

8. http://www.pinknews.co.uk 6th January 2015.

9. 'The Joiners Arms is Closing and it's a TRAVESTY,' *Vice* magazine, 4th November 2014.

10. For more on Putin's new legal reforms concerning 'non-traditional' sexual behaviour see Morris, Sarah, 'Vladimir Putin's attack on homosexuality is shattering the lives of Russians,' *Independent*, 13th January 2014.

11. *Guardian*, 13th October 2010.

11. LITERATURE

1. W.B. Yeats, 'Outlaws…' from Ross, David A., *Critical Companion to William Butler Yeats: A Literary Reference to His Life and Work*, Facts on File, 2009.

2. Mary Humphrey Ward, 'The dark and dangerous side of the women's movement,' http://spartacus-educational.com/WmarsdenD.htm The site is also the source of Dora Marsden's quote, 'the opposition of the capitalist press,' the description by the Crichton Royal Hospital of her condition as 'deep melancholia,' and general information on her life and work.

3. These early writings of Michael Moorcock, 'I think the fantasy…' and his description of Elvis Presley as talentless are both taken from issue 5 of his own *Jazz Fan* fanzine (1956). This can be viewed via the Image Hive at the Moorcock's Miscellany website http://www.multiverse.org/imagehive/index.php/bookcovers/fanzines/album109

4. *Comix* are small press comics which are usually satirical.

5. Quotes from Erica Smith drawn from an email interview by the author specifically for this chapter, but also making use of Erica's article 'Tell Me About Riot Grrrl', written in 2009 for Jane Graham's proposed anthology *Where Have All The Zine Girls Gone*, but unpublished; accessed via Erica's Facebook page and used with permission.

6. From an interview for this book, 2015.

7. From an interview for this book, 2015.

8. From an interview for this book, 2015.

12. MUSIC

1. DeNora, Tia, *Music in Everyday Life*, Cambridge University Press, 2000, p. 86.

2. Osgerby, Bill, *'Teenage Kicks': Youth and Consumption in Post-War Britain' in Youth in Britain Since 1945*, Blackwell, Oxford, 1998, pp. 31, 40–49.

3. Frith, Simon, *Sound Effects: Youth, Leisure and the Politics of Rock 'n' Roll*, Pantheon Books, New York, USA, 1981, p. 33.

4. Perone, James, *Mods, Rockers, and the Music of the British Invasion*, Praeger

Publishers, Connecticut, USA, 2009, p. 35.

5. Negus, Keith, *Popular Music in Theory: An Introduction*, Polity Press, Cambridge, 1996, pp. 141–142, 155.

6. Frith, p. 11, 14.

7. Cited in Boynes, Georgina, *The Imagined Village: Culture, Ideology and the English Folk Revival*, Manchester University Press, 1993, p. 26.

8. Meek, Jo, 'Eel Pie's Place in Rock History' in *BBC News Online* (30th January 2007), http://news.bbc.co.uk/1/hi/entertainment/6310309.stm (accessed 19th January 2015).

9. Membery, York, 'Rock Legends of Eel Pie' in *The Sunday Express Online* (20th April 2009), http://www.express.co.uk/expressyourself/96061/Rock-legends-of-Eel-Pie (accessed 19th January 2015).

10. Wheatley, Jennifer C., *The British Beat Explosion*, Aurora Metro, London, 2013.

11. Macan, Edward, *Rocking the Classics: English Progressive Rock and the Counterculture*, Oxford University Press, 1997, pp. 18–19.

12. Weinstein, Deena, *Heavy Metal: A Cultural Sociology*, Lexington Books, New York, USA, 1991, pp. 16–17.

13. Hebdige, Dick, *Subculture: The Meaning of Style*, Routledge, London, 1979, p. 113.

14. Greene, Doyle, *The Rock Cover Song: Culture, History, Politics*, McFarland and Company Inc., North Carolina, USA, 2014, p. 29.

15. LeBlanc, Laurane, *Pretty in Punk: Girls' Gender Resistance in a Boys' Subculture*, Rutgers University Press, New Jersey, USA, 1999, p. 37.

16. LeBlanc, p. 35.

17. Greene, p.29.

18. Haenfler, Ross, *Goths, Gamers, and Grrrls: Deviance and Youth Subcultures*, Oxford University Press, 2010, p. 30.

19. Greene, p. 30.

20. Laing, Dave, 'Listening to Punk' in Gelder, Ken (ed.) *The Subcultures Reader*, second edition, Routledge, Oxon and New York, 1985, 2005, p. 448. See also pp. 449–459.

21. Laing, p. 448.

22. Haenfler, p. 33.

23. Shapiro, Harry, 'Dances With Drugs: Pop Music, Drugs and Youth Culture' in South, Nigel (ed.) *Drugs: Cultures Controls and Everyday Life*, Sage, London, 1999, p. 24.

24. Thornton, Sarah, *Club Cultures: Music, Media and Subcultural Capital*, Polity Press, Cambridge, 1995, p. 57.

25. Thornton, p. 89.

26. Warren, Emma, 'The Birth of Rave' in *The Guardian Online* (12th August 2007), http://www.theguardian.com/music/2007/aug/12/electronicmusic

ENDNOTES

(accessed 25th January 2015).

27. Bainbridge, Luke, 'Acid House and the Dawn of a New Rave World' in *The Guardian Online* (23rd February 2014), http://www.theguardian.com/music/2014/feb/23/acid-house-dawn-rave-new-world, (accessed 25th January 2015).

28. Bainbridge, Luke, 'Madchester Remembered: "There Was Amazing Creative Energy at the Time"' in *The Guardian Online* (21st April 2012), http://www.theguardian.com/music/2012/apr/21/madchester-manchester-interviews-hook-ryder (accessed 24th Janurary 2015).

29. Sawyer, Miranda, 'How Manchester Put the E into Enterprise Zone' in *The Guardian Online* (21st April 2012), http://www.theguardian.com/music/2012/apr/21/madchester-manchester-stone-roses (accessed 24th January 2015).

30. Reynolds Simon, *Generation Ecstasy: Into the World of Techno and Rave Culture*, Routledge, New York, 1999, p. 60.

31. Ward, Danielle, *The Influence of the 'Hip-Hop Lifestyle' on the Possession and Use of Weapons by Young Male Gang Members in the UK*, dissertation, Sheffield Hallam University, 2011, p. 14, http://www.cjp.org.uk/EasysiteWeb/getresource.axd?AssetID=5419&type=full&servicetype=Attachment (accessed 17th March 2015).

32. Higgs, John, *The KLF: Chaos, Magic and the Band who Burned a Million Pounds*, Phoenix, London, 2013, p. 193.

33. Thornton, p. 65.

34. Thornton, p. 123.

35. Thornton, p. 90, 145.

36. Thornton, p. 141–144.

37. Thornton, p. 147.

38. Negus, Keith, *Popular Music in Theory: An Introduction*, Polity Press, Cambridge, 1996, p. 36.

39. Adorno, Theodor, 'Culture Industry Reconsidered' in *The Culture Industry: Selected Essays on Mass Culture*, Routledge, London, 1991 [1975], p. 85.

40. Adorno, p. 92.

41. Negus, p. 414.

42. Frith, p. 5.

43. Negus, p. 141.

44. Peterson, Richard A. and Berger, David G., 'Cycles in Symbol Production: The Case of Popular Music' in *American Sociological Review* vol. 40 no. 2, 1975, pp.158–173, http://www.jstor.org/discover/10.2307/2094343?sid=21105815452343&uid=4&uid=3738032&uid=2 (accessed 1st January 2015).

45. Negus, p. 85.

46. Thornton, p. 148.

47. Hesmondhalgh, David, 'The British Dance Music Industry: A Case Study of Independent Cultural Production' in *The British Journal of Sociology* vol. 49 no. 2, 1998, p. 237, http://www.jstor.org/discover/10.2307/591311?sid=21105817409623&uid=2&uid=4&uid=3738032 (accessed 1st February 2015).

48. Huba, Jackie, *Monster Loyalty: How Lady Gaga Turns Followers into Fanatics*, Portfolio/Penguin, New York, USA, 2013, p. 3.

49. Gaffney, Kevin, *The Lady Gaga Saga*, MA Dissertation, Royal College of Art, 2010, http://m.friendfeed-media.com/2186dc874d35185271bb3c371471e52e266a4417 (accessed 30th December 2015).

50. Winterman, Denise and Kelly, John, 'Five Interpretations of Lady Gaga's Meat Dress' in *BBC News Magazine Online* (14th September 2010), http://www.bbc.co.uk/news/magazine-11297832 (accessed 15th March 2015).

51. Ward, Kate, 'Lady Gaga Says She Stayed Incubated in Grammy 'Vessel' for 72 Hours' in *Entertainment Weekly Online* (15th February 2011), http://www.ew.com/article/2011/02/15/lady-gaga-egg-72-hours (accessed 15th March 2015).

52. Talbott, Chris, 'Lady Gaga Was Puked On (For Art) During Her SXSW Show' in *The Huffington Post* (14th March 2014), http://www.huffingtonpost.com/2014/03/14/lady-gaga-sxsw_n_4963216.html (accessed 14th March 2015).

53. Gray II, Richard J., *The Performance Identities of Lady Gaga: Critical Essays*. McFarland, London, 2012.

54. Gaffney.

55. Hiatt, Brian, 'New York Doll: Lady Gaga Worships Warhol. Kisses Girls (For Real). And She's the Biggest New Pop Star of 2009' in *Rolling Stone* (11th June 2009), Wenner Media LLC, New York, USA, pp. 58, 56–61.

56. Davisson, Amber L., *Lady Gaga and the Remaking of Celebrity Culture*, McFarland and Company Inc., North Carolina, USA, 2013, p. 23.

57. Hiatt, p. 59

58. Huba, pp 40–44.

59. Ayson, Em, *Mother Monster's Little Monsters and Identity: An Investigation of the Subcultural and Post-Subcultural Identities of Lady Gaga Fans*, BA Dissertation, University of East Anglia, 2013.

60. Dahlgreen, Will, 'The Average Brit Knows 3.1 Lesbians and 5.5 Gay Men' at YouGovUK, (4th July2014), https://yougov.co.uk/news/2014/07/04/average-brit-knows-31-lesbians-55-gay-men/ (accessed 5th February 2015).

13. NEGATIVE SPACE

1. *Time Out*, March 2015.

2. Mailer, Norman, 'The White Negro: Superficial Reflections on the

Hipster,' 1957, https://www.dissentmagazine.org/article/the-white-negro-superficial-reflections-on-the-hipster (accessed 25th August 2015).

3. 'Senior Muslim lawyer says British teenagers see ISIS as "pop idols"', *Guardian*, 5th April 2015.

4. From an interview for this book, 2015.

14. THEATRE

1. Segel, Harold B., *Pinocchio's Progeny*, The John Hopkins University Press, Baltimore, USA, 1995, p.14.

2. Innes, Christopher, *Avant-Garde Theatre 1892–1992*, Routledge, London, 2003, p. 3.

3. Tynan would go on to attempt his own countercultural piece fourteen years later, with *Oh! Calcutta!* (1969), a show with sketches written by Beckett, John Lennon, Sam Shephard and number of other counterculture and avant-garde figures. In some ways a British (and international) answer to *Hair* (1967), it similarly grew from a fringe work into a cultural sensation, while featuring even more nudity and sexual frankness than even *Hair* dared. Though it debuted Off-Broadway, it was a largely British production, and transferred to London in 1970, where it ran for over 3,900 performances.

4. *Guardian*, 9th May 2014.

5. *Telegraph*, 8th May 2014.

6. Peter Brook, National Theatre Platform http://www.nationaltheatre.org.uk/discover-more/platforms/platform-papers/peter-brook

7. *Guardian*, 19th March 2015.

8. *Oh! What a Lovely War!* is still a subversive piece of theatre even in 2015. Restaged twice in the 1960s and then three times since 2000, it is, in this centenary year of the start of the First World War, at odds with the jingoistic tone adopted by the government of the United Kingdom, and was singled out, along with *Blackadder Goes Forth*, as the kind of liberal pacifist propaganda that endangers our children's ability to perceive history 'correctly'.

9. Eyre, Richard and Wright, Nicholas, *Changing Stages*, Bloomsbury, London, 2000, p. 264.

10. Sainer, Arthur, *The Radical Theatre Notebook*, Avon Books, New York, USA, 1975, pp 12–13.

11. Eyre and Wright, p. 268.

12. Although to my mind the 60s really kicked into gear between the 14th and 16th of April 1966, when the Beatles recorded 'Rain' and 'Paperback Writer'.

13. Kershaw, Baz, *The Radical in Performance*, Routledge, Oxford, 2005, p. 60.

14. 'Something in the air' was a 1969 UK Number One hit by the band Thunderclap Newman (formed by Pete Townsend from The Who and their manager Kit Lambert).

15. The People Show, 2014.

16. These existed all over Europe, in the larger cosmopolitan centres. The Chat Noir in Paris, the Letuchaya Mysh in Moscow, the Cabaret Fledermaus in Vienna all ran famous Artist's Cabarets; in Barcelona, the Quatre Gats involved a young Pablo Picasso. Charles Rearick describes the appeal and ambience of the Montmartre cabaret: 'As a refuge from the workaday world, the cabaret imparted the illusions of theatre, but with much more spontaneity and interaction and spectacle, clients and performers... When not performing, the artists mingled with the customers, a kind of festive fraternity took the place of rigid roles and hierarchies entrenched in everyday society outside.' Rearick, Charles, *Pleasures of the Belle Epoque: Entertainment and Festivity in Turn of the Century France*, New Haven, 1985, p. 59.

17. Sainer, p. 16.

18. Huyssen, Andreas, *After the Great Divide: Modernism, Mass Culture, 'Postmodernism'*, Indiana University Press, Bloomington and Indianapolis, USA, 1986, p. 187.

19. Hartnoll, Phyllis, *The Theatre: a Concise History*, Thames and Hudson, London, 1989, p. 259.

20. Kershaw, Baz, *The Radical in Performance*, Routledge, Oxford, 2005, p. 62.

21. Nuttall, Jeff, *Bomb Culture*, MacGibbon & Kee, London, 1968, p. 161.

22. Compare the UK situation with that of the U.S, where parts of the countercultural theatre scene began to be described as 'off-off-Broadway'. Writing in 1966, *Village Voice* critic Michael Smith described it thus: 'It is amateur theater done largely by professionals. It is theater with no resources but the most sophisticated audience in America. It is both casual community theater and dedicated experimental theater. It is proposing an alternative to an established theater which hardly knows it exists.' (Smith, quoted in Cody and Sprinchorn, 2007: p. 990) Cody, Gabrielle H. and Sprinchorn, Evert, *The Columbia Encyclopaedia of Modern Drama*, vol. 2. Columbia University Press, New York, USA, 2007, p. 990.

23. Kershaw, p. 59.

24. Barba, Eugenio. *TDR (The Drama Review/Tulane Drama Review)*, vol. 19, no. 4 p. 53.

25. Cohen-Cruz, Jan (ed.), *Radical Street Performance: an International Anthology*, Routledge, London, 1998, p. 169.

26. Innes, p.8.

27. *Saved* was another production which fell foul of the Lord Chamberlain: in this case those involved in producing the play were prosecuted and fined. This drew the ire of many, including Laurence Olivier who wrote in the play's defence; ultimately the case reflected badly on the Lord Chamberlain's office, and was an important factor in its demise a few years later in 1968.

28. McGrath, John, *The Year of the Cheviot – the Cheviot, the Stag and the Black, Black Oil*, Methuen, London, 1981, p. 56.

29. Sainer, p. 12.

ENDNOTES

30 Though there is good evidence that *Fountain* is actually the work of one of Duchamp's friends, either Louise Norton, a writer and editor, or Baroness Elsa von Freytag-Loringhoven, a fellow Dadaist.

31. Berghaus in Sandford, Mariellen R. (ed.), *Happenings and Other Acts*, Routledge, London and New York, 1995, p. 368.

32. In that same year, 1965, Ginsberg stated that 'Liverpool is at the present moment the centre of consciousness of the human universe,' (Ginsberg, quoted in Bowen) though Bowen suggests that he was really referring to the Beatles, rather than the Liverpudlian countercultural poets and performance artists who had joined the American Beat poets on stage in the International Poetry Incarnation. Bowen, Phil. *A Gallery to Play to: The Story of the Mersey Poets*, Liverpool University Press, 2008, p. 65.

33. Nuttall, quoted in Bowen, p. 64.

34. Both Suvin and Berghaus suggest a 'downturn of the Happenings trend in 1967' (Suvin, cited in Sandford), and in Europe in particular, a 'profound and pervasive politicisation of the Happenings genre'. (Berghaus, cited in Sandford). Sandford, p. xvii.

35. Heddon, Deirdre and Milling, Jane, *Devising Performance: a Critical History*, Palgrave Macmillan, Basingstonke, 2006, p. 17.

36. Tom Wolfe crystallised this idea in his 1976 essay 'The 'Me' Decade and the Third Great Awakening'.

37. Marcuse, Herbert, *An Essay on Liberation*, Penguin, London, 1969, p. 6.

38. Two names closely associated with the avant-garde: Jarry is credited with its invention.

39. Sierz, Aleks, *In-Yer-Face Theatre*, Faber and Faber, London, 2001.

40. Heddon and Milling, p. 50.

41. Berghaus, Gunter, *Avant-Garde Performance*, Palgrave Macmillan, Basingstoke, 2005, p. 262.

42. Schechner, 1992: p. 8.

15. YOUTUBE AND SOCIAL MEDIA

1. In software development, a *beta test* is the second phase of software testing in which a sampling of the intended audience tries the product out.

2. 'The Real HELLO, HARTO!' https://www.youtube.com/watch?v=l1XRx1RvkvY

3. 'Top That! | The Most Inspiring Coming Out Videos on YouTube | Pop Culture News' published by POPSUGAR Girls' Guide, 10th October 2014, https://www.youtube.com/watch?v=EM_Qd0_VYFQ

4. According to a survey conducted by the charity Youth Chances (http://www.youthchances.org) in 2014.

5. All quotes from Lucy Sutcliffe from an interview for this book, 2105.

6. http://www.bbc.co.uk/news/uk-england-hampshire-26327661

7. From an interview for this book, 2015.

Index

Out-of-chapter references are marked with italics.

4. Dance

5. Disability Arts and Activism

6. Environmentalism

14. Theatre

15. Youtube and Social Media